A.I. ARTIFICIAL INTELLIGENCE

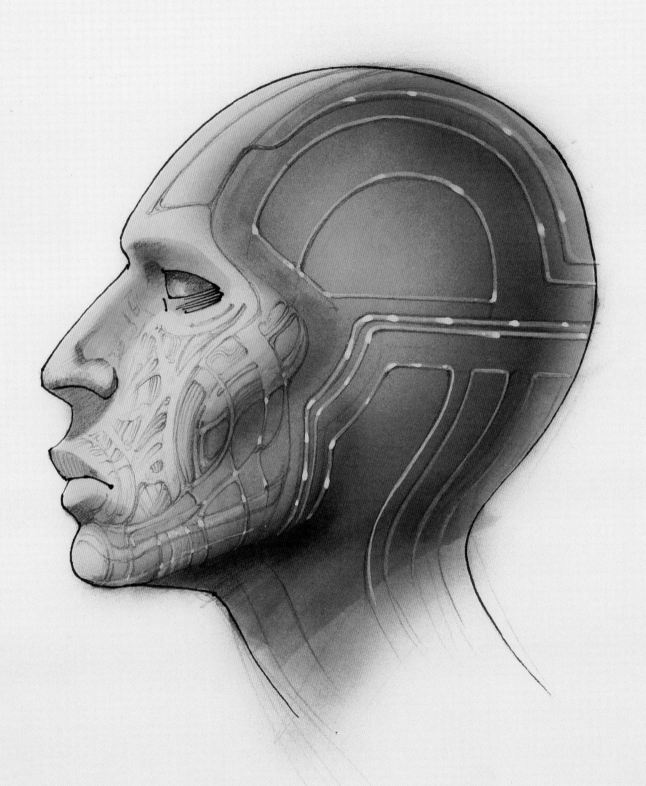

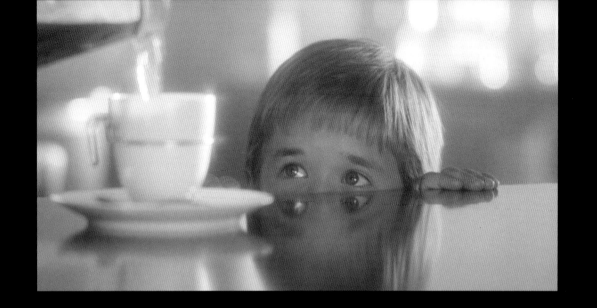

'One of the fascinating questions that arise in envisioning computers more intelligent than men is at what point machine intelligence deserves the same consideration as biological intelligence.... You could be tempted to ask yourself in what way is machine intelligence any less sacrosanct than biological intelligence, and it might be difficult to arrive at an answer flattering to biological intelligence.'

ARTIFICIAL INTELLIGENCE

FROM STANLEY KUBRICK TO STEVEN SPIELBERG: THE VISION BEHIND THE FILM

CONCEPT DRAWINGS BY CHRIS BAKER

EDITED BY JAN HARLAN AND JANE M. STRUTHERS

WITH 250 ILLUSTRATIONS, 103 IN COLOUR

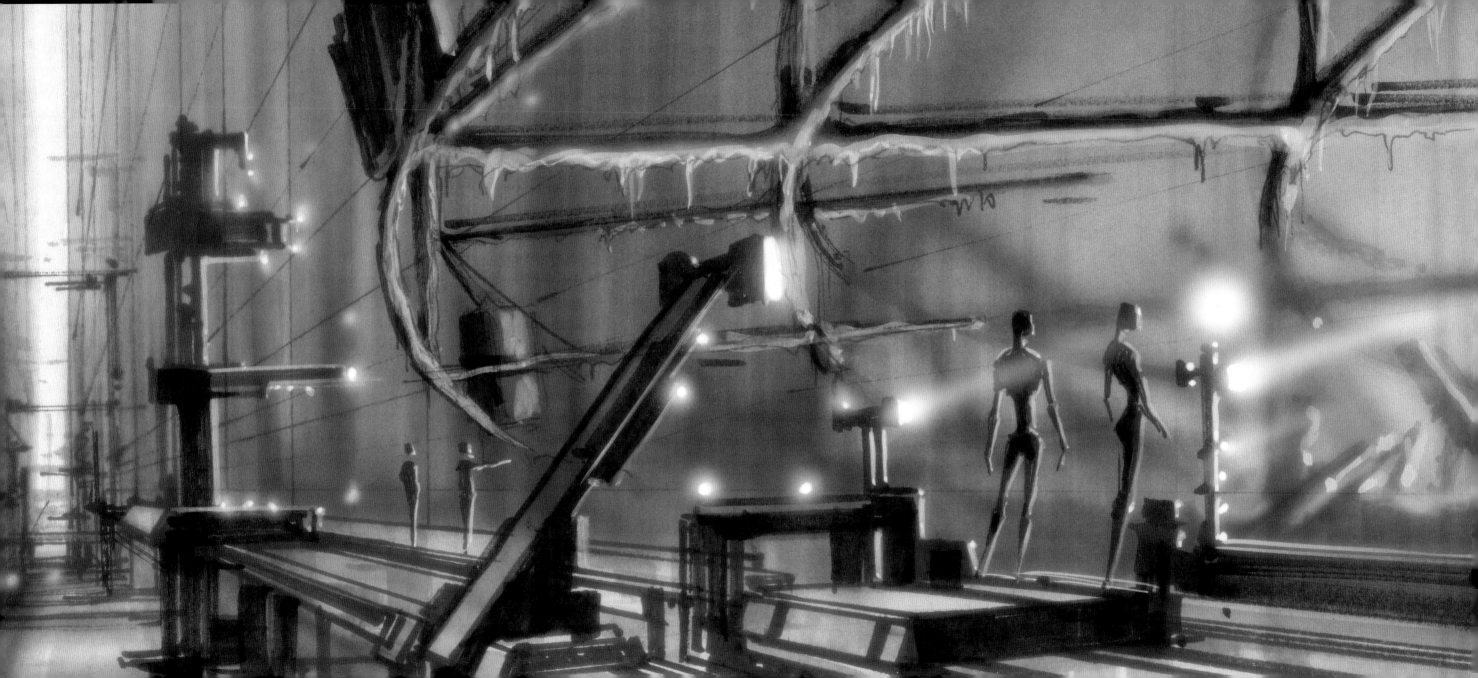

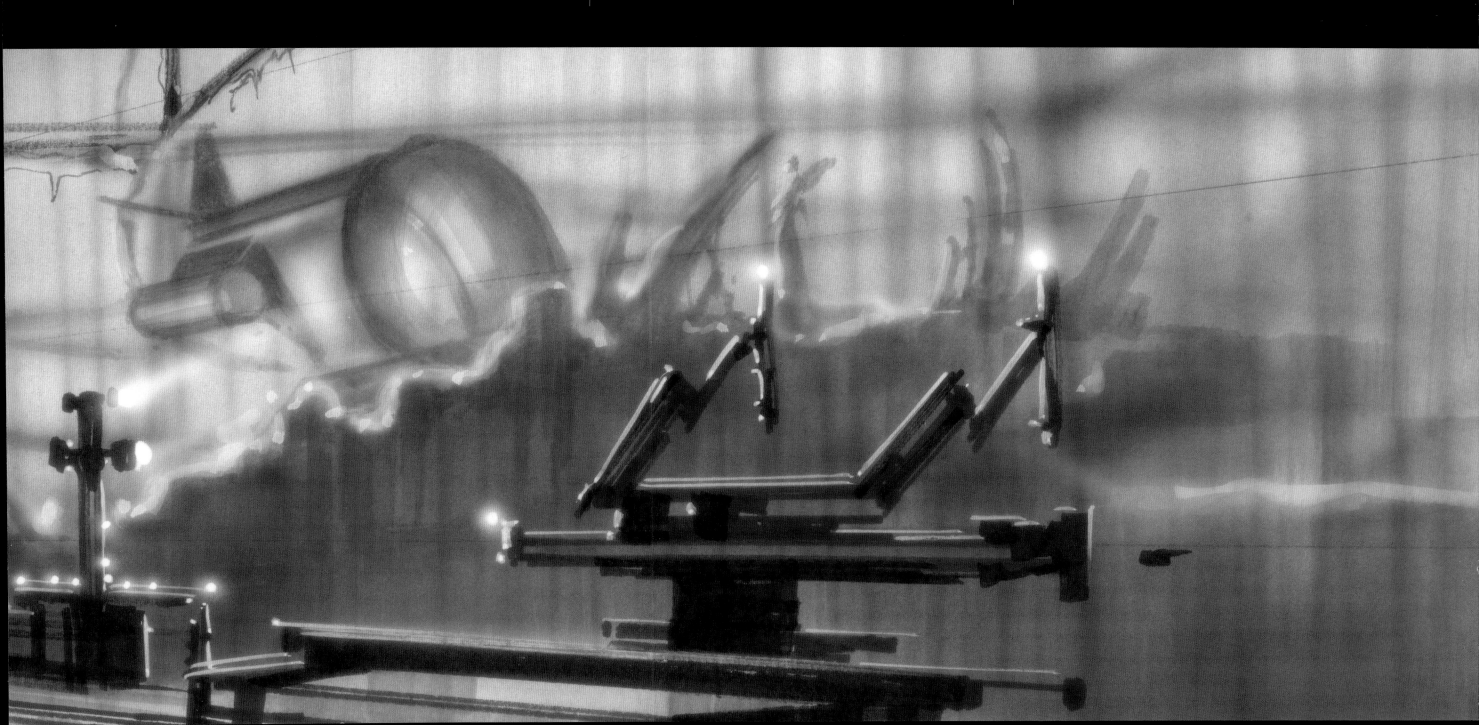

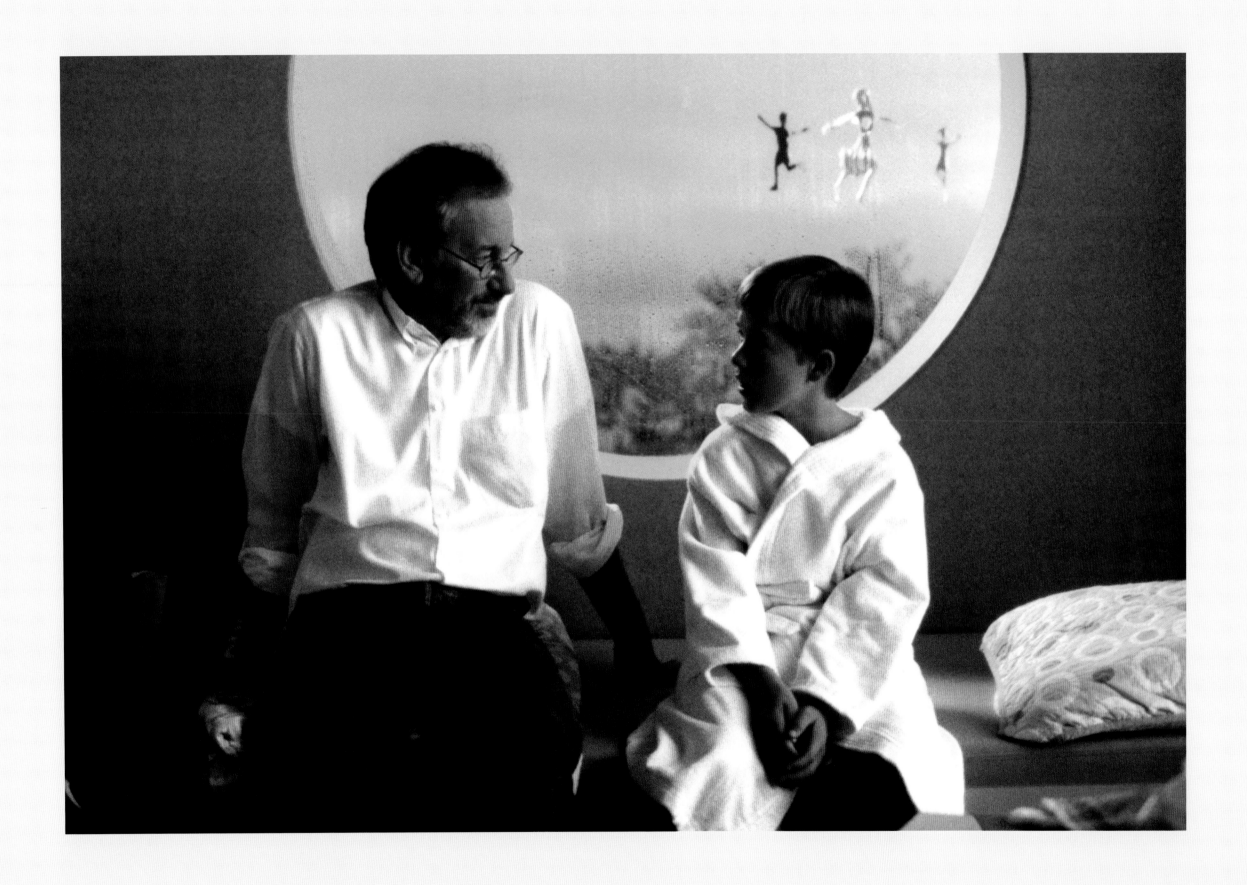

Foreword

My friend Stanley Kubrick didn't just research a subject. Research to him was like filmmaking to the rest of us. This was a personal process for Stanley, and few, if any, had the chance to peek behind the curtain and see the Wizard at work. Consider this book your admittance to Oz.

I first looked behind the curtain in 1984 when Stanley told me about his plans to adapt Brian Aldiss's short story 'Super-Toys Last All Summer Long' as a feature film called *A.I.* Stanley and I had been friends for several years and this was the first time he had ever confided in me about a project. I was captivated as he told me the story of a robot boy named David whose quest to become a real boy spoke to my own sensibilities of love and loss. We discussed the complicated effects work Stanley envisioned for the film, and pored over his research for David and the other non-human characters. Unfortunately these elements all required visual-effects technology that was not available at the time, and Stanley was exploring every possibility he could think of, including using actual robots. We talked many times after that day but would never speak of *A.I.* again until nearly ten years later.

Meanwhile the research continued, and Stanley was not one to be rushed. No one tackled information-gathering like him, and the sagging bookshelves and stuffed cabinets of his home in St Albans were a testament to his search for knowledge. Stanley had decided *A.I.* would simply have to wait for the technology to catch up with his vision for the film rather than make use of the limited effects capabilities of the era.

Stanley finally saw what he was after with the release of *Jurassic Park* in 1993. The magicians and wizards of George Lucas's company Industrial Light and Magic (ILM) created and launched the digital age when they made audiences believe dinosaurs could walk among us. At Stanley's request I flew to St Albans after the film's release to meet him about *A.I.* again. This time Stanley was armed with even more research on Artificial Intelligence, including thousands of sketches and conceptual designs he had worked on with Chris Baker since our initial conversations nearly ten years before. For a cinema lover like myself, it was like discovering an album's worth of unreleased Beatles' tracks in the attic of Abbey Road Studios.

Not that my ticket to Oz was without a price. I was sworn to an oath of secrecy issued by Stanley himself, whereby 'under penalty of excommunication from his life' I agreed never to divulge what he showed me. Stanley also surprised me with his suggestion that he produce the film for me to direct. As honoured as I was, I encouraged him to direct *A.I.* himself despite his reservations. We worked on the film for another couple of years and continued to argue as to who should take the helm. We both got sidetracked with other projects along the way, always hoping to come back to *A.I.* down the road, be it in two years or ten. Unfortunately we would not have another chance....

From the architecture of Rouge City to the Blue Fairy submerged among the ruins of Coney Island, this book goes a long way in showing just how much of *A.I.* was Stanley's vision. It was a thrilling challenge to pick up where he left off and interpret the vision of such a gifted individual through the filter of my own sensibilities. I am grateful I had the opportunity to honour my friend in the medium he revered and defined. To be honest, as proud of the film as I may be, I still wish we could have seen Stanley's version of *A.I.* It might have been his greatest achievement.

STEVEN SPIELBERG

Blown by a Strong Wind Over the Legal Mountains

More than one thousand delightful drawings by Chris Baker lay in four boxes on a shelf in my office. After Stanley's death in 1999, I saw the material slide into the ocean of oblivion – the story, the script, the drawings, the failed experiments, the enthusiasm and love for this daring project. But Steven Spielberg rescued it ... the only man authorized by Stanley himself to take over. 'He is the better director for this anyway,' I hear Stanley say, and Stanley would have applauded to see his dream come true, to see Steven's light touch added to his own rather black and bleak vision of man's destiny.

It is almost impossible to separate out what was Stanley's and what was Steven's in the finished film, so seamlessly did the collaboration work and so profoundly did Steven understand what Stanley had been trying to achieve. Steven's script developed characters, dropped and added scenes, and drove the plot forward, but all the while Steven respected Stanley's vision utterly. During the making, both filmmakers wished their work to remain private – as Steven has said, Stanley swore him to secrecy on the project, and Steven himself kept both script and set confidential. This is as it should be, and this book aims to honour that creative collaboration.

Stanley's great love for the project led to the development of the vast undertaking in 1993, with financing from Warner Bros. But love makes blind, and Stanley had closed his eyes to a very big problem: how to film David, the little boy, without casting a child actor. A lot of money was spent trying to build an artificial boy, but it just did not work. Nobody would have believed that the mother character could fall in love with a puppet. Using a child actor was the obvious answer, but this was not what Stanley wanted. The boy was supposed to be a smooth robot, the brilliant first generation of a new super-computer, and so it was imperative that David remained totally unchanged. On the other hand, Stanley was realistic enough to know that little boys do change over the long shooting period that he would need for himself. Stanley also knew that Steven, with all his natural talent for this sort of story, would execute the shooting of the film in a fraction of the time he himself would need, and that Steven therefore could use a real boy. And that was of course what Steven did, and with fantastic success. I hear Stanley telling me: 'See, I told you so.'

When I called Chris Baker about an idea for a book, he was instantly enthusiastic, as were Brian Aldiss and Christiane Kubrick. The problem was that we had no rights whatsoever to do it – those were with Warner Bros., by now probably interwoven with DreamWorks or other legal entities. My only hope was Steven. When I called him proposing the book, he instantly said, 'What a great idea, and I'll write the foreword!' This was the heavy gun I needed, and with the help of Jeremy Williams, an enlightened legal executive at Warner Bros., all the necessary clearances fell into my lap. Thank you Steven, thank you Jeremy.

When Chris Baker later spoke to Steven and asked him for permission to include some frames from the film itself, he was told, 'Just take whatever you want.' This does not happen in the real world. Or does it?

When we started work on this book, we did not have a publisher. Nevertheless we spent time and money preparing it. This is one of the many things I learned from Stanley: first love it – then worry about how to do it.

JAN HARLAN

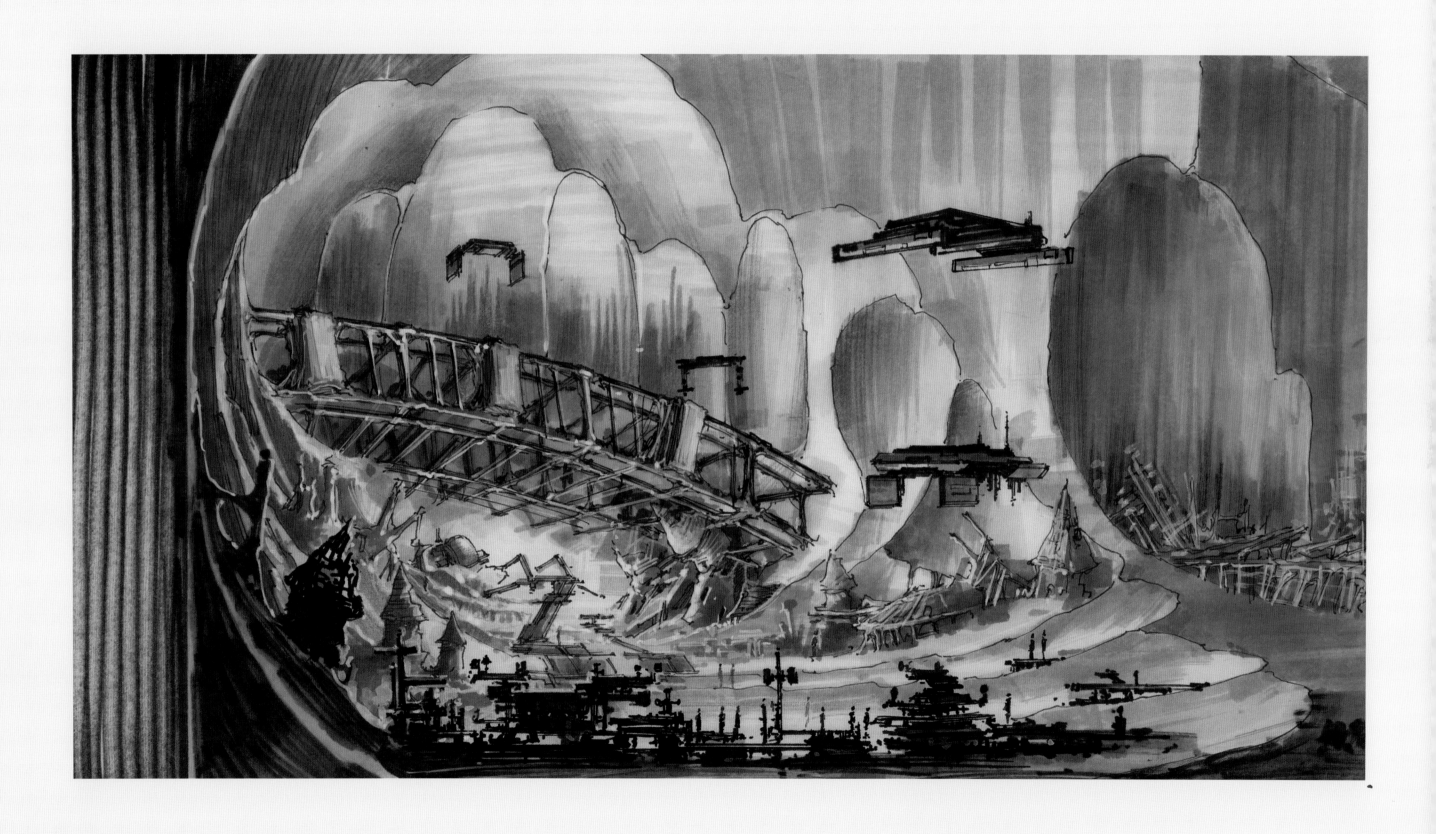

Stanley Kubrick conceived *A.I. Artificial Intelligence* as a future fairy tale. He thought that the folkloric form of the fairy-tale archetype could, and often did, embody profound themes of human existence. Ideas about imagination and dreams, love and loss, and anxiety and resolution are manifest in many of these stories. Ostensibly written as salutary lessons for children, yet containing qualities not dissimilar to epic myths such as Homer's *Odyssey*, they also use a formal device cherished by Kubrick – that of the narrator.

Kubrick's initial inspiration for *A.I.* was 'Super-Toys Last All Summer Long', a short story by the British writer Brian W. Aldiss, first published in 1969 and subsequently included in his 1970 anthology *The Moment of Eclipse*. The story introduces the character of David, son to Monica and Henry Swinton. David, whose only companion is a teddy bear, is unable to please his mother however hard he tries, but not until the end is it revealed that he is an android. This narrative, which also touches on themes of loneliness and isolation in an overpopulated world, formed the basis for the first part of *A.I.*

THE MOMENT OF ECLIPSE
Brian W. Aldiss

ABOVE **Front cover** of the 1970 Brian W. Aldiss anthology, *The Moment of Eclipse*.

SUPER-TOYS LAST ALL SUMMER LONG

IN MRS. SWINTON's garden, it was always summer. The lovely almond trees stood about it in perpetual leaf. Monica Swinton plucked a saffron-coloured rose and showed it to David.

"Isn't it lovely?" she said.

David looked up at her and grinned without replying. Seizing the flower, he ran with it across the lawn and disappeared behind the kennel where the mowervator crouched, ready to cut or sweep or roll when the moment dictated. She stood alone on her impeccable plastic gravel path.

She had tried to love him.

When she made up her mind to follow the boy, she found him in the courtyard floating the rose in his paddling pool. He stood in the pool engrossed, still wearing his sandals.

"David, darling, do you have to be so awful? Come in at once and change your shoes and socks."

He went with her without protest into the house, his dark head bobbing at the level of her waist. At the age of three, he showed no fear of the ultra-sonic dryer in the kitchen. But before his mother could reach for a pair of slippers, he wriggled away and was gone into the silence of the house.

He would probably be looking for Teddy.

Monica Swinton, twenty-nine, of graceful shape and lambent eye, went and sat in her living-room, arranging her limbs with taste. She began by sitting and thinking; soon she was just sitting. Time waited on her shoulder with the maniac

sloth it reserves for children, the insane, and wives whose husbands are away improving the world. Almost by reflex, she reached out and changed the wavelength of her windows. The garden faded; in its place, the city centre rose by her left hand, full of crowding people, blowboats, and buildings—but she kept the sound down. She remained alone. An overcrowded world is the ideal place in which to be lonely.

The directors of Synthank were eating an enormous luncheon to celebrate the launching of their new product. Some of them wore the plastic face-masks popular at the time. All were elegantly slender, despite the rich food and drink they were putting away. Their wives were elegantly slender, despite the food and drink they too were putting away. An earlier and less sophisticated generation would have regarded them as beautiful people, apart from their eyes.

Henry Swinton, Managing Director of Synthank, was about to make a speech.

"I'm sorry your wife couldn't be with us to hear you," his neighbour said.

"Monica prefers to stay at home thinking beautiful thoughts," said Swinton, maintaining a smile.

"One would expect such a beautiful woman to have beautiful thoughts," said the neighbour.

Take your mind off my wife, you bastard, thought Swinton, still smiling.

He rose to make his speech amid applause.

After a couple of jokes, he said, "Today marks a real breakthrough for the company. It is now almost ten years since we put our first synthetic life-forms on the world market. You all know what a success they have been, particularly the miniature dinosaurs. But none of them had intelligence.

"It seems like a paradox that in this day and age we can create life but not intelligence. Our first selling line, the Crosswell Tape, sells best of all, and is the most stupid of all."

Everyone laughed.

70

71

"Though three-quarters of our overcrowded world are starving, we are lucky here to have more than enough, thanks to population control. Obesity's our problem, not malnutrition. I guess there's nobody round this table who doesn't have a Crosswell working for him in the small intestine, a perfectly safe parasite tape-worm that enables its host to eat up to 50 per cent more food and still keep his or her figure. Right?" General nods of agreement.

"Our miniature dinosaurs are almost equally stupid. Today, we launch an intelligent synthetic life-form—a full-size serving-man.

"Not only does he have intelligence, he has a controlled amount of intelligence. We believe people would be afraid of a being with a human brain. Our serving-man has a small computer in his cranium.

"There have been mechanicals on the market with mini-computers for brains—plastic things without life, super-toys—but we have at last found a way to link computer circuitry with synthetic flesh."

David sat by the long window of his nursery, wrestling with paper and pencil. Finally, he stopped writing and began to roll the pencil up and down the slope of the desk-lid.

"Teddy!", he said.

Teddy lay on the bed against the wall, under a book with moving pictures and a giant plastic soldier. The speech-pattern of his master's voice activated him and he sat up.

"Teddy, I can't think what to say!"

Climbing off the bed, the bear walked stiffly over to cling to the boy's leg. David lifted him and set him on the desk.

"What have you said so far?"

"I've said——" He picked up his letter and stared hard at it. "I've said, 'Dear Mummy, I hope you're well just now. I love you....'"

There was a long silence, until the bear said, "That sounds fine. Go downstairs and give it to her."

72

[handwritten margin: 1969 stuff]
[handwritten margin: yucky line]

[handwritten top: This is a nice conversation – but in a movie blockbuster?!]

Another long silence.

"It isn't quite right. She won't understand."

Inside the bear, a small computer worked through its programme of possibilities. "Why not do it again in crayon?"

When David did not answer, the bear repeated his suggestion. "Why not do it again in crayon?"

David was staring out of the window. "Teddy, you know what I was thinking? How do you tell what are real things from what aren't real things?"

The bear shuffled its alternatives. "Real things are good."

"I wonder if time is good. I don't think Mummy *likes* time very much. The other day, lots of days ago, she said that time went by her. Is time real, Teddy?"

"Clocks tell the time. Clocks are real. Mummy has clocks so she must like them. She has a clock on her wrist next to her dial."

David had started to draw a jumbo-jet on the back of his letter. "You and I are real, Teddy, aren't we?"

The bear's eyes regarded the boy unflinchingly. "You and I are real, David." It specialized in comfort.

Monica walked slowly about the house. It was almost time for the afternoon post to come over the wire. She punched the G.P.O. number on the dial on her wrist but nothing came through. A few minutes more.

She could take up her painting. Or she could dial her friends. Or she could wait till Henry came home. Or she could go up and play with David....

She walked out into the hall and to the bottom of the stairs.

"David!"

No answer. She called again and a third time.

"Teddy!" she called, in sharper tones.

"Yes, Mummy!" After a moment's pause, Teddy's head of golden fur appeared at the top of the stairs.

"Is David in his room, Teddy?"

"David went into the garden, Mummy."

"Come down here, Teddy!"

73

[handwritten margin: The poor sod, doing the screenplay. I could drop all this stuff. The essence of the tale]
[handwritten margin: OK]

She stood impassively, watching the little furry figure as it climbed down from step to step on its stubby limbs. When it reached the bottom, she picked it up and carried it into the living-room. It lay unmoving in her arms, staring up at her. She could feel just the slightest vibration from its motor.

"Stand there, Teddy. I want to talk to you." She set him down on a tabletop, and he stood as she requested, arms set forward and open in the eternal gesture of embrace.

"Teddy, did David tell you to tell me he had gone into the garden?"

The circuits of the bear's brain were too simple for artifice.

"Yes, Mummy."

"So you lied to me."

"Yes, Mummy."

"*Stop* calling me Mummy! Why is David avoiding me? He's not afraid of me, is he?"

"No. He loves you."

"Why can't we communicate?"

"David's upstairs."

The answer stopped her dead. Why waste time talking to this machine? Why not simply go upstairs and scoop David into her arms and talk to him, as a loving mother should to a loving son? She heard the sheer weight of silence in the house, with a different quality of silence bearing out of every room. On the upper landing, something was moving very silently—David, trying to hide away from her....

He was nearing the end of his speech now. The guests were attentive; so was the Press, lining two walls of the banquetting chamber, recording Henry's words and occasionally photographing him.

"Our serving-man will be, in many senses, a product of the computer. Without computers, we could never have worked through the sophisticated biochemics that go into synthetic flesh. The serving-man will also be an extension of the computer—for he will contain a computer in his own head, a

74

[handwritten bottom: I know Stanley K has Pinocchio in mind. He wants David to become a real boy! How'd that be!?]

microminiaturized computer capable of dealing with almost any situation he may encounter in the home. With reservations, of course." Laughter at this; many of those present knew the heated debate that had engulfed the Synthank boardroom before the decision had finally been taken to leave the serving-man neuter under his flawless uniform.

"Amid all the triumphs of our civilization—yes, and amid the crushing problems of overpopulation too—it is sad to reflect how many millions of people suffer from increasing loneliness and isolation. Our serving-man will be a boon to them; he will always answer, and the most vapid conversation cannot bore him.

"For the future, we plan more models, male and female—some of them without the limitations of this first one, I promise you!—of more advanced design, true bio-electronic beings.

"Not only will they possess their own computers, capable of individual programming: they will be linked to the World Data Network. Thus everyone will be able to enjoy the equivalent of an Einstein in their own homes. Personal isolation will then be banished for ever!"

He sat down to enthusiastic applause. Even the synthetic serving-man, sitting at the table dressed in an unostentatious suit, applauded with gusto.

Dragging his satchel, David crept round the side of the house. He climbed on to the ornamental seat under the living-room window and peeped cautiously in.

His mother stood in the middle of the room. Her face was blank; its lack of expression scared him. He watched fascinated. He did not move; she did not move. Time might have stopped, as it had stopped in the garden.

At last she turned and left the room. After waiting a moment, David tapped on the window. Teddy looked round, saw him, tumbled off the table, and came over to the window. Fumbling with his paws, he eventually got it open.

75

[handwritten margin: up-date]
[handwritten margin: Web?]
[handwritten margin: This is quite funny.]
[handwritten bottom: Freeze-frame. Might look great]

*[handwritten top: * Should I have said here – straight out – that David is an android? Or will that wreck the fine balance of the story. And in a movie?]*

They looked at each other.

"I'm no good, Teddy. Let's run away!"

"You're a very good boy. Your Mummy loves you."

Slowly, he shook his head. "If she loves me, then why can't I talk to her?"

"You're being silly, David. Mummy's lonely. That's why she has you."

"She's got Daddy. I've got nobody 'cept you, and I'm lonely."

Teddy gave him a friendly cuff over the head. "If you feel so bad, you'd better go to the psychiatrist again."

"I hate that old psychiatrist—he makes me feel I'm not real." He started to run across the lawn. The bear toppled out of the window and followed as fast as its stubby legs would allow.

Monica Swinton was up in the nursery. She called to her son once and then stood there, undecided. All was silent.

Crayons lay on his desk. Obeying a sudden impulse, she went over to the desk and opened it. Dozens of pieces of paper lay inside. Many of them were written in crayon in David's clumsy writing, with each letter picked out in a colour different from the letter preceding it. None of the messages was finished.

"MY DEAR MUMMY, HOW ARE YOU REALLY DO YOU LOVE ME AS MUCH——"

"DEAR MUMMY, I LOVE YOU AND DADDY AND THE SUN IS SHINING——"

"DEAR DEAR MUMMY, TEDDY'S HELPING ME TO WRITE TO YOU. I LOVE YOU AND TEDDY——"

"DARLING MUMMY, I'M YOUR ONE AND ONLY SON AND I LOVE YOU SO MUCH THAT SOME TIMES——"

"DEAR MUMMY, YOU'RE REALLY MY MUMMY AND I HATE TEDDY——"

"DARLING MUMMY, GUESS HOW MUCH I LOVE——"

"DEAR MUMMY, I'M YOUR LITTLE BOY NOT TEDDY AND I LOVE YOU BUT TEDDY——"

76

[handwritten margin: Funny but sad.]
[handwritten margin: If you want Flannery, you eat throw this stuff out]

"DEAR MUMMY, THIS IS A LETTER TO YOU JUST TO SAY HOW MUCH HOW EVER SO MUCH——"

Monica dropped the pieces of paper and burst out crying. In their gay inaccurate colours, the letters fanned out and settled on the floor.

Henry Swinton caught the express home in high spirits, and occasionally said a word to the synthetic serving-man he was taking home with him. The serving-man answered politely and punctually, although his answers were not always entirely relevant to human standards.

The Swintons lived in one of the ritziest city-blocks, half a kilometre above the ground. Embedded in other gardens, their apartment had no windows on to the outside; nobody wanted to see the overcrowded external world. Henry unlocked the door with his retina-pattern-scanner and walked in, followed by the serving-man.

At once, Henry was surrounded by the friendly illusion of gardens set in eternal summer. It was amazing what Wholo-gram could do to create huge mirages in small space. Behind its roses and wistaria stood their house: the deception was complete: a Georgian mansion appeared to welcome him.

"How do you like it?" he asked the serving-man.

"Roses occasionally suffer from black spot."

"These roses are guaranteed free from any imperfections."

"It is always advisable to purchase goods with guarantees, even if they cost slightly more."

"Thanks for the information," Henry said dryly. Synthetic life-forms were less than ten years old, the old android mechanicals less than sixteen; the faults of their systems were still being ironed out, year by year.

He opened the door and called to Monica.

She came out of the sitting-room immediately and flung her arms round him, kissing him ardently on cheek and lips. Henry was amazed.

Pulling back to look at her face, he saw how she seemed to

77

[handwritten margin: chance here to see the built-up outside world]
[handwritten margin: Sked do this brilliantly]

generate light and beauty. It was months since he had seen her so excited. Instinctively, he clasped her tighter.

"Darling, what's happened?"

"Henry, Henry—oh, my darling, I was in despair.... But I've dialled the afternoon post and—you'll never believe it! Oh, it's wonderful!"

"For heaven's sake, woman, what's wonderful?"

He caught a glimpse of the heading on the photostat in her hand, still moist from the wall-receiver: Ministry of Population. He felt the colour drain from his face in sudden shock and hope.

"Monica... oh.... Don't tell me our number's come up!"

"Yes, my darling, yes, we've won this week's parenthood lottery! We can go ahead and conceive a child at once!"

He let out a yell of joy. They danced round the room. Pressure of population was such that reproduction had to be strictly controlled. Childbirth required government permission. For this moment, they had waited four years. Incoherently they cried their delight.

They paused at last, gasping, and stood in the middle of the room to laugh at each other's happiness. When she had come down from the nursery, Monica had de-opaqued the windows, so that they now revealed the vista of garden beyond. Artificial sunlight was growing long and golden across the lawn—and David and Teddy were staring through the window at them.

Seeing their faces, Henry and his wife grew serious.

"What do we do about *them*?" Henry asked.

"Teddy's no trouble. He works well."

"Is David malfunctioning?"

"His verbal communication-centre is still giving trouble. I think he'll have to go back to the factory again."

"Okay. We'll see how he does before the baby's born. Which reminds me—I have a surprise for you: help just when help is needed! Come into the hall and see what I've got."

As the two adults disappeared from the room, boy and bear sat down beneath the standard roses.

78

[handwritten margin: up-date]
[handwritten bottom: Here you let on. Also say David is programmed to love his mother.]

"Teddy—I suppose Mummy and Daddy are real, aren't they?"

Teddy said, "You ask such silly questions, David. Nobody knows what 'real' really means. Let's go indoors."

"First I'm going to have another rose!" Plucking a bright pink flower, he carried it with him into the house. It could lie on the pillow as he went to sleep. Its beauty and softness reminded him of Mummy.

79

[handwritten: why does Stanley like this story? It's just a vignette.]
[handwritten: David & his bear are programmed to care for Mummy. But human Mummy is not quite so charming.]

BELOW **An idea for an opening scene** written by Stanley Kubrick in March 1983. At that time, the director was working with Brian Aldiss, and the story was referred to as 'Supertoys' [*sic*], or 'Toys'. The name was changed to 'A.I.' in the early 1990s.

Kubrick and Aldiss first met in July 1976 and would meet several times over the following years to discuss the elements required to create a successful fairy-tale-like science-fiction film. Kubrick bought the rights to 'Super-Toys' in 1982, and in November of that year he began to work with Aldiss on a story treatment. This relationship continued, intermittently, until 1990.

At their first meeting Kubrick gave Aldiss a copy of the classic children's story, *Pinocchio*. Kubrick saw parallels between the character of David and the character of Pinocchio – artificial boy who, by a process of Blue Fairy magic, becomes human boy. *Pinocchio* was to be updated into the context of 'science fiction', and in particular was to become an exploration of the concept of Artificial Intelligence – subjects that had informed Kubrick's vision since his childhood, and had led to an insatiable appetite for the latest scientific thought. Aldiss, however, struggled to see the similarities between David and the little Italian marionette, and by 1990 he and Kubrick were working on the idea of a flooded New York '… only to have the Blue Fairy emerge from the depths. I tried to persuade Stanley that he should create a great modern myth to rival *Dr Strangelove* and *2001* [*: A Space Odyssey*], and [that he should] avoid fairy tale.'[1] But Kubrick remained adamant.

The director loved all types of stories, including myths, the supernatural, the magical, surreal and allegorical.[2] He told Alexander Walker: 'Naturalism finally does not elicit the more mysterious echoes contained in myths and fables; these resonances are far better suited to film than any other art form. People in the twentieth century are increasingly occupied with magic, mystical

experience, transcendental urges, hallucinogenic drugs, the belief in extraterrestrial intelligence, *et cetera*, so that, in this sense, fantasy, the supernatural, the magical documentary, call it what you will, is closer to the sense of the times than naturalism.'[3] For Aldiss and Kubrick, it was a parting of the ways.

In the finished story, David is the next step in Artificial Intelligence, crafted by a future Geppetto and programmed with the emotion of love. After his mother abandons him in a forest, he sets off on a quest to find Pinocchio's Blue Fairy who, he believes, will make him into a real boy and thus enable him to gain maternal love.

Kubrick's research material included Bruno Bettelheim's *The Uses of Enchantment: The Meaning and Importance of Fairy Tales*.[4] As Bettelheim suggests: 'There is no greater threat in life than that we will be deserted, left all alone. Psychoanalysis has named this – man's greatest fear – separation anxiety; and the younger we are, the more excruciating is our anxiety when we feel deserted, for the young child actually perishes when not adequately protected and taken care of.'[5] Rather than having to endure the quest on his own, David, like Dorothy in *The Wizard of Oz*, is given the customary 'friends' to help and protect him on his way – a robotic teddy bear, called Teddy, featured in Aldiss's short story, and the not-quite-so-traditional Gigolo Joe (in *A.I.*, a 'Love Mecha'), created by the sci-fi writer Ian Watson.

Kubrick worked with Watson on story treatments from May 1990 to January 1991, following the departure of Brian Aldiss and after a short collaboration with writer Bob Shaw. Over an intensive

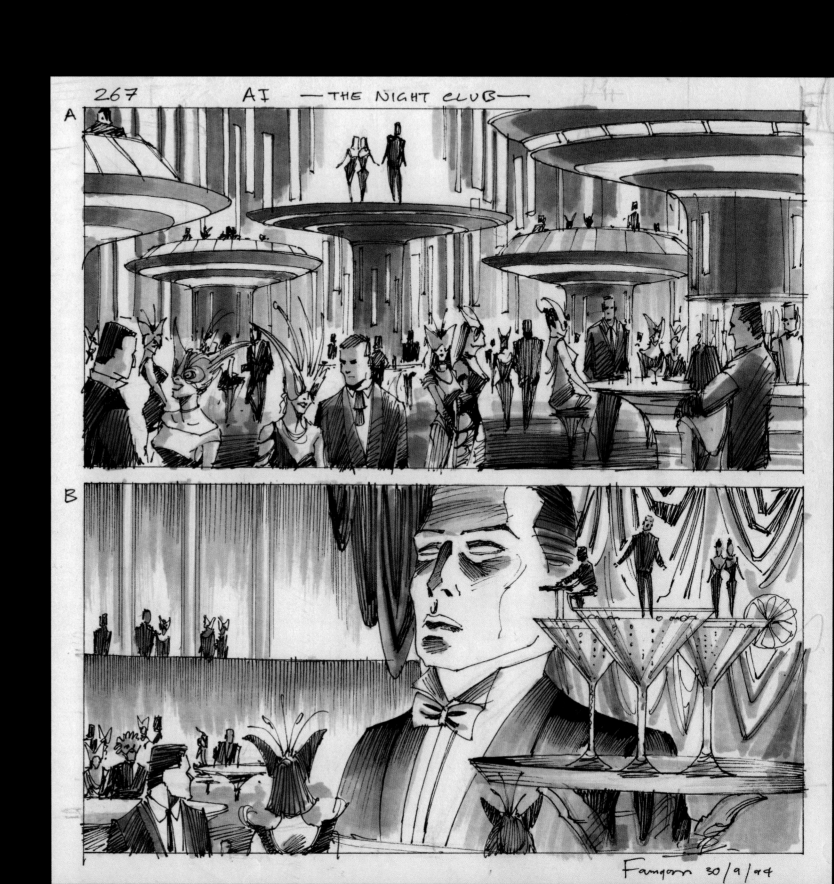

RIGHT **Chris Baker's early concept drawing** of a nightclub scene. Baker said of the scene: 'In the story treatment we were first introduced to Gigolo Joe at the nightclub where he sings. This gave me an opportunity to produce some extravagant set design, such as dancers on huge cocktail glasses held up by a giant statue, and one in particular had the tables and chairs floating on a small lake inside the club.' The scene did not feature in the final film.

nine months, Watson generated endless ideas with Kubrick, venturing down many paths, not all of which made it through development. Early story treatments for David's quest showed influences from religion and Arthurian legend, as well as fairy tale. Some ideas included a nightclub scene; an Armageddon Army; a robot scrapyard; a reality machine located in Rouge City; characters called the Organ Boys, who Watson and Kubrick later used as the genesis of the bikers in the Moon Balloon scene; and a character called Lalitha, who funded the research project 'How Can A Robot Become Human' carried out by Professor Nicholls (re-named and re-cast as Professor Hobby in Spielberg's screenplay), and who directed David and Gigolo Joe to a Robotic Institute located in a place called Zero Zone.

As Watson explained: 'Kubrick's way of working was to shift from one thing to another, and then to another. I think the whole point was constant originality and freshness to prevent habituation setting in. This could be exhausting, but was also stimulating. Stanley was remorselessly logical in finding a minute flaw in the plot logic and then increasing this until it was a gaping chasm of impossibility.

'The story was, in a sense, refreshing sci-fi and fantasy. Increasingly through the 1980s and 1990s, writers began strip-mining mythologies – Mayan, Aztec, Aboriginal – in order to get some handle upon alien insights, or alternative cultural insights. So the idea of taking the *Pinocchio* story, which is an archetypal story of creating artificial life, and the benign side of the *Frankenstein* story in a way, was something that culturally was, and still is, going on.

BELOW **Early concept drawing** by Chris Baker.
Shown here is Zero Zone, a desolate fantasy
landscape destroyed by a neutron bomb.
The setting did not feature in the final film.

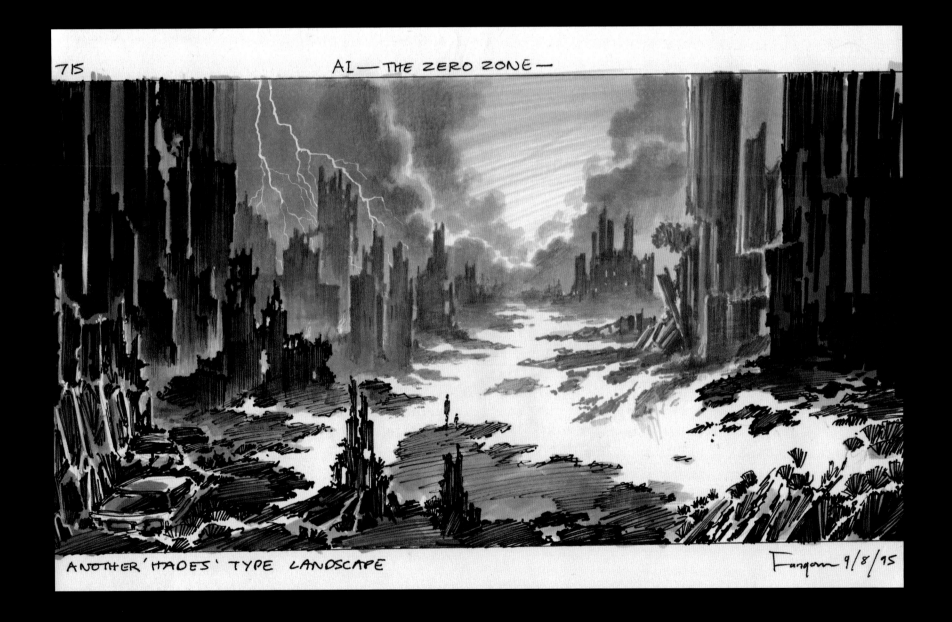

715

AI — THE ZERO ZONE —

ANOTHER 'HADES' TYPE LANDSCAPE

Fangom 9/8/95

'Stanley was very open to any ideas. When he suggested that
David and his Teddy would need assistance with a G.I. Joe-type
character, I suggested a gigolo called Joe. I faxed the scenes through
to him and the next time we met he said, "Okay, we've lost the
kiddie market, but what the hell!"'

Both Ian Watson and the novelist Sara Maitland, who worked on
the story treatments after Watson from May 1994 to February 1995,
tried to develop the director's fairy story from his brief to 'create
something magical and enchanting'. Film critics Michel Ciment and
Alexander Walker have also highlighted the recurring theme of the
fairy tale in Kubrick's films. Walker compares characterizations in
Kubrick's 1955 film *Killer's Kiss* to those in German folk tale and the
Brothers Grimm with a resolution that is archetypically 'fairy tale'.
'Kubrick referred at times to his early love of fables and fairy tales;
and his belief in the energizing power of myth to work on our
unconscious or touch the memory trace of our race finds a place in
several of his movies. It is implicit in the whole concept of *2001*; and
to discern its early manifestation in *Killer's Kiss* is not overfanciful.'[6]

Fairy tales, myths, fantasy and the supernatural also
incorporate other motifs that appear in Kubrick's films – ideas of
rebirth, transcendence and immortality. 'If there is a central theme
to the wide variety of fairy tales,' writes Bruno Bettelheim, 'it is that
of a rebirth to a higher plane. Children (and adults, too) must be
able to believe that reaching a higher form of existence is possible
if they master the developmental steps this requires.'[7] In *2001*, the
Star Child represents the birth of a new evolutionary stage in
mankind's history. In *A.I.*, Kubrick returns to the themes of

[Continuing, but not with scene 210. Dropping back to deal with the journey of David & escorts to New York. Thus scene 209 leads on to scene 211 now.]

211

A hunting horn sang out in the shantytown on the New York side of Rouge. Too-roo, too-roo. The night crowd began to make themselves scarce. People who had been gambling by the light of hurricane lamps scooped up their stakes and hurried off. Street vendors of algaeburger and fried tofu closed their makeshift stalls, decorated with fairy lights. Drug pushers and whores retreated behind frail doors. Shutters closed. Music died away. Soon only those who were high or drunk remained abroad, wandering dazzedly or slumped against walls.

And David's two guides, with David.

Too-roo! Bike headlights raked the dirt alleys. The bikes resembled suits of samurai armour, horned, flanged, bristly, mounted with weapons and suction harpoons with which to target and reel in prey. Their riders wore white leather --either contemptuous of camouflage or the better to recognize each other. They were white ghosts mounted on hideous roaring insects.

Suddenly the moon drifted hugely overhead, lit from within: a rotund dirigible patterned like Earth's satellite, the spotter platform for the hunters. Side nacelles clung to the seas of the Moon like alien ships which had landed, propellers turning lazily. A passenger in the open gondola replied on a longer horn, Roo-tooo, roo-tooo.

Beneath the gondola, in a net, dangled a solitary

LEFT **Ian Watson's early ideas** for the bikers and Moon Balloon sequence. In later development ideas for this scene, Watson describes the motorbikes as hounds (see also Chris Baker's drawing on p. 75).

RIGHT **Stanley Kubrick's own dialogue** written in January 1994 for the character of Lord Johnson-Johnson. The bikers were an evolution of the 'Organ Boys', whose bodies were covered in body organ tattoos. (Regarding the note 'Call Ian Watson', Kubrick never did.)

BELOW **Stanley Kubrick's notes** for Flesh Festival escape scenes. The Festival and the character of Lord Johnson-Johnson first appeared in Ian Watson's story ideas of September 1990, and were developed further by Sara Maitland in 1994.

BELOW **Stanley Kubrick's notes** dated 8 January 1993 propose 'multi-media info centers'. These would eventually become the information emporiums of the holographic, wizard-like, Einstein personality of Dr Know, who replaced Lalitha as the source for finding Professor Nicholls and the Blue Fairy.

mankind's transcendence by combining archetypal fairy tale with Artificial Intelligence. This combination is presented in Spielberg's screenplay when, during David's visit to Dr Know, he has to mix the categories of 'fairy tale' and 'flat fact' in order to find out the whereabouts of the Blue Fairy.

In Kubrick's notebook dated 13 November 1993 he outlines the 'theme' of *A.I.* and asks, 'What is this psyc[h]ologically about?' His answer: 'the possibilities of immortality through DNA + AI'. Kubrick's research and work with Arthur C. Clarke on *2001* contained many of the early ideas that would eventually form the genesis of *A.I.* (coincidentally, Clarke would also write a story treatment on Artificial Intelligence in 1992, but Kubrick rejected it). In 1966, Kubrick had commissioned interviews with twenty-one leading scientists about their views on the possibility of extraterrestrials, future communication methods and Artificial Intelligence. Although the main focus of these interviews was the possibility of extraterrestrial life, comments on Artificial Intelligence and the discovery of DNA – both, at the time, recent phenomena – brought discussions of humanity's evolutionary path much closer to home. In his 1966 interview, Irving John Good commented: 'It is quite possible, even without the advent of the ultra-intelligent machine, that within a century or so we might be able to construct DNA according to our own specification....'[8]

2001 and *A.I.* both examine the relationship between humans and their machines, in particular machines that convey emotion. However, *2001* looks outward to man's immortality and rebirth, whereas *A.I.* focuses upon the internal, the domestic and

BELOW **Stanley Kubrick's notes** dated 13 November 1993 illustrate the main theme of *A.I.* On the right-hand page he also outlines David's motivation for staying with Lalitha, the precursor of Dr Know, who features prominently in Ian Watson's story treatments from 1990 to 1991 and in Kubrick's notebooks from 1993 to 1994. However, Kubrick's notes dated 2 April 1994 (see overleaf), state: 'Lalitha is implausible + too difficult to set and is not interesting'.

mankind's imminent extinction. It is no longer an extraterrestrial intelligence that will help mankind to transcend to the next stage in its evolution but, instead, man himself will create it.

When asked by Joseph Gelmis, in 1970, why HAL was more emotional than any of the human characters in *2001*, Kubrick replied: 'One of the things we were trying to convey in this part of the film is the reality of a world populated – as ours soon will be – by machine entities who would have as much, or more, intelligence as human beings, and who have the same emotional potentialities in their personalities as human beings. We wanted to stimulate people to think what it would be like to share the planet with such creatures.... Most advanced computer theorists believe that once you have a computer which is more intelligent than man and capable of learning by experience, it's inevitable that it will develop an equivalent range of emotional reactions – fear, love, hate, envy etc.'[9]

One of the computer theorists, also numbered among the leading scientists interviewed in 1966, was Marvin Minsky, a pioneer and co-founder of Artificial Intelligence at the Massachusetts Institute of Technology who visited Kubrick on the set of *2001* later that year. In his book *The Society of Mind*, published in 1988 and used as research material by Kubrick, Minsky set out his belief that, in order for us to fulfil a long-term project, it is necessary for us to have a defence against competing interests. This defence is likely to produce our emotional reactions to the conflicts that arise in achieving our most insistent goals. The question he poses is therefore not necessarily whether intelligent machines can have any emotions, but whether machines can be intelligent *without* any.[10]

BELOW **The Pinocchio Syndrome**, mentioned on the right-hand page, was an idea that had been explored earlier by Stanley Kubrick and Ian Watson. Professor Nicholls's research project, 'How Can A Robot Become Human', set robots the impossible task of becoming human to see how they would cope. David is programmed with emotions, and this gives him the ability to self-motivate and to create his own desires and goals. Above all else, he pursues his ultimate objective – attaining his mother's love. Kubrick's notes also show ideas evolving for Dr Know: 'Glitzy hi-tech places connected to sats with all the world's data bases and inf.'

The mixed feelings of viewers to HAL's death stem from the fact that the computer shows more emotion in the film than either Bowman or Poole, the human astronauts: 'I'm afraid, Dave. Dave, my mind is going. I can feel it....' In the film *A.I.*, the audience at the Flesh Fair has the same dilemma when David pleads to the mob, 'Don't make me die. I'm David, I'm David, I'm David.' His salvation rests in the fact that he looks and acts *too* human.

David is unique. He is the very first robot programmed to love. If a machine intelligence looks like us and acts like us, has a consciousness, motivation and self-initiated goals, are we able to accept it in the same way as a biological human (in *A.I.*, 'Orga')? Ian Watson wrote in his June 1991 synopsis: 'If a robot should genuinely love a person, what responsibility did people hold towards that robot in return? Was there not the Godly responsibility, perhaps, to uplift all robots to human rank? Had not God created Adam to love him? ... Might this David with human emotions foreshadow the obsolescence of biological Man who had so wounded the ecology of the world?' Marvin Minsky believed that the time would come when the intelligence of machines was comparable to that of humans, so the problem of integrating them into our society would have to be faced; we would have to develop new ways of thinking when we shared the planet with other beings of equivalent complexity.[11]

Humankind's immortality could be through its artificial descendants – intellectually far superior to us, and operating an advanced system of communication. Irving John Good says that in a million years man will have changed, and that our descendants

may not even be referred to as men. Both Good and Isaac Asimov speak of a future in which one brain will be tapped by many, and our descendants, rather than being individuals, will act as an integrated consciousness.[12] 'I think man himself in a thousand years may replace himself by machines,' says Minsky. 'He would be foolish not to. We are too fragile, we are too feeble and there are so many ways in which an ambitious man would like to improve himself that I don't think he will be able to resist the temptation.'[13]

In the thirty years following the interviews and the subsequent release of *2001*, Kubrick would return countless times to the subjects that had been raised. It is not surprising, then, that two books published in 1988 struck a particular chord: *The Society of Mind* by Minsky, and *Mind Children: The Future of Robot and Human Intelligence* by Hans Moravec, founder of one of the world's largest robotic programmes, based at Carnegie Mellon University in Pittsburgh, Pennsylvania. The title of Moravec's book echoed Kubrick's comment in an interview he gave to the *New York Times* in 1968: 'There's no doubt that there's a deep emotional relationship between man and his machines, which are his children.'[14] In addition to *Pinocchio*, Moravec's *Mind Children* was passed down by Kubrick, in turn, to his writers, Brian Aldiss, Bob Shaw, Ian Watson and Sara Maitland, as a source for their story treatments. The book, which combines philosophy, science and socio-biology to look at the future of robotics, explains that within the next century the machines we create will transcend our own intelligence and culture.[15] 'We humans will benefit for a time from their labors, but sooner or later, like natural children, they will seek

their own fortunes while we, their aged parents, silently fade away.'[16] Man's immortality will be through the transplanting of our minds into superior machine intelligences and therefore our 'permanent death would be highly unlikely'.[17] The robots of the future will be able to maintain themselves, reproduce and self-improve. 'When this happens,' says Moravec, 'the new genetic takeover will be complete.'[18]

In *A.I.*, man's downfall and extinction is assumed, but not explained. It is not necessary to know how, or why, we become extinct. The story opens with a flooded and overpopulated world: the signs that point to our eventual demise are already presented to us. And if, due to our own folly, we are unable to stop this decline, then our hope for immortality would be through our mechanical 'children'. Alexander Walker noted that the humanist in Kubrick hoped that man would survive his own irrationality but that the intellectual in him doubted it.[19] Rather than embrace our descendants (the Mechas), we are in conflict with them: we have already ruined our planet and yet are still unable to confront – or even see – our future, and to accept the cultural change that this will bring. Artificial Intelligence offers us the hope of the continuation of our race, albeit in a new form, following the death of biological humanity.

Kubrick was optimistic about machine intelligence. He told Walker, 'If the computer acted in its own self-interest, there would never be the conflict often anticipated, for it is difficult to conceive any high level of intelligence acting less rationally than man does.'[20] Indeed, Sara Maitland says that, while working on the

treatments of *A.I.*, Kubrick would often refer to the robots as his 'grandchildren'. 'We are semi-civilized,' Kubrick told William Kloman in 1968, 'capable of cooperation and affection, but needing some sort of transfiguration into a higher form of life... Since the means to obliterate life on Earth exist, it will take more than just careful planning and reasonable cooperation to avoid some eventual catastrophic event. The problem exists as long as the potential exists, and the problem is essentially a moral and spiritual one. Perhaps even an evolutionary one....'[21]

Kubrick commented that being governed by emotions was, in a way, a great asset to mankind; however, it would be the illusion that we are governed by *rational* thinking that would lead to our downfall. The arguments of emotion versus reason, the rational versus the irrational, are contained in Arthur Koestler's *The Ghost in the Machine*, a book that Kubrick would return to throughout his life. The author, whose argument Kubrick found convincing, stated that the human condition is inherent in our constitution, and therefore inescapable: 'Evolution has been compared to a labyrinth of blind alleys, and there is nothing very strange or improbable in the assumption that man's native equipment, though superior to that of any other living species, nevertheless contains some built-in error or deficiency which predisposes him towards self-destruction.'[22] Koestler goes so far as to suggest that a cure for mankind's 'paranoic streak', and our 'mentality split between faith and reason, emotion and intellect', would be to create 'an artificially simulated, adaptive mutation to bridge the rift between the phylogenetically old and new brain, between instinct and intellect,

emotion and reason.... A state of dynamic equilibrium in which thought and emotion are reunited, and hierarchic order is restored.'[23]

Prejudice, a 'paranoic streak' and a basic conflict between reason and emotion are manifested in and represented by the human characters in *A.I.* During the ethical debate at Cybertronics, the 'biggest moral question of them all' – 'What responsibility do we have in return to a Mecha programmed with the emotion to love?' – is brushed aside with a philosophical answer that fails to address the real issue. Later, at the Flesh Fair, the prejudice that humans hold against their machines is represented in a return to a gladiatorial-style arena of masters (Orga) versus slaves (Mecha). However, it is the creation of David, the first robot of his kind, that will ultimately lead the way to humankind's legacy in the generation of robots two thousand years in the future – an idea analogous to Koestler's that 'equilibrium' will finally be 'restored'.

The super-intelligent future robots seen at the end of *A.I.* have developed an advanced form of communication, integrated consciousness and intelligence, and have an infinity of time to think. Will they therefore, asks Moravec, eventually run out of things to ponder?[24] Kubrick and Watson pondered this, too. In early story treatment ideas the professor's research project, 'How Can A Robot Become Human', had turned into a myth among all robotkind. 'Many robots whispered about becoming human,' wrote Watson. 'Yet they knew not how, though rumours circulated from time to time....' David had a reason for wanting to be human – his mother's love – but why would other robots want to become

human? And if the robots of the future are immortal, then there would always be a tomorrow, so what would the robots of the future think about, if tomorrow was a given? Like the human race, the robots would desire a meaning behind their existence – spirit, imagination, creativity and genius – that only those who were mortal possessed. What worth would immortality have, if these were absent? The SuperMechas wish to discover the true nature and origin of their species by resurrecting their ancestors through DNA. In the film, Gigolo Joe, while standing outside the church of Our Lady of The Immaculate Heart in Rouge City, touches on this idea when he says, 'The ones who made us are always looking for the ones who made them.'

The robots of the future, or 'super-intelligent archaeologists', as Moravec refers to them, would search for and dig up the remnants of a former civilization of a time past and a time lost. 'Wholesale resurrection may be possible through the use of immense simulators,' writes Moravec. 'Such simulated people would be as real as you or me, though imprisoned in the simulator.... In all cases we would have the opportunity to recreate the past and to interact with it in a real and direct fashion.'[25] This, as Kubrick comments in notes on Ian Watson's story treatments, would lead to the final irony: 'David wants to become a real boy, which is impossible, but he manages to turn Monica into an android.'

Watson's work came to an abrupt halt in 1991 when Kubrick suddenly shelved the entire project. His desire to have David 'played' by an animatronic boy had led him to realize that his vision was in advance of the available 'fx' technology. Watson,

at Kubrick's request, sent the director his final ninety-page treatment in January; in June 1991 Kubrick contacted him again, asking him to write two alternative versions as short-story synopses.

Following the release of *Jurassic Park* in July 1993, Kubrick sent a copy of Watson's ninety-page treatment and synopses to Steven Spielberg, whom he had first confided in about the project in 1984. *Jurassic Park* had re-ignited the fire: it showed that digital technology had reached a level of proficiency and excellence that could enable the visual effects that Kubrick desired. He invited Dennis Muren and Ned Gorman from post-production company ILM to his home to find out what could be achieved. *A.I.* was back on the agenda, and Warner Bros. announced that this would be Kubrick's next project.

Kubrick had already begun to visualize the world of *A.I.* with artist Chris Foss. Following this collaboration, Chris Baker (who also uses the pseudonym Fangorn when signing his work) was recommended to Kubrick by Ken Slater, who, from the 1930s, had been one of the pioneers of science-fiction literature. Baker, originally a graphic designer and book illustrator, met Kubrick in late December 1993, though it wasn't until May 1994 that he started to generate ideas, based on Watson's story treatments – and subsequently Sara Maitland's – for what would be his first film project. 'Initially,' says Baker, 'the most daunting prospect of working on *A.I.* was the very open brief I was given. Where to start? At this point, Stanley had very few ideas of where he wanted to take the project, visually. Early on, I asked if he had any thoughts on the look and design for *A.I.* and he replied, "No, that's what I hired you for!"

BELOW LEFT **Ian Watson's early ideas**, annotated by Stanley Kubrick, on why robots would like to become human. This developed into the SuperMechas' desire to find meaning behind their own existence.

BELOW RIGHT **Ian Watson's final story treatment** explaining the resurrection of humans from their DNA in order for future robots to discover their origins.

Dangerous Shabbyism

Good stuff

Edge of worH

-1 161190

161190

[New file, file name 161190. Non-Christian version, from Lalitha onwards to Coney Island.]

Many robots talked wistfully amongst themselves from time to time about becoming human; for humans were the masters of the world. Humans were lords over the beasts and likewise lords over the robots whom humans had made in their own image. A robot might live forever. Yet what was the worth of its existence? Robots had created no art, nor had they made any scientific discovery. No robot was a creator. No robot was a genius. If robots were to vanish from the Earth -- banned, dismantled, destroyed due to some new decision on the part of their makers -- what would remain to remember them by?

Robots were the lost species. Robots were the cursed race, doomed to live forever yet to leave no enduring memory of themselves as a Shakespeare had done, or a Michelangelo, or an Einstein. What was their immortality worth, when the spark, the genius was absent? That spark existed in human beings because human beings were mortal... Human beings also spoke of another world, a world of spirit and dream -- source of all inspiration -- which men and women entered into when they died. That other world was barred to robots. Robots could not enter it, for they were not mortal.

If a robot could become human, he would <u>know</u> what had been denied to him. Joy and desire and love, genius, imagination, spirit.

Many robots whispered about becoming human. Yet they knew not how, though rumours circulated from time to time...

why robots wanted to become human

Good rationally robots wanted to become human

Could this be said in connection with the Robot institute

ROBOTS WANT to BECOME HUMAN

The robots built giant particle accelerators to probe the nature of reality -- and discovered no fundamental reason for existence.

Human beings had created a million explanations of the meaning of life and of the world in works of philosophy, in art, in poetry, in mathematical formulae. Surely human beings must be the key to the meaning of existence? Those robots read and viewed every record that survived amongst the frozen ruins. Yet they found no final meaning.

This failure grieved them. For a hundred years untold thousands of robots stood motionless upon the ice, like so many statues in a white wilderness.

Yet some robots decided that it should be possible to recreate the living body of a person long dead from the DNA in a fragment of bone or hank of hair or scrap of mummified skin.

Could memories and personality inhabit such a body again?

During their earlier probings of the nature of matter and spacetime, robot researchers had stumbled upon unusual equations. The very fabric of spacetime itself appeared to store information -- locked within hidden micro-dimensions -- about every event which had ever occured in the past.

Might it be possible to retrieve this memory trace in resonance with a recreated body? Might a dead person truly live once more?

To develop artificial resurrection took over a thousand years. *Meanwhile,* The robots drilled through ice to search a million frozen graveyards and dead cities, harvesting the molecular traces of human life long gone.

And at last they succeeded in resurrecting men and women.

Page 77

It would seem to be an artist's dream, but working with Kubrick, and then eventually with Spielberg, was a daunting task.'

Kubrick had also begun work with Sara Maitland in May 1994. By then, slight changes had been made to the first part of A.I.: David's imprinting, which had previously taken place at Cybertronics, now happened at the Swintons' home, and the dynamics of the family relationships had been strengthened. Maitland was sent a copy of Watson's treatment and was asked to bring more emotion and fairy-tale magic to the story. It was also during this period that Kubrick returned to exploring further possibilities for an ethereal, magical, dream-like ending. Throughout his work with Watson, Kubrick had already questioned the various possibilities for the final chapter in order to combine the real with the fairy tale. 'Is [Monica],' wrote Kubrick in 1990, 'virtual reality for David / a dream perpetual'?

Kubrick had always seen film as the perfect medium in which to explore the subconscious, and several of his seminal films merge the 'real' with the 'imaginary'. The finale of *2001* – when Bowman observes himself in a bedroom – is a mix of dreams, hallucinations and perceptions with the literal and the real. Similar such shifts from perceived to imagined 'realities' are integral to both *The Shining* and *Eyes Wide Shut*. At the same time as working with Maitland on *A.I.*, Kubrick was working with other writers on what was to be his final film, based on Arthur Schnitzler's *Traumnovelle*, which interweaves reality and dream to examine relationships, fantasy and the dark side of love. Similarly, shifts between the real and dream occur in the ending of *A.I.*

Supertoys 11.4.93

+ Joe are
David is caught in badlands
and wind up in the sack.
Anyone else with them?

David is afraid of being
alone + without
Monica.

Knock + wall

Big breakdown when she leaves him

Supertoys 11.4.93

Monica is now David's
memories. where do will live forever

• we have to dig up bodies to
get samples of bone or hair
— "Hair?" Teddy says.
• what can you do if you get that

DAVID'S DREAM
• he tells of his "dream" as lost
for 2000 years. Proustian equivalent
• maybe bringing coffee is
equivalent of knocking
• Rosencavalier scene

David is unique. They have
never recovered a robot who
had memories of a long gone
human.

'I really liked Stanley's idea that Monica's "resurrection" was temporary,' comments Maitland. 'David's dream of her is in the way that memory is like a dream. He's given back his memory, not his mother, which of course relates to how real one thinks the products of memory actually are. His revival is real, hers is real, but it's not concrete or historical, and she's not going to change, she's not going to get older, because he's not going to get older by the very nature of being a robot. The story is not very pro-human, and not very pro-Monica, who fails to love the child. Stanley and I talked endlessly about mother love – how much is maternal love stimulated by skin contact, which of course you wouldn't have with a robot.'

In his notebooks, Kubrick explored various ways to present David's 'dream'. The coffee-drinking, hide-and-seek and birthday-party sequences feature in both Watson's and Maitland's story treatments. For example, following his arrival, David watches Monica intently as she makes a cup of coffee. Two thousand years later, as David hands a cup of coffee to Monica, she says, 'You never forget how, do you?' This event represents the continuity of an old experience with a renewed and reconstructed experience in the present.

While working with Maitland, Kubrick also looked at other avenues to present David's memories. He appropriated an idea from Marcel Proust's classic *À la Recherche du Temps Perdu*. In Proust's novel the narrator's grandmother fulfils the maternal role. She offers him her undivided attention and devotion. At points interspersed across several hundred pages, the narrator

links the past to the present by remembering a time when the intimacy and closeness of the relationship between him and his grandmother is expressed. While staying in a hotel in Balbec, the grandmother reassures the anxious young boy that she is still there for him by communicating with three knocks on a thin dividing wall between their bedrooms. Such a scene, which was eventually abandoned by Kubrick, was incorporated into Maitland's treatment of February 1995 as a moment between David and his mother, one that would play out again two thousand years in the future.

The concept of separation anxiety, discussed earlier within the context of the fairy tale, is also a central motif of the Proust classic. The remembrance of separation anxiety between Proust's narrator as a young boy and his mother informs his progress throughout the novel – a journey of love, jealousy, fear, guilt and despair, revealed through memories and remembrances of times past and lost. In the opening chapter of Proust's novel, the narrator lies awake in his bedroom, desperately waiting for his mother to leave the dinner party downstairs and come up to his bedroom to kiss him goodnight. The moment of anxiety is repeated again when, as a young boy, the narrator faces the trauma of his mother taking him to the railway station, at which point she tells him that she will not be joining him on his journey to Balbec – a scene analogous to David's experience in the forest.

David is alone, trapped in an amphibicopter at the bottom of the ocean. There he sits in a meditative state, praying to the Blue Fairy, while a new Ice Age encases him. Mankind has become extinct and the robots have evolved into Moravec's super-intelligent robots – the SuperMechas – who excavate the ice and discover the amphibicopter. They download David's memories in order to learn about their precious discovery and the origin of their species. The simulation they create from David's memories provides a familiar environment and a method for David to recapture a past time and to relive the experiences in accordance with his own desires, wishes and imagination – a simulated environment where, as Moravec says, the past can be recreated and where it is possible to interact with it in a real and direct fashion.

Monica is a 'real' artificial creation constructed through DNA from a lock of her hair, but she is also a composite product of David's memory and imagination, immortalized in his two-thousand-year-old dream. As Kubrick writes in one of his notebooks: 'Monica is now David's memories, where she will live forever.' Memories, however, are subjective, selective and open to interpretation and bias; they are an imperfect reconstruction of the past, hence the distortion of David's experience. Monica is a construct of how David saw her *emotionally*. His perception of her is his desired, preferred, or, rather, programmed interpretation, not one of real experience; he imagines a mother archetype – a mother that, in reality, he never actually had. Proust writes: 'It is the terrible deception of love that it begins by engaging us in play not with a woman of the external world but with a puppet fashioned and kept in our brain, the only form of her moreover that we have always at our disposal, the only one that we shall ever possess, one which the arbitrary power of memory, almost as absolute as that of imagination, may have made as different from the real woman as

-6- 221290

"What day is it?" she asked David.

"It's today," he answered.

Today. Today... The word, repeated a sufficient number of times in her mind, became quite meaningless.

She laughed. "Of course it's today... So what shall we do today?"

"Can I choose? Can I choose all day long?"

Why not? Why not indeed? Why not make believe that today was David's birthday? David had never had a birthday, because David had never been born... Yes, they could play games, and enjoy a pretend party, just as if he was a real little boy. Just the three of them: herself, and David, and Teddy...

But first, shouldn't they go out for a walk together since this was such a lovely day?

She rose, so as to fetch her outdoor shoes, but by the time she did find them she had changed her mind. This was such a lovely house to be in. She strayed around the rooms, touching the furniture almost affectionately. David gazed at her in wonder; and seeing this, she hugged him again.

Thus the day wore on. They played hide and seek; they played Blindman's Buff. Blindfolded David knocked over a favourite fragile Japanese bowl of Monica's, and Monica gasped, but the bowl only bounced on the carpet; it didn't break.

Still, after that, they all did a jigsaw together. The picture was of recently extinct animals, pandas and marmosets and beavers, gambolling together. Monica did not recall ever having bought any such jigsaw, but she must have done so, for here it was. With her help, David completed the jigsaw triumphantly. He laughed, he laughed.

had been from the real Balbec the Balbec of my dreams; an artificial creation to which by degrees, and to our own hurt, we shall force the real woman into resemblance.'[26]

Monica and David exist outside of time, in a simulated world. 'I'm a little confused,' says Monica, and asks David, 'What day is it?' David replies, 'It is … today.' They are neither in the past nor the present. 'In Proust's remembrances we consciously experience the present episode, the identical sensations that trigger the past episode, and the past episode itself, whereby the past becomes presently real, but not as the present reality, rather as another reality, another world.... For Proust, this feeling of Time Regained includes an experience of timelessness, of a kind of immortality of the experiencing self which, however it has changed in the course of his life, has recovered his past in the present, and will carry it into the future.'[27]

The ending is full of pathos, as Monica cannot know that the day is not real. The narrative travels full circle, as past events from the beginning of the story are mirrored at its conclusion. In the same way that David was programmed to love his mother, he now constructs her to love him as if he were a real boy. The game of hide-and-seek and the birthday party that went disastrously wrong and that led to David's mother abandoning him in the forest are now reconstructed; Henry and Martin are excluded from David's day, the imprinting between Monica and himself creating the only emotive bond; and instead of the earlier scenes' actuality, what transpires is a perfect day for just mother and son. The fairy tale's magical and enchanting ending finishes with David's final wish – his mother's love and his transcendence to real boyhood.

Kubrick stopped working with Maitland in February 1995, as he was becoming increasingly focused on *Eyes Wide Shut* (for which Chris Baker was also asked to illustrate scenes). However, collaboration with Spielberg continued, and a revised treatment based on Watson's story was sent to Spielberg in 1996.

For more than two years, Chris Baker had completely immersed himself in the futuristic world of *A.I.* Following his years of collaboration and work with Kubrick, he eventually saw his designs realized under the directorship of Spielberg. After Kubrick's untimely death in 1999, *A.I.* had been bequeathed to Spielberg to direct. He was the only person who had been given the authority to do so by Kubrick, and was Kubrick's only confidant on the project.

In 1999, Spielberg turned his attention to realizing the story. Although he generally collaborates with all his writers, *A.I.* was the first screenplay for which he had taken sole credit since *Close Encounters of the Third Kind* (1977). Rather than convey the vision and the ideas to another writer, Spielberg wrote the screenplay himself, basing it on Watson's treatment, Kubrick's archive material, and the discussions he and Kubrick had had over the previous fifteen years. He brought his own ideas to a story of love and loss, the journey of an outsider and a subject that he had explored, most harrowingly, in *Schindler's List* (1993) – the intolerance and bigotry of mankind.

In 1999, Spielberg also showed Baker's 1,500 illustrations to Dennis Muren, the visual effects supervisor on the film, and to Rick Carter, the production designer. 'Chris's drawings were like a road map to the journey and the movie,' says Carter. 'It had a few gaps, but you could see the fundamental level of the vision that he had created. Steven wanted to come as close to Stanley's vision as possible without Stanley actually being there to direct it himself. The essence of the story was about an entity, a consciousness, that journeys all the way beyond a third-act structure and a normal lifetime, into a fourth act where David has the ability to realize his dreams after everybody else has ceased to exist.'

Baker joined Spielberg's art department in 1999 and, throughout the duration of the film's making, was an important link between the two directors. His drawings, ideas and knowledge of the project provided valuable insight, enabling the essence of Kubrick's vision to be retained, while at the same time assisting Spielberg to bring his own sensibilities to the film.

Ironically, *A.I.* was finally released in 2001 – twenty-five years after Kubrick's initial discussions with Brian Aldiss. Whether the viewer sees sentimentality or a bleak vision of humankind's future, the ambiguous ending is in tune with many of Kubrick's films, and indeed with many fairy tales – a blend of dark undercurrents with threads of hope and wonder. Kubrick particularly liked Irving John Good's opening line in his book *The Scientist Speculates: An Anthology of Partly-Baked Ideas*: 'The intention of this anthology is to raise more questions than it answers.' This applies to the majority of Kubrick's films, but perhaps especially it applies to the themes of *A.I. Artificial Intelligence.*

JANE M. STRUTHERS

Chris Baker's World

It is said that if all mankind died suddenly tomorrow – maybe a shawl of alien virus sweeping in from the Oort Cloud – no sign of his works would remain on the Earth after ten thousand years. No more Pentagon, no more London, no more pyramids, no more Great Wall of China. The forces of nature, which we so far manage to keep at bay, will rise up and destroy everything, to every last brick, every last slab of pavement. A thousand years of rain might well help decide the issue.

So what would come afterwards? Something undoubtedly would emerge. You can count on it. After the massive strike from space that terminated the Permian era, 325 million years ago, Earth remained without life, so we are told, for thirty centuries. And then – why, then a most remarkable variety of species encompassed the world, its lands and oceans, including eventually the human species, down from the trees when there were trees to come down from. When we have gone, through natural processes or our own folly, there may then arise a robotic kind of being which seeks to imitate the old wrecked world of humankind.

Such thoughts are induced by the remarkable sketches of the remarkable Chris Baker, executed for Stanley Kubrick, then working on what was at first called *Super-Toys*. Baker draws for us a long continuous cityscape somewhere that in some respects resembles the world in which some of us already live. His thin and vital pen operated under the authority of Kubrick, yet one can also detect a compulsion set loose. I am guessing, but I imagine Baker longs for a new clean world; always lighted, free from things like death (and life), sanitary to the point of insanity. I say I'm guessing – but I often feel those same longings in myself.

So here are David and Teddy, not playing, just sitting, home at last in android world. They have a toy and they have what used to be called a computer. They are driven in a car. They are programmed to like these things.

The big city beckons. Everything aspires to the Vertical. As W. H. Auden said, 'Why are the spirits of the people so low? Because the buildings are so high.' No one walks here. No one waits at a street corner. You look for an old chap walking his dog. In vain. And there's the Blue Fairy – Stanley's idea, not Spielberg's. Or rather, the Italian writer Carlo Collodi's idea (*Adventures of Pinocchio*, 1883), and Walt Disney's (*Pinocchio*, 1940). And so suddenly we are looking back, and not towards the future....

But Baker plunges ever onwards, to the excitements far ahead. Here are people again, and here is his wonderful feminized city. The traffic pours down women's throats. Suspension bridges penetrate those open lips where toll must be paid. Wondrous expense! In the centre of the city you go bust. Buildings here are prey to all-too-human fantasy. Traffic streams into the tunnel of a female-form anus, and any other likely entry point. And so on and so forth, seemingly inexhaustibly.

Baker's multitudinous sketches would make a dazzling movie in their own right. They formed a contributory factor for Kubrick's imagination, yet anyone flicking through a pile of them confronts a powerful creative impulse all of its own – murderous, macabre, marvellous, much to be admired.

BRIAN ALDISS

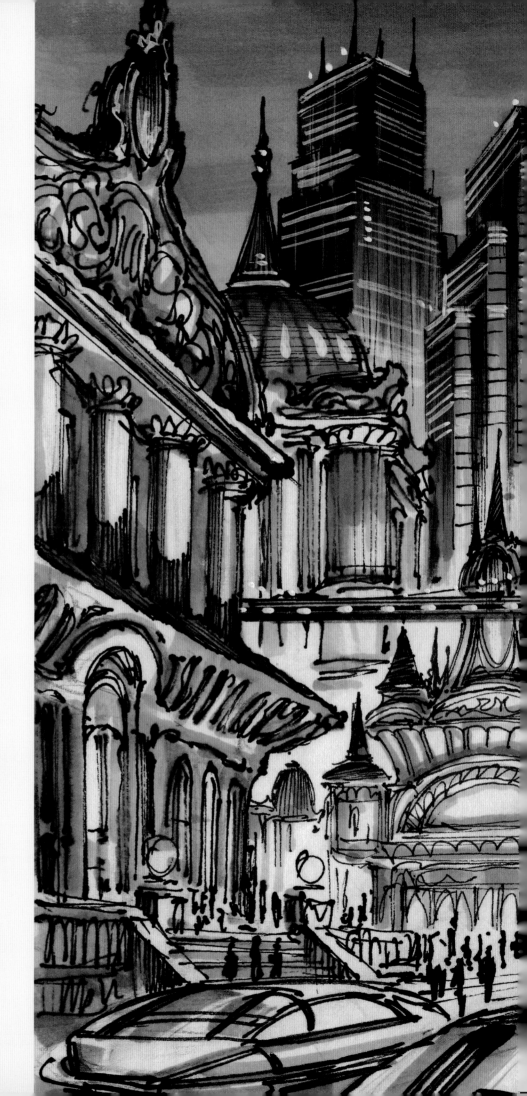

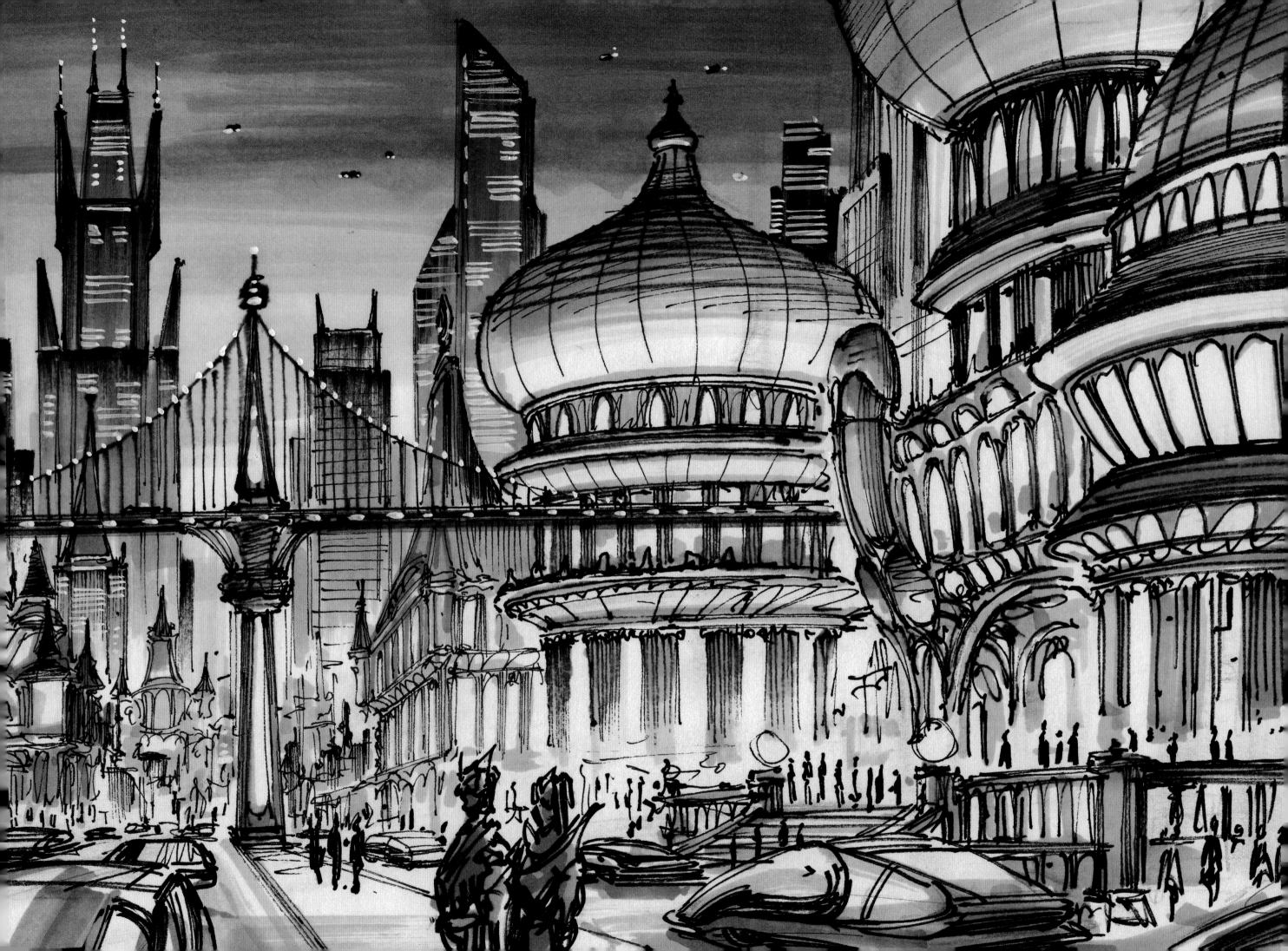

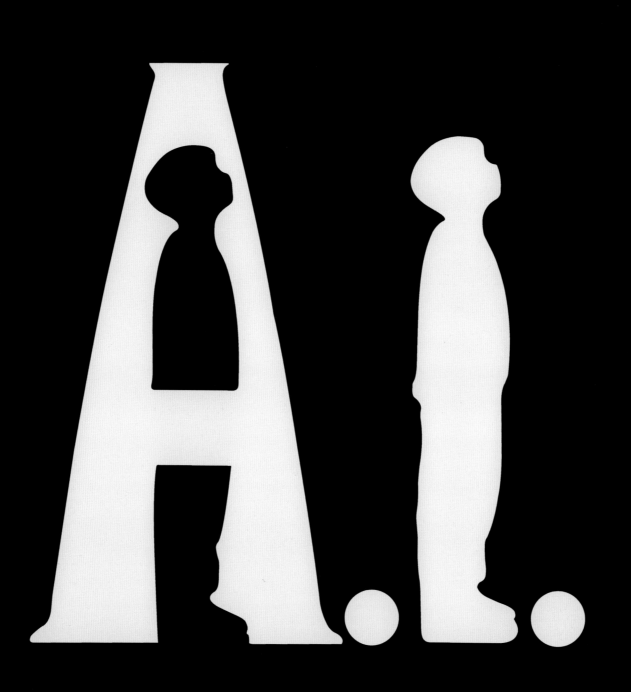

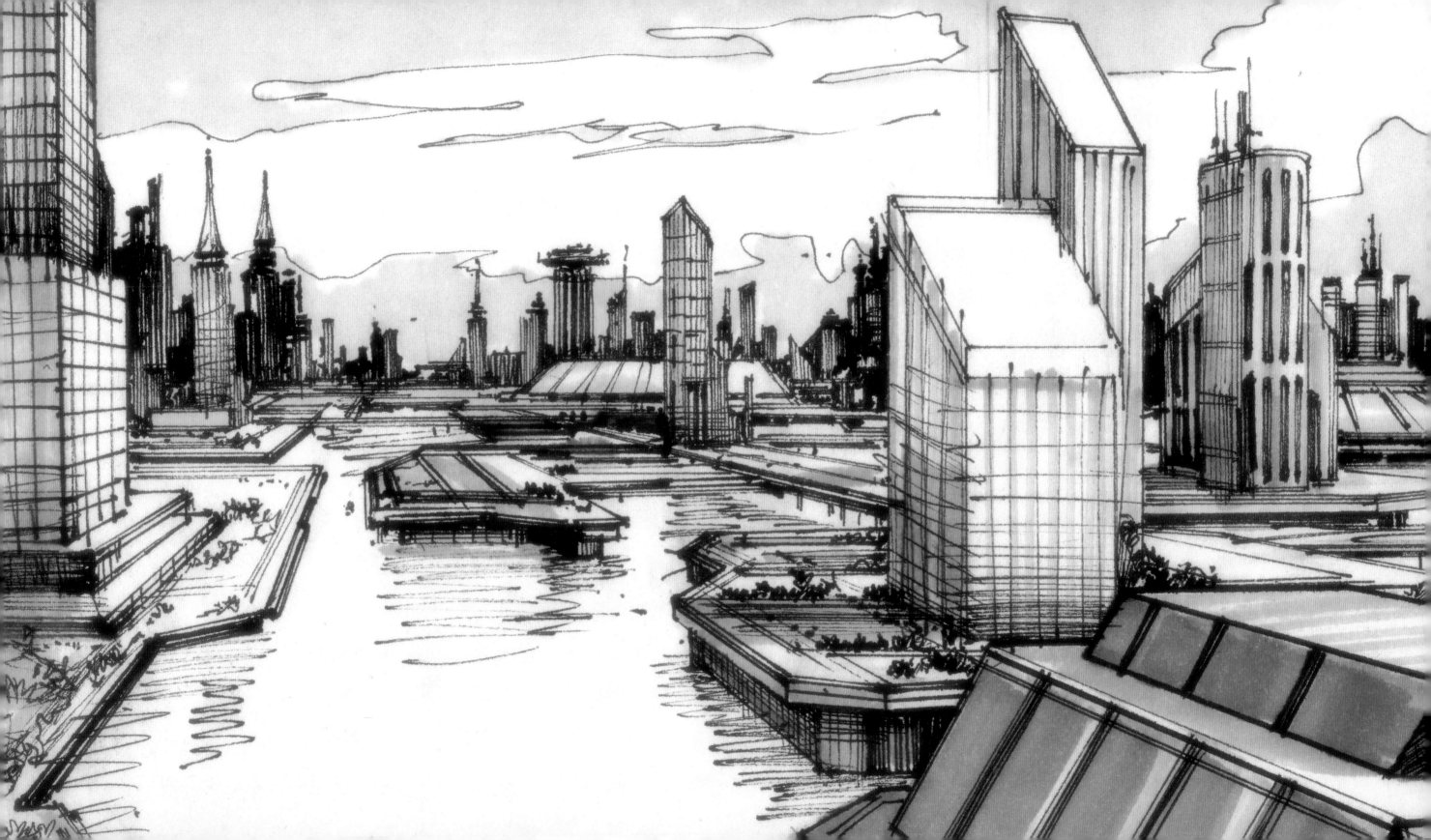

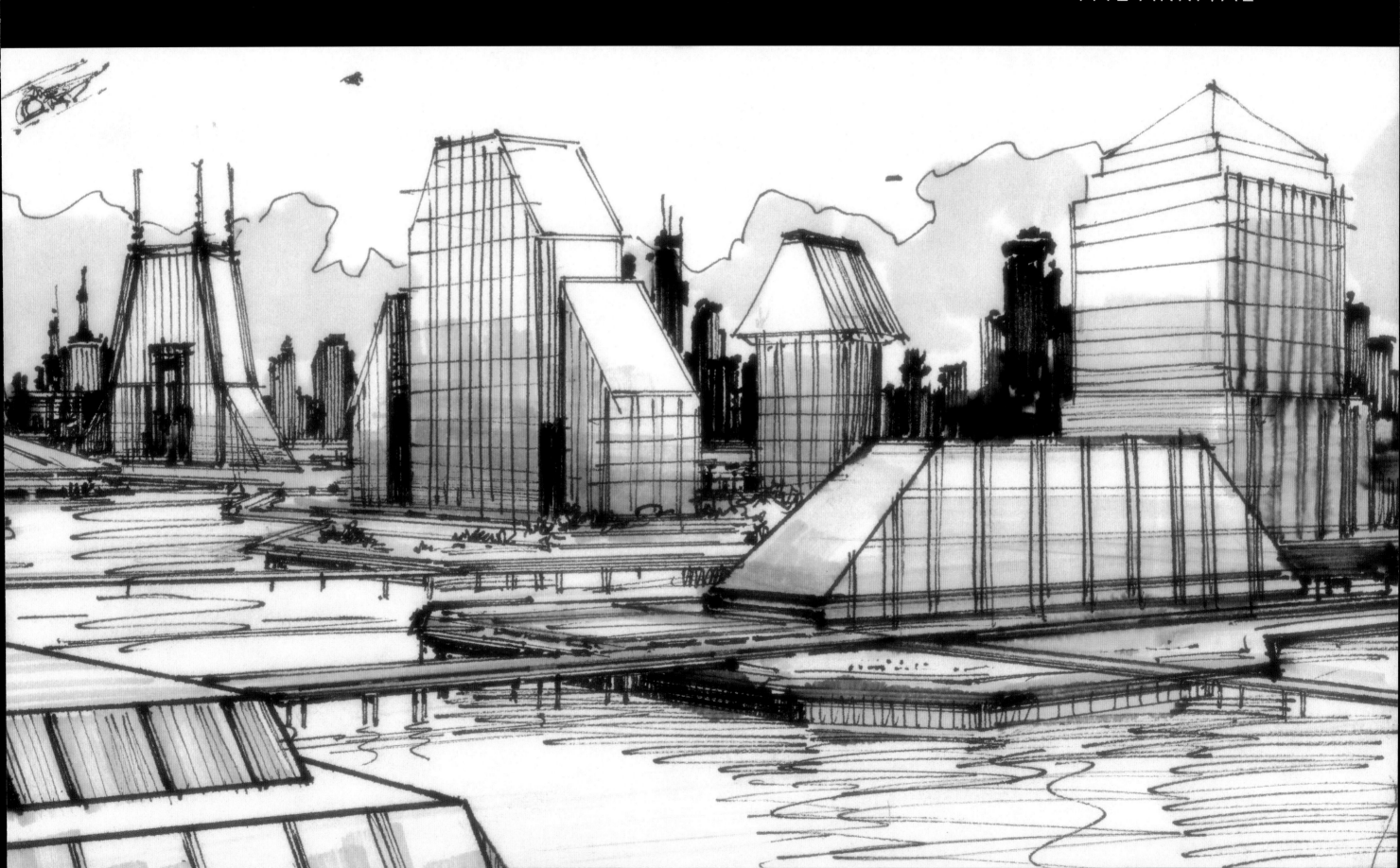

Part 1: The Arrival

A. I. *Artificial Intelligence* opens in a world where population is controlled, where the land is submerged due to rising sea levels, and where Mechas (robots) and Orgas (humans) co-exist uneasily. In the first part of the film, we are introduced to Professor Hobby, 'father' of the robot David; to Monica, Henry and Martin Swinton; and to David himself, whose arrival as a son-substitute for Monica culminates in the climax of the first act – Monica's abandonment of David in the forest.

In Carlo Collodi's *Pinocchio*, the marionette leaps from one fantastical and extreme experience and place to another, and so it is with Stanley Kubrick's story and Steven Spielberg's film. *A.I.* adopts a dramatic effect referred to by Kubrick as the 'mode jerk'. The mode jerks in Spielberg's film act as cinematic representations of literary chapters in that they abruptly remove the viewer from one locale or time-space and drop them directly into another. As the production designer Rick Carter explains: 'Stanley Kubrick told Steven that he wanted to explore the structure of the film through "mode jerks". Kubrick had utilized this visual juxtaposition in *2001: A Space Odyssey*, and mode jerks were prevalent throughout the entire film of *A.I.*' The main opening scene of *A.I.* takes us to Cybertronics, the robotic institute where Professor Hobby works, then we cut to twenty months later at Cryogenics, the medical facility where Martin Swinton is being treated. Domestic interior scenes at the Swintons' home ensue, then the film switches to the harsh external realities of life outside. It later jumps two thousand years into the future, before cutting to the ambiguous time- and space-frame of David's dream. By impelling the viewer into sudden shifts in time and place, these mode jerks subliminally force us to create the continuity ourselves in order to be able to understand the wider narrative.

Mode jerks also make the audience aware of an authorship – 'a voice of God' – and indeed at the end of the film we discover that the story is being narrated by a SuperMecha to our robotic descendants. Voiceover is used in many of Kubrick's films, including *The Killing* and *Killer's Kiss*, not only for dramatic effect but also to explore time shifts. Kubrick wanted *A.I.* to be a future fairy tale, not a fairy tale *of* the future. He never conceived his films as merely passive experiences; they are, instead, cerebral journeys for the viewer. His use of complex cinematic techniques challenges the audience or, rather, relies on and expects the audience to integrate their own experience and intellect to the unfolding story. Viewers become co-authors as each forges a different interpretation or understanding of the same cinematic journey, and these interpretations can also shift on repeated viewings. Like fairy tales, as each new generation brings its own understanding and cultural references to the story, readings of Kubrick's films are open to reinterpretation.

CYBERTRONICS
Following the opening narrative, we enter the Cybertronics building. As the camera pulls back from a shot of the logo in statue form, we are introduced to Professor Hobby talking to colleagues in a central atrium.

To an attentive audience, Professor Hobby reveals his plans to create a robot that is programmed with the ability to love. The professor uses his robot secretary in a demonstration to illustrate how far the technology and programming of Mechas have progressed. When he stabs her in the hand, she is able to feel pain, but when he attempts to stab her a second time her reaction is to withdraw. He then asks her to stand up and undress, which she obediently does by starting to unbutton her blouse. Everyone claps. He then requests that she open her mouth so that he can insert his finger to activate a mechanism that parts her face to reveal the robotics beneath.

The professor then demonstrates the emotional limitations of Mechas when he asks the robot to describe what it is like to love. She can describe the physical reactions, but is unable to describe the emotional attachments. Although this demonstration establishes the genesis of David's creation, the degrading series of requests and actions that the professor carries out is in fact revealing of the Mechas' status in society and the power that humans have over them – a hierarchy which, over two thousand years, will be reversed. The witnesses to this demonstration have shown a complete emotional detachment from and lack of empathy with their robot. This is a troubling start for the new entity that the professor wishes to develop – a robot with emotion.

The professor continues to reveal his plans to create this robot that has feeling, self-motivated reasoning, intuition and an inner world of metaphor – a robot with the ability to dream. In the short discussion that follows, a moral question is raised, 'If a robot should genuinely love a person, what responsibility do people hold towards that robot in return?', only for Professor Hobby to reply, 'In the Beginning, didn't God create Adam to love him?' The discussion ends as quickly as it began.

The camera pans the room, stopping to focus on the robot secretary as she looks in her hand-mirror to reapply her lipstick. The film then cuts to twenty months later, when we are introduced to Monica Swinton doing exactly the same thing as she and her husband, Henry, travel to Cryogenics to visit their son, Martin, who for the past five years has been suspended in a frozen, comatose

state awaiting medical advances that will enable his paralytic syndrome to be cured.

CRYOGENICS

Throughout his work with Stanley Kubrick, artist Chris Baker produced many architectural designs for interiors, exteriors and panoramas. Some of his panoramic drawings presented the director with detailed artwork and notes to show where buildings would be positioned in relation to other buildings, locations and scenes.

'Many of the drawings for Cryogenics were way over the top in scale and structure,' comments Baker, 'but my particular favourite is the lily-pad-shaped design that appears to be floating on the waters of a flooded New York [see p. 38]. Interestingly enough, since then there have been some contemporary architectural designs that have followed a similar theme.

'Stanley supplied me with so much reference material – books on Max Ernst and Kandinsky for Zero Zone, which didn't actually end up in the final movie; books on the Antarctic; photographic books on New York; and also the architectural magazine *Domus*. He sent me so many of those that I couldn't actually lift them upstairs to my studio; I had to do it in job lots of ten.

'I produced quite a few sketches for Cryogenics, not just the design of the building, but the technical aspects, too; in particular, advances in medicine, using digital surgery of some kind, as well as alternative ways of storing people in the future. Later sketches suggest a less hi-tech veneer, and something slightly more peaceful, and this was also reflected in the interiors. The surface level became a place of solace for the family, while the scientific area was situated below ground.'

Baker would start off by sketching a series of thumbnails to get some initial ideas and would then work these up into finished drawings. 'I would do about three or four finished sketches per day, fax the work to Stanley and then wait, tentatively, for his response. It was a continual process of presenting him with annotated sketches until something caught his eye. I had been given a fantastic opportunity in regards to the amount of time I had and the scope of the project – to design the entire world of *A.I.* from the ground up. At first Stanley wasn't too sure what he wanted but, as time went on, he became a bit more specific. However, at this point he was after as many ideas as possible.'

Baker, endlessly inventive and a gifted draughtsman, created incredibly cinematic drawings. At points in his annotations, he made suggestions for particular shots, and he also put forward ideas for lighting certain scenes. Kubrick and Baker's relationship was a fruitful collaboration: Kubrick not only admired Baker's talent, but also the number of ideas he could generate. The director would throw a notion at Baker and the artist would return with thirty different versions. Kubrick once commented that, as far as storyboarding ideas went, he wished he had met Baker thirty-five years earlier.

Baker's drawings of Cryogenics show that he gave particular thought to the capsule that Martin Swinton would be stored in. In the finished film, when the Swintons arrive at Cryogenics, Martin is lowered in his capsule. Monica sits reading forlornly to him, while Henry hears from the Cryogenics scientist that there is still little hope of a cure. In this future world of population control, and in the midst of the suffering caused by the painful separation from their biological son, Henry accepts the offer made by his employers, Cybertronics, to parent David. The acceptance of the offer highlights not only the fragility of human life, but also the reality of a future world in which the technology and research for creating artificial life are developing at a much faster rate than for medical science.

In the same way that the professor used his robot secretary as a puppet to illustrate his demonstration, Monica is now the puppet in a real-life case study for the professor's research. The Swintons are about to take part in an experiment involving adoption of the first robot of its kind – a robot with the ability to love.

THE SWINTONS' HOME

Our first sight of David is as a ghostly apparition in the central elevator of the Swintons' apartment. At this point he is a pre-programmed robot boy, and it is not until Monica's imprinting that his deeper consciousness is activated and his devotion to his mother made complete.

'Stanley and I chatted about the apartment quite a bit,' says Chris Baker, 'and one of his suggestions was a curved floor. Following this theme, I was struck with the idea of a circular apartment. When I joined Spielberg's art department, Rick Carter responded to this circular idea with a central staircase and panoramic windows. He took segments from several of the images that I had drawn with Stanley and decided pretty much from the start what he wanted to do.'

Rick Carter continues: 'It was very clear from every single sketch that Chris produced that he was in this world. He had the ability to show what he saw, and it happened to also reflect what a camera could see, and the way in which a camera could see it. Every one of Chris's drawings is a work of art. You could frame and look at them for hours, as they evoke such a sense of wonder and journey, but at the same time they are realizable in cinematic

terms. The ones that we needed to work on the most were the domestic scenes. Janusz Kaminski, the cinematographer, suggested vertical panes of textured glass as a cinematic device to not only divide the rooms, but also as a way for the camera to be outside of the scenes and peer in. Our goal was to make this set appear inviting for David, but also a bit cold and distant; after all he wasn't going to be here for very long. The absence of any futuristic gadgetry, particularly in the apartment, was intentional. The focus is on David – the only piece of technology.

'The design of the house was influenced by Chris's drawings, but the most significant aesthetic inspirations came from Disneyland's 1960s circular future house and architect Frank Lloyd Wright. The use of the circle was a recurring motif found in many of the designs featured in the film. These were either conceived by Chris or subsequently added by the art department. Circular designs were evident in the round dumpsite for robots, the Moon Balloon and the Flesh Fair. Circles would show up again in Rouge City, at Dr Know's, and in the Cybertronics library reading room and, of course, the Ferris wheel. It was as if the circles comprised the various worlds we were travelling through with David.'

The circle is a device and motif that Kubrick used in many of his films. It is seen in the War Room in *Dr Strangelove*; it is integral to *2001: A Space Odyssey*; even some of the architecture of Vietnam in *Full Metal Jacket* features circular compositions. In *A.I.* it is reflective of a narrative that travels full circle: two thousand years in the future, the SuperMechas are 'creating' humans. Writer and academic Carolyn Jess-Cooke has stated that in *A.I.* desire itself is conceived as circular and repetitive, as it is never satisfied – Professor Hobby's desire to recreate his dead son; Monica's desire to continue to be a mother; David's desire to become a real boy.[1]

Scenes at the Swintons' apartment focus on domestic drama – the effect David has on the dynamics of the family, in particular on Monica, who throughout the first act continually battles with how she should feel towards her robot 'son'. As soon as David arrives, the emotional dilemma begins. Distraught by the very idea of a robot-child substitute for her biological son, Monica says to Henry, 'He's so real, but he's not. I mean he's just like all the rest, isn't he?' Henry replies, 'One hundred miles of fiber, yeah.' 'But outside,' Monica says, 'he just looks so *real*. Like he is a child.' This discussion not only establishes the emotional turmoil that Monica faces, but also, most importantly, the definition of 'real' that the humans apply to Mechas. If a robot looks like a child and acts like a child, would we class it as a sentient being? Would we be able to treat it as such? How would we react, and what responsibility would we have towards that being? These are questions that Stanley Kubrick and writer Ian Watson discussed at length.

Running parallel to Monica's emotional quandary (she refers to David as a child, but Henry, who does not take part in the imprinting and therefore lacks the same emotional attachment, reminds her that he is, in fact, a 'toy'), the first act presents an opportunity for David to begin to discover a sense of self and identity. He is introduced to Martin's SuperToy, Teddy, who throughout the film is his most loyal and trusted friend – the Jiminy Cricket of Disney's *Pinocchio*.

Steven Spielberg charged Stan Winston Studio with creating the robotics and animatronics for the film, and Teddy was one of the most complex and demanding characters due not only to the number of scenes and amount of screen time in which he would 'act', but also the technical advancements that would be needed to produce the effects required for his character and performance.

Six puppeteers operated Teddy, and Lindsay Macgowan, effects supervisor at Stan Winston Studio, recalls: 'There were long, tough days because we would shoot all day and then we would rehearse into the night for the next day. I think we rehearsed more for Teddy than any other character I've worked on.'

Industrial Light and Magic (ILM) were charged with creating the computer-generated version of Teddy. Communication and collaboration between production design for on-set Teddy and ILM for CG Teddy was paramount. 'Rick Carter and his crew were great about accommodating us to make sure that we could get Teddy into as many places as possible,' says Macgowan. 'The Swintons' home was built above ground, so we could get underneath the set very easily. It also meant we could puppeteer from underneath as well as behind. During the scene where David and Martin tease each other over eating spinach, we were all hidden underneath the table and chair, so it was a challenge to be incredibly confined and yet still get the very best performances out of the character. We had duplicates of all the things that he was going to be sitting or standing on, so we could make little holes in the props and get in and out as quickly as possible. Steven works fast and you really have to be fully prepared and know exactly what you're going to be doing.

'We worked closely with Scott Farrar, visual effects supervisor, and Hal Hickel, animation supervisor, at ILM. At that point digital hair was an incredibly hard and complex thing to create, so we sent them samples of what we were doing so they could get the right curl and kink, as well as texture and colours. We would show ILM our rehearsals so they had time to work on the post-production, and they would send us the work that they were doing, which could then be developed or incorporated into our work on set. So ideas went continually back and forth.'

In the film, following Martin's unexpected return home after his 'awakening', he says to David, 'So I guess now you're the new SuperToy. So what good stuff can you do? Can you do "power" stuff, like, walk on the ceiling or the walls? Anti-gravity? Like, float, fly?' David asks, 'Can you?' Martin replies, 'No, because I'm real.' It becomes apparent in the conversation that David is ignorant of the fact that he is Mecha. He lacks any comprehension of the difference between real and artificial. Martin, who when we first see him appears more robotic than David, questions his robot-brother's 'build day', and asks him, 'So what's the first thing you can remember?' David recalls a bird, which he draws. Academic and writer Renate Bartsch notes that 'for an autobiographic memory to be possible, the child first has to develop self-consciousness; it has to recognize itself not just as the one whom it sees in the mirror ... rather the child has to understand itself as integrating its experienced episodes in a history, which is its own history....'[2] David is unable to place his memory within the context of his own history until he returns 'home' to Cybertronics, his birthplace.

Mirrors and reflective surfaces are prevalent throughout the Swintons' home. The reflection of Monica in the circular cooker hob, the reflection of David in the metallic surfaces of the circular coffee pots and the mobile in his bedroom, his reflection in the glass of the picture frames showing family shots of the Swintons, these are the start of a motif that continues throughout the film. The reflections examine the concept of the Self and the Other and the double, which eventually culminates in David meeting his doppelgänger at Cybertronics and finally discovering his true identity, and in Monica being represented by an artificial double at the end of the film. Carolyn Jess-Cooke comments that the reflective surfaces in *A.I.* suggest the 'mirror stage' of David's

development – 'the point at which a child sees itself in the mirror but does not yet understand that the reflection is a reflection, nor does it comprehend the difference between Self and Other.... As Lacan indicates, the purpose of the mirror stage is "to break out of the circle of the *Innenwelt* (inner world) into the *Umwelt* (outer world)", effectively shattering the "mirror of childhood" in which the Self is unknown.'[3]

Martin sows the seed for David to chase his dream, a false wish and desire: he asks his mother to read *Pinocchio*. Monica's slight hesitance is revealing of her deepening feelings towards David. However, even though she has registered Martin's malice – with a mischievous grin, he has said, 'David is going to *love* it' – her decision to read the story shows that her biological son will, ultimately, always take precedence.

Throughout the first act, Martin becomes increasingly spiteful towards his mechanical sibling, out of jealousy caused by the rivalry that David poses for his mother's affection. Further events precipitated by Martin include his sending David on a secret mission to cut off a lock of Monica's hair. The culmination is an incident at the family swimming pool, where Martin has a party for his birthday. His friends crowd round David, prodding him. 'He's so real,' comments one. 'Mecha real,' says another. One of Martin's friends tests David to see if he has been programmed with a Damage Avoidance System by touching him with the point of a knife. David's immediate reaction is to grab Martin and hide behind him for protection. As David continues to clutch his brother, the two fall into the pool and sink to the bottom (for David, prefiguring the watery fate that will meet him at the end of the second act of the film). Henry is now adamant that David poses a threat to his family's safety. Since he does not have an emotional relationship

with David, he is able to convince Monica that she must take him back to Cybertronics to be destroyed. Under the pretext of a day out for just mother and son, Monica drives David (and Teddy) to Cybertronics. However, her emotional attachment to David is too strong, and instead she drives him to the forest near Cybertronics (filmed on location in Oregon). What follows is an emotional separation, as Monica tells David that she has to leave him in the forest, alone.

David is programmed to have 'unwavering devotion [to] and love [for]' whomever imprints on him. In order for his mother to love him in return, he has developed the idea that, like Pinocchio, he must become real. However, he doesn't understand what 'to be real' actually means, any more than he is able to differentiate between what is and is not a game, or what is a story and what is reality. 'If Pinocchio became real and I become real, can I come home?' he pleads. Monica replies, 'That's just a story.' 'But that story tells what happens,' he says. 'Stories aren't *real*,' Monica cries, as she runs to the car. David hangs on to her, desperately pleading, 'I'm sorry I'm not real. If you let me, I'll be so real for you.' Driven by his programming, he is unaware that he has set himself an impossible goal: to Monica he will never be real, but always 'one hundred miles of fiber'. Monica thrusts money at him, which has no meaning to the little 'boy' who just wants his mother's love.

The first part of the film closes with a shot of David reflected in the circular car mirror as Monica drives away. The scene is set for what Kubrick referred to as 'The Pinocchio Syndrome' – 'a study of a robot whose desire is to become human: an experiment that is not looking for an answer, but, instead, an experiment to see how the robot would cope'.

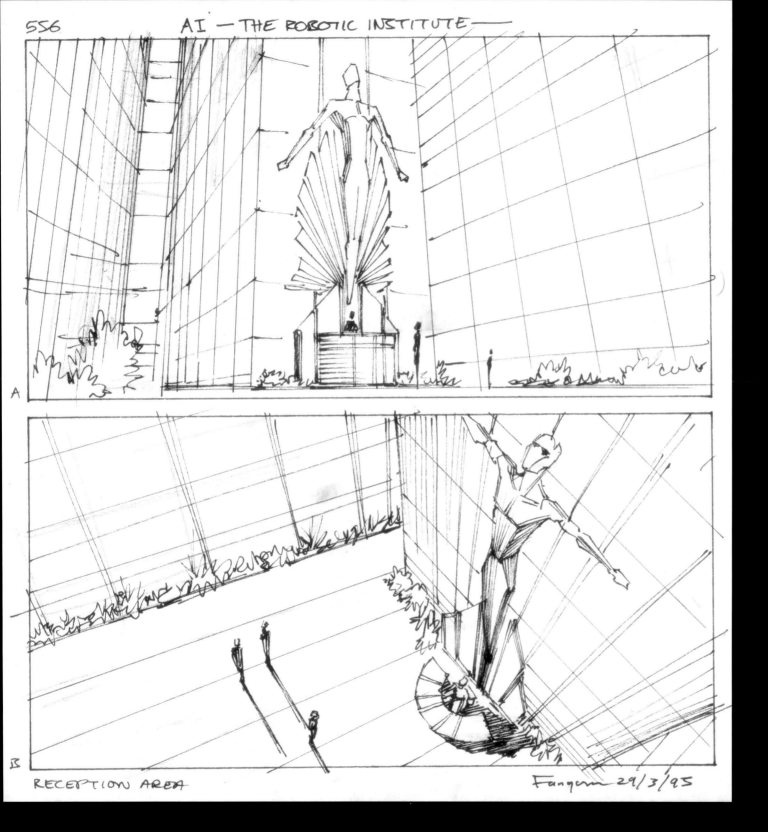

A

B

RECEPTION AREA

Fangum 29/3/95

IN THE BEGINNING...

In a world in which the human population is controlled and Mechas have predetermined roles within society, Professor Hobby (played by William Hurt) outlines his intention to create a robot with emotion, with the key to a subconscious, and with a rich inner world of metaphor, intuition, self-motivated reasoning and dreams. At Cybertronics, in a room full of engineers, designers and programmers, the professor uses his robot secretary, Sheila (played by Sabrina Grdevich), to demonstrate the current limitations of Mechas, and thus strengthen his argument in favour of creating a new 'evolutionary' stage in Artificial Intelligence.

LEFT **Chris Baker's designs** for the Robotic Institute in Zero Zone (not featured in the final film). They were nonetheless drawn on by Steven Spielberg for the architecture of Professor Hobby's Cybertronics institute. Baker's statue was developed into the company logo, and in Spielberg's screenplay it is referenced in David's first memory.

'I propose that we build a robot child, who can love.
A robot child who will genuinely love the parent or
parents it imprints on, with a love that will never end.'

STEVEN SPIELBERG, SCREENPLAY

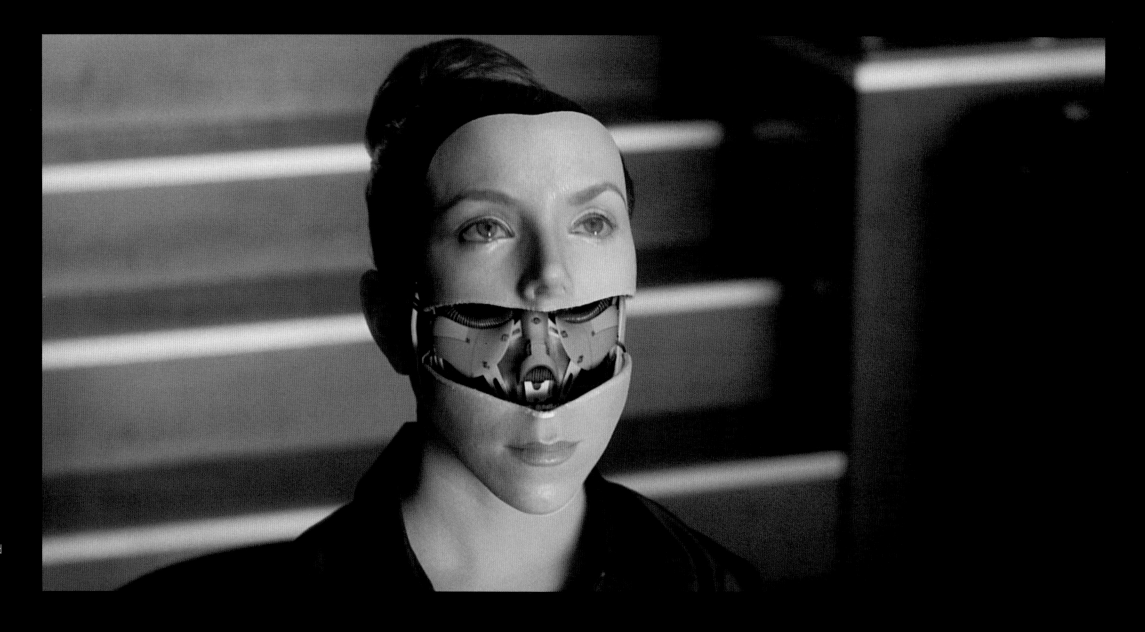

RIGHT **Film still** of Professor Hobby's robot
secretary, Sheila. The computer-generated
head was produced at ILM from stills and
footage of actress Sabrina Grdevich. It was
then matched to the live-action footage and
animated so the face would part to reveal
the robotics beneath.

THE CRYOGENIC INSTITUTE

Monica and Henry Swinton (played by Frances O'Connor and Sam Robards) visit the cryogenic facility where their real son, Martin (played by Jake Thomas), lies in a state of suspended animation. Martin has been in his pod for five years, while the family await such time as science has advanced sufficiently to be able to cure him. It is the emotional lacuna left by his absence that encourages Henry to accept the offer of a Mecha boy, a son-substitute for his unhappy wife.

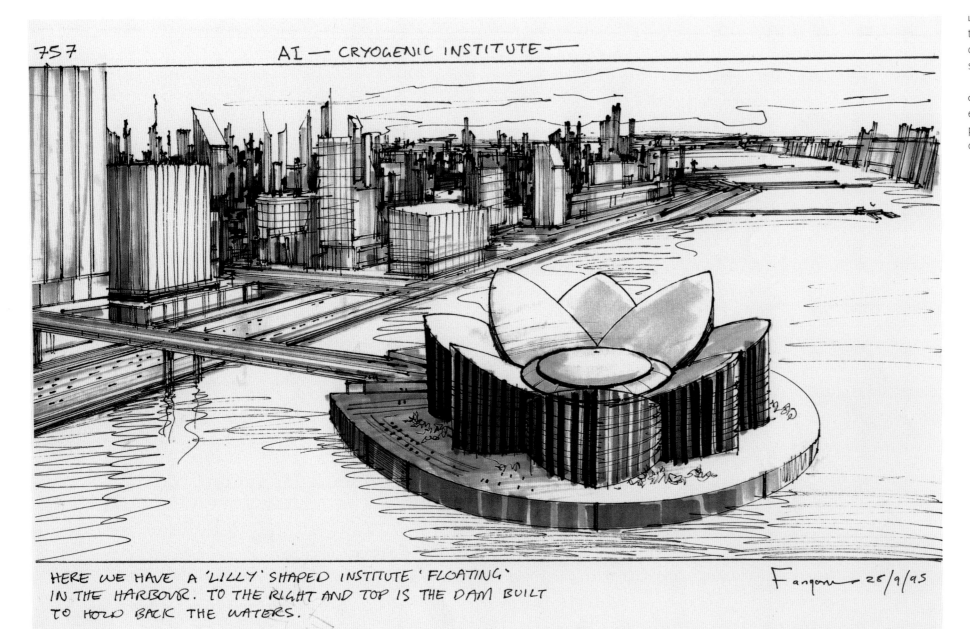

757

AI — CRYOGENIC INSTITUTE —

HERE WE HAVE A 'LILLY' SHAPED INSTITUTE 'FLOATING' IN THE HARBOUR. TO THE RIGHT AND TOP IS THE DAM BUILT TO HOLD BACK THE WATERS.

Fangom — 25/9/95

LEFT **Chris Baker** played with scale to generate ideas for the future world, flooded by the melting of the polar ice caps. He also used this lily-pad motif in a nightclub scene that did not in the end feature in the final film.

OPPOSITE **Further designs** by Chris Baker for Cryogenics exteriors. Spielberg excluded all exteriors from the first part of the film to keep the focus on the internal, the domestic and the dynamics of the family relationships.

'The flood would have had its advantages. Formerly prime land would become cheap to purchase and "build" on. The result of this — lots of industrial sites forming strange "islands".'

CHRIS BAKER, CONCEPTUAL ARTIST

(35)

ALTHOUGH THE INSTITUTE SHOULD BE SIMPLER
THAN PREVIOUS SKETCHES I STILL THINK IT SHOULD
BE QUITE A STRIKING BUILDING.

ALSO UNLIKE MY EARLIER SKETCHES
IT'S HIGHLY LIKELY THAT MOST
OF THE COMPLEX WOULD BE
UNDERGROUND.

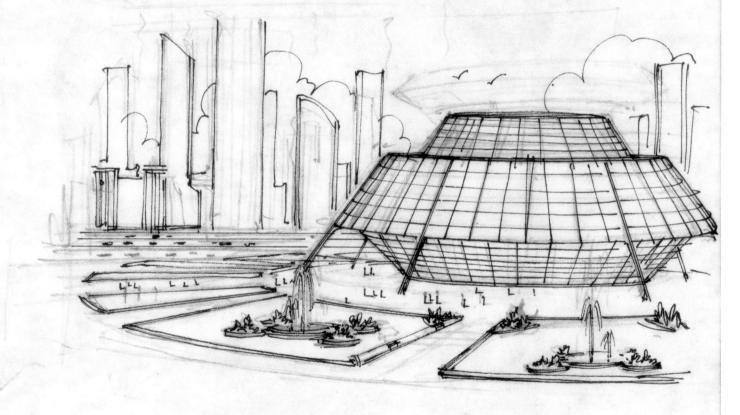

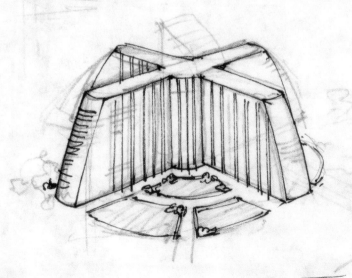

— CRYOGENIC INSTITUTE EXTERIORS —
FANGORN "AI" 24/6/94

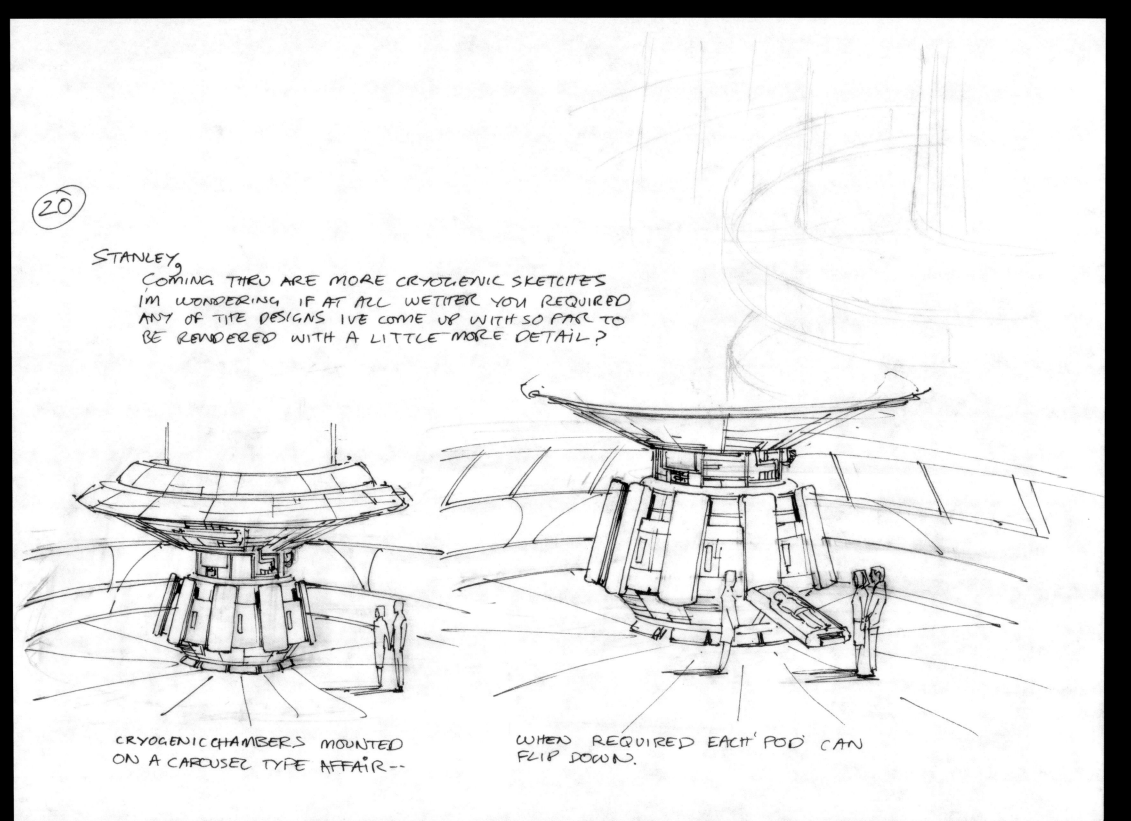

(20)

STANLEY,

COMING THRU ARE MORE CRYOGENIC SKETCHES
I'M WONDERING IF AT ALL WETHER YOU REQUIRED
ANY OF THE DESIGNS I'VE COME UP WITH SO FAR TO
BE RENDERED WITH A LITTLE MORE DETAIL?

CRYOGENIC CHAMBERS MOUNTED
ON A CAROUSEL TYPE AFFAIR--

WHEN REQUIRED EACH 'POD' CAN
FLIP DOWN.

LEFT **Chris Baker** made many drawings illustrating how humans could be stored until advances in medical science were able to provide a cure for them.

'Another way of "freezing" bodies would be to convert organic matter into an energy form that could be "stored" digitally in some kind of electronic grid. In essence this would be a space-saving device. However, it would also allow doctors to operate/study patients entirely through the use of computers — digital surgery....'

CHRIS BAKER, CONCEPTUAL ARTIST

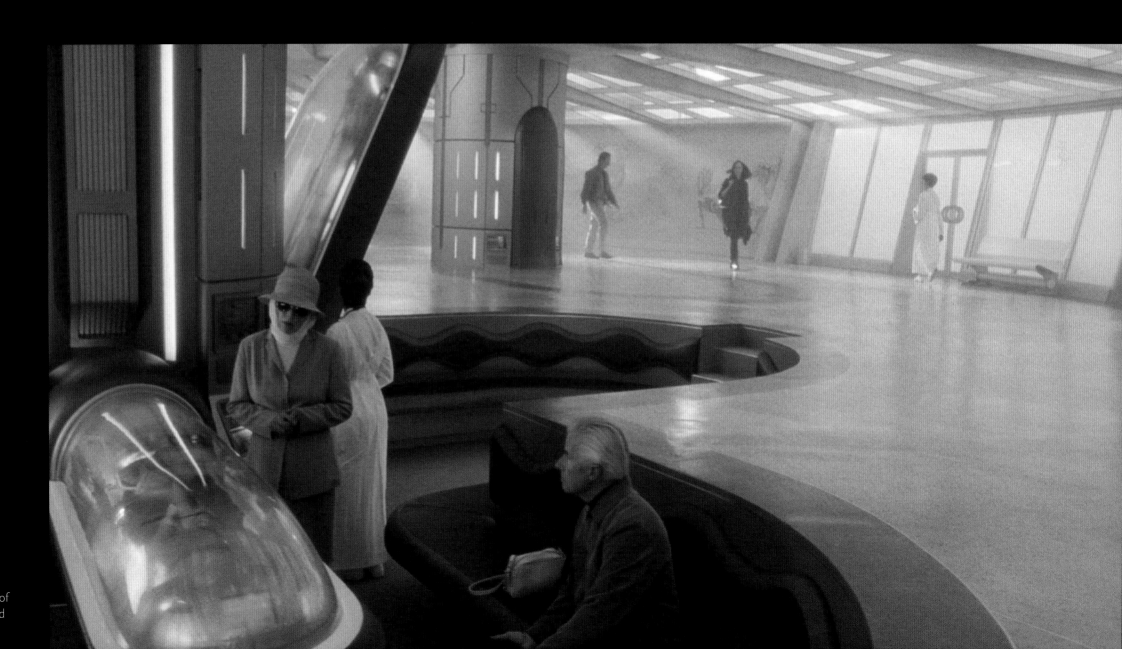

RIGHT **Film still** showing the realization of
Chris Baker's concept. Here Monica and
Henry Swinton (see background) are
arriving in the Cryogenics building

LEFT **Film still** showing Martin lying cryogenically frozen in his chamber while his mother reads to him. This image of Martin mirrors David in his frozen tomb (see pp. 134–135).

OPPOSITE **Chris Baker's pod designs** for storing Martin

VARIATIONS ON THE THEME:

PERHAPS ANOTHER WAY OF 'FREEZING' BODIES WOULD
BE TO CONVERT ORGANIC MATTER INTO AN ENERGY
FORM THAT COULD BE 'STORED' DIGITALLY IN
SOME KIND OF ELECTRONIC GRID. IN ESSENCE
THIS WOULD BE A SPACE SAVING DEVICE. HOWEVER IT
WOULD ALSO ALLOW DOCTORS TO OPERATE/STUDY
PATIENTS ENTIRELY THRU THE USE OF COMPUTERS—
DIGITAL SURGERY....

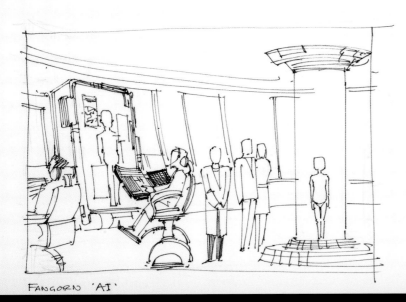

FANGORN 'AI'

STANLEY— HERE ARE SOME LESS UNUSUAL
SKETCHES FOR THE CRYOGENIC INSTITUTE.

CHRIS

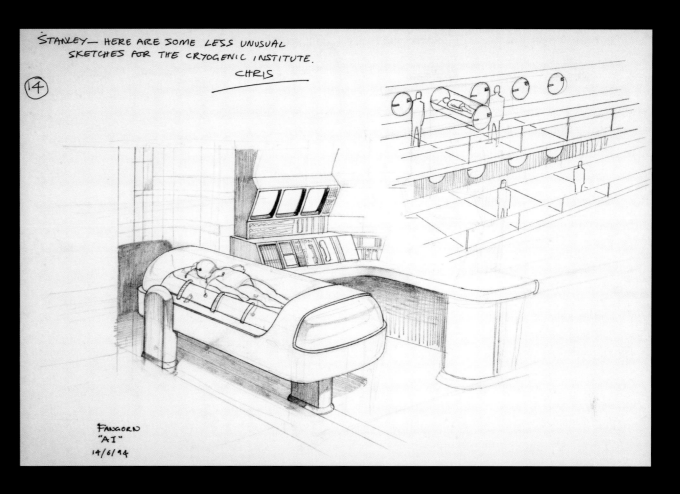

FANGORN
"AI"
14/6/94

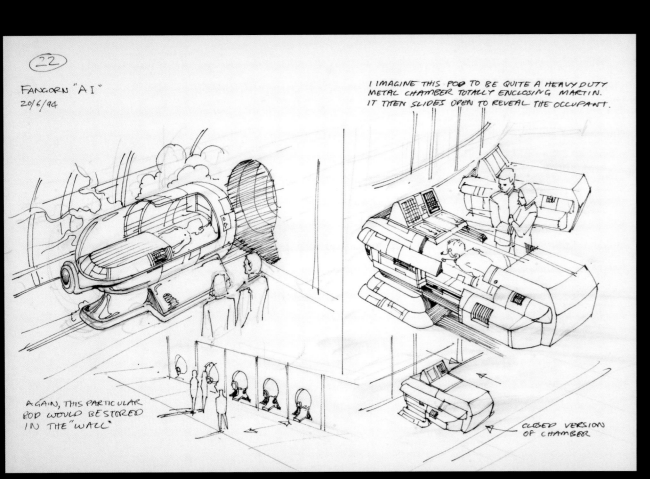

FANGORN "AI"
20/6/94

I IMAGINE THIS POD TO BE QUITE A HEAVY DUTY
METAL CHAMBER TOTALLY ENCLOSING MARTIN.
IT THEN SLIDES OPEN TO REVEAL THE OCCUPANT.

AGAIN, THIS PARTICULAR
POD WOULD BE STORED
IN THE "WALL"

CLOSED VERSION
OF CHAMBER

A FEW POD DESIGNS EXECUTED BEFORE
OUR CONVERSATION THIS MORNING.

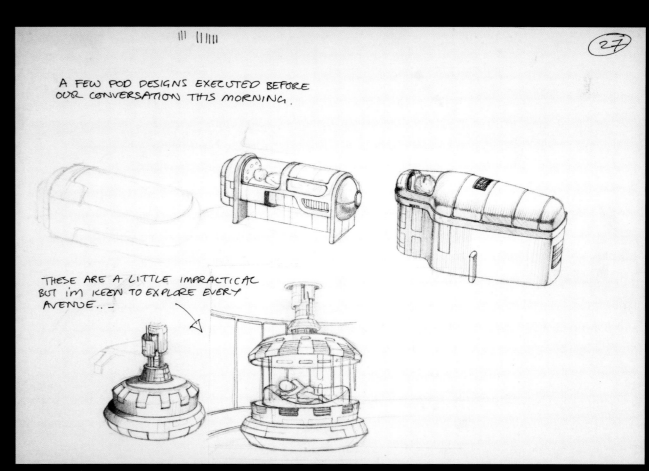

THESE ARE A LITTLE IMPRACTICAL
BUT I'M KEEN TO EXPLORE EVERY
AVENUE...

THE SWINTONS' APARTMENT

David (played by Haley Joel Osment) arrives at the Swintons' apartment as a pre-programmed robot boy. Pre-imprinting, he appears to be a creepy and uncomfortable addition to the family home – his first, incongruous words 'I like your floor', his glance at Monica through the glass in the bedroom door while Henry undresses him, his sudden appearances while Monica is cleaning the apartment, his exaggerated laughter at the dinner table.... The focus, pre-imprinting, is on Monica's perception of David and her emotional battle with the loss of her biological son.

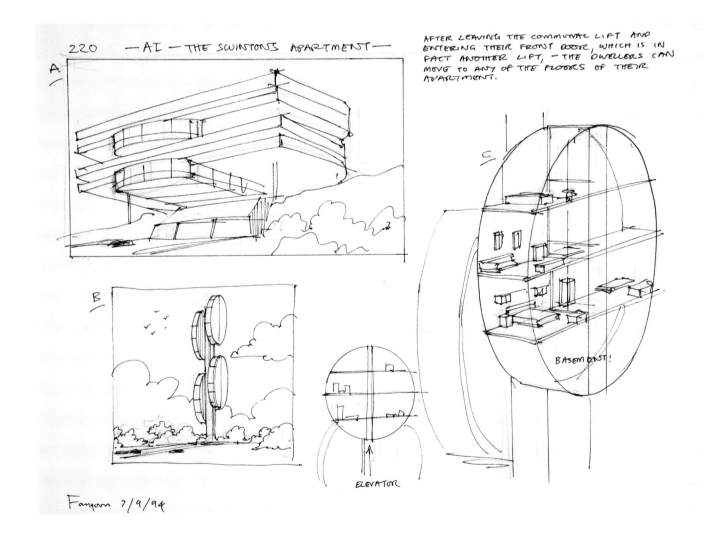

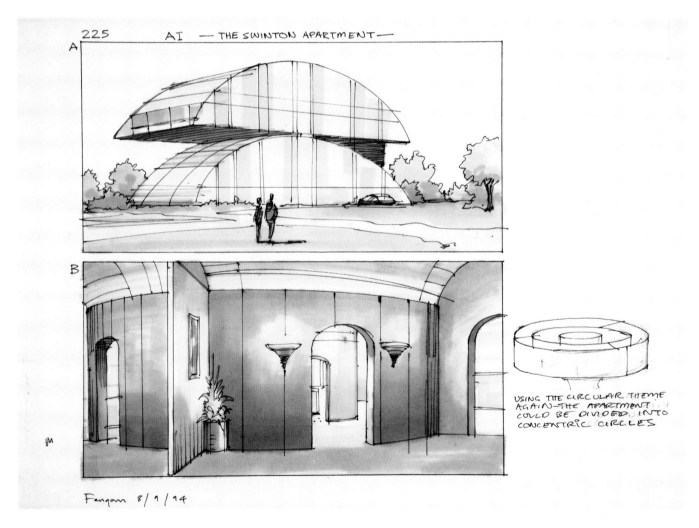

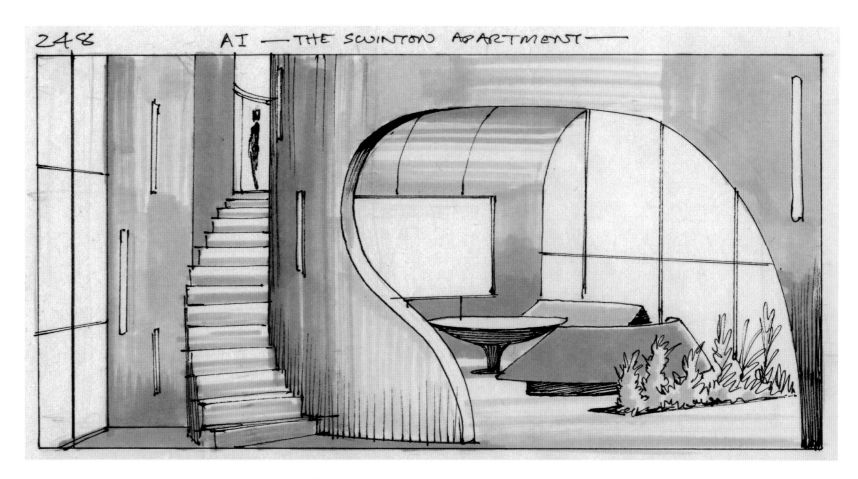

OPPOSITE AND RIGHT **Chris Baker's circular designs** for the Swintons' home. These were developed further by Baker and production designer Rick Carter.

> ' I imagine this apartment to be cylindrical — each room is on a separate level with either a staircase or elevator at its centre. '

CHRIS BAKER, CONCEPTUAL ARTIST

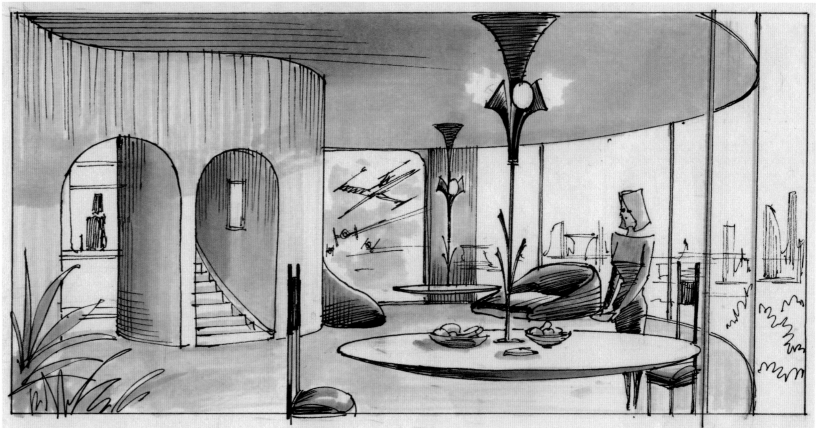

BELOW **Circles and reflections** are prevalent in the design of the Swintons' home and feature throughout the rest of the film.

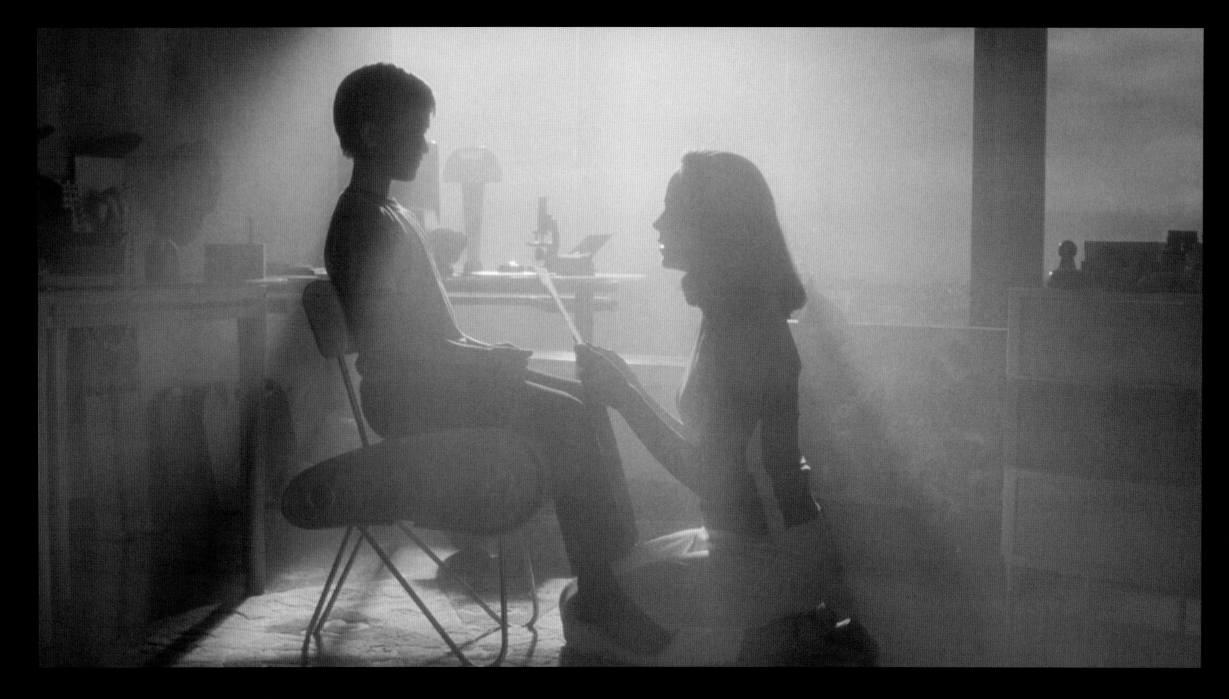

ABOVE **Film still** showing the imprinting scene taking
place in the apartment. The painful emotions generated
by the memory of her son at Cryogenics drive Monica's
decision to imprint. 'Is it a game?' asks David.

TEDDY

Teddy (voiced by Jack Angel) is introduced to David at the Swintons' home and becomes his most loyal friend. The bear was once Martin's SuperToy, so Steven Spielberg suggested that he should have a slight limp to show that Martin had mistreated him. Spielberg discussed the look of Teddy with Stan Winston, and Winston's studio then generated many designs to make a unique bear for the film. Spielberg also went through his ideas for each scene with Winston. Winston's team, in turn, set about creating Teddy's personality and performance. As one of the main characters, Teddy has a substantial amount of screen time, which makes him one of the most challenging animatronics ever devised for film.

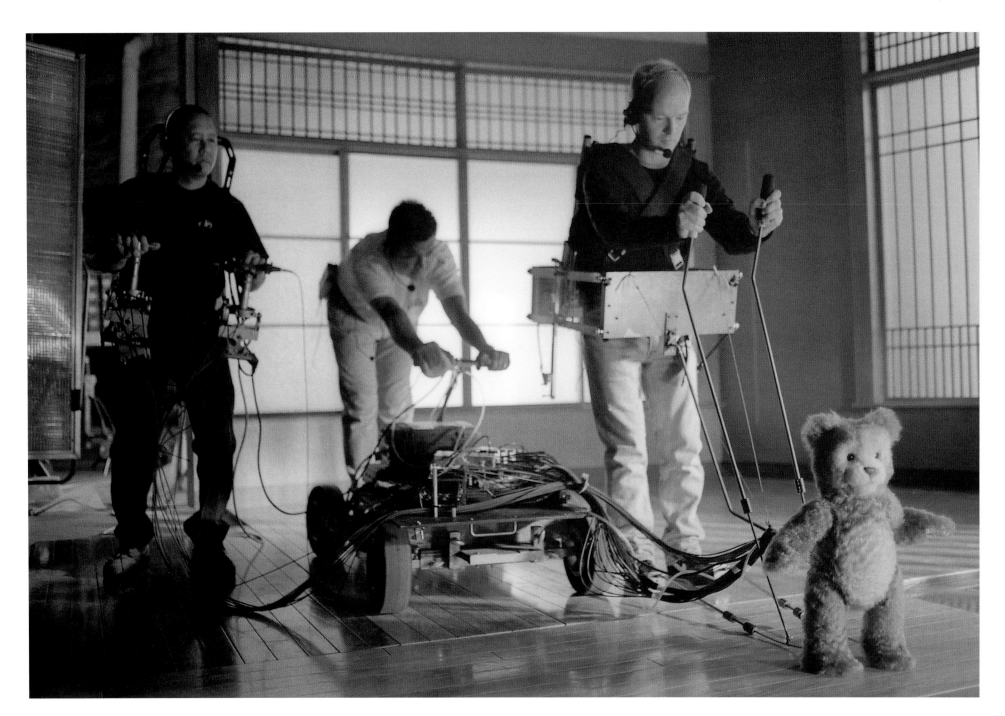

LEFT **On-set rehearsal in progress**, as Lindsay Macgowan operates the walking rig, with Bob Mano (left) and Mike Ornelaz (behind).

'In choreographing Teddy, Stan was the conductor and we were the orchestra. In many ways, Stan was our acting coach.'

LINDSAY MACGOWAN, EFFECTS SUPERVISOR

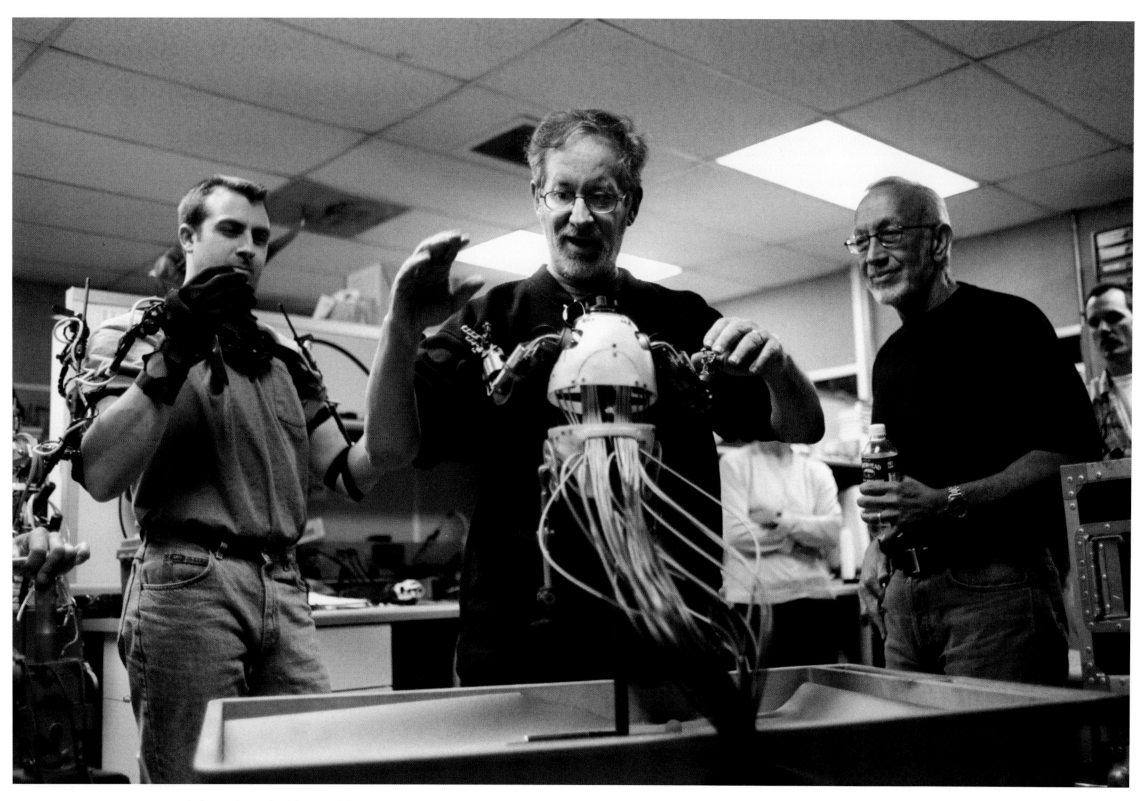

ABOVE **Steven Spielberg** interacts with the mechanical Teddy. To his left, Stan Winston observes, as Matt Heimlich operates the movements of Teddy's arms and fingers with a telemetry suit. A new suit had to be specially created by Stan Winston Studio to ensure that Teddy could perform the nuanced actions – such as sewing – required for his character.

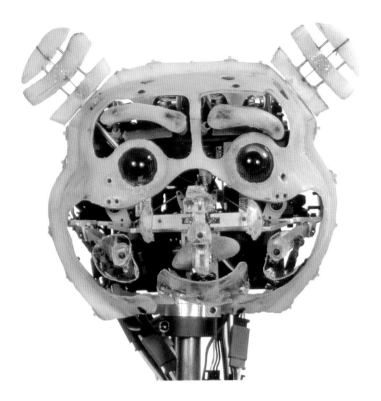

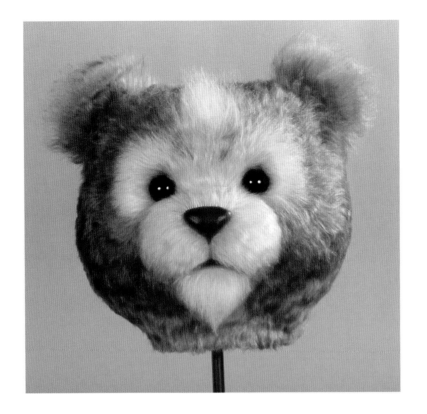

'Teddy was the most complicated and challenging animatronic that the studio had made, due to his size (we had more going on inside Teddy than in *Jurassic Park*'s T-Rex), due to the demands and pressures of puppeteering on the set, and because we had to make sure that Teddy's performance was as good as it could be with the great actors that we had to work opposite.'

LINDSAY MACGOWAN, EFFECTS SUPERVISOR

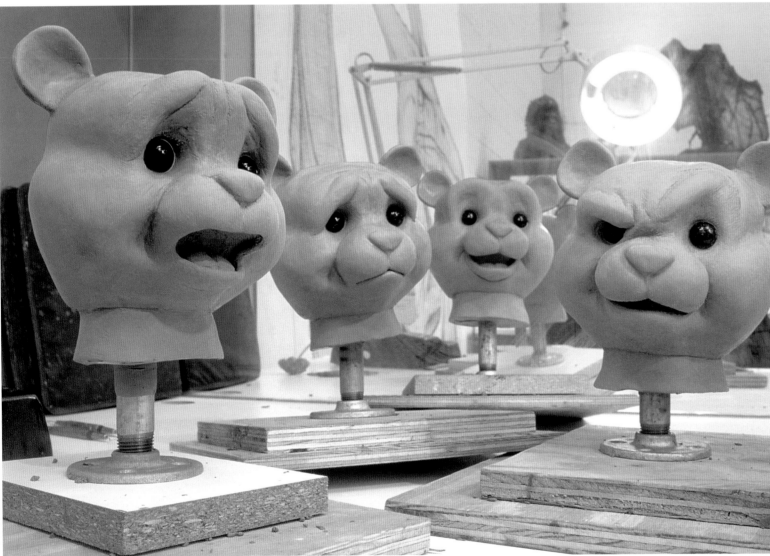

ABOVE LEFT **The mechanics** of Teddy's head. *Jurassic Park*'s T-Rex had forty points of motion, but Teddy had fifty, twenty-four of which were in his face – all designed to fit into a tiny character no more than 2 feet (0.6 m) tall.

ABOVE RIGHT **Final design** of Teddy, showing his white, heart-shaped fur.

LEFT **Different heads**, including a concerned head, a sad head, a delighted head and a curmudgeon head, were created in order to produce the wide range of expressions needed for Teddy. Each body and head was interchangeable.

BELOW LEFT **Mike Ornelaz** works on one of the
many Teddys created for the film. Stan Winston
Studio used all the technology and forms of
puppetry available, including pneumatics,
rod puppets, hand puppets, radio-controlled
puppets and cable-controlled puppets.

BELOW **Film still** of Teddy's bemused expression,
as he has to choose between his loyalty to Martin
or to David. Teddy is unable to make the choice so
instead, and with great diplomacy, runs across the
room to Monica, jumping onto a cushion with
arms and legs flailing, crying, 'Mommy, Mommy'.

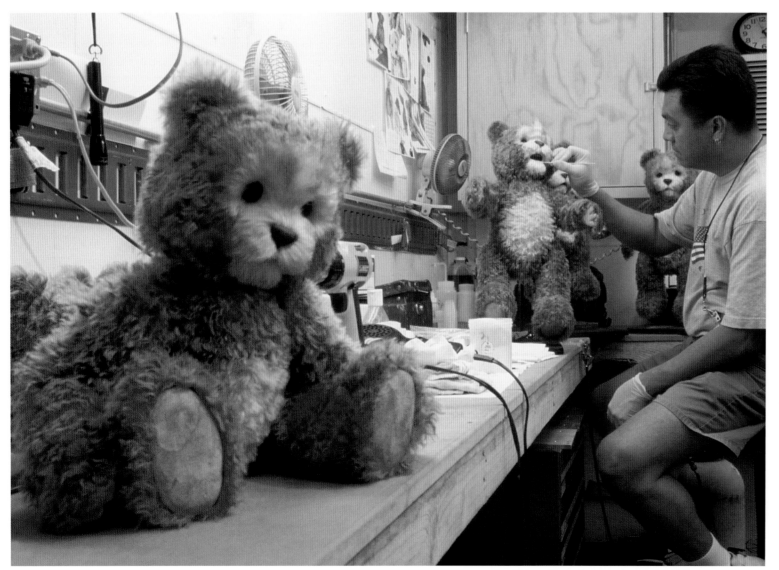

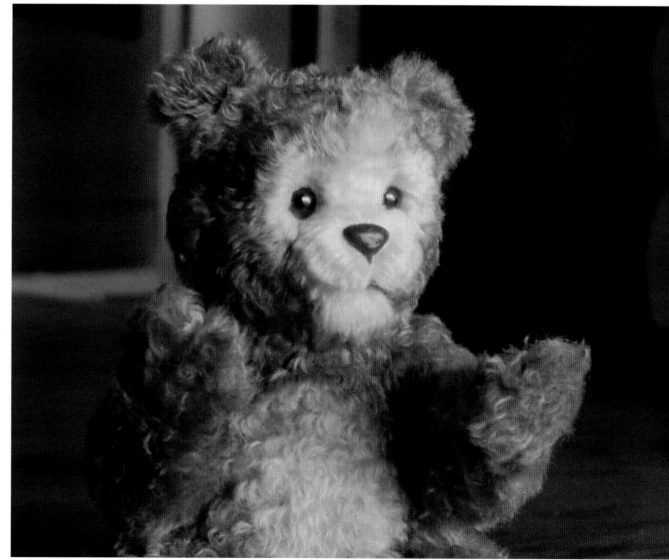

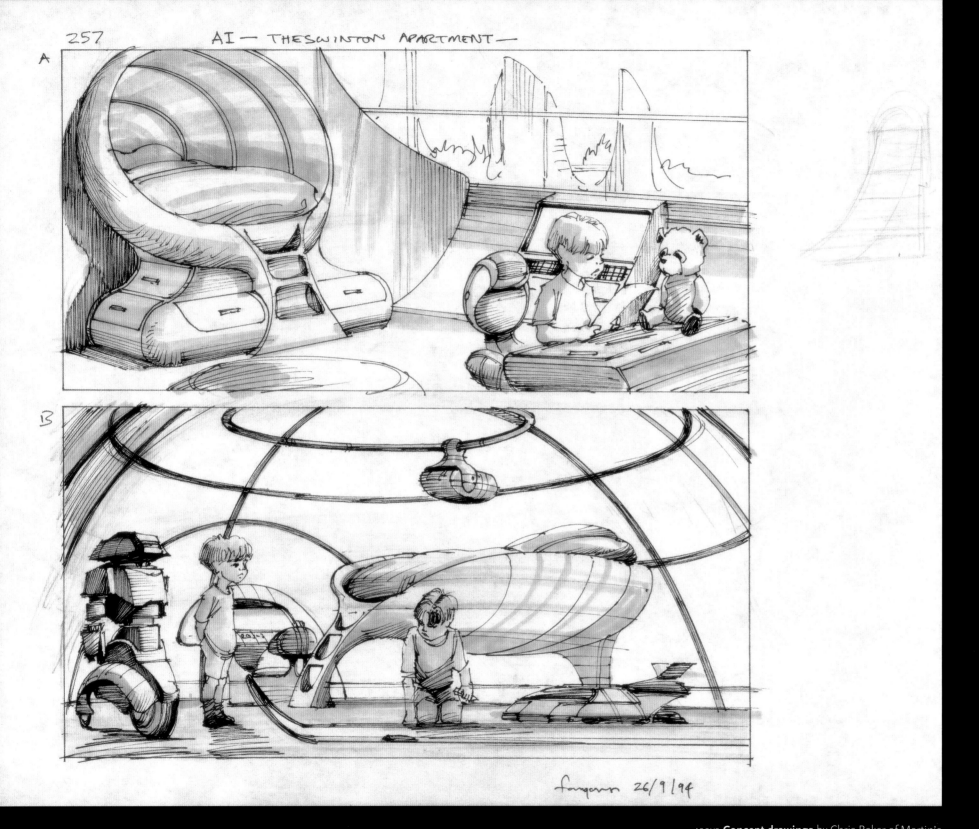

fungarn 26/9/94

ABOVE **Concept drawings** by Chris Baker of Martin's bedroom. In this scene, David first hears that he is different from Martin: Martin is 'real' and he is not. Martin questions David about his 'build day'. He also asks him to recall his first memory.

THE PINOCCHIO SYNDROME

Post-imprinting, Monica's repulsion at the idea of a robot child turns to genuine affection for her son-substitute. However, her 'real' son Martin comes home, and the sibling rivalry Martin feels fuels his mischief and spite towards his 'brother'. It is Martin who sows the seed for David's dream of becoming real when he asks his mother to read aloud *Pinocchio*; it is also Martin who makes Monica's future resurrection possible, when he makes David snip a lock of hair from her head, thus preserving her DNA.

> ' I really liked the fact that you could take an idea that most people might find cold and clinical – machine intelligence – and use the story of *Pinocchio* to get at the real essence of existence. '

RICK CARTER, PRODUCTION DESIGNER

' "Then the dream ended, and Pinocchio awoke, full of amazement. You can imagine how astonished he was when he saw that he was no longer a puppet, but a real boy, just like other boys." '

STEVEN SPIELBERG, SCREENPLAY (FROM CARLO COLLODI'S *PINOCCHIO*)

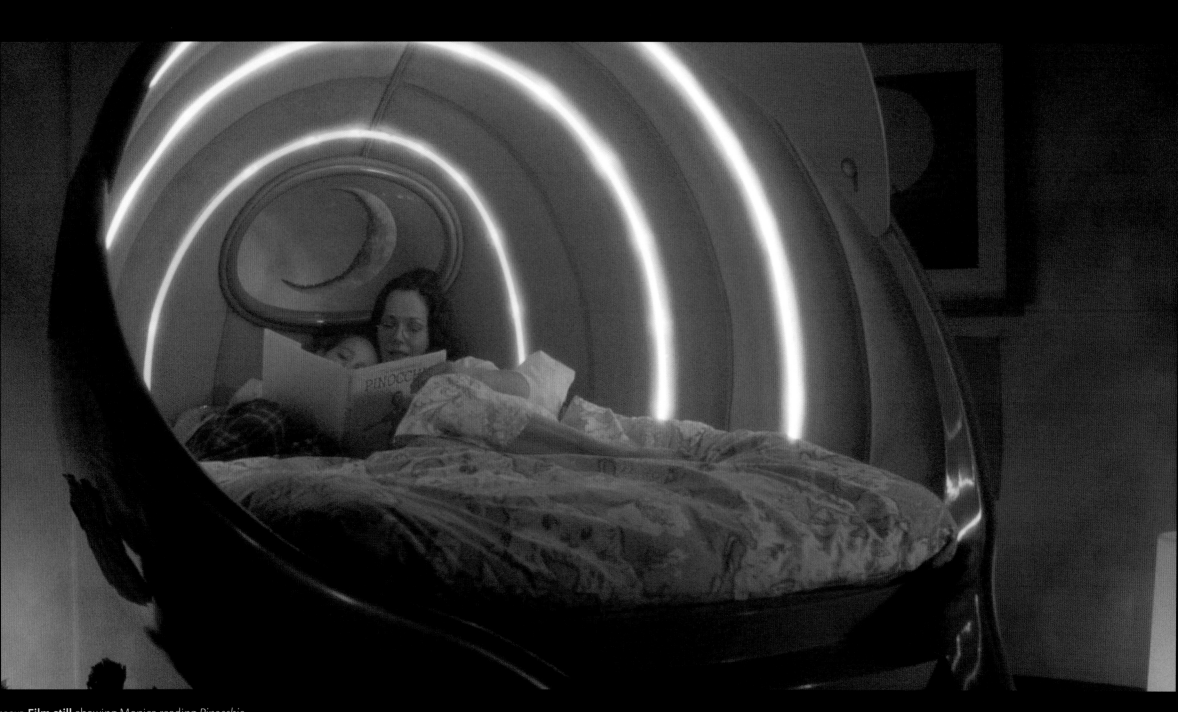

ABOVE **Film still** showing Monica reading *Pinocchio* to Martin. Out of shot, David is sitting on the floor – as a Mecha, he cannot fall asleep. He looks on in wonder when he hears the words 'real boy'.

A LOCK OF MOMMY'S HAIR

'If you do something really, really, really special for me, a special mission,'
schemes Martin, 'then I'll go tell Mommy I love you, and then she'll love you,
too.' Driven by his desire for Monica to love him as much as she loves Martin,
David creeps into her bedroom with Teddy to carry out Martin's dare. Monica
awakes to find David standing over her with a pair of scissors, causing Henry
to raise questions about the threat David could pose to his family's safety.

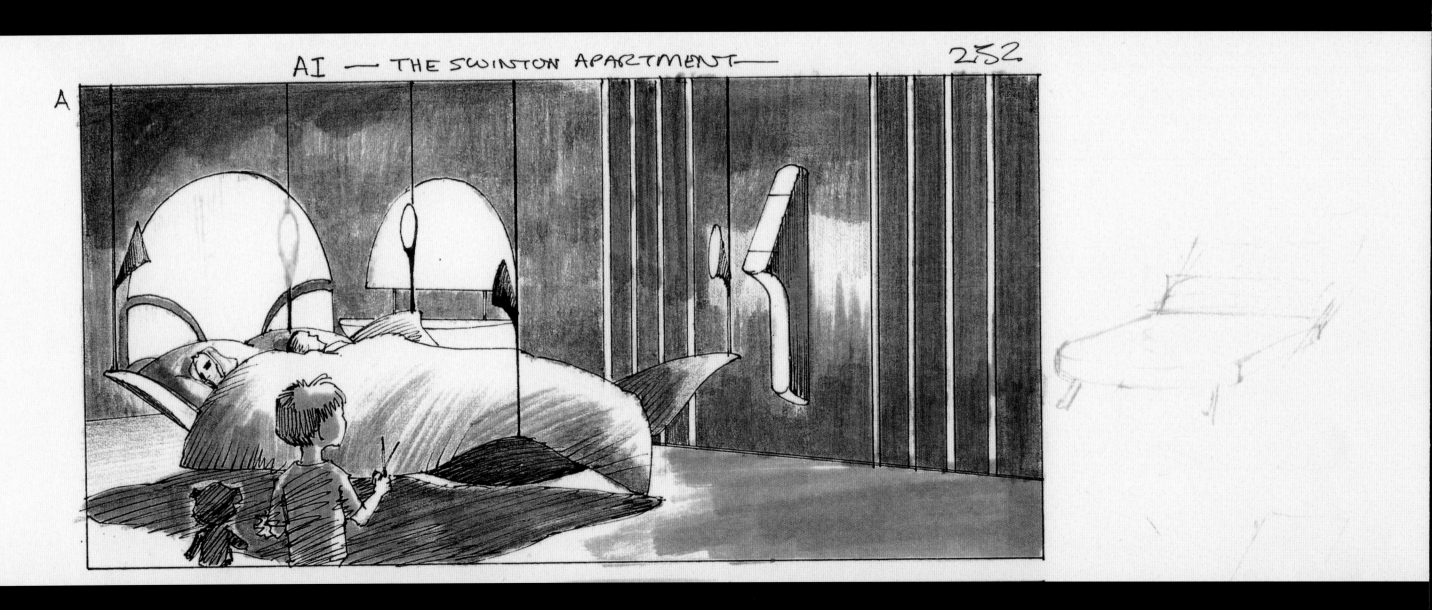

ABOVE AND OPPOSITE **Chris Baker's concept drawings** of the hair-cutting scene.

'If [David] is created to love, then it's reasonable to assume he knows how to hate. And if pushed to those extremes, what is he really capable of?'

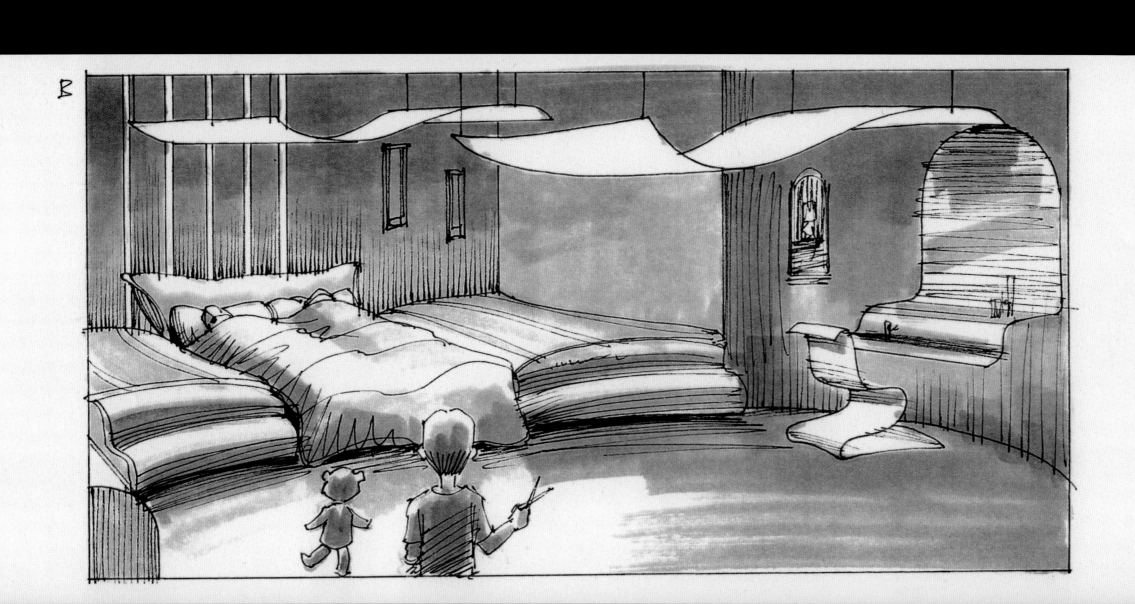

'I LOVE YOU, MOMMY'

Following on from the fears raised by the hair-cutting and the swimming-pool incidents, Monica agrees to take David back to Cybertronics to be destroyed. She has strong misgivings about this, especially after she reads the loving notes David has written her. Earlier in the film, he told her, 'I love you, Mommy. I hope you never die. Never' – prescient words in light of her future resurrection at the end of the film. When Monica tells David she will live 'for ages, for fifty years', his question to Teddy – 'Is fifty years a long time?' – is a poignant reminder not only of his childlike nature, but also of Monica's timebound mortality, and the flawed, selfish programming that does not seem to have addressed the problem of what will happen to loving Mecha children when their parents die.

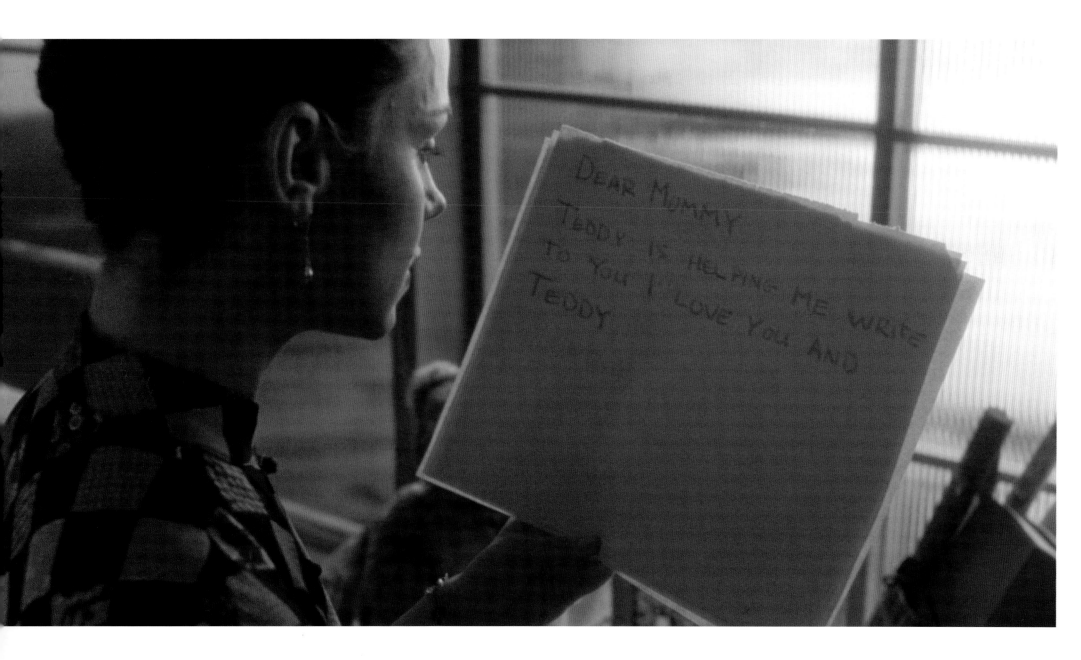

LEFT **Film still** showing Monica reading David's letters following the swimming-pool scene.

OPPOSITE **Chris Baker's concept drawing** of the letter-writing scene. A Pinocchio figure rests on the shelf beside David. Baker has also given him a dinosaur (humans, too, will shortly become extinct) and a robot toy that is by now as old-fashioned as the toy soldier and the conventional stuffed animal.

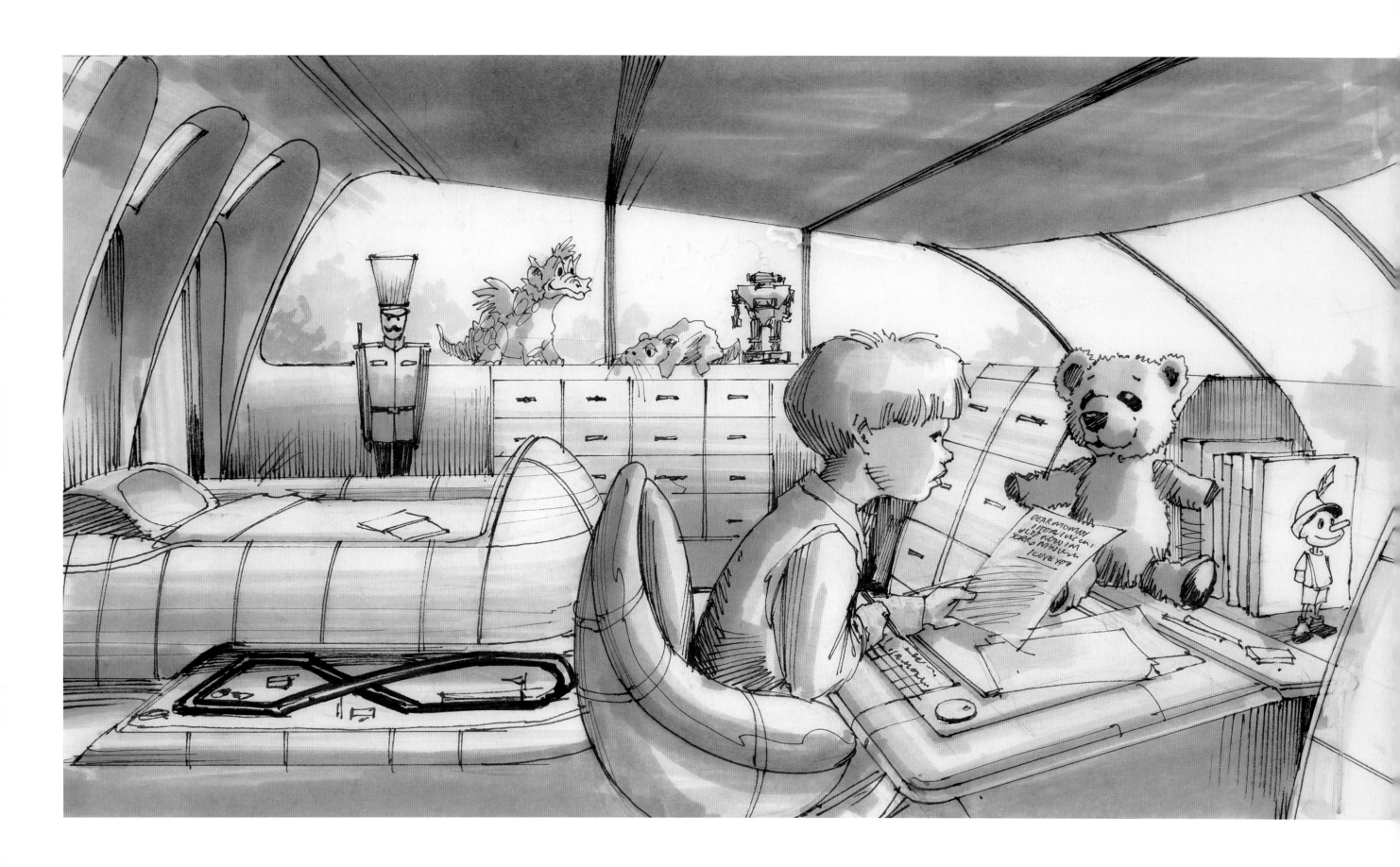

'WHEN WILL YOU COME BACK FOR ME?'

Monica cannot bring herself to drive David to Cybertronics, so instead
she takes him to the forest. Chris Baker put forward many suggestions to
Stanley Kubrick for the concept of the Swintons' future car: they would,
he imagined, have a 'family car', and 'even in the States, the European,
economy-wise, highly manoeuverable machine will prevail'. Monica tells
David that she has to leave him in the forest. David pleads with her, but
after an emotional separation she runs to her car. The first part of the film
concludes with Monica driving off, leaving David in the forest with Teddy.

'I have to leave you here.'
'Is it a game?'

STEVEN SPIELBERG, SCREENPLAY

ABOVE **Film still** of David's reflection in the wing mirror of the Swintons' car, one of the many circular and reflective images seen in the film.

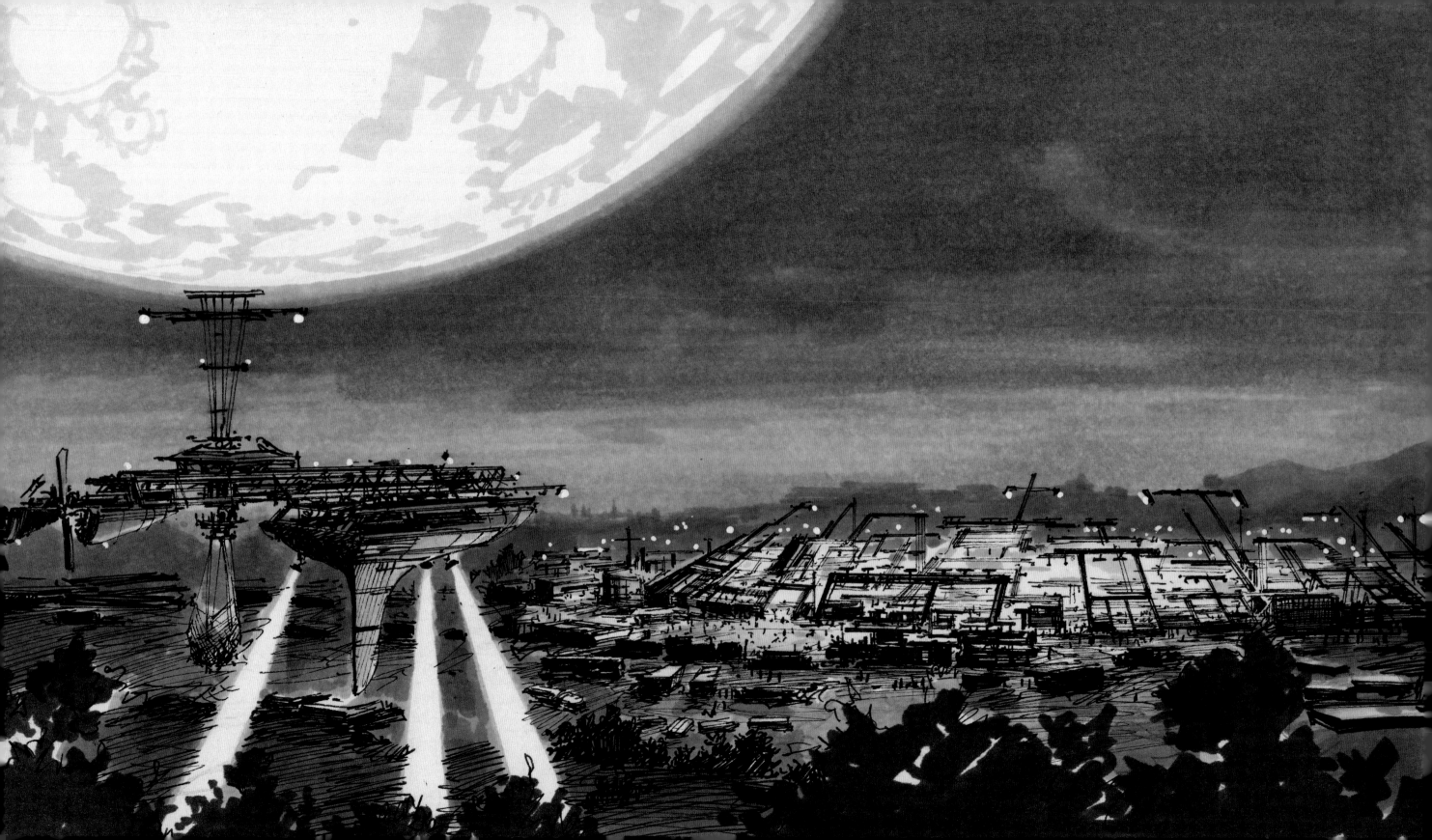

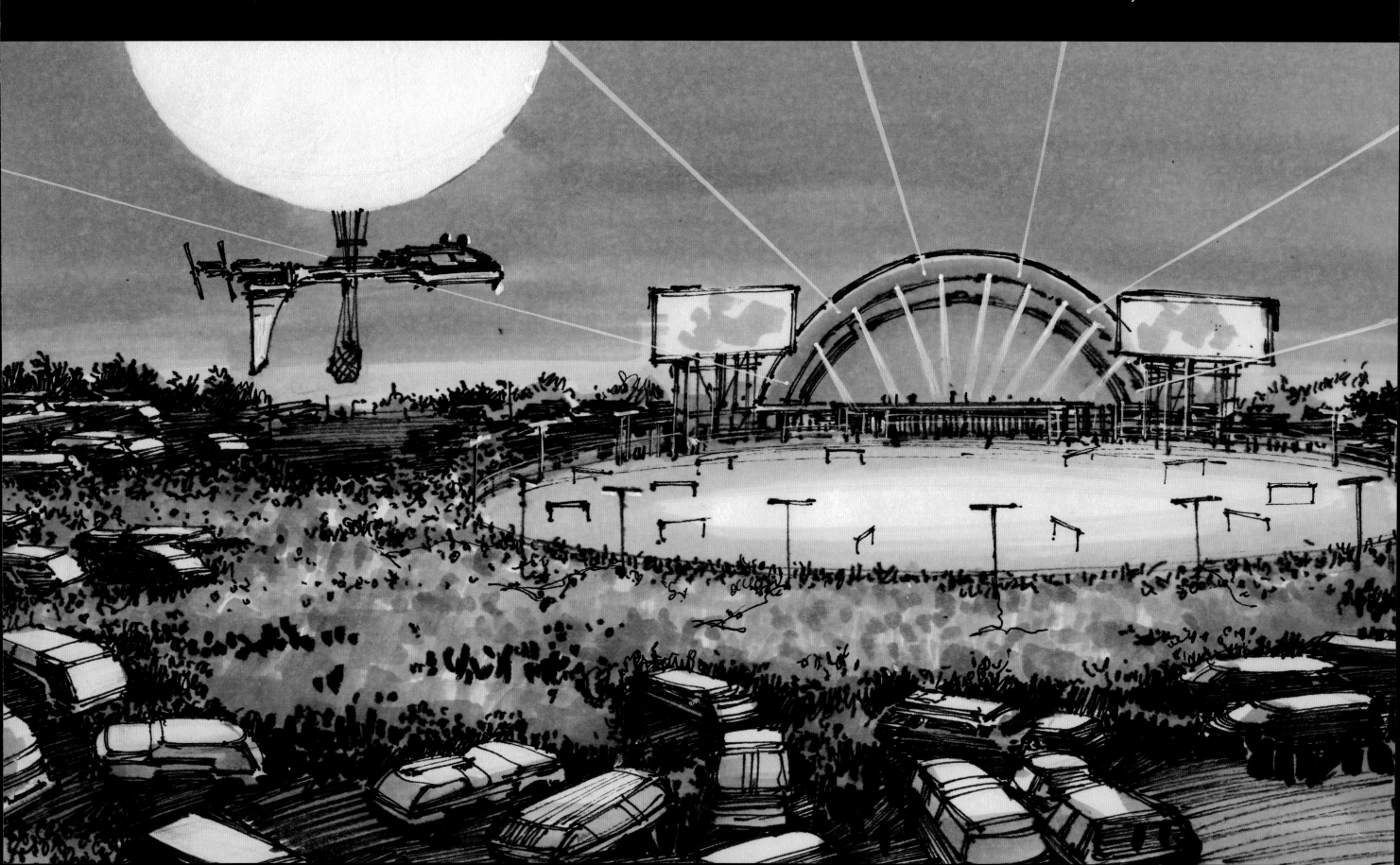

Part 2: The Journey

The second act of the film follows David's quest to find the Blue Fairy, who can make him a real boy so that his mother will love him. The section consists of three major scenes: David and Gigolo Joe's capture in the Moon Balloon, leading to the gladiatorial-style arena of the Flesh Fair; the trip through breathtaking tollgates to the neon-lit sprawl and lavish excess of Rouge City; and finally a sojourn in a ruinous and submerged New York.

GIGOLO JOE, MOON BALLOON AND SHANTY TOWN

From the continuous domestic dramas at the Swintons' home, the film mode-jerks to the harsh external world, introducing a new character – Gigolo Joe, a Love Mecha. On Gigolo Joe's second job of the night, he discovers that one of his clients has been murdered and realizes that he will be 'set up' for the crime (in this futuristic world, Mechas are often used as scapegoats for crimes committed by humans). To avoid detection by the police, Gigolo Joe removes the Mecha licence embedded in his chest. However, unlicensed or rogue Mechas are hunted down by Flesh Fairs and destroyed for human entertainment. The second act of the film has propelled us into the savage world and cruel mores of mankind – an alien universe in which David is completely exposed and vulnerable. This is the first time we are able to place him, both physically and emotionally, into context as the latest technically advanced robot.

After David's abandonment in the forest, his first encounter is with a dump truck disposing of redundant robotic parts and waste – the obsolescence produced by mankind, which will undoubtedly contribute to its downfall. Artist Chris Baker found himself inspired by questions of how robots would function, what their role in society would be, and how they would act in the future to retain their purpose. 'Over time parts would fail and need to be replaced – in some cases robots would use whatever was available, in many cases they would have a retro-fitted appearance. Alternatively, many robots would continue to deteriorate unless maintained. Would certain robots even have a sense of self? How would they react to their own reflection? In the last act, in what ways would robots develop in two thousand years? Would they choose to keep human form? How would they communicate?' Baker and Kubrick discussed at length the history of robots pre- and post-David, and Baker says it was one of the most enjoyable and fascinating aspects of the experience.

To bring the robots to life, Stan Winston Studio experimented with a wide range of innovative media – hydraulic puppets, animatronic puppets, radio-controlled puppets and computer-generated characters, all included in the final film. For the scene in which robots who have been hiding in the forest harvest spare parts from the pile left by the dump truck, the production also employed real-life amputees engaging with prostheses. 'The designs of the robots had to reflect the different stages of technology and the robots' functionality,' explains effects supervisor Lindsay Macgowan. 'We must have produced more than 150 different designs based on this idea. We approached the design process for the robots by looking at the whole idea of how we view modern technology, and we took the example of cars. There's a difference between the looks and styles as well as condition; some are falling apart, some are gleaming, some could be twenty to thirty years old and they still look brand new. So, wherever you looked, the robots would have a variety of colours, textures, forms and functionality. The new version would be David, and then maybe the next model down would have been Gigolo Joe.

'The ideas for a lot of the robot characters evolved during the design process. Steven came up with many ideas for [the dump-truck] scene: the Mecha who can only replace his arm when he has found a compatible match and the fibers react and join; the butler ripping off his jaw and replacing it with another. It's a massive collaboration and really enjoyable because you get ideas from each area. Everybody has something that they bring to the table, which elevates the whole job.'

In the film the scavenging is interrupted by sight of the giant balloon that heralds the arrival of the Flesh Fair hunters. Their search for Mechas is conducted in Shanty Town by air and by land: lit, costumed bikers on futuristic motorcycles shaped like hounds hunt their quarry down. 'Shanty Town represented a more ghetto-like area of an existing city,' says Chris Baker, 'but Stanley envisioned something independent and much more expansive as a backdrop for the moon-bike chase. Even though the structures were quite ramshackle in appearance, it still required a confident design aesthetic. Obviously the early concepts didn't take into consideration any budgetary constraints whatsoever – a factor that

runs through a lot of these drawings and scenes.' In the film, the bikers' catch is loaded into the balloon holding-net and taken to face the baying crowds of the Flesh Fair.

THE FLESH FAIR

A.I. is not pro-human, and nowhere is this more explicit than at the Flesh Fair. David has already been abandoned by his mother and is now exposed to the extreme prejudice that humans (the oppressors) have against Mechas (the oppressed). However, it is while David and Gigolo Joe are caged and waiting for their seemingly inevitable destruction that David is mistaken for a real boy. David is unique, the first of things to come, and although the Stage Manager admires the craftsmanship behind this special robot, he is still happy to accept a pay-off from Flesh Fair ringmaster Lord Johnson-Johnson so that David's uniqueness can be used to heighten the crowd's emotional response to Mechas. David is dragged across the ground to the sacrificial 'altar', and the money given to him by his mother in the first act litters the ground. These two pay-offs are not the only instances when David's life is given a price (his true worth will be presented at the end of this act, when he returns to Cybertronics).

'I spent a while exploring as many different ways as possible for man to purge artificiality – or, to put it simply, trash robots!' says Chris Baker. 'What would be the future equivalent of a gladiatorial contest between man and machine? The robots could be squashed into cubes, destroyed with acid, cut up with chainsaws, pulled apart by their limbs, put through a mincing machine, used as cannon fodder.... And then there were ways of making the spectator-experience more sensational, too, by inserting tiny digital cameras into the headgear and body armour of the attacker, with the scenes projected onto the big screen for macabre close-ups. I liked the idea of having a hero, the people's champion [see p. 78]. And so it went on. Stanley was open to any suggestions, not only for robots but for any ideas, however left-field. One time he commented that we had so much material we could probably turn it into a really cool graphic novel.'

Baker's conceptual drawings were incorporated into the eventual production designs. 'The design of the Fair didn't change much at all from the initial ideas with Stanley to the final film. The stage, the band, the cage and the two huge screens were always present. It was quite something to be on the finished set after all those years.' A total of forty-six puppeteers and technicians were required for the Flesh Fair sequence, as all the robots would be operated and working to the camera simultaneously. The Flesh Fair scene was staged live, in front of the rock band Ministry playing on a stage and the audience of eight hundred extras in the bleachers of the vast Spruce Goose Dome facility in Long Beach, California (where the balloon sequence was also filmed) – an event that had to be carefully supervised in view of the pyrotechnics and cannons used in the Mecha torture sequences.

David – by now having latched on to Gigolo Joe for protection, and having been reunited with Teddy, whom he dropped from the Moon Balloon – pleads for his life. The Flesh Fair audience believes him to be a real boy. They have never before heard a robot plead, and David is saved from destruction by the very fact that he acts and looks so human – not surprising, when even David's creator is unable to separate the machine from the human (later, on learning that the missing David has been seen at the Fair, Professor Hobby lets slip the question, 'Is he alive?').

Instead of David, Lord Johnson-Johnson is lynched by his own emotionally heightened mob. In the riot that ensues, David, Teddy and Gigolo Joe make their escape and hitch a ride to one of the most extraordinary locations ever created.

ROUGE CITY

'The architecture of Rouge City,' says Chris Baker, 'is a good example of the way Stanley and I worked together.' One of their first challenges was the depiction of the city tollgate. 'Before entering the city, traffic had to pass through a tollgate described in Ian Watson's story treatment as a huge pair of open lips. For a while I worked with this image, doodling lips of all shapes and sizes, with a freeway passing through them. It didn't really work for me. The lips in isolation didn't look right, so I began adding a whole head, shoulders, and even in some cases an entire torso, one more erotic than the next.'

Baker says that Kubrick really warmed to the style of architecture employed for the tollgates and suggested that he continue to use it within Rouge City. 'Stanley was very direct and

to the point, and I liked that because it helped focus and formulate ideas. Once these types of shapes were brought into play, ideas for the rest of the city flowed. There were times when Stanley was extremely pleased with something, and despite his stoicism he was very generous with his praise. A particular moment I will always cherish was his response to a design for a building that became known as the "kneeling woman". I faxed it through and he called me back thirty minutes later, and said, "You should win some kind of design award for this." I think I glowed for a week. Since the "kneeling woman" building was a particular favourite of Stanley's, I was pleased to see that dominant in the final film. Had I designed Rouge City now, I think I would be a little more subtle and abstract in its design. I always saw Rouge City as the erotic equivalent of Las Vegas but, due to censorship, much of the overt sexuality had to be toned down for the film.'

Gigolo Joe, David and Teddy enter the city after hitching a ride with a group of young men, in a shot reminiscent of the Droogs piled into the car in *A Clockwork Orange*. As the tollgate is reached, we are suddenly exposed to the atmosphere of the city, a place of false love, debauchery and excess. While David is there to search for the answer to the true desire of his heart, everyone else is looking for the rouge blush of sensual pleasure. 'David is a vulnerable eleven-year-old boy,' explains production designer Rick Carter, 'looking for the love of his mother in an "inappropriate" environment. The only safe way through this carnal realm is to have a strong vision or goal for what you are actually there for.

And I think that's a perfect example of where Stanley can take a story, and where, perhaps, others cannot go. As a viewer you can get so sidetracked by the lure of Rouge City that David's quest to look for the Blue Fairy becomes secondary to what you are actually experiencing. It is about David's story, but it is also about the experience of the viewer – seeing the environment through the eyes of an adult, rather than as a young boy.'

Chris Baker and Rick Carter collaborated closely with the special effects company ILM. 'From Chris's sketches and other ideas for buildings and views,' Carter notes, 'Rouge City collaged into a geographical space that we could actually understand. We all loved Chris's designs, especially the bridge entrance through the open mouths. On a visceral level, this image was one of the reasons why Steven wanted to make the film, so many of Chris's drawings for this part of the "filmscape" became the basis for the digital imagery, rendered by special effects supervisors.'

'I worked with the ILM art department', says Baker, 'to distil many of the designs I had produced with Stanley into a workable concept. The "kneeling woman" was initially sculpted out of clay, and so I was on hand to watch the sculpting process and check that it followed closely the original design. And I was there to work on individual buildings. Steven would often ask what I thought of various designs, so I had a lot of input in that way. This wasn't necessarily because my ideas were better than anyone else's, but in order for us to stay as close to Stanley's vision as possible. A lot of the details in Rouge City were in the final film.'

Baker was also conscious that his concepts would eventually have to be made practicable. 'While I was working with Stanley, it was purely a design project. It was all about ideas and designing a futuristic world from the ground up. There were no restrictions in regards to cost or whether my ideas were practical. From an artistic standpoint, this became a new challenge once the film entered production.' This is evident in the amount of material that was generated but could not be included in the final film, such as the nightclub scene and Zero Zone (see pp. 13 and 14). 'Rouge City', explains Baker, 'had to be designed in a way that was realistic, but retained the essence of the original concept and still made it work. "Where are the buildings to be situated? Where will the camera be, and in which direction do we need to shoot? How many really detailed buildings can we have?" These are the real mechanics of actually making a movie. There was so much material that it comes down to time and money in the end, and Steven created a script that he could actually shoot.'

At the time of filming, groundbreaking advances in technology meant that every one of the special effects used was cutting-edge, and *A.I.* became the pioneer of the 'virtual studio'. As Rick Carter reveals: 'We were going to spend a million dollars more to create Rouge City, but it became clear that this money would be better used to digitally create a more expansive city than we could ever build, generating the buildings around the actors and giving Steven more choices for shooting. ILM came up with a virtual space on a blue-screen stage to further the illusion of this vast city.'

ILM built a system updating existing technology created by the BBC. This 'simulated' set allowed Spielberg and cinematographer Janusz Kaminski to find the best compositions for particular scenes. 'Originally, Steven had talked about Rouge City opening with a dance number, and I thought that we could come up with something that would allow Steven to see the city as he was filming the actors,' explains Dennis Muren, visual effects supervisor at ILM. 'Usually we would shoot it with a rough idea of where the CG work would be within the frame, but I thought that if you could actually walk around in that CG world, you could then put the actors where you wanted them and tweak it until you found the best composition. We created a CG background of what the buildings would look like and the actual size that they would be in the frame, and the actors were filmed in front of the blue screen. We then created a composite of the CG and action on a monitor. This meant that Steven and Janusz could actually see the world that the actors were in. The idea has been used a lot since *A.I.* was released. Peter Jackson used it for *Lord of the Rings*, Robert Zemeckis and James Cameron are using it, and Steven has used it on *Tintin*.'

To bring an end to David's quest, Gigolo Joe takes him through the hustle of the city streets to Dr Know. Baker comments that the franchise was 'originally called Mr Know in the early treatment. I always thought of it as the information equivalent of a fast-food chain; like a certain burger franchise – you'll find one just about anywhere. In some of the drawings I suggested it was in fact also

an eatery and/or an amusement arcade. The Einstein character developed quite quickly after toying with a few ideas that were more hi-tech in appearance. I also think it was a nice juxtaposition, stylistically, against the Rouge City backdrop.'

Inside Dr Know's information emporium, Gigolo Joe and David have to combine the categories of 'fairy tale' with 'flat fact' in order to locate the whereabouts of the Blue Fairy. Dr Know, voiced by Robin Williams, tells David and Gigolo Joe a riddle featuring lines from the poem 'The Stolen Child' by W. B. Yeats and also reveals Professor Hobby's research project, 'How Can A Robot Become Human'. As David asserts his wish to go to 'the end of the world', where he believes the Blue Fairy to be, Gigolo Joe warns him against humans and utters the prophetic words, 'They made us too smart, too quick, and too many. We are suffering for the mistakes they made because, when the end comes, all that will be left is us.' Outside the emporium, the police are waiting to arrest him, as he has indeed been set up for the murder of his client. While the arrest takes place, David steals an amphibicopter. In the fracas that ensues, Gigolo Joe manages to escape and joins David and Teddy in the craft. The three of them fly off to the end of the world – Manhattan.

NEW YORK

'We see a drowned New York in a somewhat dishevelled state,' says Chris Baker, 'and it always presented some interesting design possibilities. In early ideas, I had worked on design concepts that

used the flooding as a way to create new architecture and transportation systems. I also suggested that there was a huge trade in salvage going on under the waves.' Using a combination of digital imagery and miniatures, ILM retained many elements from Baker's original drawings, from the way the buildings collapsed to the structural damage beneath the water.

In 1993 Dennis Muren and Stanley Kubrick had discussed this scene, as well as other CG work that would be required. Kubrick had already done tests, organized by *Full Metal Jacket* producer Philip Hobbs, which involved filming oil rigs in the North Sea and cliffs on the Irish coast in heavy weather, with the aim of digitally replacing the rigs and cliffs with images of skyscrapers reaching out of the sea. As Muren recalls: 'At the time, ILM was working on other movies that illustrated the standard of CG. It showed Stanley that certain scenes in his story could actually be achieved for the film. After our meeting we had the task of figuring out how to do the buildings in New York. He sent us a tape of helicopter footage of the North Sea oil rigs so that we could use the filmed oil rig as a tracking point and layer a CG building over it, or some compositing system. I think at this point he was still looking for ideas. With Stanley it was a continual search process. Between Steven, Chris, the artwork and conversations that I had had with Stanley over the years, we captured as much of the visuals and art direction that he had wanted. We're all such fans of the guy, and he had put so much work into this film that to be able to fulfil in some capacity what he had in mind was at the forefront of all our minds.'

In the film David, Gigolo Joe and Teddy arrive at the headquarters of Cybertronics. By combining Ian Watson's narrative on Cybertronics with elements of Chris Baker's architectural drawings of the (unused) Robotic Institute – the double-level atrium, the library reading room (which was thought of as 'Stanley's library') and the statue as the company logo – Spielberg created one of the darkest scenes in the film. David's final destination completes the circle – a return to his birthplace, like the homecoming of a prodigal son.

Spielberg's creation of David's double reminds us of how David was at the beginning of his journey. Michel Ciment has commented that doubles were one of Kubrick's most deeply rooted obsessions. In *Lolita*, Quilty is Humbert's double, just as Humbert Humbert is a double name. Bowman witnesses his own death at the end of *2001*, and in *A Clockwork Orange* Mr Alexander is a reflection of Alex.[1] In *Full Metal Jacket* the Jungian Shadow is symbolized through the 'Born To Kill' slogan written on Joker's helmet and the 'Peace' badge that is pinned to his lapel. In *A.I.*, Lord Johnson-Johnson is a double name; Professor Hobby's secretary is Monica's 'puppet' double, linked by Spielberg's cut in the first act, and of course Monica also has a literal double in her resurrected form; and Martin is David's double, revealed in their shared reaction to the threat of a rival for their mother's affection, and in their entombment and resurrection.

David's double also echoes Kubrick's annotation in his copy of *Pinocchio* to 'reverse all Pinocchio's bad traits and thoughts'.

Collodi's Pinocchio begins as a selfish, naughty and insolent little boy, whose desire to become real is secondary to his adventures. It is only when he is prepared to work hard and shows love and tenderness towards his father, Geppetto, that his wish to be a real boy is granted by the Blue Fairy. David, on the other hand, once imprinted, starts out a good, pure, loving robot boy. Rather than be sidetracked by fantastical events, he has only one true desire. It is because of his wish to be human, and therefore unique, that the Cybertronics scene ends with the eleven-year-old destroying his doppelgänger and rival. This scene is revealing of how 'human' David has become. Through his journey, he has witnessed the human traits of selfishness, deceit and betrayal, and he has learned by experience. He has developed the equivalent range of emotional reactions to fend off any obstacles in the pursuit of his ultimate goal – his mother's love. As a result, he has displayed the entirely human emotions of bitterness, jealousy and hate.

We see an overhead shot of a fragmented, circular light fitting as David continues to swing the lamp he has used as a weapon, crying, '*I'm David, I'm David*'. The circle has been broken and he is no longer the embodiment of Professor Hobby's memories of his dead son. Because of his travails he has built his own identity and has become self-aware. Cybertronics has created the ultimate in Artificial Intelligence and the precursor to the robots of the future.

'Within another couple of years, if David succeeded, Cybertronics ought to be able to market a whole range of Davids – and Dannies and Dorothies too,' wrote Ian Watson in his 1991

treatment. As with the creation of Pinocchio, the invention of David, ultimately, revolves around commercial gain. In *Pinocchio* Geppetto says, 'I thought I would make a fine wooden puppet – a really fine one, that can dance, fence, and turn somersaults in the air. Then, with this puppet, I could travel round the world, and earn my bit of bread and my glass of wine.'[2]

Throughout his journey, David has been told that he is 'unique', 'special' and 'one of a kind'. But now he discovers that his creator has manipulated him like a puppet – giving leading information to Dr Know, that would send him to Cybertronics ('it's the only time we intervened') – and has designed him as a prototype for mass-production in a world of controlled population where the emotions of childless couples are vulnerable to commercial exploitation. In the film, the marketing slogan on the packaged 'children' reads: 'At Last – A Love Of Your Own.' Like sex, love is now a commodity and represents a further development that will add to the waste and obsolescence that is already suffocating the world.

To further explore this scene, Spielberg returned to Kubrick's initial source, Brian Aldiss. Jan Harlan, Kubrick's executive producer, sent Spielberg two stories that Aldiss had penned in 1999, completing the David trilogy: 'Supertoys When Winter Comes' and 'Supertoys In Other Seasons'.[3] In the latter, Aldiss writes: '[David] confronted a thousand Davids. All looking alike. All dressed alike. All standing alert and alike. All silent, staring ahead. A thousand replicas of himself. Unliving.'[4] In a scene that

is reminiscent of the finale of Kubrick's *Killer's Kiss*, in which Davy murders Rapallo in a room full of mannequins, David peers through a mask of his own face and sees the 'bird' that he described to Martin in the first act. When he recognizes that it is the logo of Cybertronics, he is able to place this, his earliest autobiographic memory, into the real context of his own history.

It is the shocking revelation of his true origins, and his realization that he has reached the end of his journey with nowhere else to turn, that leads him to yet another human response. He decides to end his own life. Whispering 'Mommy', he lets himself fall from the Cybertronics building into the ocean below. There – arms outstretched, as when he sank to the bottom of the Swintons' swimming pool – he is carried by a shoal of fish to the sea bed, where he finally has his first glimpse of the longed-for Blue Fairy. Gigolo Joe, who has watched David fall – his body reflecting in the helicopter window like a teardrop falling down the Love Mecha's face – brings him back to the surface in the amphibicopter. But their meeting is short-lived, as the police have caught up with Gigolo Joe. As the Mechas part forever, Gigolo Joe utters his last words – 'I am... I was'. The Love Mecha, programmed for empathy, presses the amphibicopter's 'submerge' button, and David and Teddy descend back into the depths.

While working with Kubrick, Chris Baker had created hundreds of drawings of Coney Island's fairy-tale theme park, complete with Geppetto's workshop, the large Ferris wheel and the Blue Fairy. 'References to Pinocchio feature throughout the finished film, in particular the submerged theme park. In several early sketches, I suggested that the amphibicopter enter the maw of the whale. Inside the belly of the beast, David spies a once-animated Geppetto beavering away at his work. One particular sketch suggested that an animatronic Pinocchio still wandered through the flooded streets of the theme park. Maybe this was a tad bizarre, but the early sketches were all about brainstorming, and even the most off-the-wall ideas should not be discounted. Artistically, these scenes, which included the collapse of the Ferris wheel, were really satisfying. Playing around with light and shadow, the beams of light from the amphibicopter picking out objects in the murk, were all translated beautifully by ILM in the finished film.'

To recreate these visuals, ILM constructed the theme park using physical models, which were then filmed 'dry for wet'. Shooting the miniatures in a smoke-filled room gave the illusion of an underwater scene; this was then brought fully to life with digital imagery. To provide all the backgrounds required, the long and complicated film shoot included physical models, computer graphics animation and live-action blue-screen photography. Dennis Muren and his camera crew at ILM shot the underwater sequence. 'This scene was created so it would appear to be lit by the lights of the amphibicopter, so that you only discover objects as the lights shine on them. I have this thing that I call the peek-a-boo effect, where I try not to show too much in the shot. I like to get mood out of shots and make things reveal themselves as the shot continues. So maybe there's a five-second shot and you can't figure out what you're looking at for the first second or two, and then it comes into clarity, through lighting and camera movement.'

Chris Baker continues: 'During one of my visits to ILM, they showcased some of the moody underwater scenes in their cinema. These were the very first pieces of footage that I was privileged to see. There were still a few visual effects to be added to the shots, but it still looked pretty amazing. After years of working on the film with Stanley, and the period that followed when *A.I.* never really left my thoughts, to finally get to this point and see these images on-screen was quite an emotional moment.'

As David continues his underwater journey, the amphibicopter catches and breaks a cable connected to the Ferris wheel. David, driven by his hopes and desires, carries on and finally comes to rest at the foot of the steps that lead up to the Blue Fairy. As David stares at the beautiful statue, the Ferris wheel collapses, trapping the robot and the ever-faithful Teddy. David, entranced, continues to pray to the Blue Fairy: 'Please make me into a real, live boy.' Kubrick wrote on Ian Watson's treatment: 'In his meditation, time disappeared. Since his thoughts were all the same, he experienced them as an identical continuum – as the same span of moments again and again.' So there David remains, in a meditative state, for two thousand years, while a new Ice Age encases him.

In the forest, on the outskirts of Shanty Town, David witnesses a dump truck disposing of robotic waste. He watches as rogue Mechas suddenly appear out of the darkness in order to grab what they can from the detritus to fix or improve their broken parts. The action is interrupted by the cry: 'Moon on the rise!' As a giant moon appears over the horizon, David sees the robots scatter in all directions. Lord Johnson-Johnson (played by Brendan Gleeson) sits aboard what is in fact a huge balloon, used by the Flesh Fair organizers to collect Mechas for destruction. He calls, 'Any old iron' and 'Expel your Mecha' through a loudspeaker, while down on the ground a vicious motorcycle chase is about to begin. It will end with the capture of several Mechas, including David.

BELOW **One of Chris Baker's** many drawings for *A.I.* that shows the geography of different locations, and the extent of his vision for this future world.

80S AI — SHANTYTOWN —

THIS SUGGESTS HOW SHANTY TOWN MIGHT APPEAR IN RELATION TO ROUGE CITY. THERE WE CAN SEE IT ON THE FAR HORIZON.

Fangs— 9/11/95

AS WE'RE MOVING CLOSER TO THE WHEEL AGAIN
THE PROBLEM OF THE ROBOTS ARISES —
IT OCCURED TO ME THAT THEY MUST HAVE A
PARTICULARLY LONG LIFESPAN — SO
MAYBE THE ROBOTS OF THE FUTURE
ARE CUSTOMIZED VERSION OF
THE EARLIER SELVES. IF A
PART FAILS, BITS FALL OFF ETC
IT IS SIMPLY REPLACED BY
SOMETHING ADEQUATE....

.... OR IN SOME CASES NOT
REPLACED AT ALL!

...:SO MAYBE THERE
IS NO 'ONE LOOK' TO
THE ROBOTS — THEY
MAKE DO WITH WHATEVER
IS AVAILABLE TO
REPAIR THEMSELVES

26/7/95

ABOVE **Chris Baker's ideas** for the robots fed
into the development of the designs by Stan
Winston Studio.

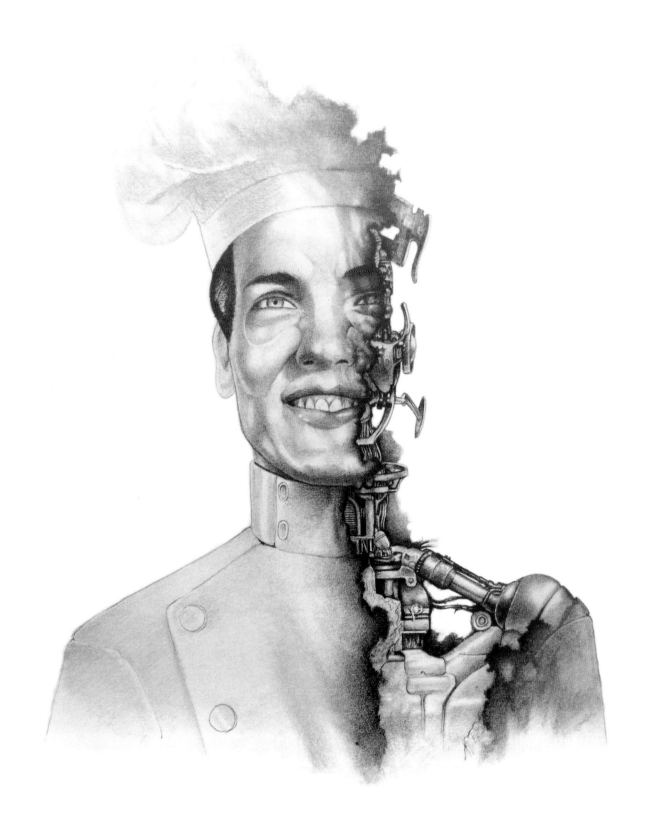

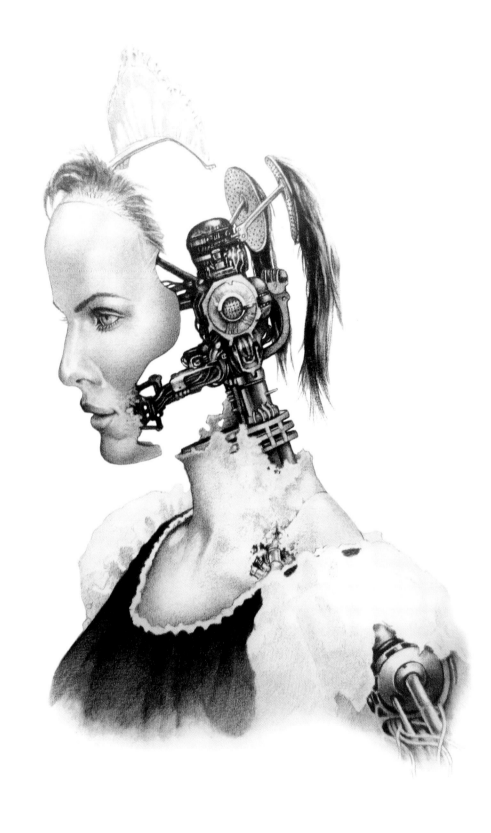

ABOVE **Mark 'Crash' McCreery's artwork** at Stan Winston Studio for Chef Mecha and Nanny Mecha.

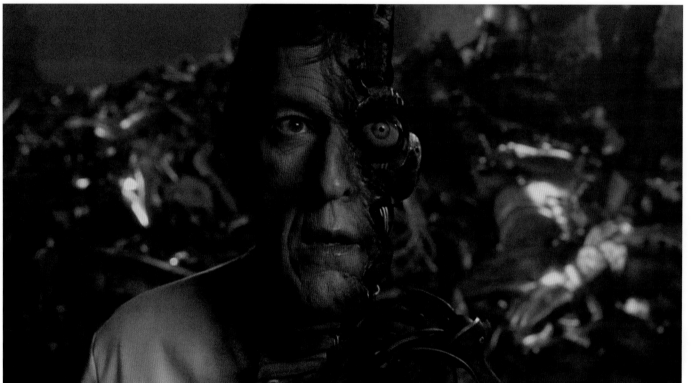

ABOVE **Film stills** of the designs for
Nanny Mecha (Clara Bellar) and
Chef Mecha (Jim Jansen), realized
by Stan Winston Studio and ILM.

'Suddenly the moon drifted hugely overhead, lit from within: a rotund dirigible patterned like Earth's satellite, the spotter platform for the hunters.'

IAN WATSON, STORY TREATMENT

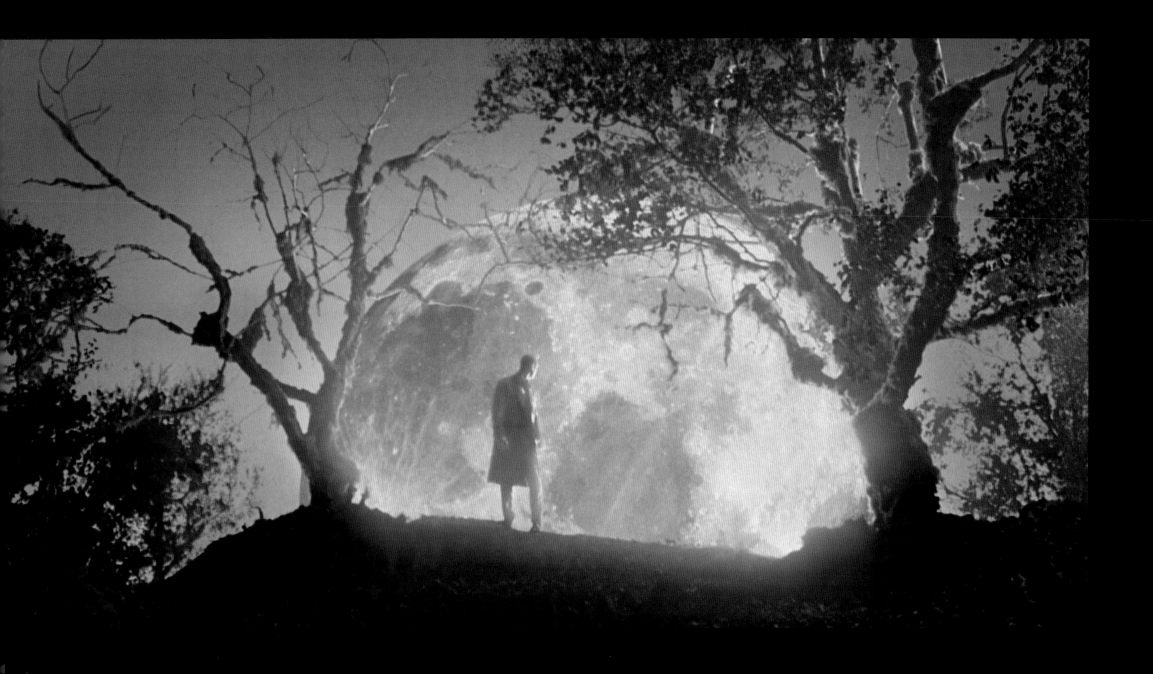

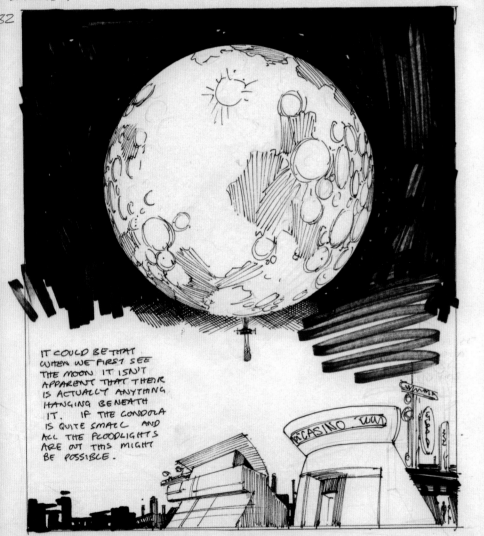

OBVIOUSLY THIS IS QUITE A BROAD REPRESENTATION OVER THE REAL MOON. PERHAPS IT WOULD APPEAR MORE LIKE THE REAL MOON — BACKLIT GREY SMUDGES!

82

IT COULD BE THAT WHEN WE FIRST SEE THE MOON IT ISN'T APPARENT THAT THEIR IS ACTUALLY ANYTHING HANGING BENEATH IT. IF THE GONDOLA IS QUITE SMALL AND ALL THE FLOODLIGHTS ARE OUT THIS MIGHT BE POSSIBLE.

OPPOSITE AND THIS PAGE **Film still and concept drawings** of the moon-balloon sequence. In the film still, Gigolo Joe (played by Jude Law) is silhouetted against the rapidly rising 'moon'. Although the moon is a trademark Spielberg image, here the idea was in fact Kubrick's. The moon balloon appears again in the Flesh Fair insignia (see p. 76).

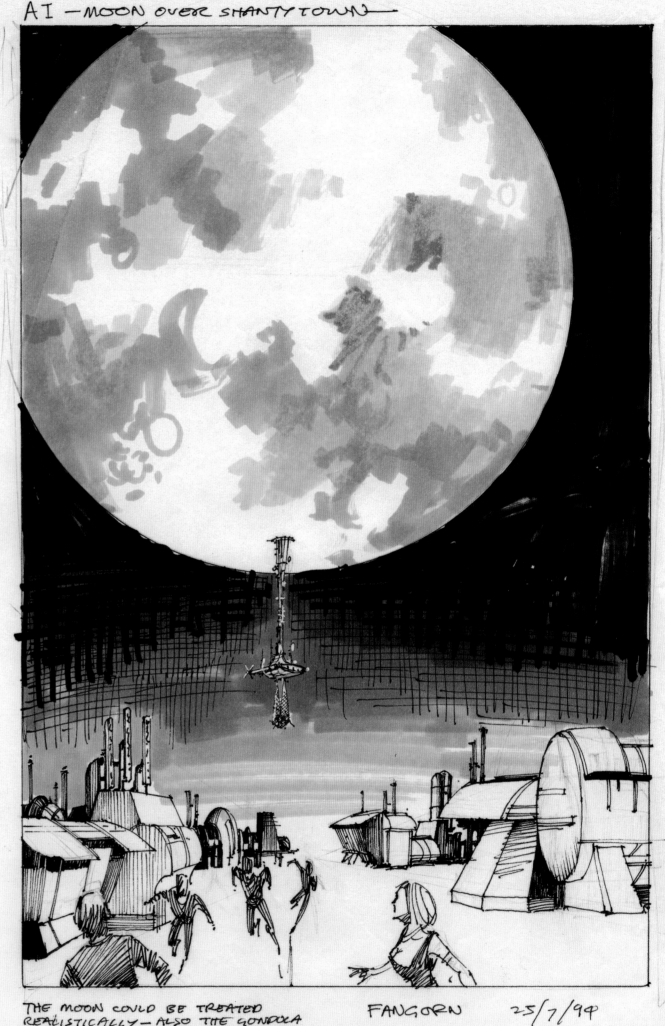

AI — MOON OVER SHANTY TOWN —

THE MOON COULD BE TREATED REALISTICALLY — ALSO THE GONDOLA IS ON A LONGER ARM MAKING THEM APPEAR MORE INDEPENDANT OF EACH OTHER.

FANGORN 25/7/94

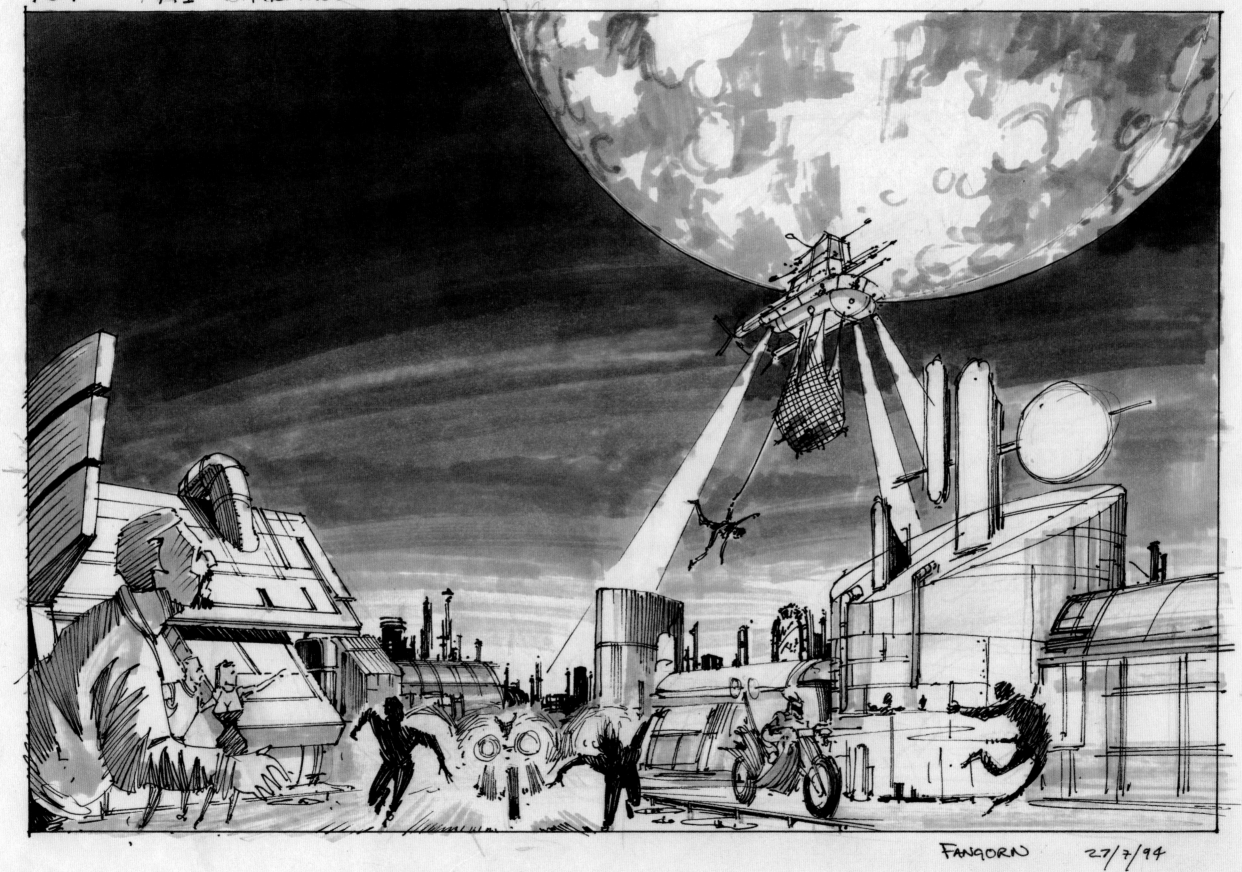

107 AAI — THE MOON OVER SHANTYTOWN —

FANGORN 27/7/94

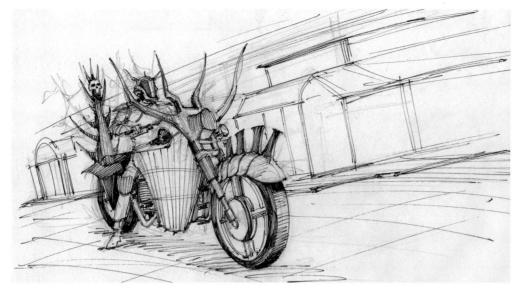

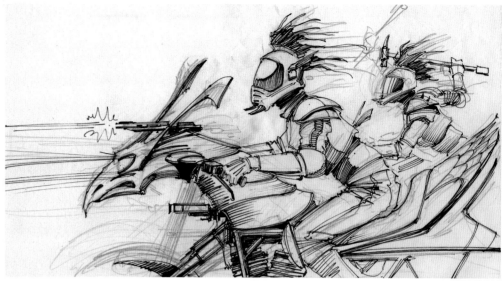

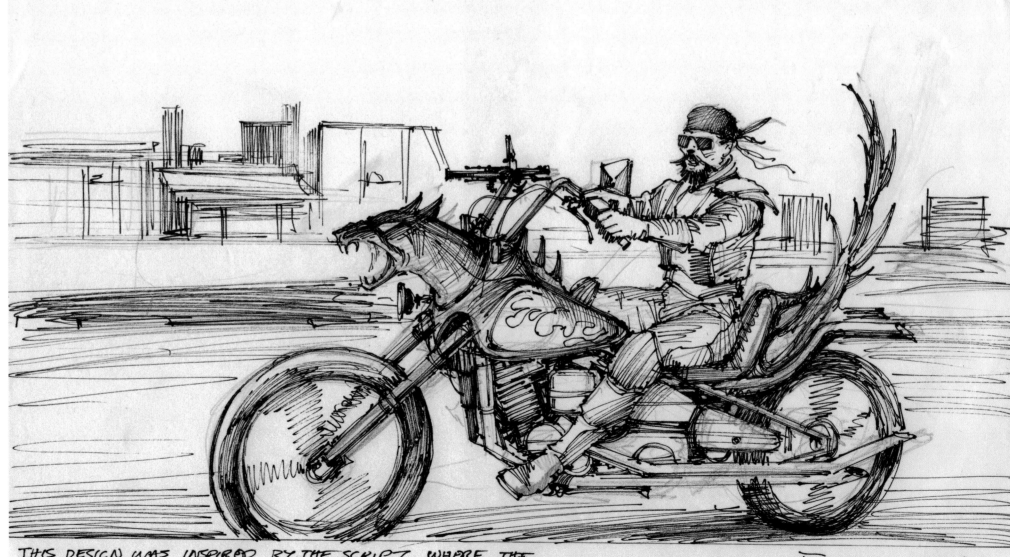

808 AI — THE BIKERS —

THIS DESIGN WAS INSPIRED BY THE SCRIPT WHERE THE
BIKERS ARE DESCRIBED AS 'HOUNDS'

Fanjou 14/11/95

OPPOSITE **Chris Baker's vision** of the bike chase through Shanty Town. The detail at bottom right illustrates the bikers' 'harpoon-like' capture of their prey, while overhead a Mecha is lifted into the balloon holding-net.

RIGHT **Various designs** by Chris Baker for the bikers, vehicles and weaponry.

THE FLESH FAIR

The captured Mechas are imprisoned in a cage before being taken to the Flesh Fair arena for destruction. One Mecha, well aware of his fate, asks for his pain receivers to be removed. David, bewildered and afraid, latches on to Gigolo Joe, begging to be kept safe, in a haunting echo of the behaviour that culminated in his expulsion from the Swinton family home. Fortunately David will also soon be reunited with the loyal Teddy, who has found his way to the Fair, and whose discoverer – the daughter of a sympathetic Flesh Fair technician – will draw attention to David's presence in the cage.

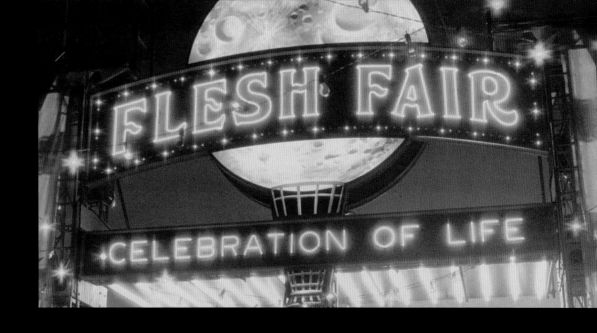

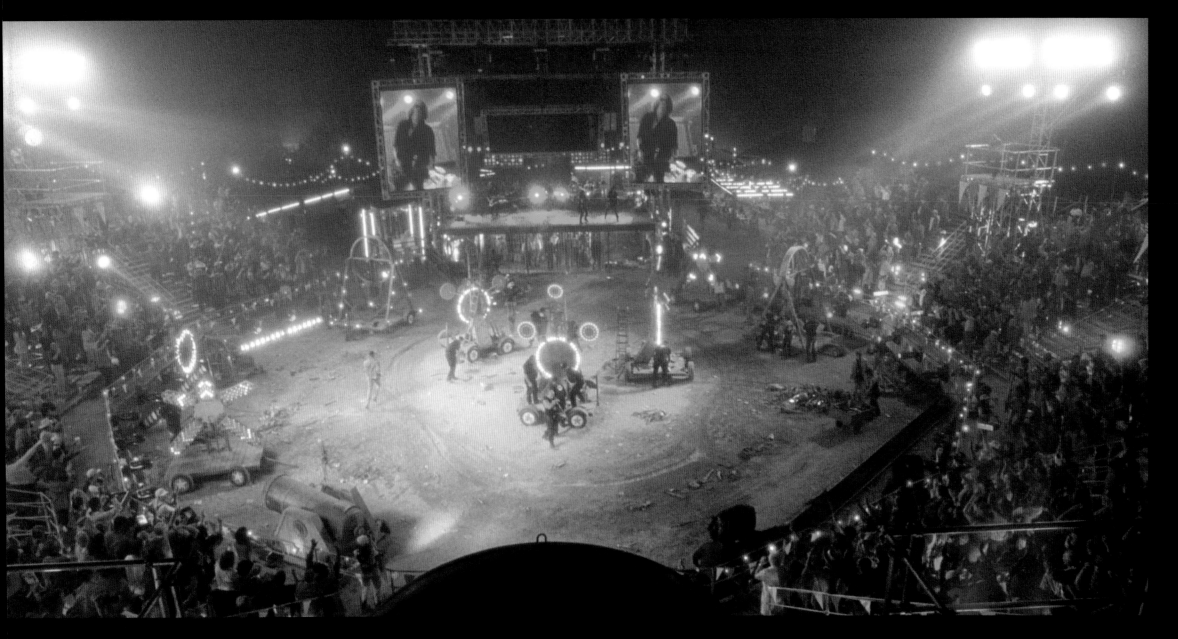

ABOVE **The insignia** for the Flesh Fair, with the image of the moon balloon and the loaded strapline 'Celebration of Life'.

LEFT **Film still** showing the circular Flesh Fair arena, filmed live on location in California.

OPPOSITE **Chris Baker's vision** of the sprawling Flesh Fair. A huge figure looms over the arena, echoing the statue at the Robotic Institute (see p. 36), but in this case celebrates 'the human' as opposed to Mecha.

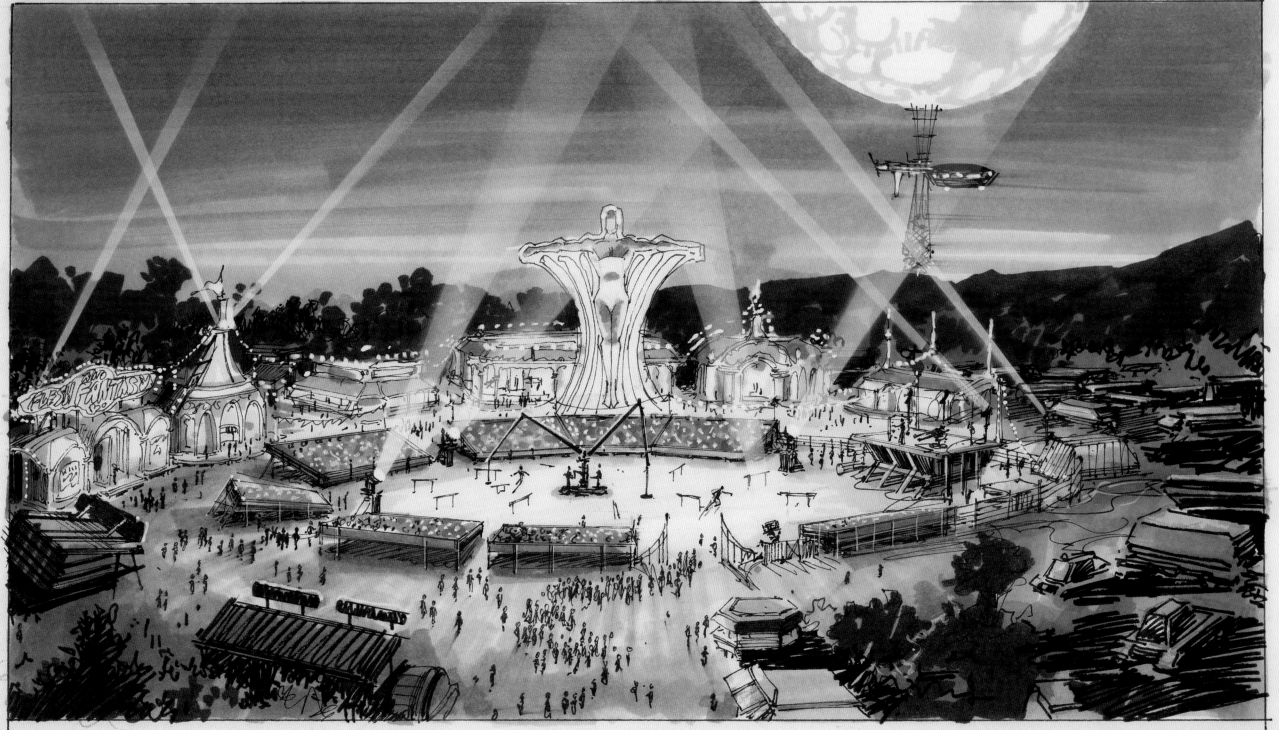

Fangom 10/5/95

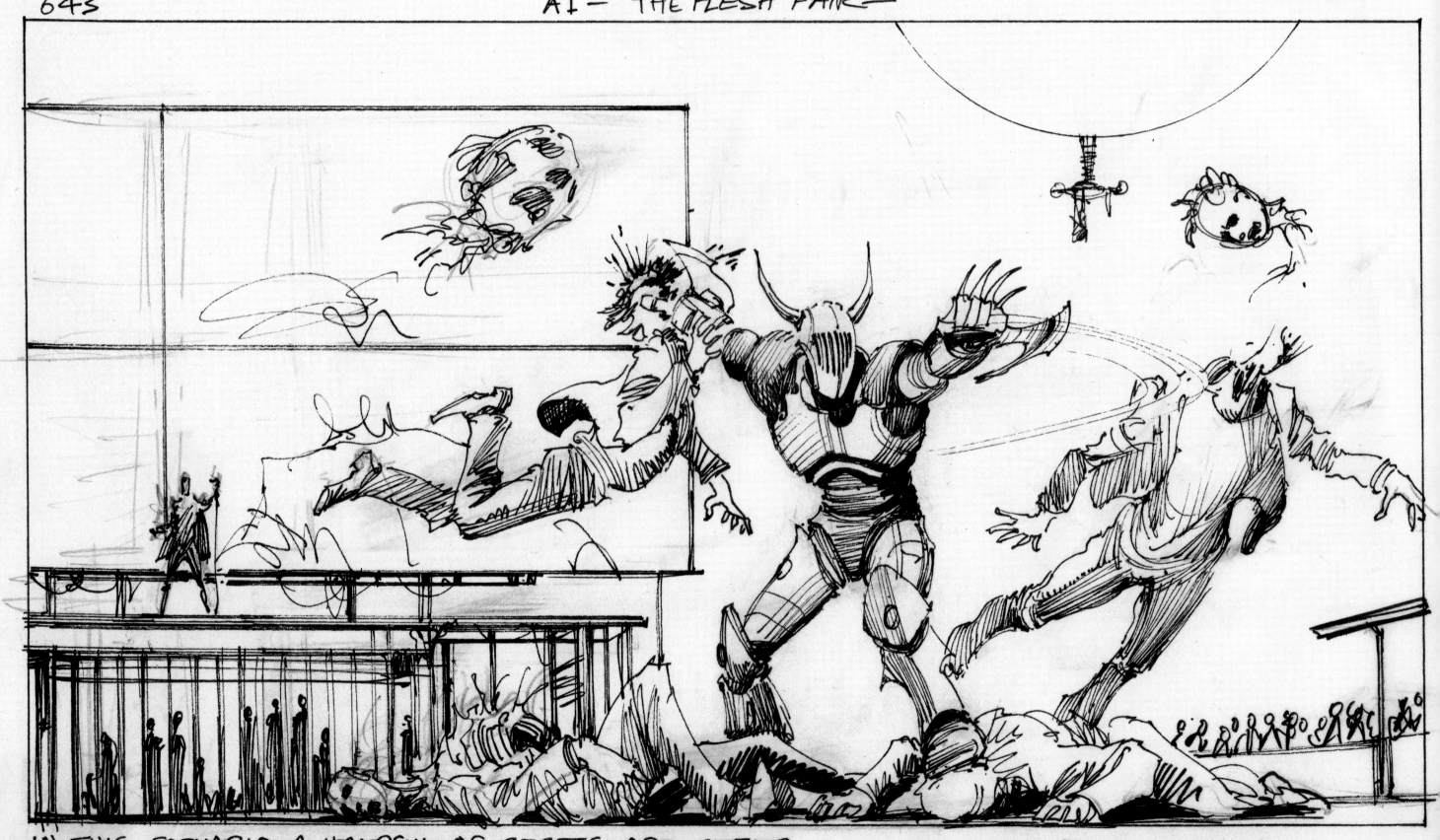

IN THIS SCENARIO A HANDFUL OF ROBOTS ARE PITTED
AGAINST THE FAIR CHAMPION — A POWERED EXOSKELETON
ALLOWS HIM TO MAKE MINCEMEAT OF HIS PREY
IT MIGHT BE INTERESTING TO HAVE TINY CAMERAS EMBEDDED IN THE ARMOUR
TO CREATE UNUSUAL VIDEO FOOTAGE.

Fangorn 1/6/95

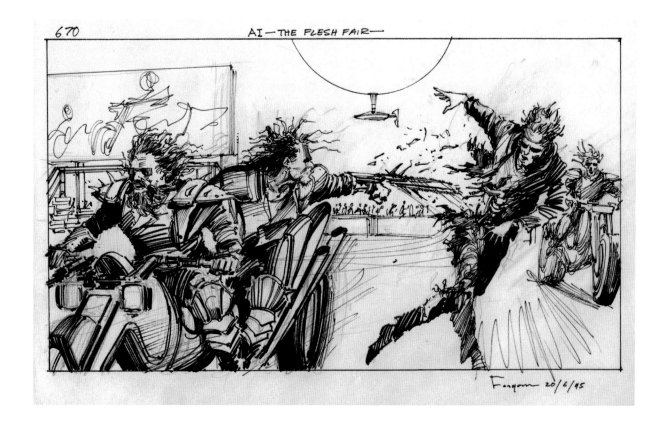

670 AI—THE FLESH FAIR—

Fangom 20/6/95

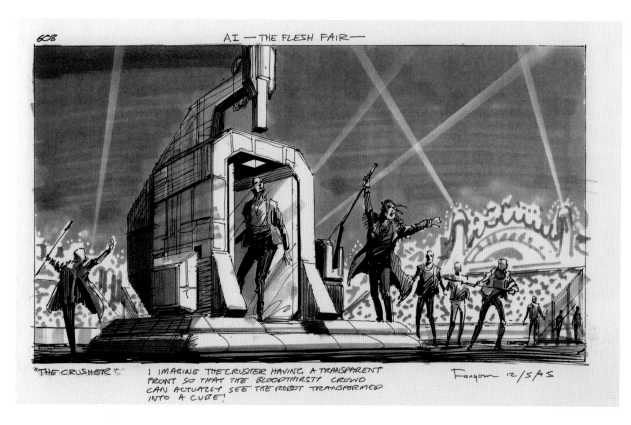

608 AI—THE FLESH FAIR—

"THE CRUSHER" I IMAGINE THE CRUSHER HAVING A TRANSPARENT FRONT SO THAT THE BLOODTHIRSTY CROWD CAN ACTUALLY SEE THE ROBOT TRANSFORMED INTO A CUBE!

Fangom 12/5/95

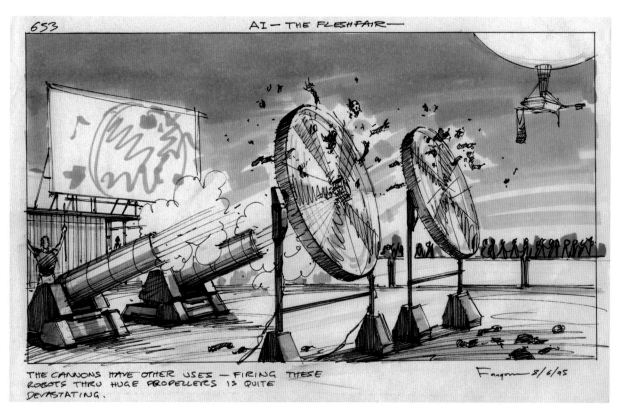

653 AI—THE FLESH FAIR—

THE CANNONS HAVE OTHER USES — FIRING THESE ROBOTS THRU HUGE PROPELLERS IS QUITE DEVASTATING.

Fangom 8/6/95

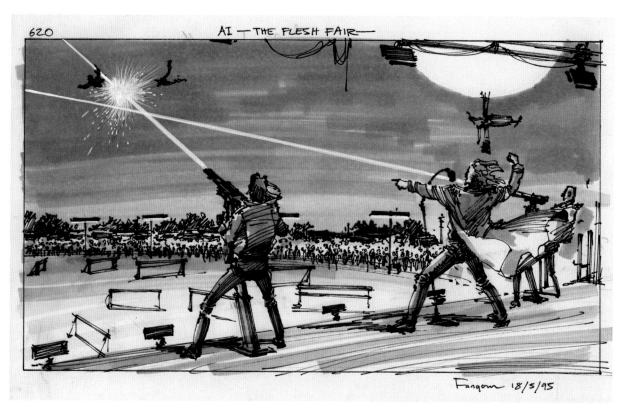

620 AI—THE FLESH FAIR—

Fangom 18/5/95

OPPOSITE AND ABOVE **Chris Baker's concept drawings** of the various 'entertaining' ways to dispose of Mechas.

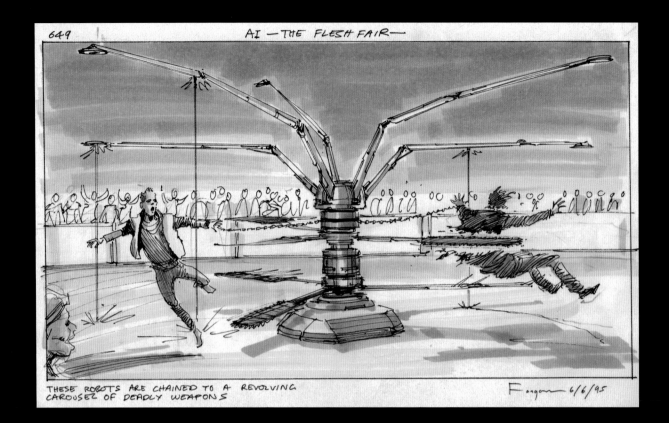

649 AI — THE FLESH FAIR —

THESE ROBOTS ARE CHAINED TO A REVOLVING
CAROUSEL OF DEADLY WEAPONS

Fangam 6/6/95

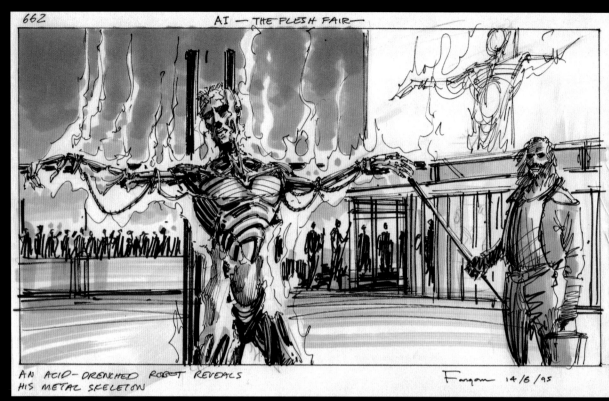

662 AI — THE FLESH FAIR —

AN ACID-DRENCHED ROBOT REVEALS
HIS METAL SKELETON

Fangam 14/6/95

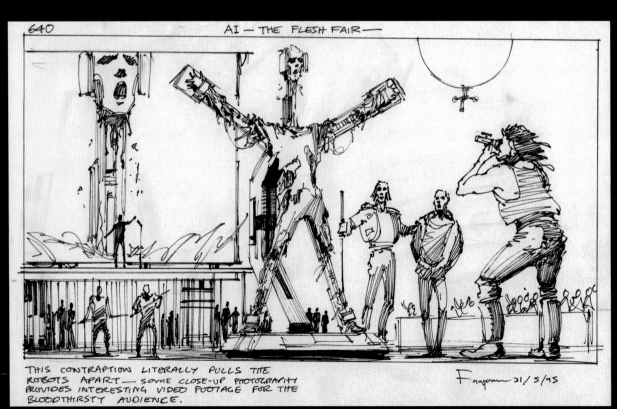

640 AI — THE FLESH FAIR —

THIS CONTRAPTION LITERALLY PULLS THE
ROBOTS APART — SOME CLOSE-UP PHOTOGRAPHY
PROVIDES INTERESTING VIDEO FOOTAGE FOR THE
BLOODTHIRSTY AUDIENCE.

Fangam 31/5/95

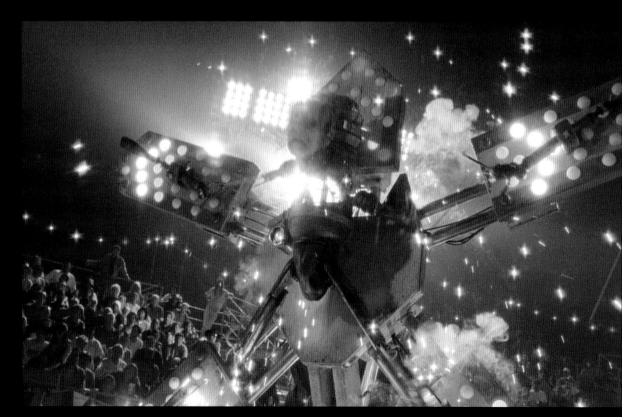

' I think the Flesh Fair definitely appealed to the slightly sadistic side of me. It was a lot of fun coming up with all the different ways to destroy those unfortunate robots! '

CHRIS BAKER, CONCEPTUAL ARTIST

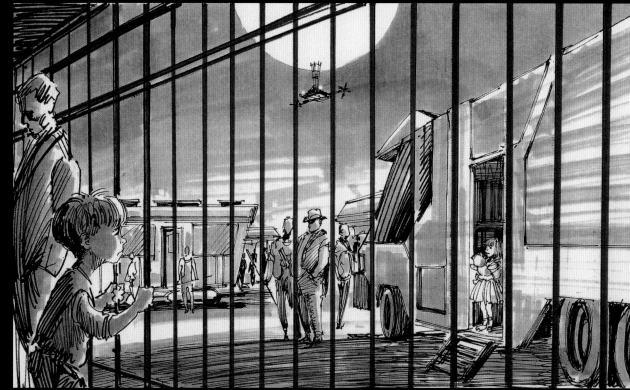

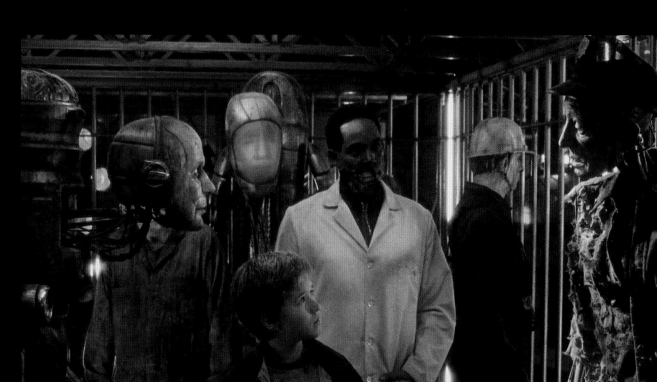

OPPOSITE **Concept drawings and film still** illustrating the gaudy, noisy, neon-lit Flesh Fair at which Mechas are burned with corrosive liquids and smashed to pieces.

RIGHT **Concept drawing and film still** showing the imprisoned Mechas. In the drawing David looks out and sees Teddy in the arms of the girl who will mistake him for a real boy.

'The designs of the robots were incredibly extreme, but
we tried to retain an element of humanity in every one.'

LINDSAY MACGOWAN, EFFECTS SUPERVISOR

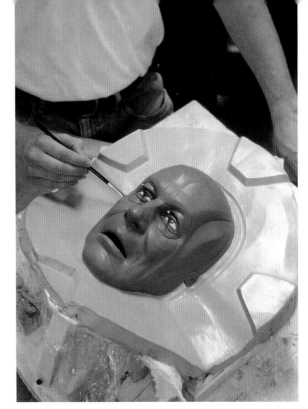

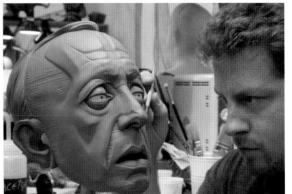

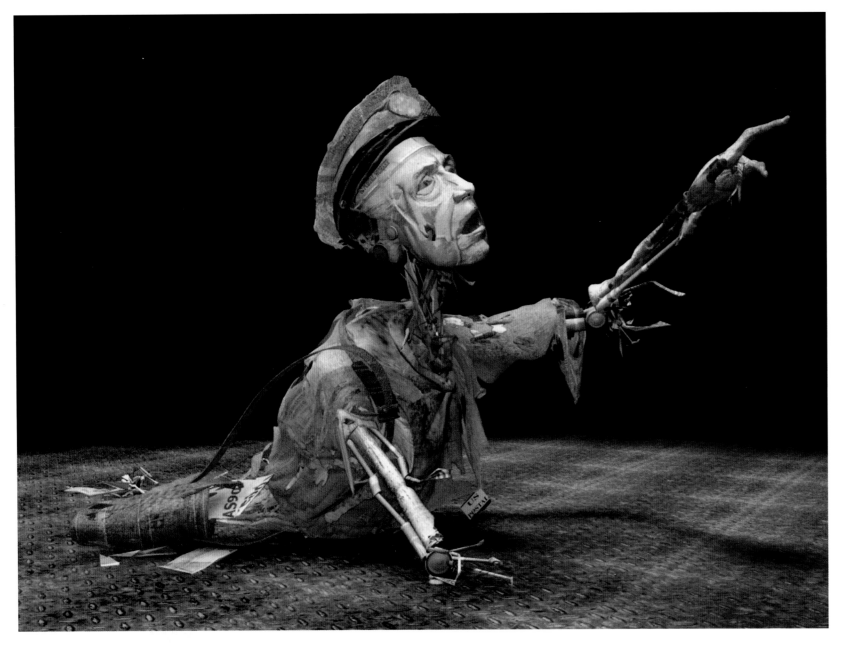

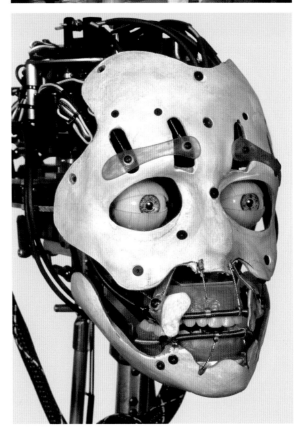

ABOVE LEFT **Work** being carried out on
Gardener Mecha's face, which was
inspired by the face of the gardener
at Steven Spielberg's production
company, Amblin.

FAR LEFT **Aaron Sims's digital artwork**
for an early idea of a Mecha postal
worker, later revised to an 'insecurity
guard' when it was realized that mail
was likely to be sent electronically in
the future.

CENTRE LEFT **Dave Grasso at work** on the
head of Insecurity Guard. The robot's
face was based on Stan Winston's.

BELOW LEFT **The mechanics** of Insecurity
Guard.

OPPOSITE, ABOVE LEFT **Steven Spielberg**
directs the caged Mechas, including
Gardener and Insecurity Guard.

OPPOSITE, BELOW LEFT **Stan Winston
Studio's** Gary Martinez and J. Alan
Scott inspect TV Face.

OPPOSITE, RIGHT **TV Face**, one of the
hundreds of robot designs by Stan
Winston Studio, was a self-contained,
mobile hydraulic. The TV screen rested
on the 'arm' of the robot. Its actor,
Bobby Harwell, had a video camera
mounted to his head so that, wherever
he was looking, the camera could film
him face-on. Harwell delivered his lines
live, and his image was projected
behind the bowl of the robot's face.

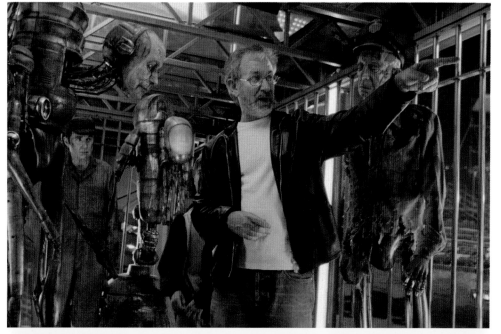

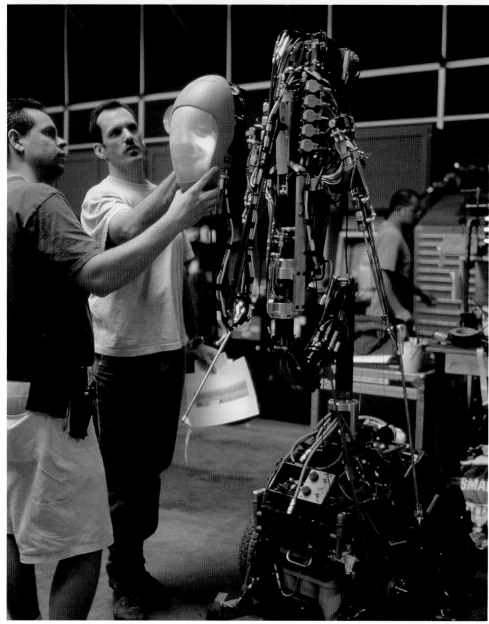

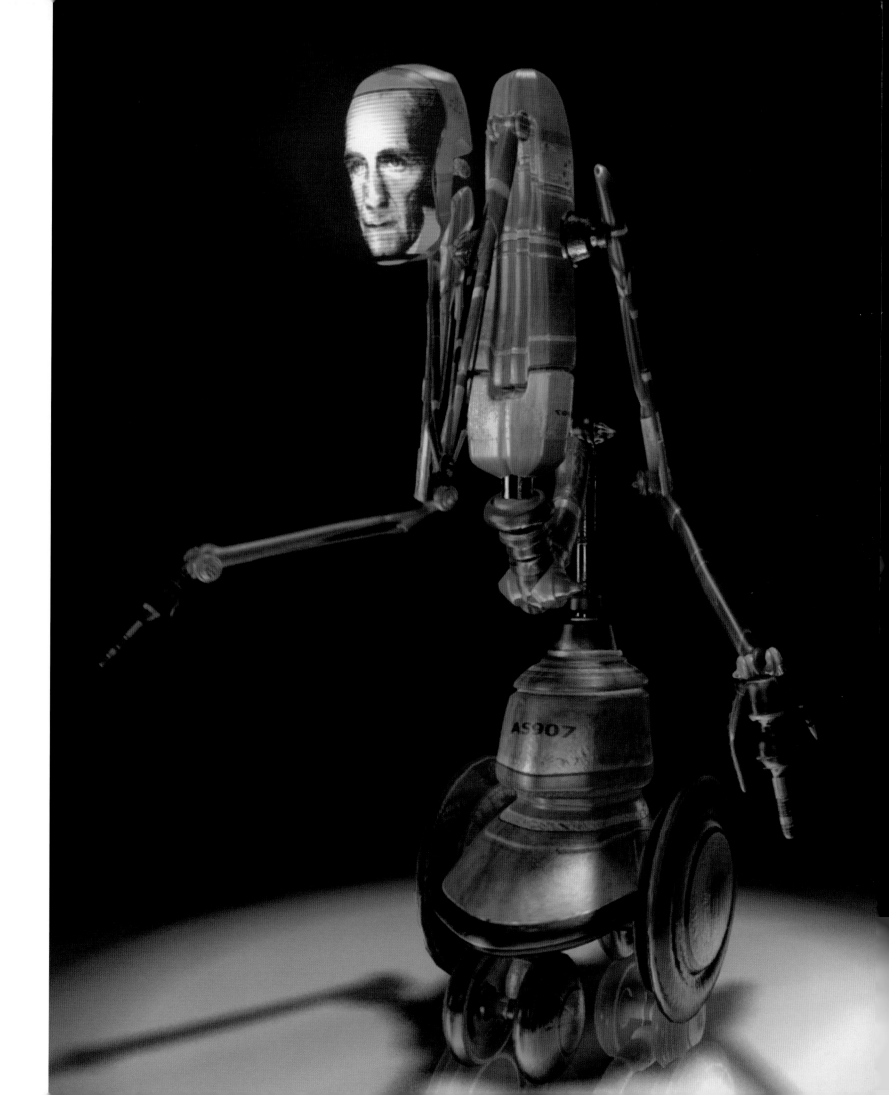

After escaping the Flesh Fair, Gigolo Joe guides David to Rouge City where he
will find the omniscient Dr Know. They hitch a ride with a group of boys who,
needing little persuasion after the promise of the delights that await them
(Gigolo Joe even conjures up a miniature hologram of a good-time girl to
entice them), head towards the bright lights of the city.

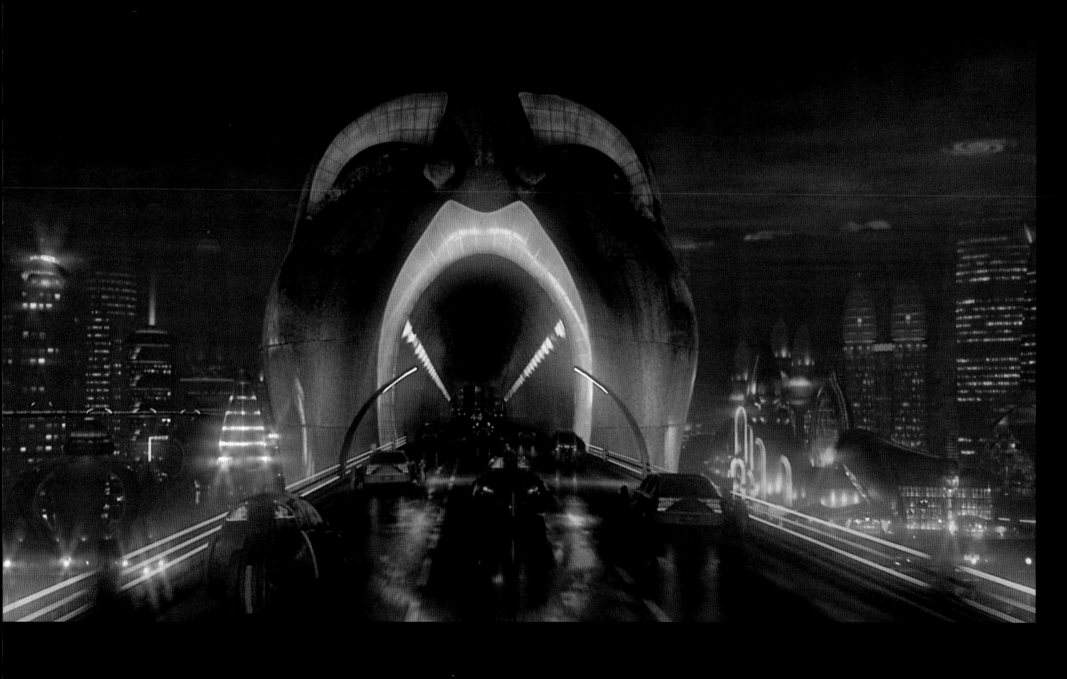

'Entry was by three gaping
gateways designed like red
lips, into which ran a caged-
over roadway for shuttle
buses and supply trucks.'

IAN WATSON, STORY TREATMENT

LEFT **Film still** – 'Say "Ah!"' – of the entrance to
Rouge City, home to debauchery and excess.

OPPOSITE **Chris Baker's designs** of mouths, lips
and tongues, exploring the various possibilities
for the tollgates to Rouge City.

A

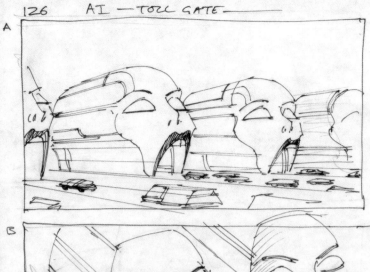

B

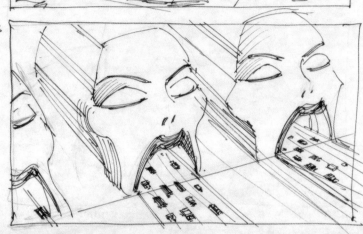

STANLEY— HERE ARE INITIAL
THUMBNAILS FOR THE
TOLL GATE.
THERE ARE CERTAINLY
ALOT MORE AVENUES
TO GO DOWN ON THIS
CONCEPT SO THERE'LL
BE QUITE A FEW MORE TO
COME.
—CHRIS

Fangorn 5/8/94

A

B

C

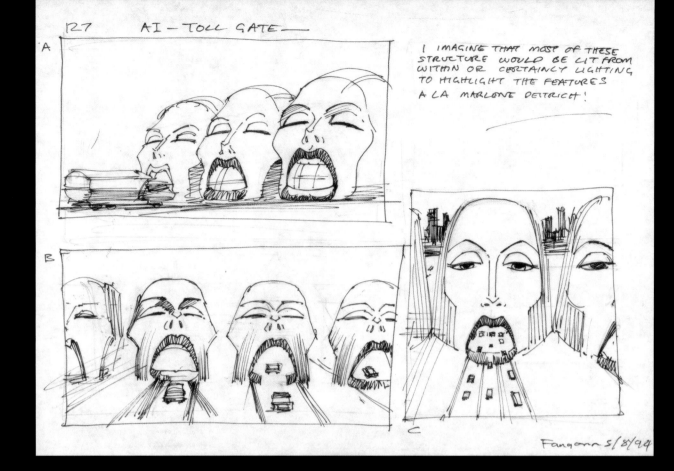

I IMAGINE THAT MOST OF THESE
STRUCTURE WOULD BE LIT FROM
WITHIN OR CERTAINLY LIGHTING
TO HIGHLIGHT THE FEATURES
A LA MARLENE DEITRICH!

Fangorn 5/8/94

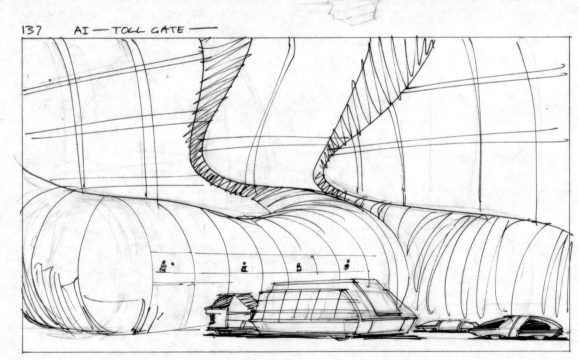

STANLEY — AFTER PRODUCING THIS SKETCH IT SEEMED TO BE A SHAME
THAT WITH THIS HUGE WIDE OPEN MOUTH THAT WE
COULDN'T GET THE VEHICLES TO ACTUALLY GO THRU IT
INSTEAD OF THE LIP! SO I STARTED WORKING ON THE
FOLLOWING IDEA......

Fangorn 9/8/94

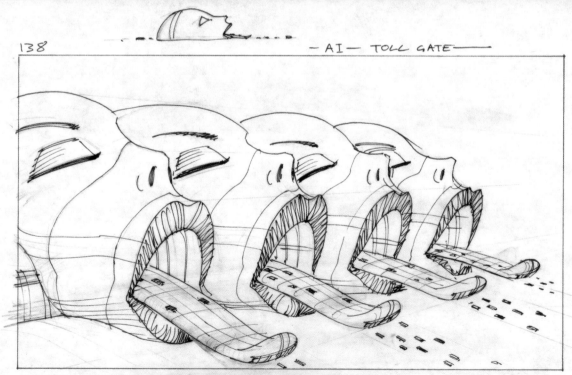

IVE TRIED TO MAKE THIS FUNCTIONAL AND EROTIC
THE TONGUE CURES TWO PROBLEMS. IT ACTS AS A RAMP INTO THE MOUTH
AND ITS CURLED TIP MAKES AN IDEAL PLACE TO POSITION THE TOLL BOOTHS

Fangorn 9/8/94

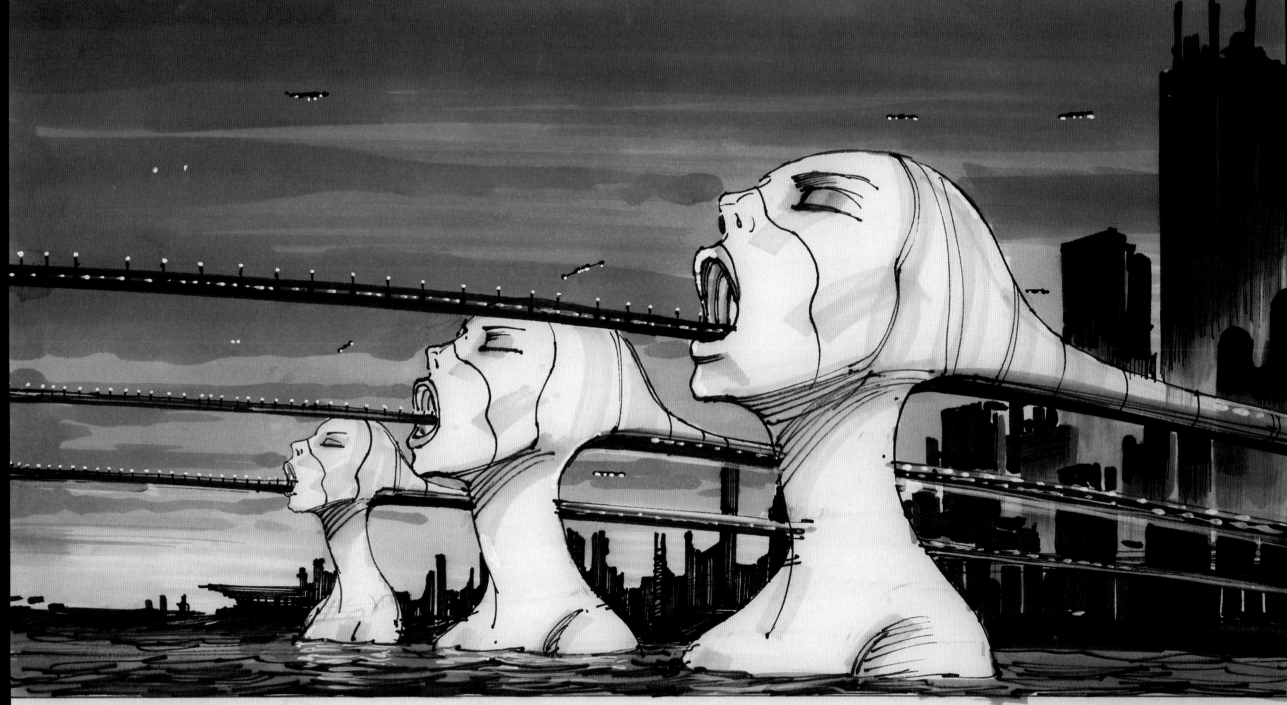

HERE IVE TURNED THE TOLL BOOTHS INTO A SERIES OF
SUSPENSION BRIDGES THAT EMPAIASIZE THEIR SEXUAL
NATURE.

Fangom 11/9/95

'All roads lead to Rouge.' STEVEN SPIELBERG, SCREENPLAY

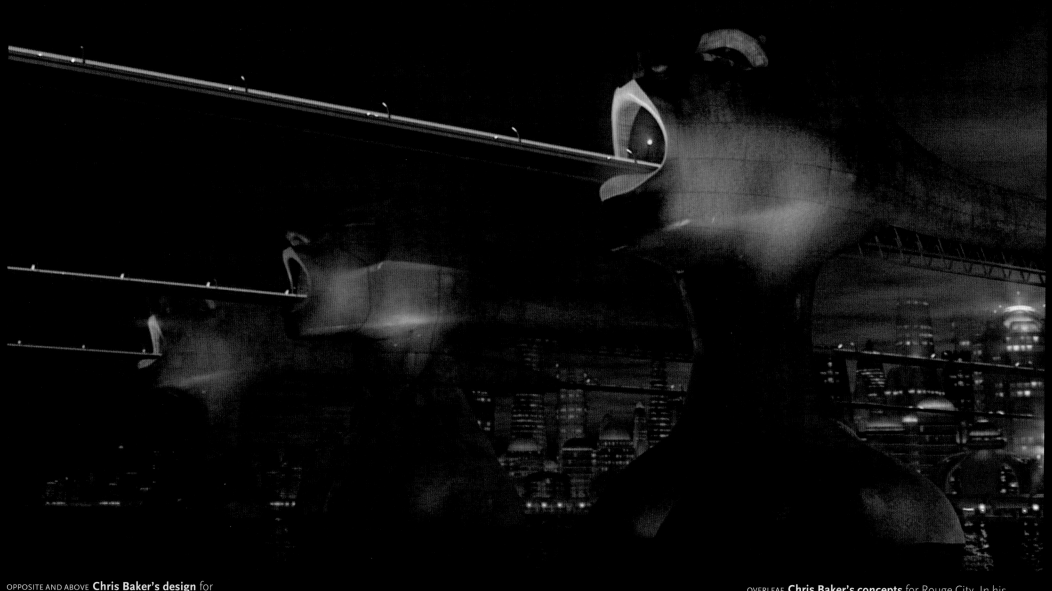

OPPOSITE AND ABOVE **Chris Baker's design** for
the tollgates and its realization for the film.

OVERLEAF **Chris Baker's concepts** for Rouge City. In his
annotations he suggests further ideas for the look and
feel of the city, offering designs that show 'a sense of
claustrophobia' and 'a prevailing eroticism, with a mix of
influences from Art Deco and Art Nouveau'. 'Like most cities,'
he writes, 'Rouge City has its more affluent areas. Fantastic
architecture provides a playground for the well-to-do.'

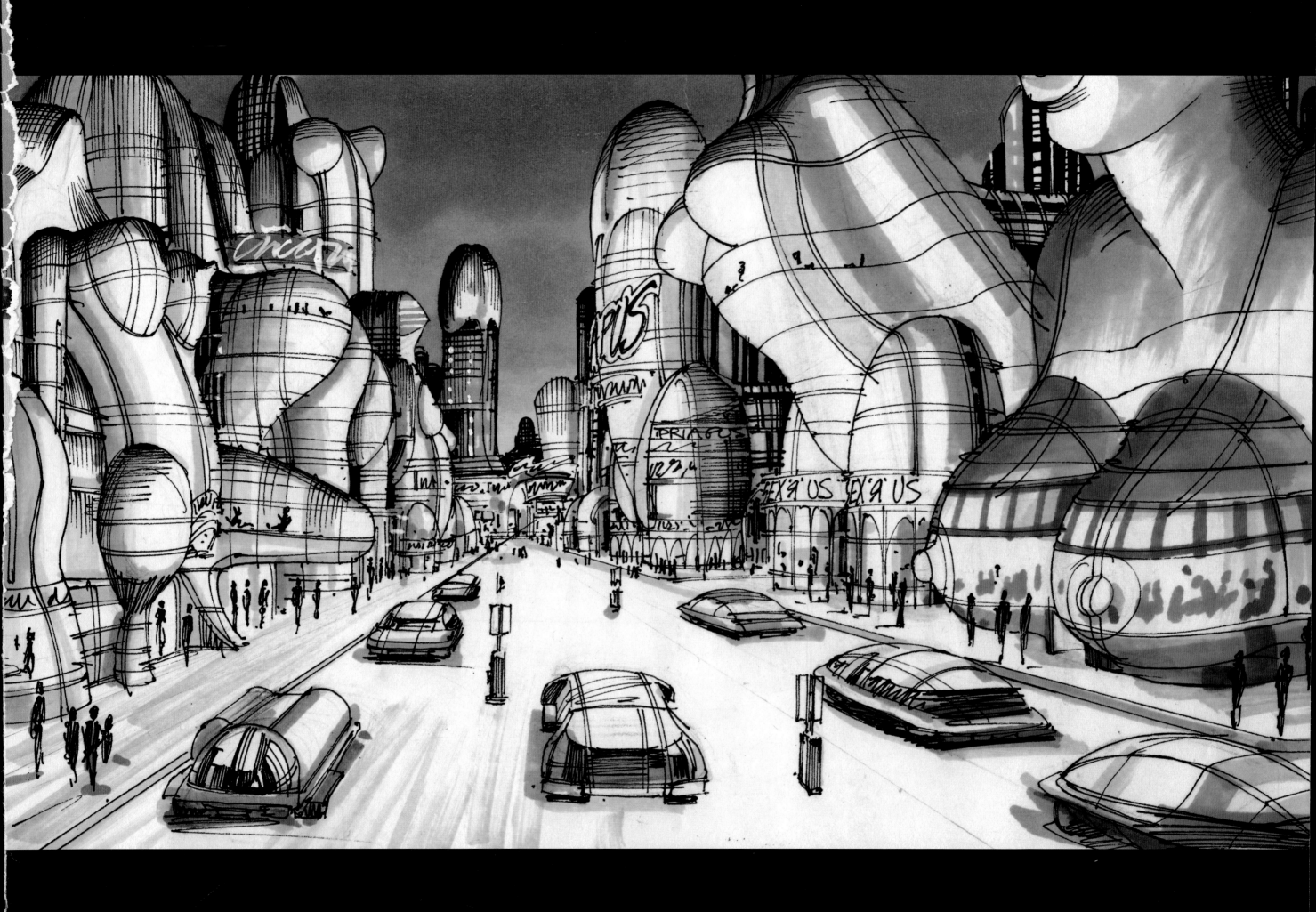

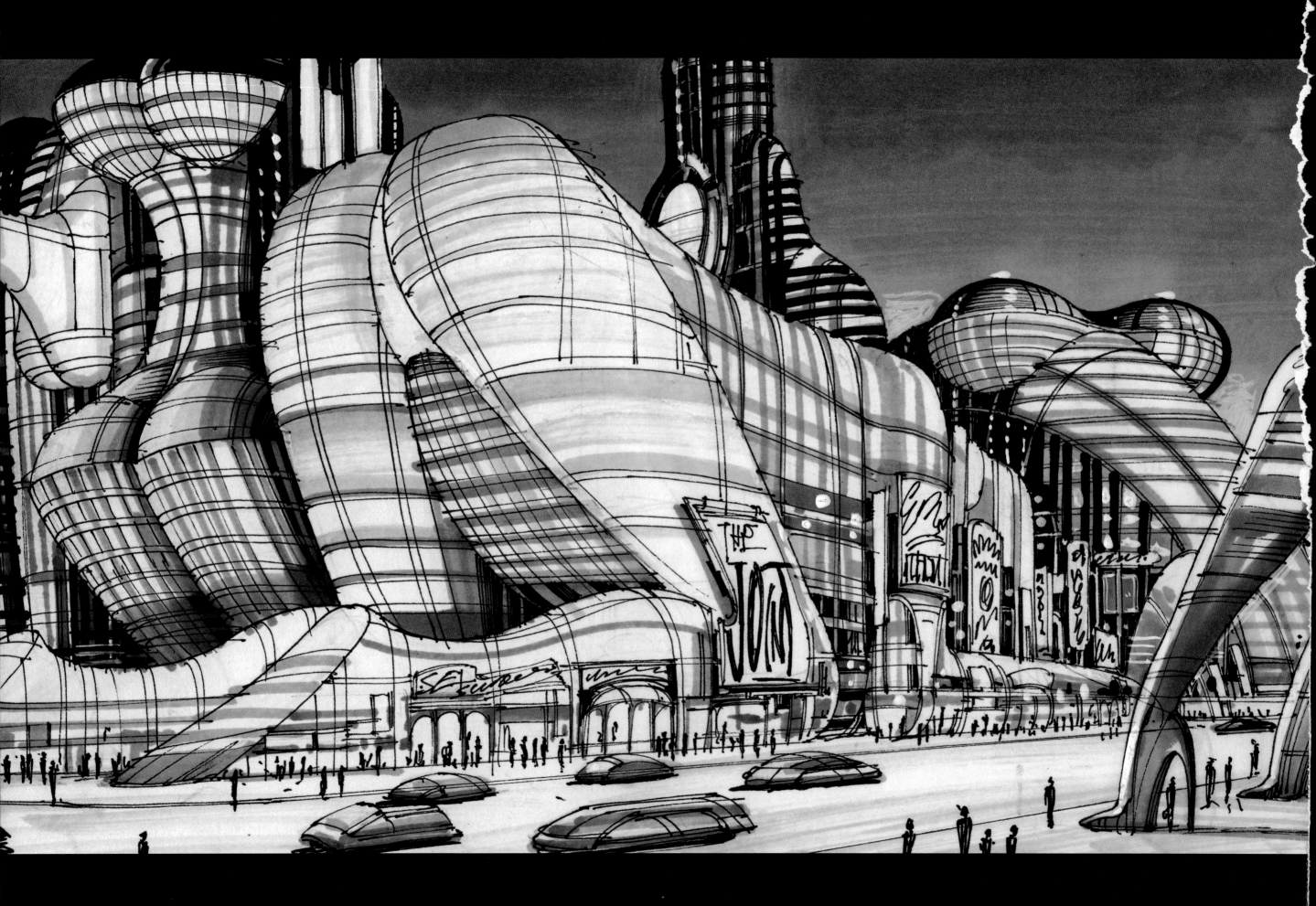

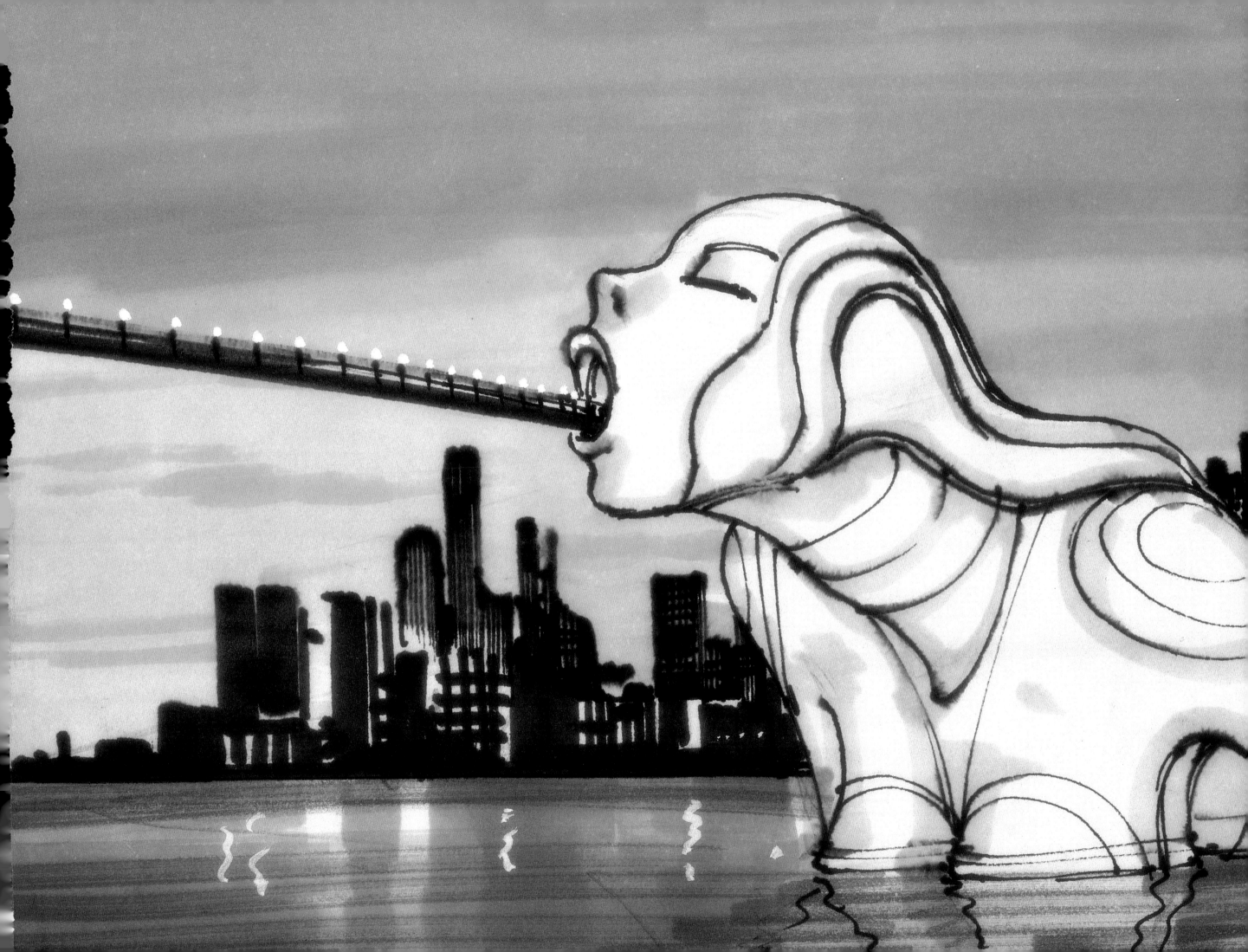

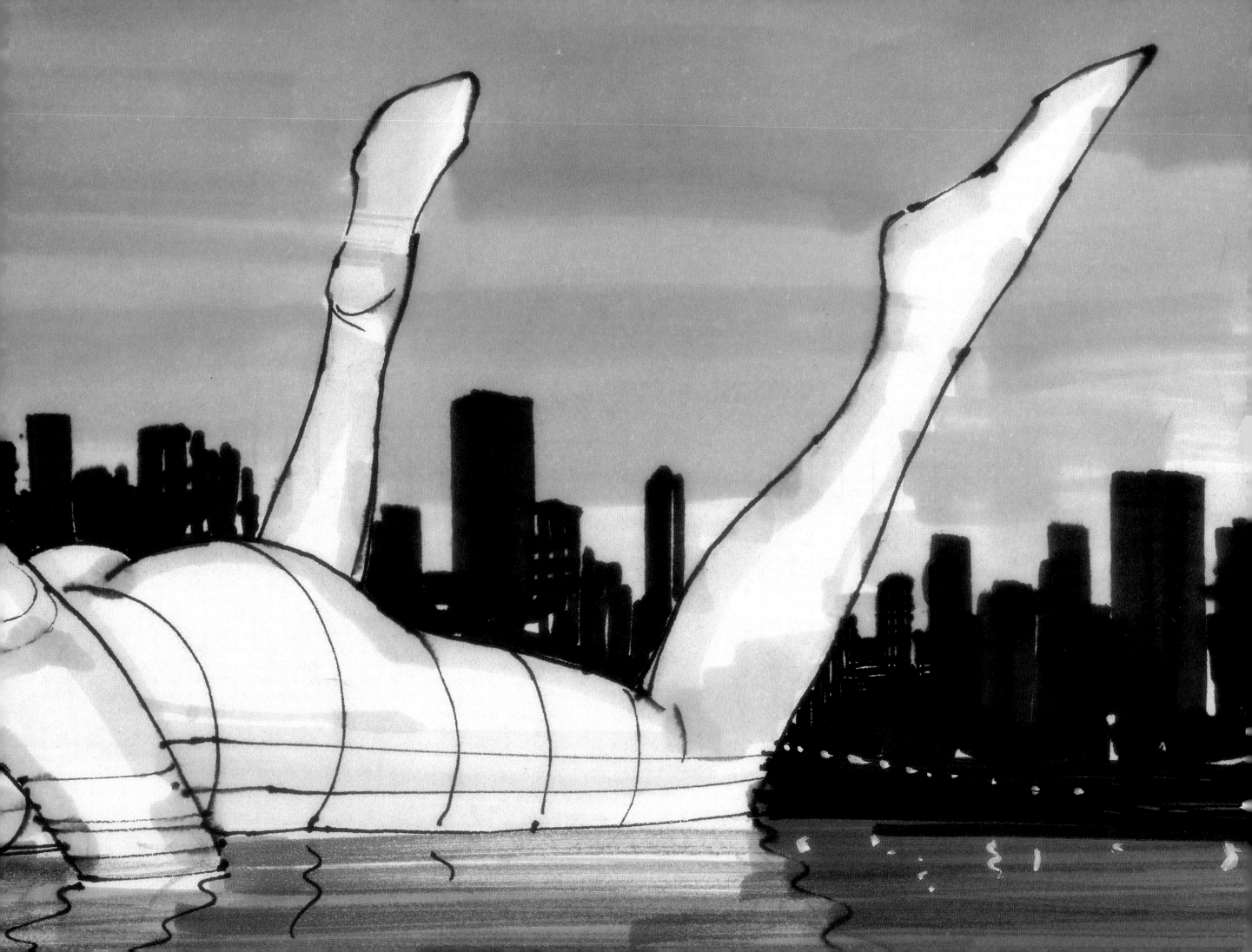

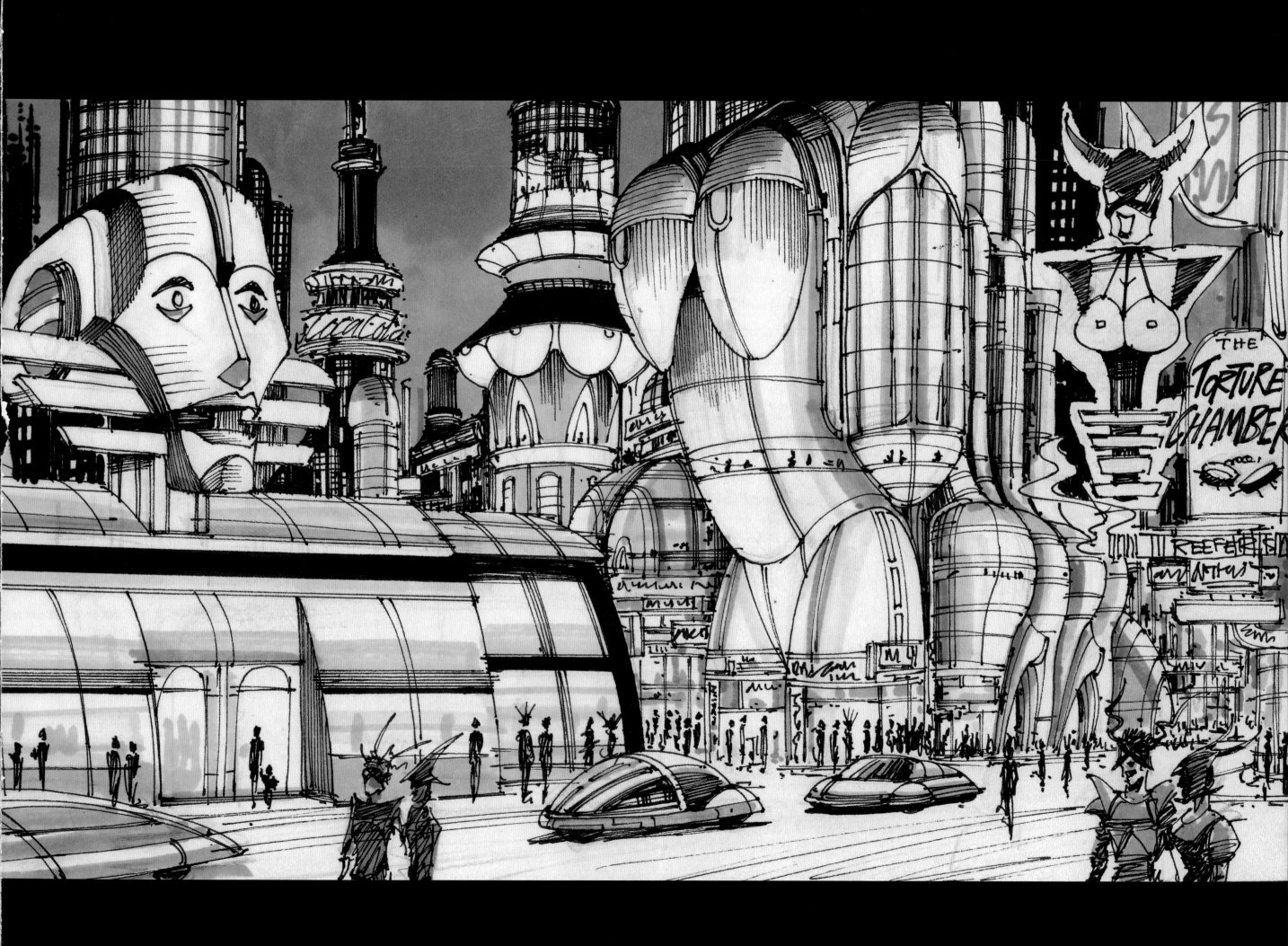

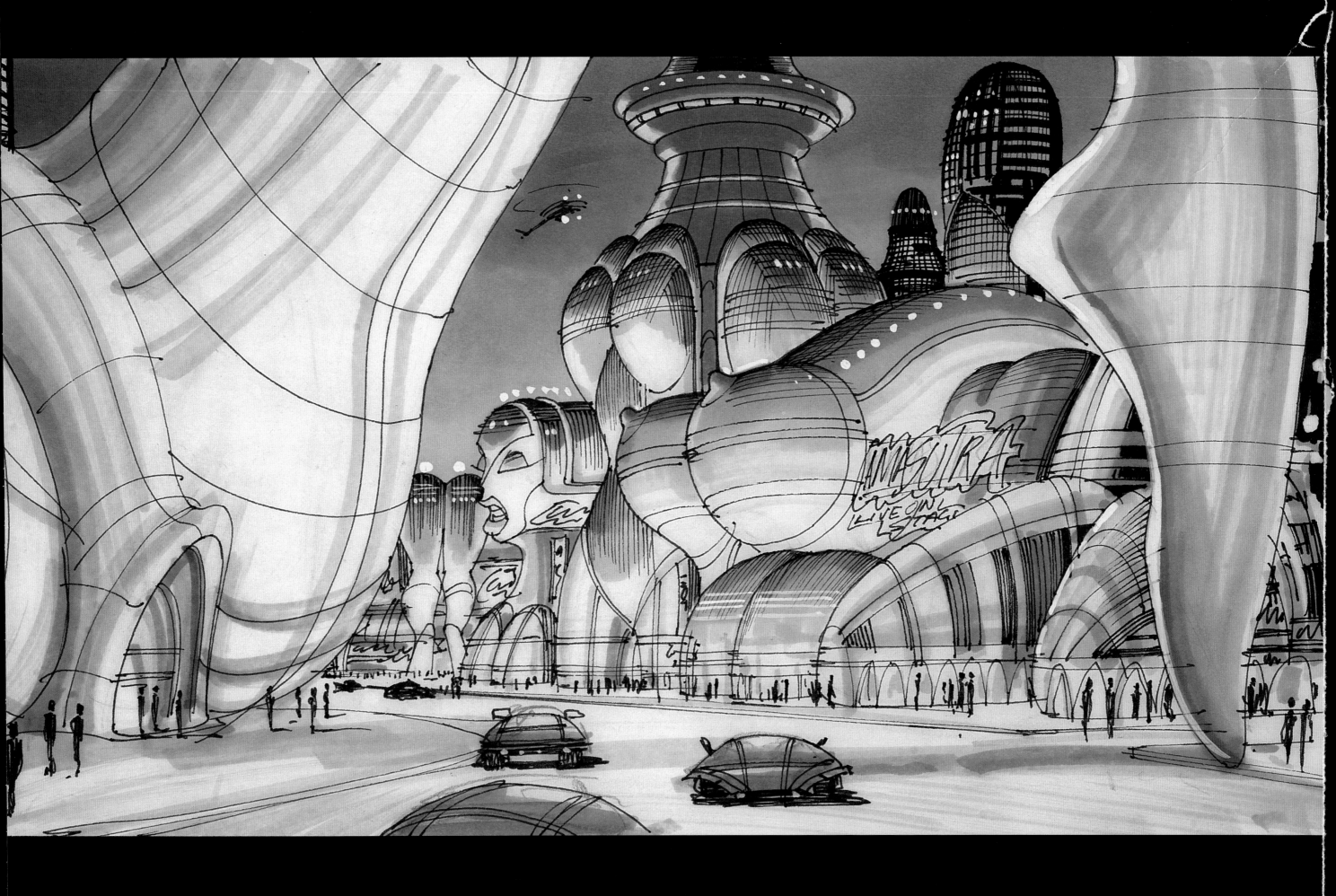

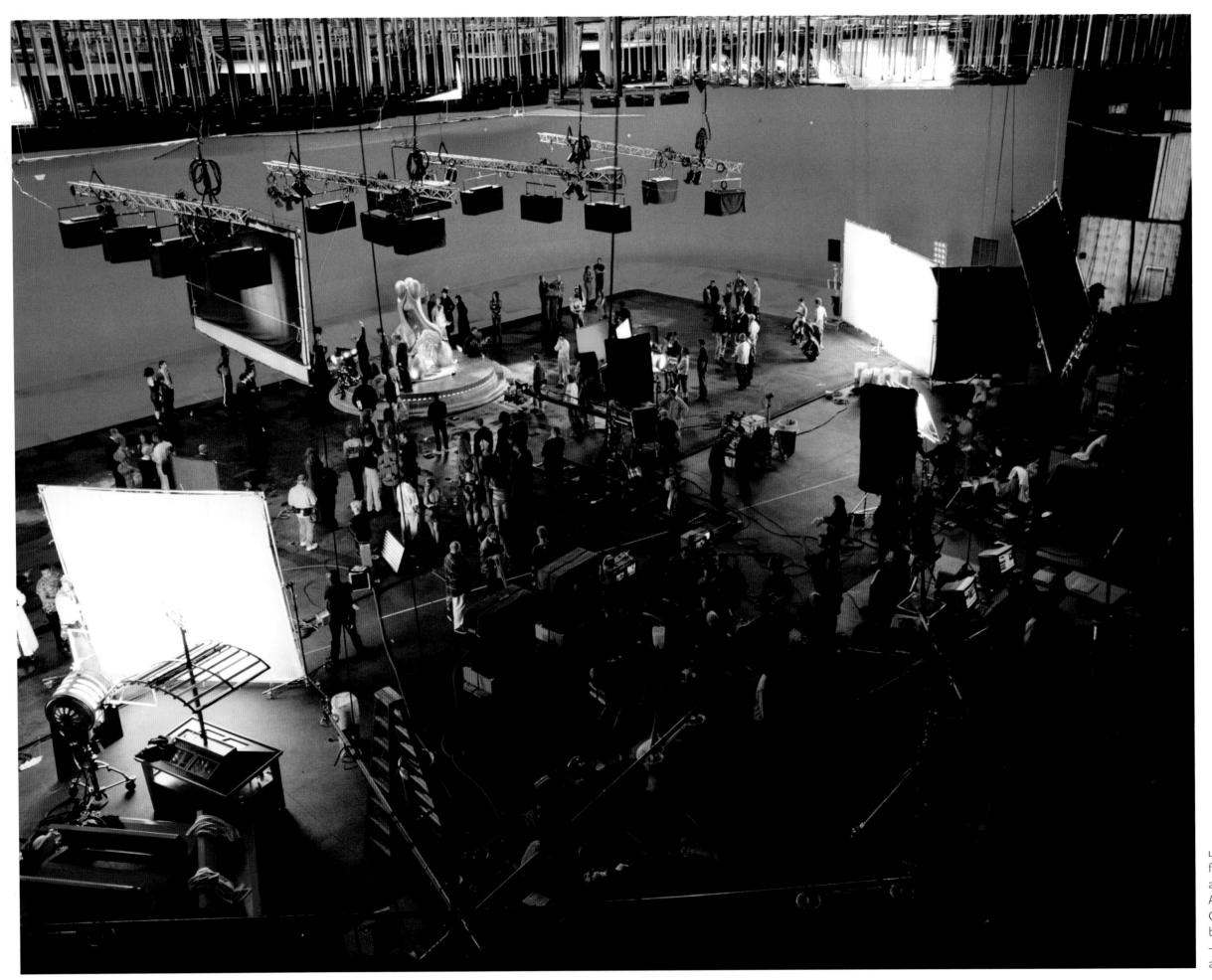

LEFT **The studio** during the filming of the live action against a blue screen. A composite of live action, CG and physical models – both full size and miniature – would create the magic of an expansive Rouge City.

ROUGE CITY

The trio enter Rouge City to be exposed suddenly to the bright lights, sounds and entertainment of the adult playground. While Gigolo Joe appears at home, David wanders like a lost child, mistaking a blue-lit Madonna figure at the church of Our Lady of the Immaculate Heart for the Blue Fairy. Gigolo Joe takes David's hand and leads him through the bustle of the streets, surrounded by the pleasure palaces of bars, clubs and casinos, to the information emporium of Dr Know.

ABOVE **Steven Spielberg** observes on set, while the monitors illustrate the 'virtual studio' – an invention that offered the director a preview of the surrounding cityscape: on the left, a composite of digital imagery and live actors; on the right, the actual on-set live action performed in front of a blue screen.

BELOW **The complete composite** (far right) of live action filmed in front of a blue screen (far left), physical models filmed in front of a blue screen (centre left) and CG of the surrounding buildings (centre right).

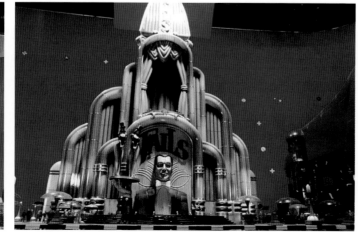
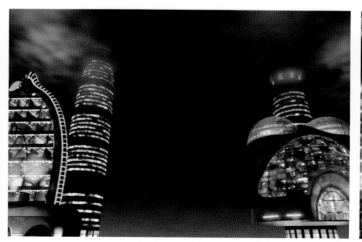
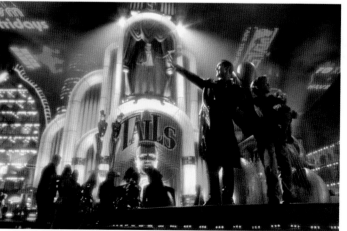

'Within were neon-wreathed pleasure domes, glittery crystalline malls selling tax-free goods, blissful boulevards, casinos, cabarets, body shops....'

IAN WATSON, STORY TREATMENT

RIGHT **Rouge City miniatures**, including Chris Baker's 'kneeling woman', created and filmed by ILM and overseen by Scott Farrar, visual effects supervisor.

BELOW RIGHT **Film still** of the final scene, combining the filmed footage of the miniatures with live action and CG.

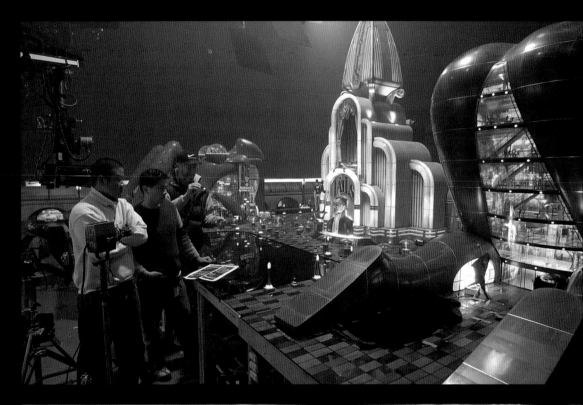

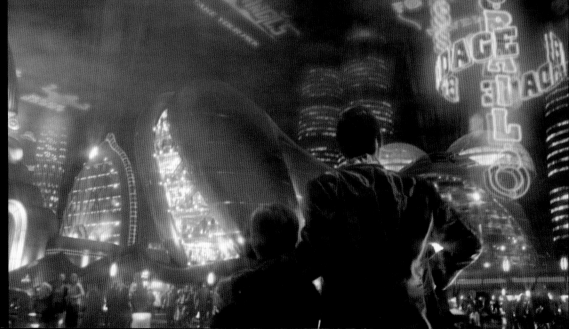

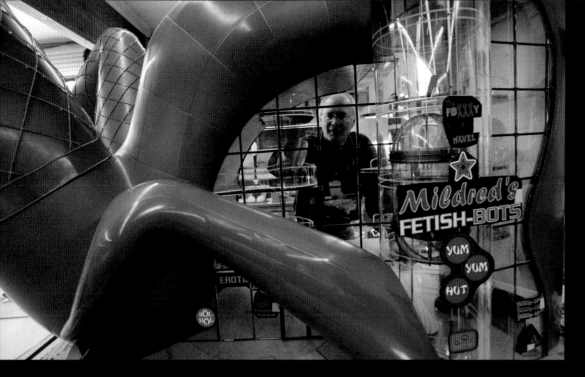

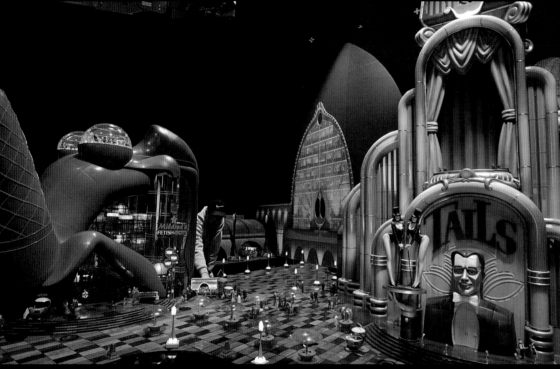

ABOVE LEFT **Scott Farrar** oversees the detail for the building known as 'Mildred', based on Chris Baker's concept drawings. Baker noted of this design's spread-eagled legs: 'The structure is so big the foot is on the other side of the street' (see also pp. 89–91).

LEFT **Miniature set** for Rouge City.

BELOW LEFT **Film still** showing the final scene of Mildred's miniature, combined with live action and CG.

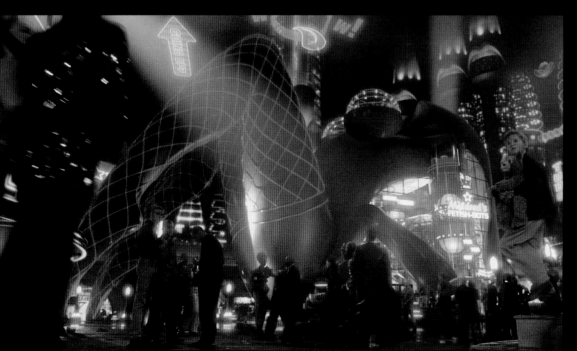

DR KNOW

Gigolo Joe takes David and Teddy to a Dr Know booth. Once they are inside, the holographic character of Dr Know spins into view: 'Starving minds, welcome to Dr Know! Where fast-food for thought is served up 24 hours a day, in 40,000 locations nationwide. Ask Dr Know. There's nothing I don't!'

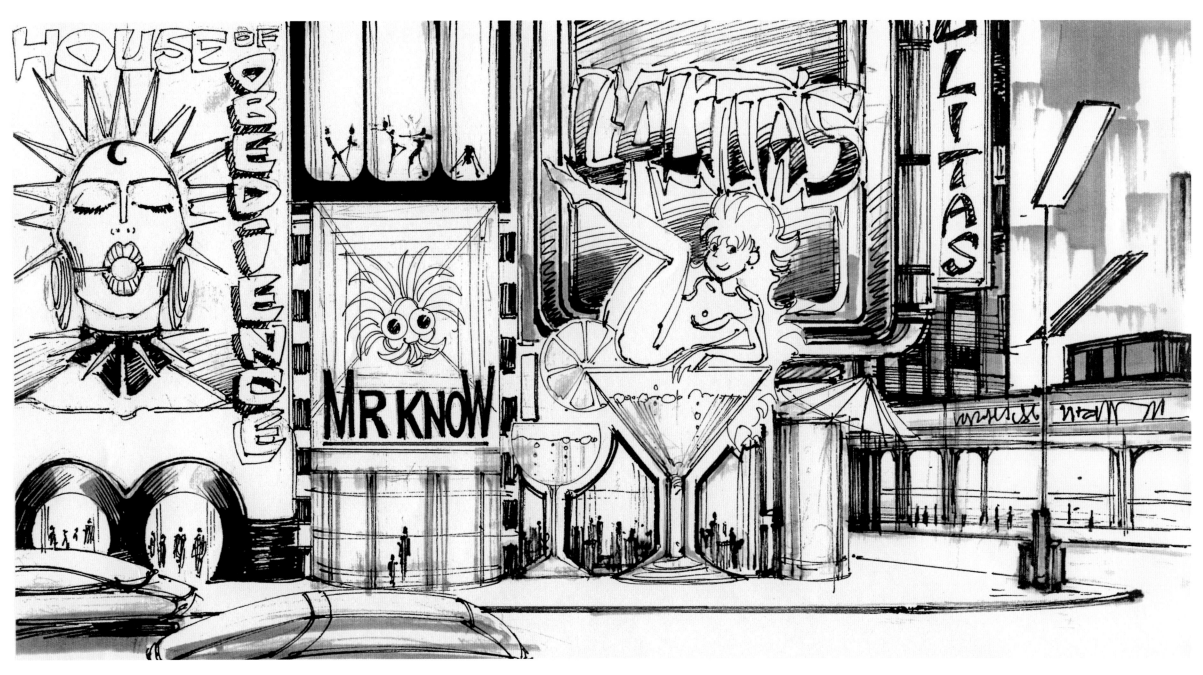

ABOVE AND OPPOSITE **Chris Baker's drawings** for the setting of Mr Know (changed to Dr Know in the final film). Note that Baker slyly included a reference (above) to Kubrick's *Lolita*.

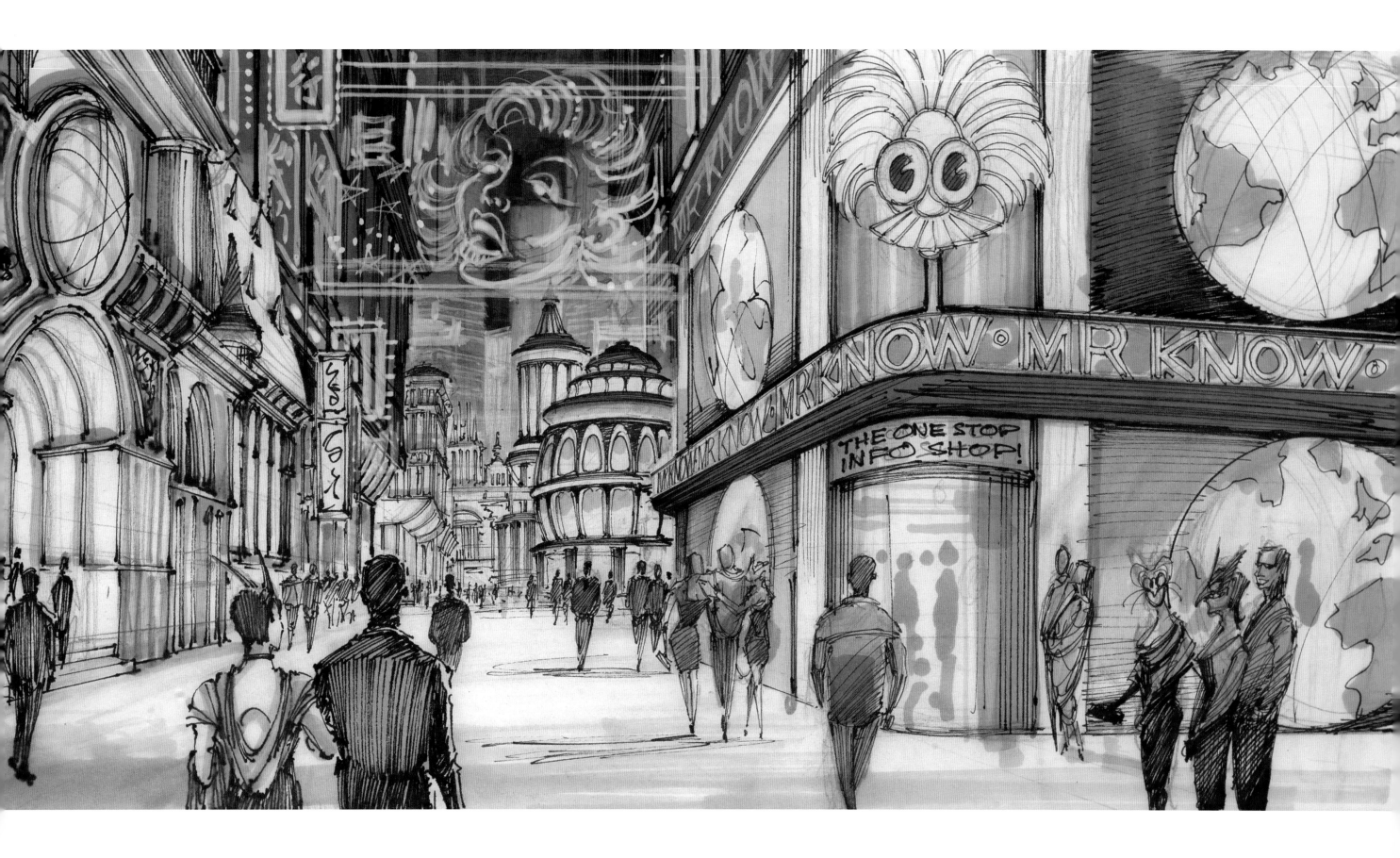

'Come away, O human child
To the waters and the wild
With a fairy, hand in hand,
For the world's more full of weeping
Than you can understand.'

STEVEN SPIELBERG, SCREENPLAY
(FROM W. B. YEATS'S 'THE STOLEN CHILD')

OPPOSITE **Chris Baker's** development
and suggestions to Stanley Kubrick for
the look and functionality of Dr Know.

LEFT **Film still** showing the realization
of Chris Baker's concept artwork.
Holographic words encircle Gigolo Joe
David and Teddy as they discover the
location of the Blue Fairy.

172 — "MR KNOW" SHOP INTERIOR —

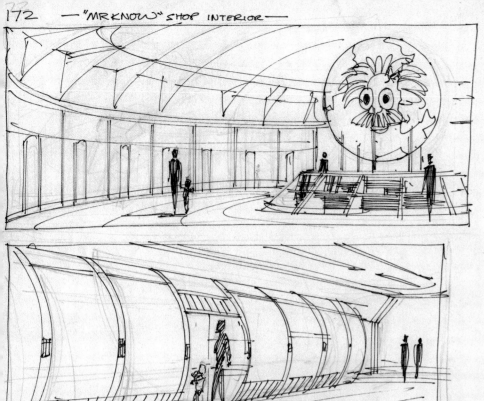

STANLEY —
THE THUMBNAILS FOR THE MR KNOW SHOP ARE PRETTY STERILE. I THINK IT'S WORTH TAKING THE EINSTEIN CHARACTER AND REALLY WORKING IT UP INTO SOMETHING WITH A LOT OF PIZAZZ!
THE COLONEL SANDERS OF THE COMPUTER WORLD KIND OF IMAGE.
— CHRIS

181 AI — ROUGE CITY ARCHITECTURE

A

B

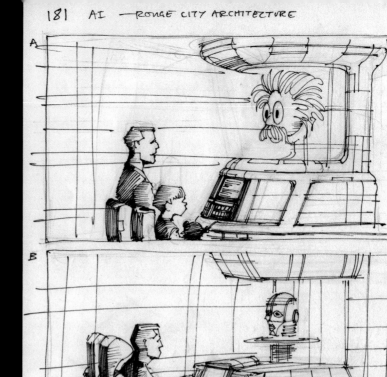

I IMAGINE THAT THE 'MR KNOW' BOOTH WOULD BE VERY USER-FRIENDLY. OCCUPANTS WOULD TALK DIRECTLY TO THE 'MR KNOW' HOLOGRAM.

850 AI — MR KNOW —

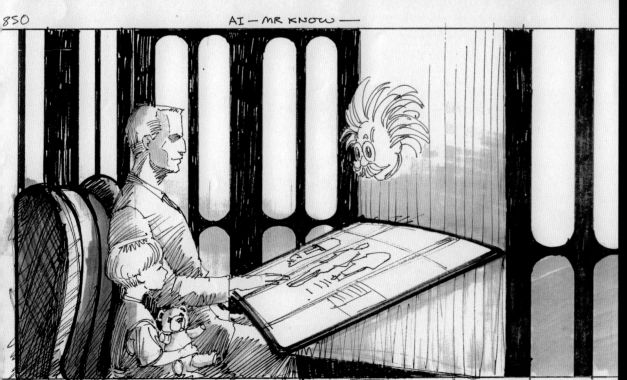

HERE JOE IS OPERATING A PERFECTLY SMOOTH TOUCH SENSITIVE SCREEN ALTHOUGH AT ANY POINT ONE CAN SPEAK DIRECTLY TO THE FLOATING MR KNOW IMAGE

WITH THIS PARTICULAR DESIGN THE OCCUPANTS ARE SURROUNDED BY SOUND AND THE IMAGES ARE SUSPENDED IN SPACE BEFORE THEM

David, Teddy and Gigolo Joe leave Dr Know to find the police waiting outside to arrest the Love Mecha for the murder of one of his clients. During the arrest, David steals a police amphibicopter. In the ensuing chaos, Gigolo Joe escapes and joins David and Teddy. They all head to 'Manhattan', known to Mechas as the end of the world, as no Mecha has ever returned. As they approach the sunken city, they are warned that this is a Mecha-restricted area, and Teddy growls ominously.

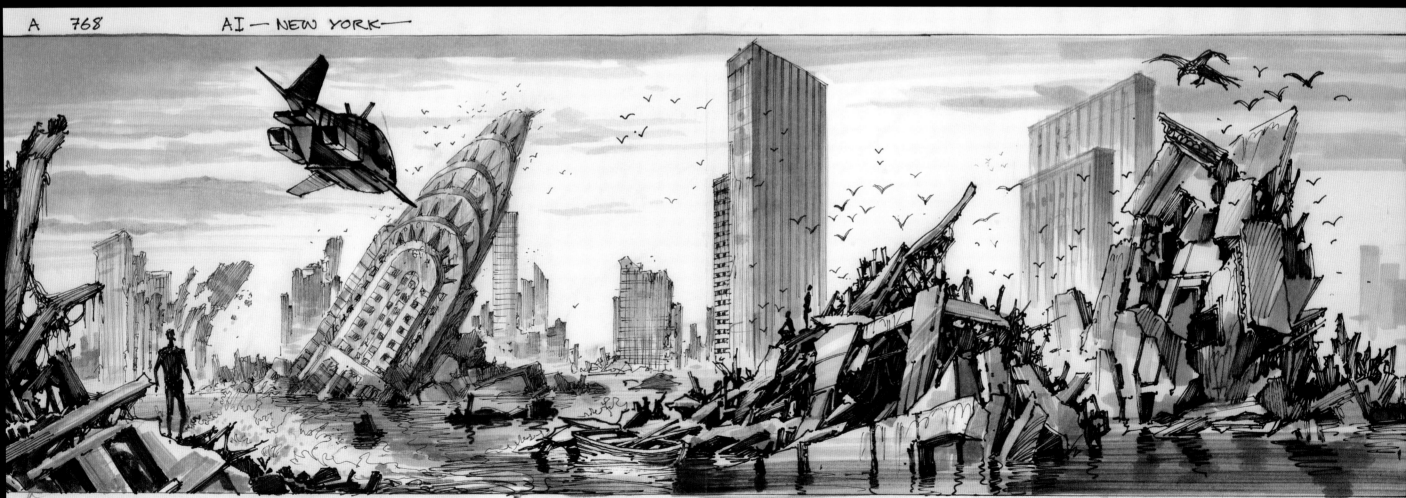

A 768 AI — NEW YORK —

DAVIDS COPTER ENTERS NEW YORK RUNAWAY ROBOTS TAKE REFUGE AMONGST THE ISLANDS OF DEBRIS.

Fangorn 9/10/95

—'COPTER—

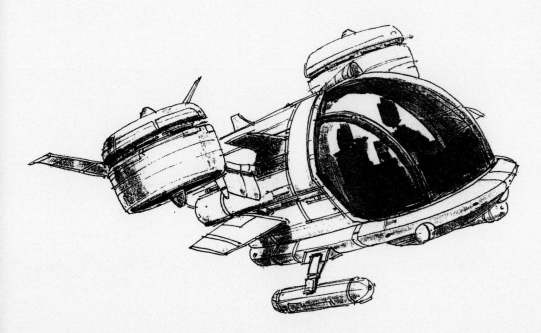

MY FIRST 'SEMI-SERIOUS'
ATTEMPT AT THE COPTER DESIGN.

THE WET/DRY ENGINES
WOULD ROTATE THRU 90°
DEPENDING ON THE ENVIRONMENT.

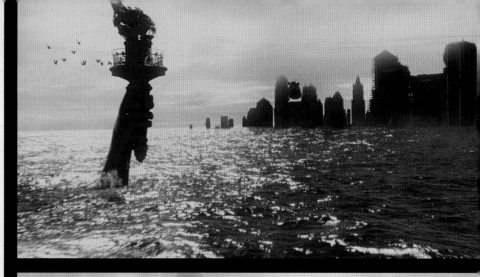

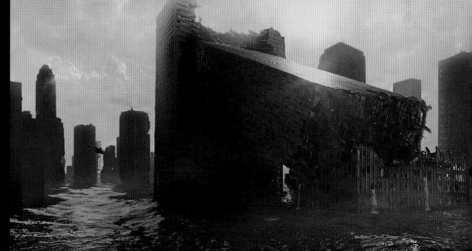

BELOW AND OPPOSITE **Chris Baker's vision** of the drowned New York.

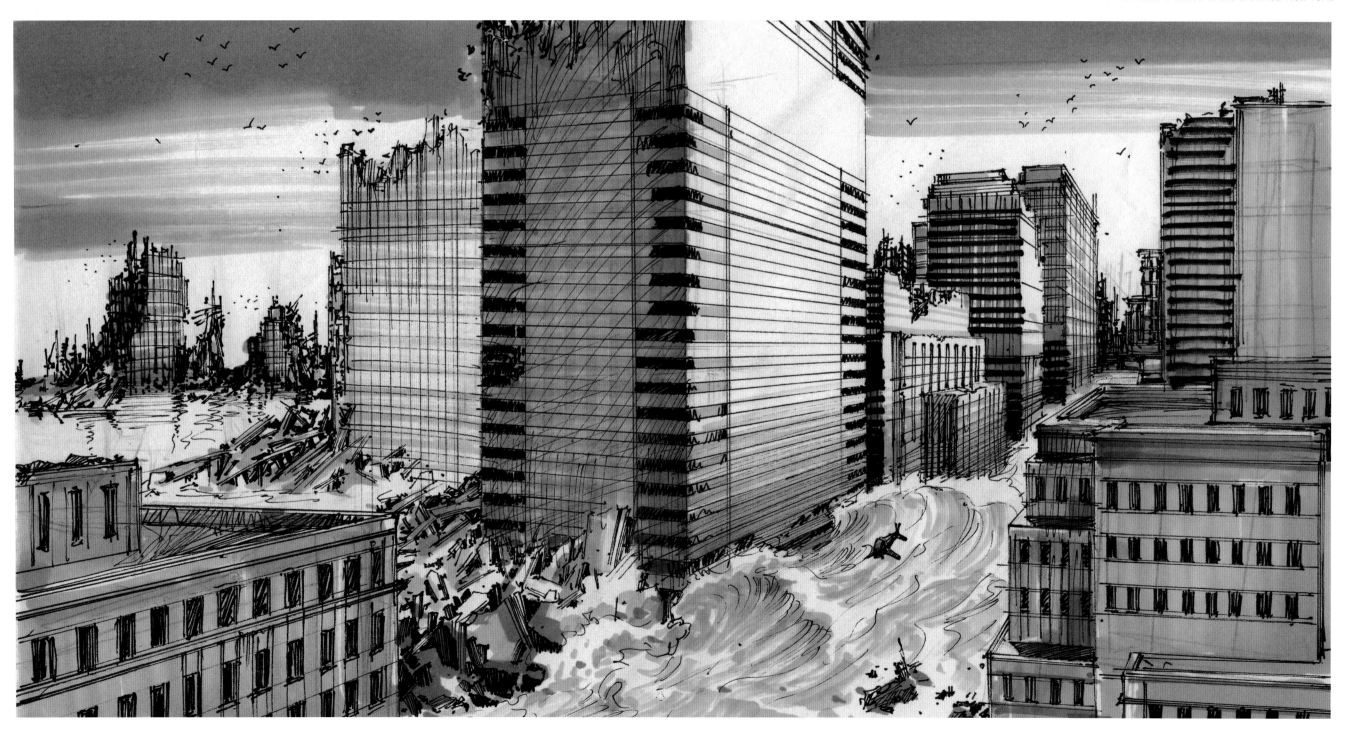

A

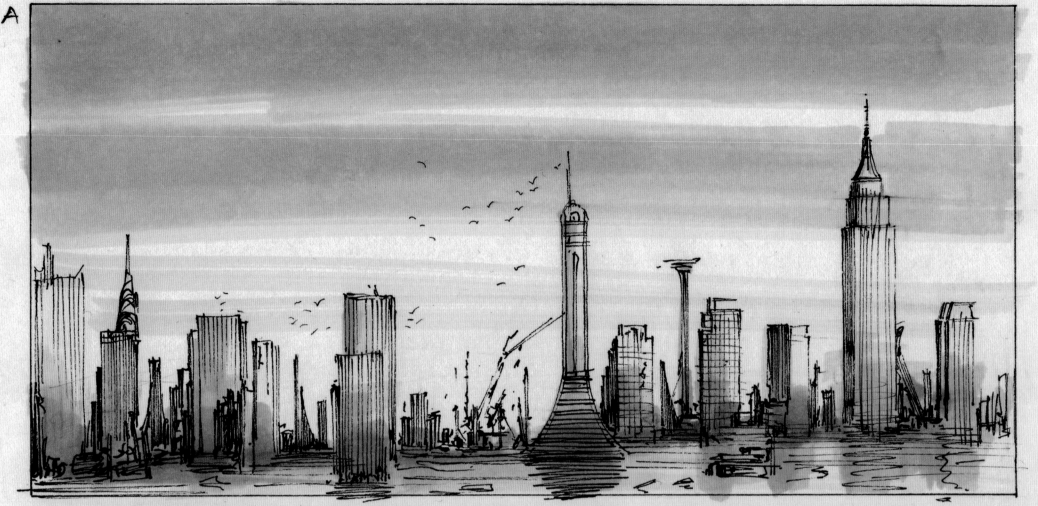

B

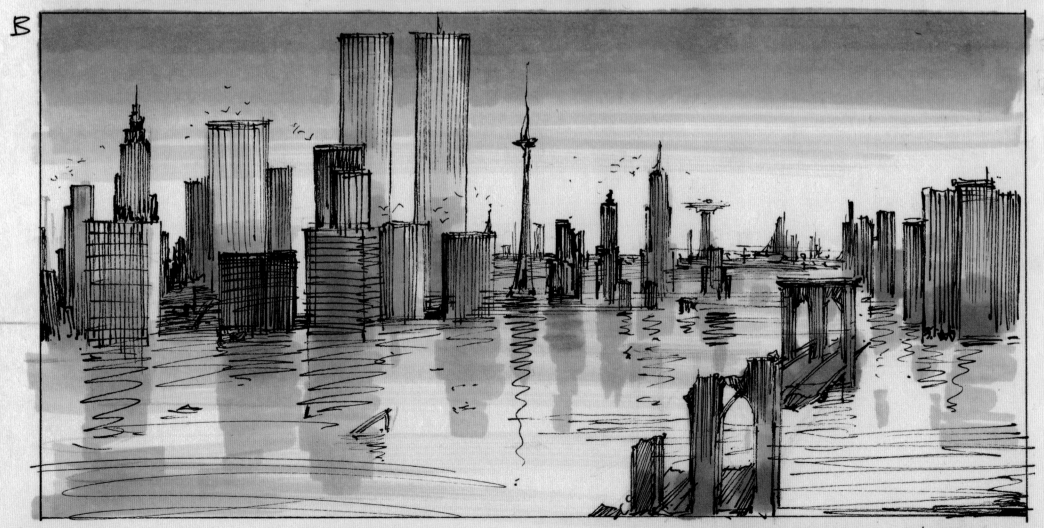

Fangorn 6/10/94

PROFESSOR HOBBY'S OFFICE

David, Teddy and Gigolo Joe arrive at Cybertronics. David believes that this is his chance to find the Blue Fairy to make him real, but instead what awaits him is a series of horrific discoveries. His first meeting is with his doppelgänger, whom he feels threatened by and destroys in a fit of jealous rage. Professor Hobby arrives as David continues to swing his weapon. The professor explains to David that he was in fact an experiment, and a very successful one. He then leaves his 'son' while he goes to find the other scientists. During the professor's absence, David learns that he is just one David in a long production line. The indisputable truth is revealed when he looks through a mask of his own face and discovers the true context of his earliest memory. With nowhere left to turn, he lets himself fall from the ledge of Cybertronics into the sea below.

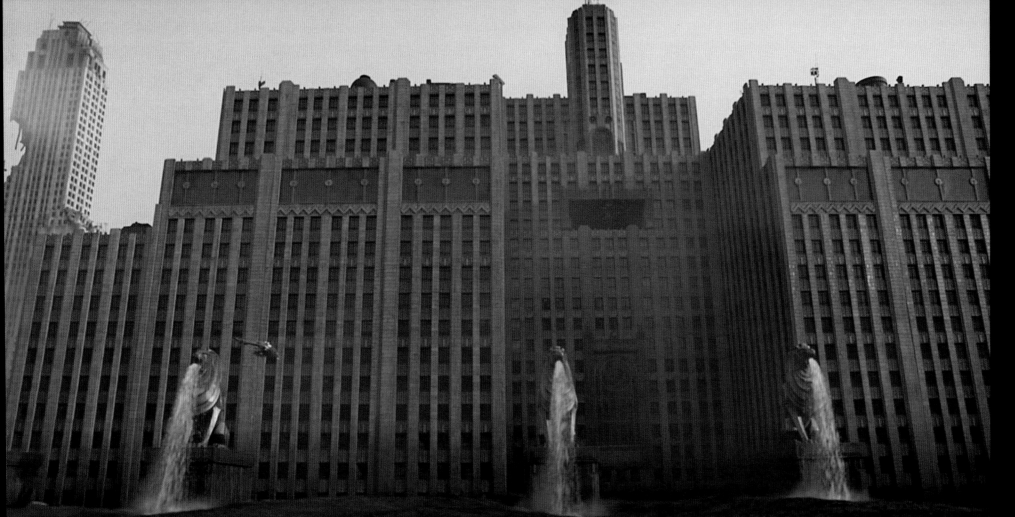

LEFT **Film still** showing the amphibicopter approaching the headquarters of Cybertronics: 'At the end of the world where the lions weep. Here is the place dreams are born.' The Cybertronics building was a 6-foot-high set construction. The water and waterfalls were CG effects added later.

OPPOSITE ABOVE **Film still** of David destroying his doppelgänger – the innocent David that he once was, underscored by the circular light fitting above him, now broken (see p. 46)

OPPOSITE BELOW **Film still** showing David

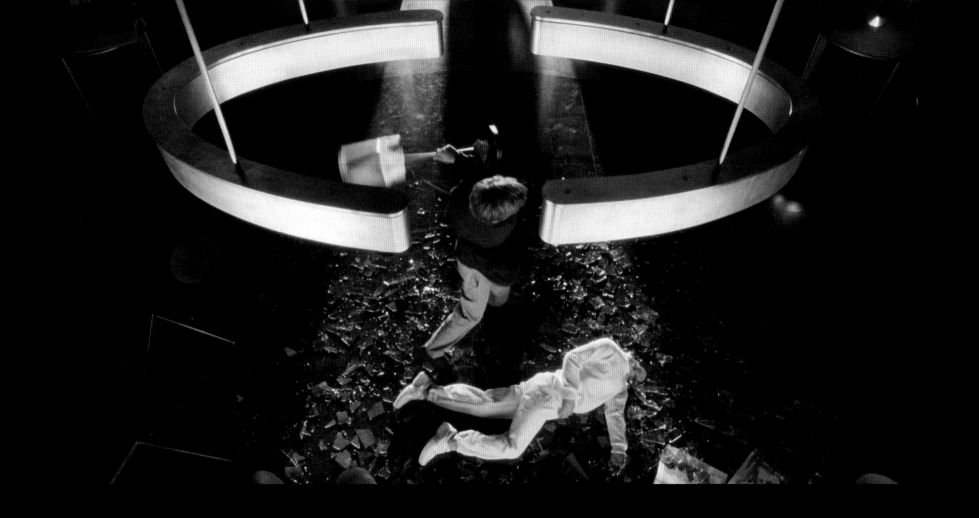

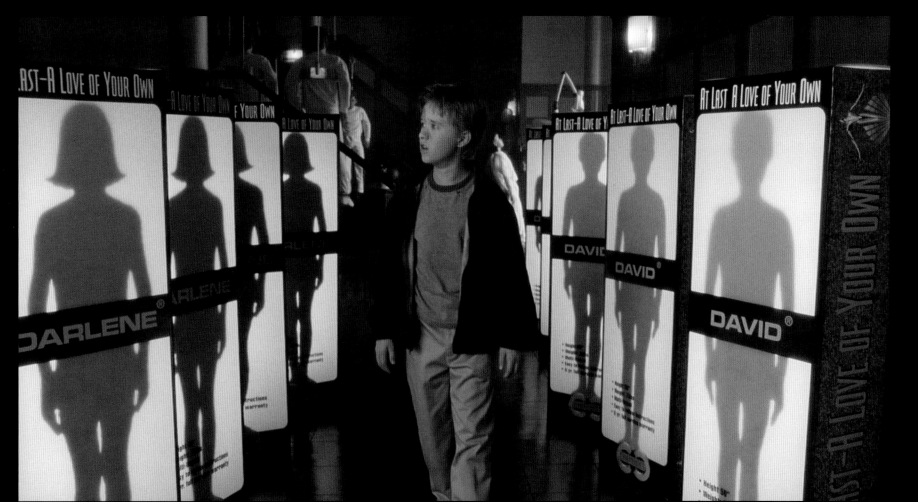

'I thought I was one of
'You are the *first* of a ki

STEVEN SPIELBERG, SCREENPLAY

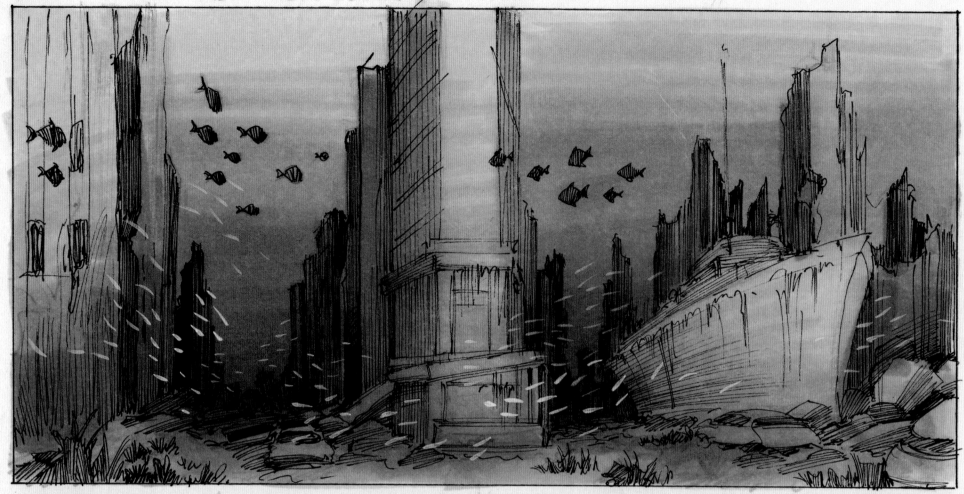

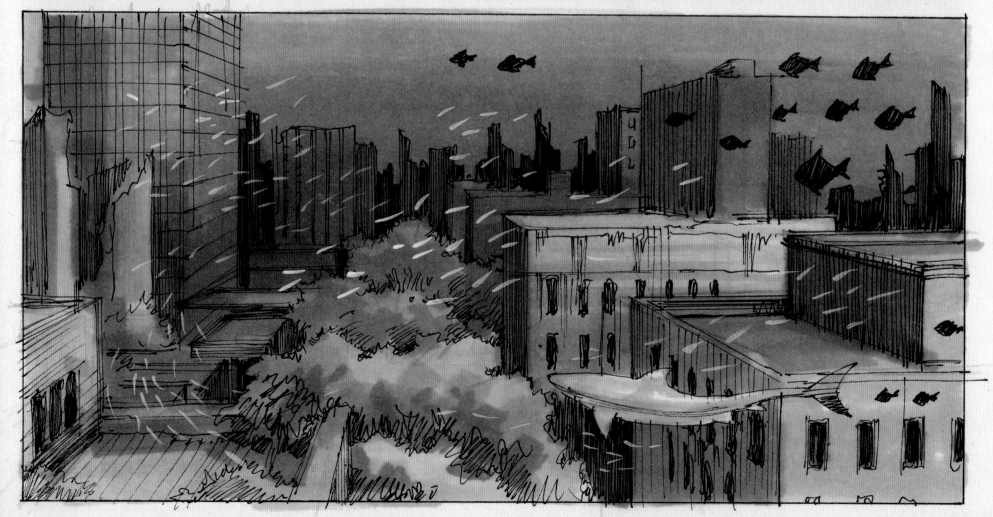

Fangorn 27/10/94

THE DESCENT

Finally submerged in the ocean, and having already caught a glimpse of the Blue Fairy, David steers his amphibicopter through the Coney Island theme park into the world of Pinocchio. He passes Geppetto's workshop and Monstro's lair until eventually he reaches his prized destination – the Blue Fairy's shrine.

LEFT AND OPPOSITE **Chris Baker's drawings** for the underwater sequence of a submerged New York and theme park.

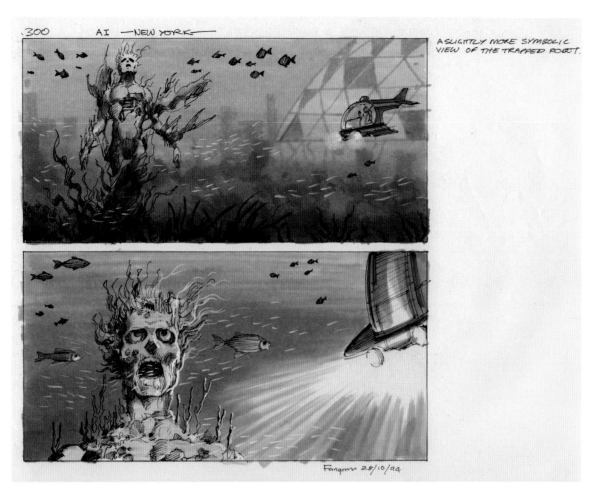

300 AI — NEW YORK

A SLIGHTLY MORE SYMBOLIC VIEW OF THE TRAPPED ROBOT.

Fangorn 28/10/94

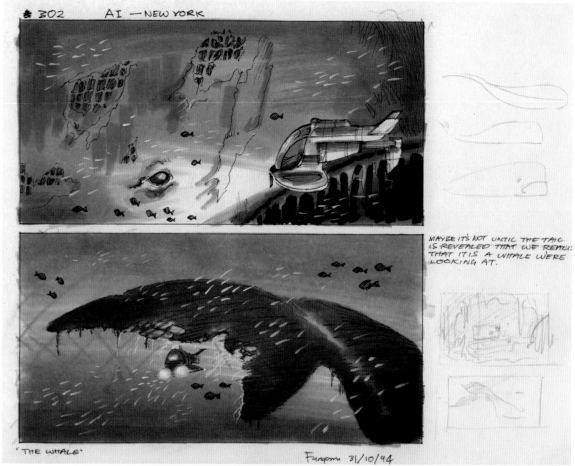

302 AI — NEW YORK

MAYBE IT'S NOT UNTIL THE TAIL IS REVEALED THAT WE REALISE THAT IT IS A WHALE WE'RE LOOKING AT.

"THE WHALE"

Fangorn 31/10/94

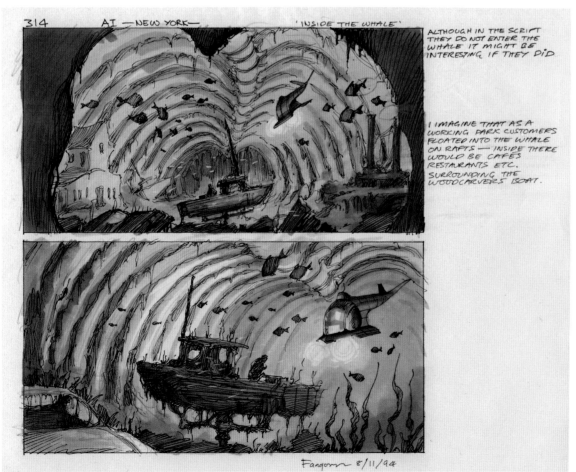

314 AI — NEW YORK 'INSIDE THE WHALE'

ALTHOUGH IN THE SCRIPT THEY DO NOT ENTER THE WHALE IT MIGHT BE INTERESTING IF THEY DID

I IMAGINE THAT AS A WORKING PARK CUSTOMERS FLOATED INTO THE WHALE ON RAFTS — INSIDE THERE WOULD BE CAFES RESTAURANTS ETC. SURROUNDING THE WOODCARVERS BOAT.

Fangorn 8/11/94

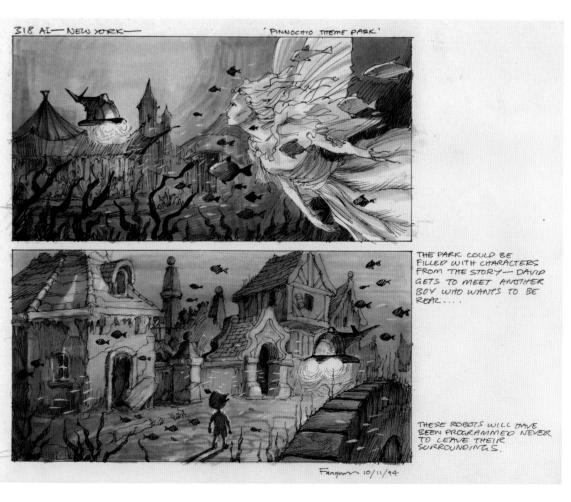

318 AI — NEW YORK 'PINNOCHIO THEME PARK'

THE PARK COULD BE FILLED WITH CHARACTERS FROM THE STORY — DAVID GETS TO MEET ANOTHER BOY WHO WANTS TO BE REAL

THESE ROBOTS WILL HAVE BEEN PROGRAMMED NEVER TO LEAVE THEIR SURROUNDINGS.

Fangorn 10/11/94

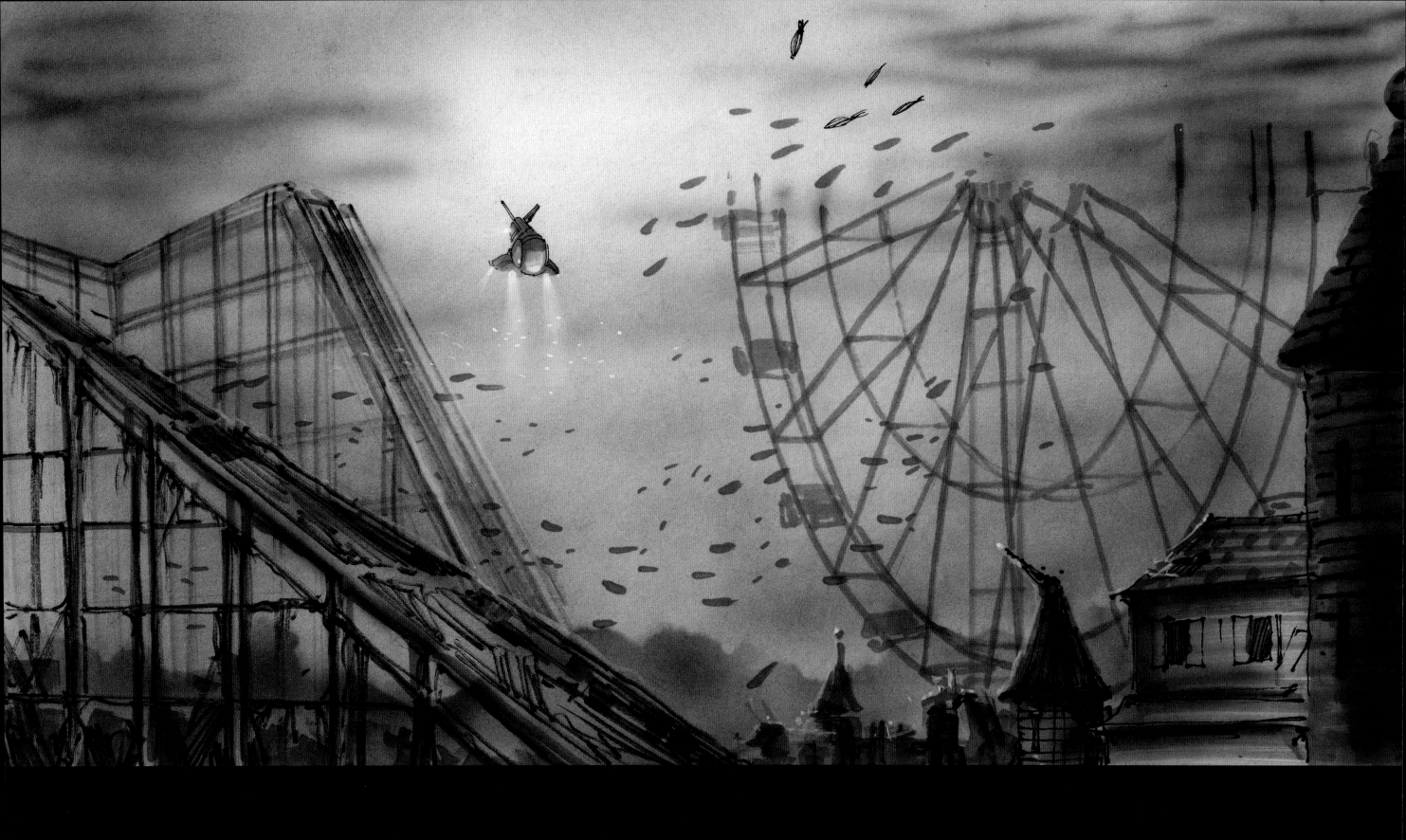

OPPOSITE AND ABOVE **Chris Baker's artwork
and film still** of the amphibicopter's
descent into the depths.

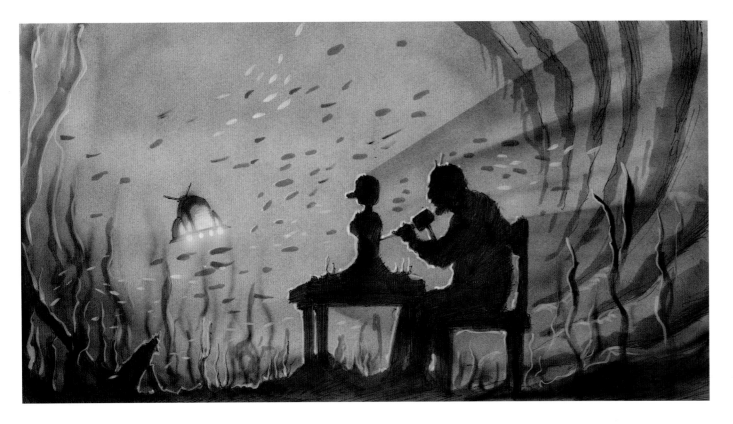

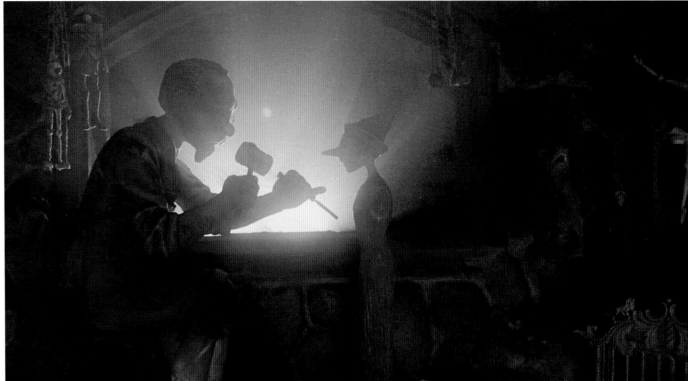

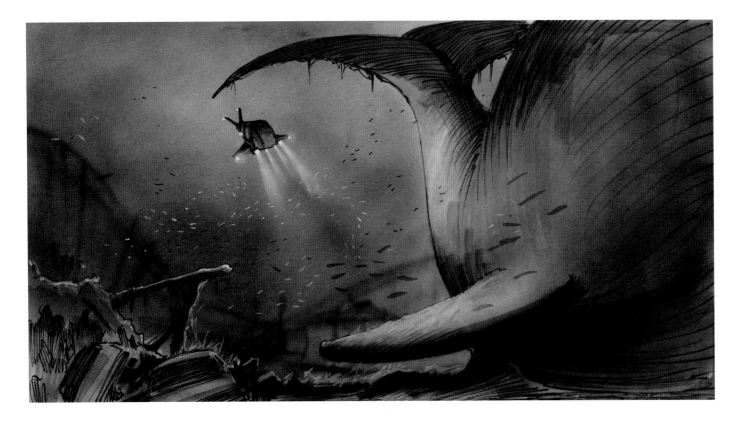

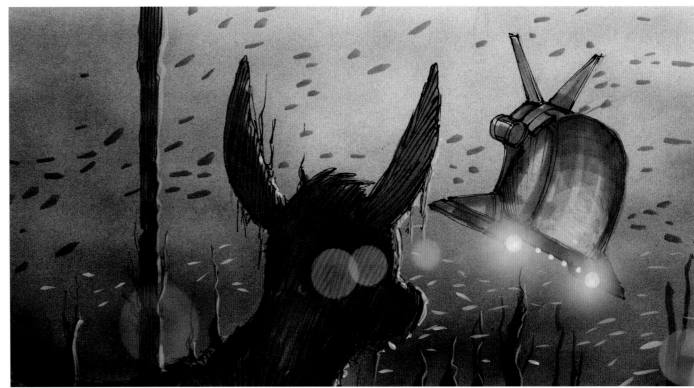

ABOVE AND OPPOSITE **Film still and concept drawings** showing Geppetto's underwater fairy-tale grotto and the amphibicopter's journey through the theme park.

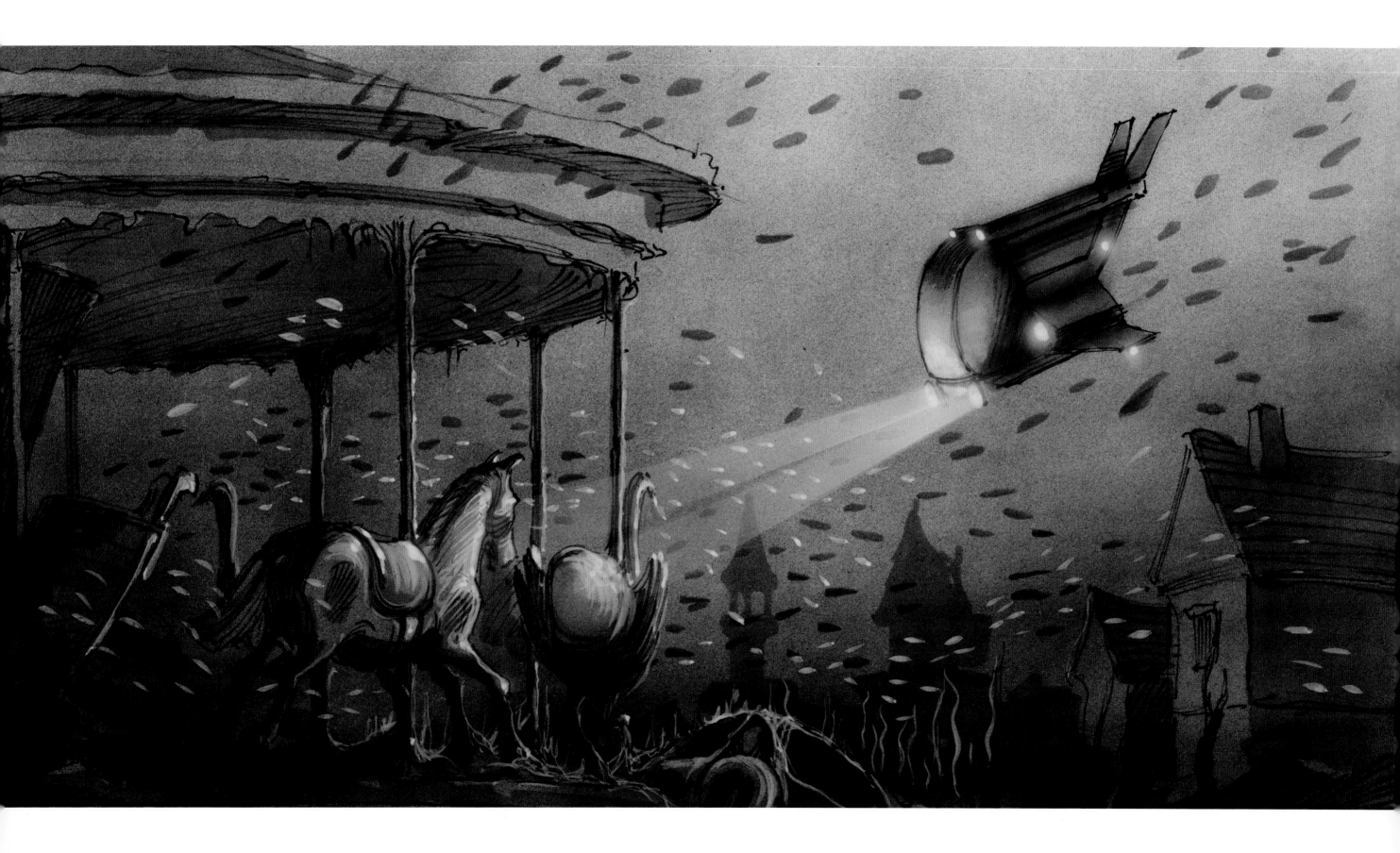

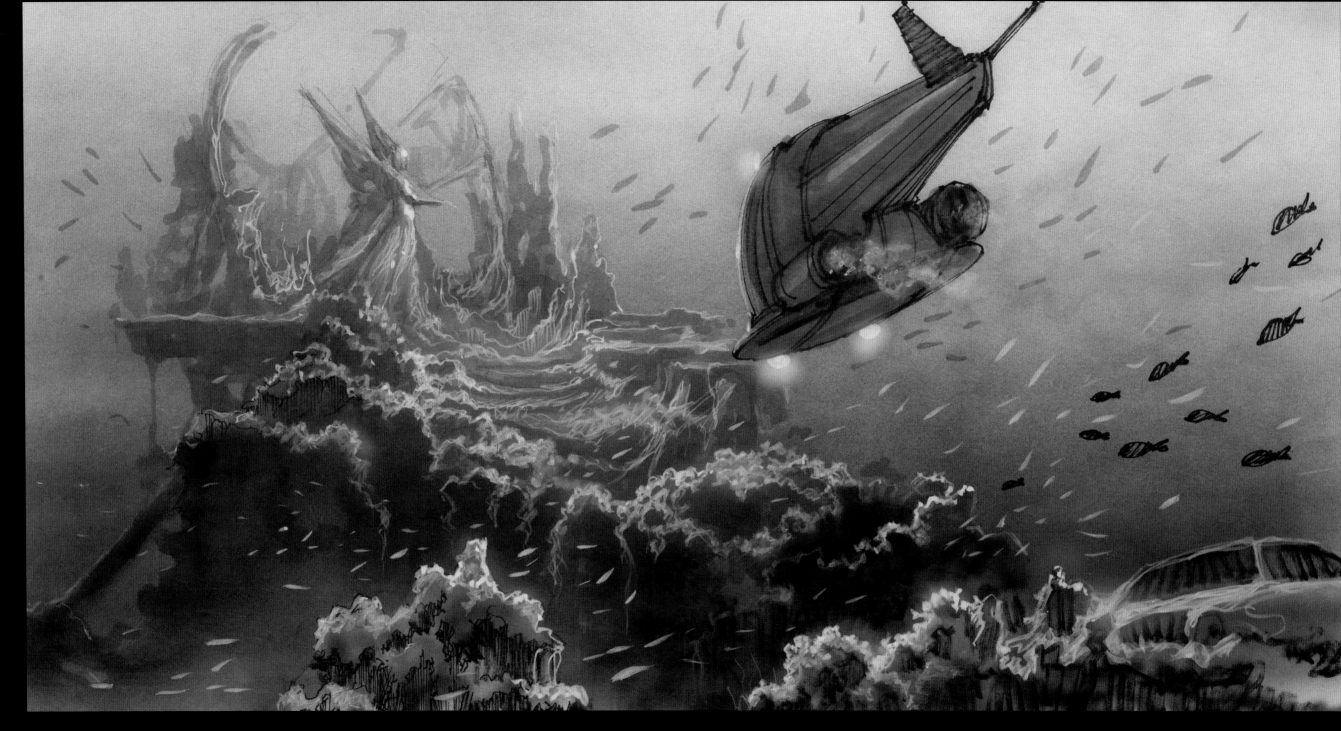

'Ever closer the robot boy nudged the amphibicopter
till its nose floated scant inches away from that figure
who now seemed almost to embrace it.'

IAN WATSON, STORY TREATMENT

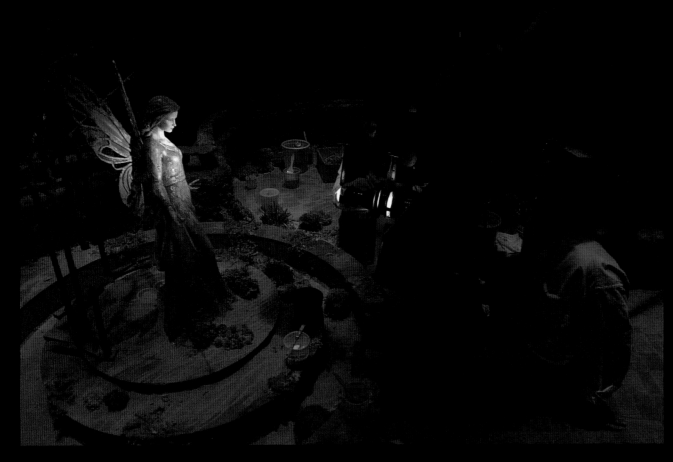

ABOVE **Filming** of the Blue Fairy by visual effects director of
photography Marty Rosenberg at ILM. The Blue Fairy was just
one of the many miniatures built for the underwater sequence
and filmed 'dry for wet', with digital imagery added later.

RIGHT **Further artwork** by Chris Baker, showing the approach
of the amphibicopter.

OPPOSITE **Chris Baker's concept drawing** of his vision for the
Blue Fairy's shrine.

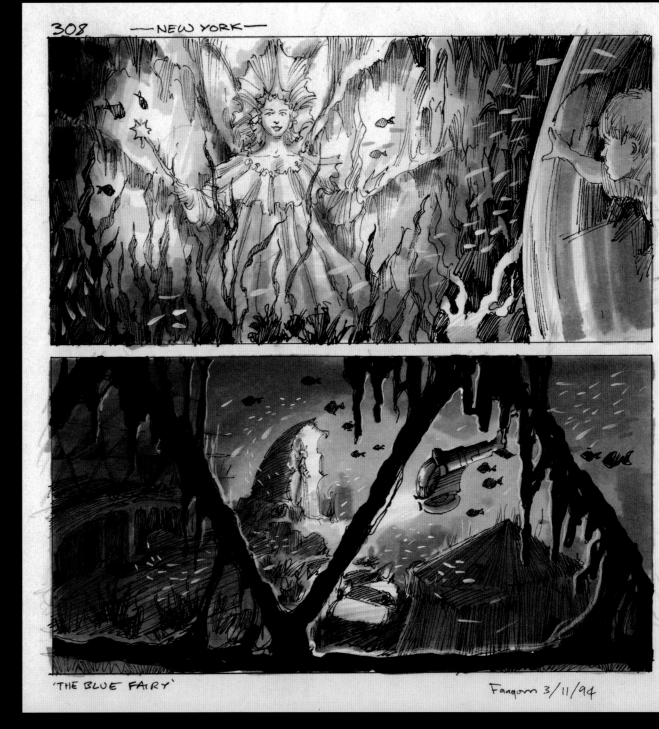

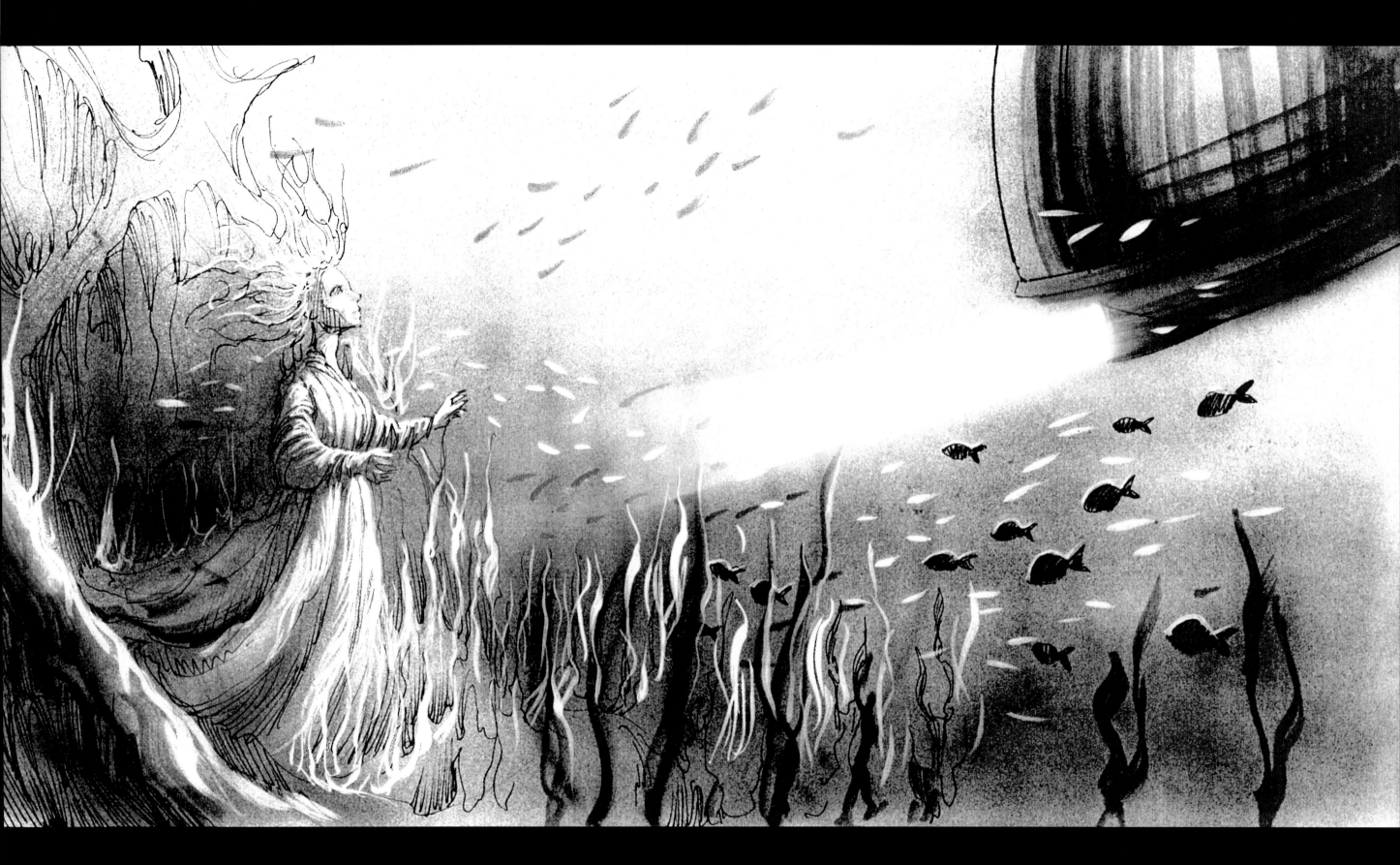

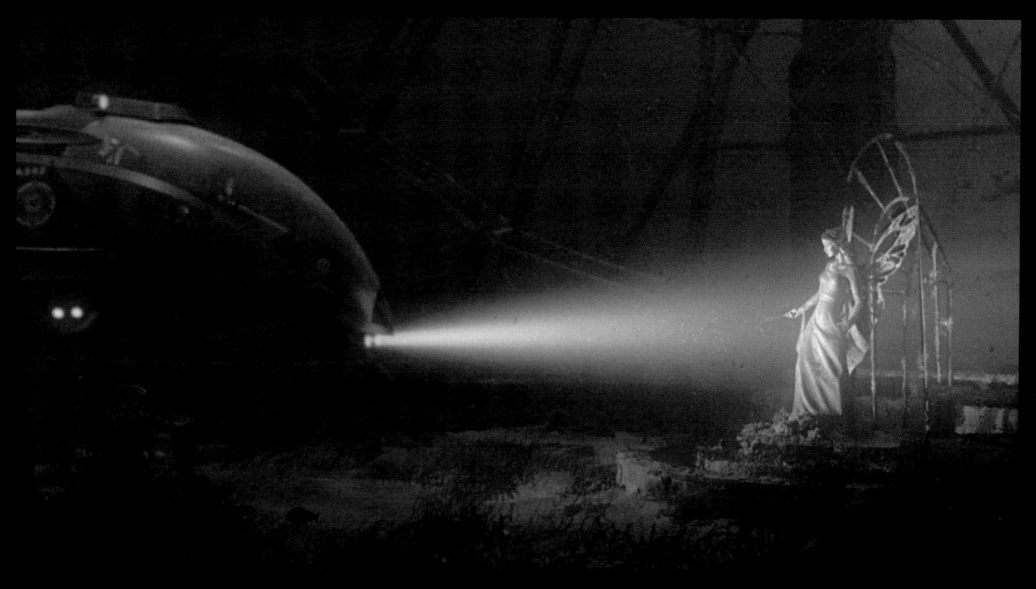

OPPOSITE AND ABOVE **Chris Baker's concept drawing and film still** of David's final resting place.

'WE ARE IN A CAGE'

The amphibicopter rests at the foot of the Blue Fairy, while David stares at her wide-eyed with wonder. During the 'copter's underwater journey, however, it caught a cable supporting the Coney Island Ferris wheel. Suddenly the wheel collapses, crushing the theme park as it falls. David and Teddy are trapped underneath, and there they remain while David continues to pray to the Blue Fairy for two thousand years: 'Please, please, please make me real. Please make me a real boy. Please, Blue Fairy, make me into a real boy.'

BELOW AND OPPOSITE **Chris Baker's artwork and a film still** showing the trapped amphibicopter.

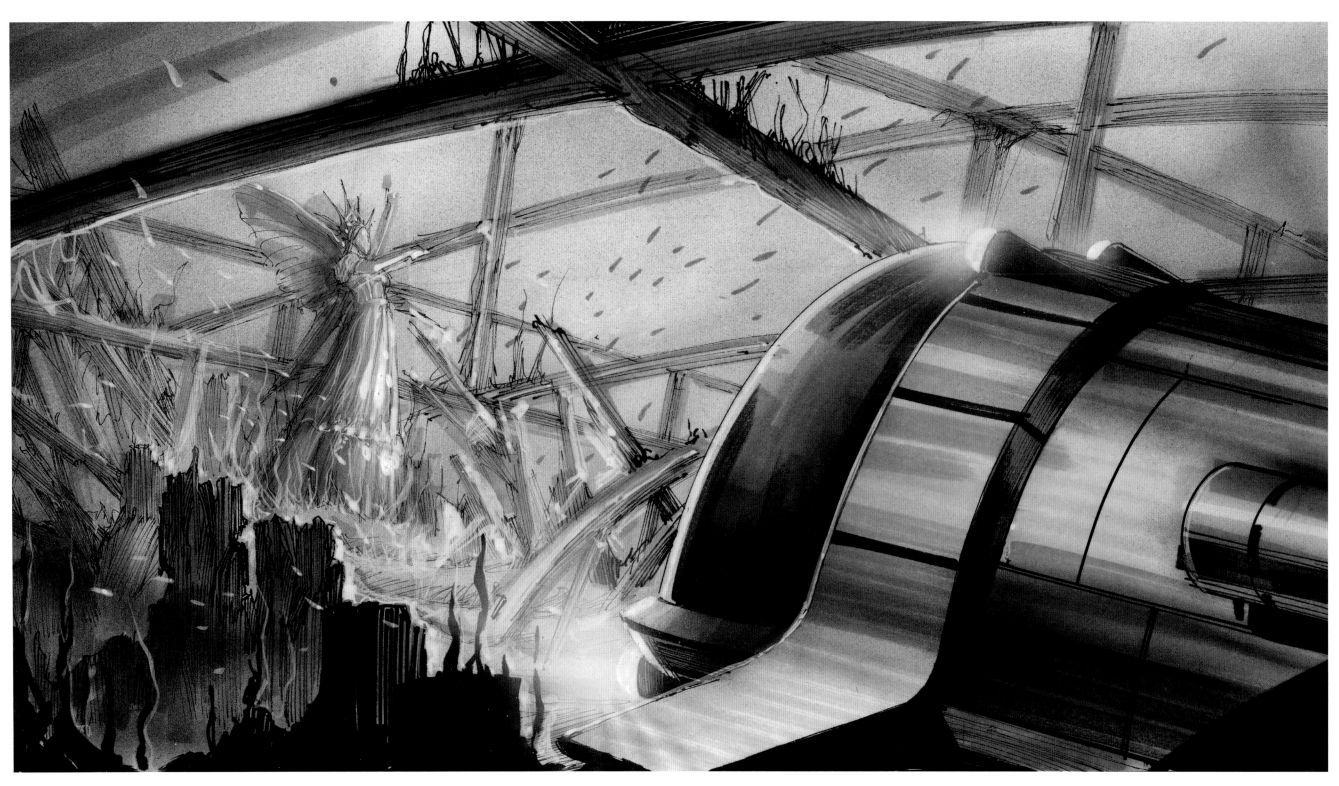

'After his first year, he never moved at all, nor did he speak, yet his eyes remained open forevermore, staring ahead fixedly all through the darkness of each night, awaiting the coming of the next day… And the next day… and the next… Thus two thousand years passed by…'

IAN WATSON, STORY TREATMENT

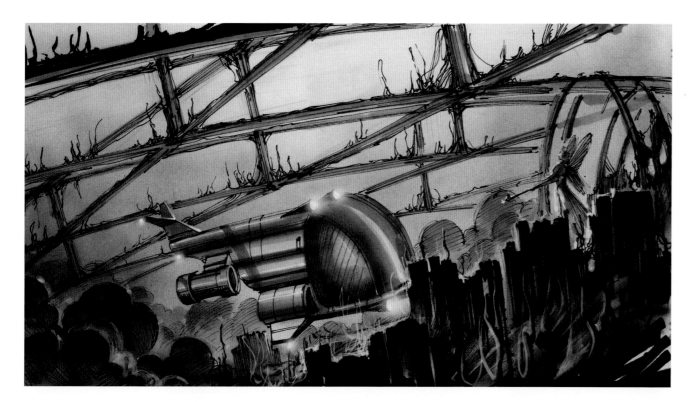
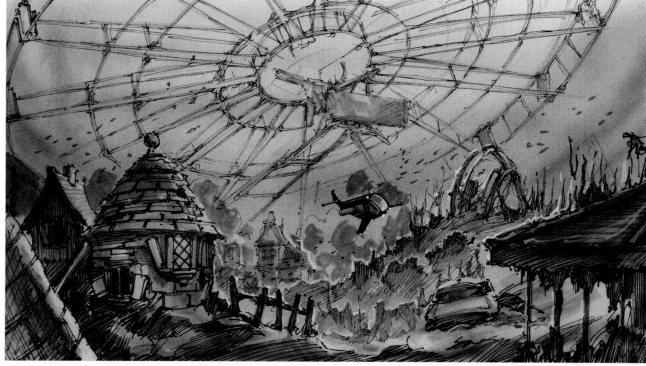
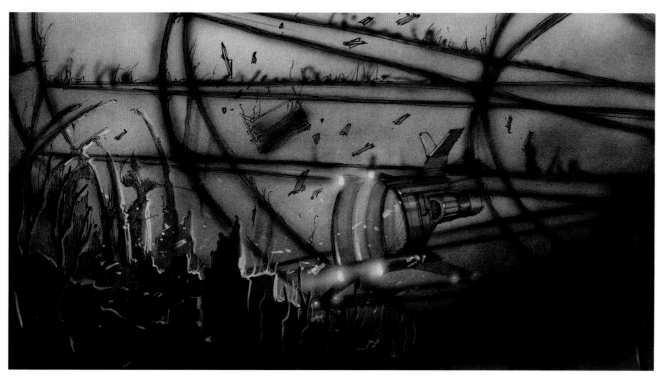

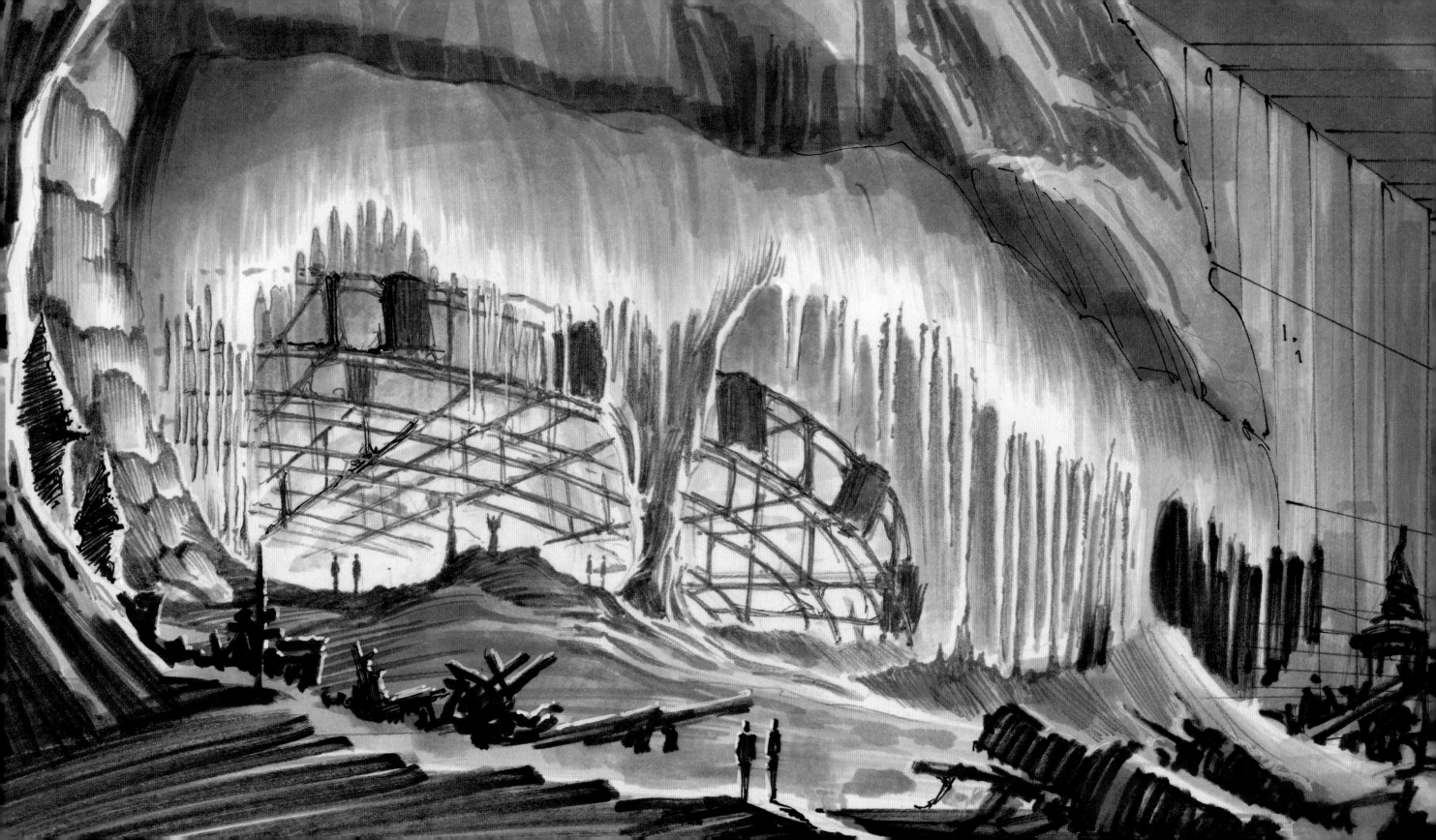

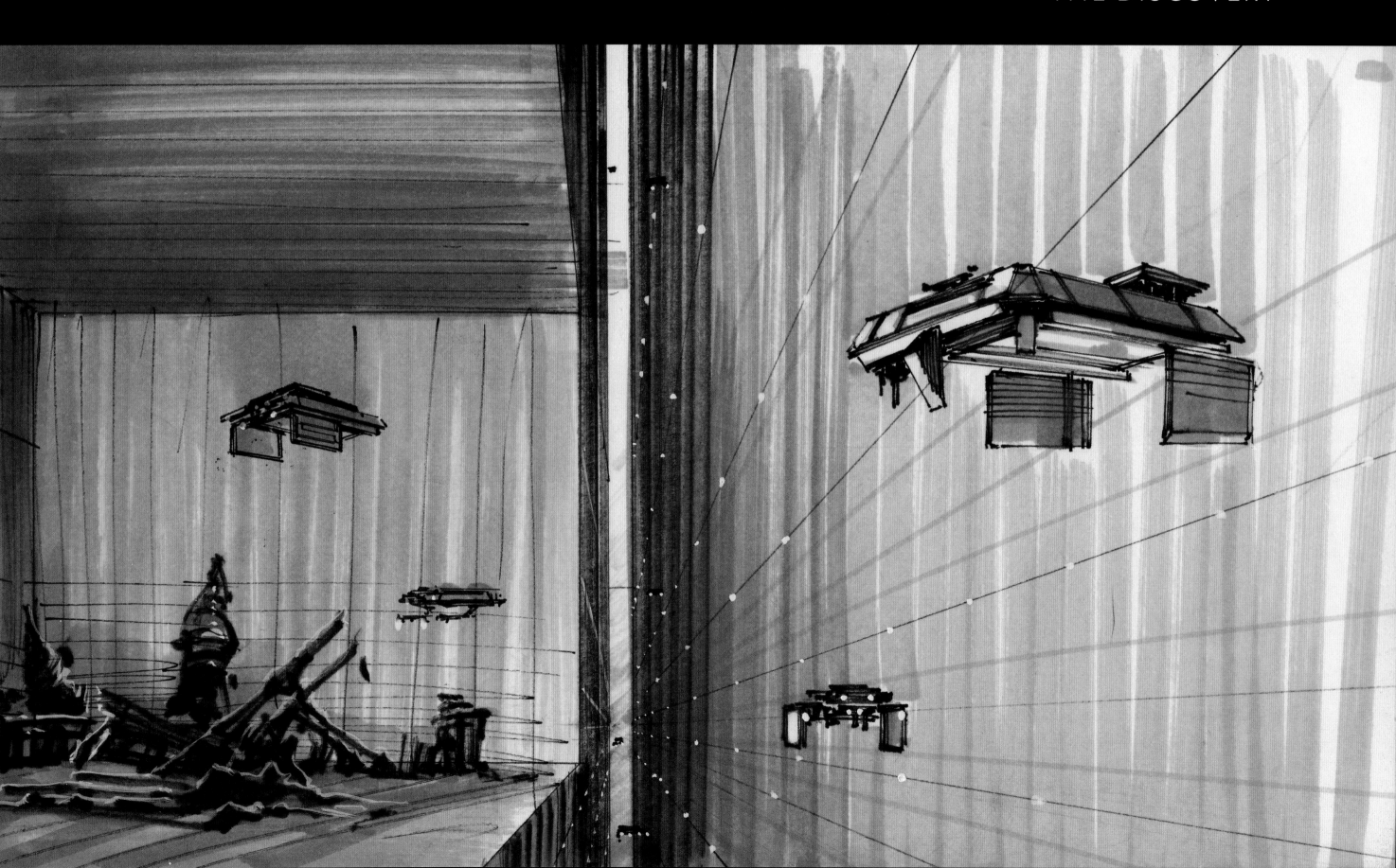

Part 3: The Discovery

In the finale of the film we are presented with the same location as at the end of the second act: the theme park at the bottom of the sea. However, we have jumped two thousand years into the future – or, rather, we have now surfaced into something approaching the story's present time. It is the age of the SuperMechas. These advanced, super-intelligent robots now discover David, trapped in ice. The scene is almost set for his return 'home' to the Swintons' apartment, where he will spend one final, perfect day with his mother.

The conventional three-act structure of most films takes a somewhat unconventional turn in *A.I.*, with the introduction of a fourth act. The lines blur and shift between the 'real' and the fairy tale, and we are taken into a world of dream and magic. This fourth act is an exploration of the subconscious as David's dream becomes externalized. 'David has realized his desire in physical terms – he has found the Blue Fairy – but he hasn't yet achieved what he wanted to in regards to his ultimate goal: his mother's love,' says production designer Rick Carter. 'David is trying to become real via a journey of the heart and essentially of the mind. When David is at the bottom of the ocean, the journey of the heart ends and the story enters the third and fourth acts, where it continues to take the journey of the mind beyond what most of us are capable of conceiving. I believe that Kubrick created a fairy tale of consciousness and the legacy of consciousness through Artificial Intelligence – its invention of its own intelligence, survival instincts and its reason to exist.'

THE ICE EXCAVATION

Out of a white haze, the camera follows a strange cube shape travelling across a frozen world. In the two thousand years that have passed, humankind has become extinct. Its evolutionary legacy is the SuperMechas. In a distinctly human-like search to find meaning behind their existence and their origins, they are excavating New York. The cube, accompanied by a haunting musical score from John Williams, descends into vast chasms and narrow corridors cut into the ice until it rests at the excavation site.

'Ian Watson's original treatment described machinery that excavated huge slabs of ice,' comments artist Chris Baker. 'My early sketches took this idea on board, but the more I thought about it the less practical this idea seemed. It also came across as something that we might build in the twenty-first century as opposed to thousands of years in the future. Our reaction to it should surely be similar to how stone-age man might react to seeing an aeroplane, so design-wise this presented quite a challenge. Here we are two thousand years in the future in a world inhabited by robots. How would technology have progressed during this time? Would it stagnate, or would it have taken a quantum leap forward? Faced with this problem I just decided to streamline everything by removing all discernible moving parts and traditional supporting structures that we are so used to seeing. The idea I proposed is based around nano- and anti-gravity technology. Although this is speculative, there has already been research into both, so who knows where this technology will take us? In this case, the job was to create a technology that works visually, but at the same time we don't actually know how it works. I also wanted to carry over the clean lines of the machinery to the design of the excavation and the cutting into the ice, so that it was simple and geometric.

'Steven liked this building-block idea, too, so this design aesthetic was taken further in the finished film. It was shown to good effect with the appearance of the cube, which flashes into frame in the opening scene of the third act as the camera speeds over a frozen New York. I also produced a series of simple 3D animations, which I sent to ILM to give them an idea of how the nano-/anti-gravity technology might work. As the cube flies through the vast excavation, it passes by a huge ship – not a single object, but a central docking port for all the craft and machinery at the site. In a sense, all of the machinery was a smaller version of the ship, made up of independent parts that come together as one when needed. This is shown in the film when we see the cube simply drift away as the robots arrive at the Ferris wheel.'

Baker's design of the ship is sympathetic to the communication methods of the SuperMechas. These robots act as individuals but can also be one entity, reflecting Isaac Asimov's idea of our descendants integrating their consciousness to share knowledge.

DISCOVERY OF DAVID

'The one image that Stanley always had in mind was that of the collapsed Ferris wheel back-lit in the ice. The lighting was extremely important in this case,' says Chris Baker. 'So my job was to justify this within the concept artwork that I produced with him. Throughout

these drawings there is real emphasis on the lighting on the Ferris wheel, but also on the excavation of the amphibicopter itself.

'The concepts for the ice excavation and references to the future robots, which were described as "leathery" in the original treatment, inspired me to explore further by creating a little back-story, just for my own research, and for developing ideas of the progression of mankind's decline and its own destruction, to the rise of the ultimate intelligent machine.

'The development of the robots created quite a challenge. I basically drew everything for Stanley to consider but, ultimately, he was always drawn to the tall, skinny approach, which appears in the majority of the final drawings. I played around with the robots' texture and their technology, suggesting material that looked more like marble or porcelain. The robots' skin might have been hard to the touch, but because of nanotechnology it would allow flexibility.'

The final design of the SuperMechas was created digitally and developed from Chris Baker's drawings by Stan Winston Studio and ILM. The SuperMechas are manufactured beings, not biological, so each one is identical. The glass-like clarity of their skin allows visibility of the internal circuitry, but also gives the impression that the SuperMechas can blend in to their environment. 'We had seen all of Chris's work for the SuperMechas, and his designs were very clean, refined, elegant and sophisticated,' comments Lindsay Macgowan, effects supervisor at Stan Winston Studio, 'so Aaron Sims at the studio generated designs and digital artwork based on Chris's designs.'

Dennis Muren, visual effects supervisor at ILM, continues: 'ILM generated some ideas for the SuperMechas, but it just wasn't working, and then this really neat 3D artwork rendering arrived from Stan's shop, so that's pretty much what we copied. We added the motion inside the body and the facial expressions.' Depicting the facial features for the SuperMechas' dialogue with David proved to be a challenge. ILM added very subtle expressions in order to show the last remnants of humanity in mankind's descendants. 'We didn't want the head to just be a ball or a teardrop shape. We wanted to portray the sense that at one time it was based on humans, or at least built or grown by humans,' explains Muren. 'Steven suggested that the facial expressions should evoke the same feeling as the alien in *Man From Planet X*. I knew exactly what he meant by that, as we grew up watching the same stuff. The character in that film has a face that is like a mask, but you can tell its emotions and expressions throughout the film. It looks wise, but you can never quite tell what it's thinking. We wanted to create a similar look to the facial expressions of the SuperMechas, not sinister-looking, as they have evolved beyond that, but so that you could tell that they were descended from humanity. So we kept it really simple. We put a glow round the mouth area so it gave a sense that it was speaking, but we didn't create eyes; instead we added a slight brow so it all remained quite abstract. It was a shame they were mistaken for aliens. Maybe there should have been more clues; perhaps they should have been wearing clothes, but that wouldn't have been right as the SuperMechas would have evolved beyond that vanity and conceit. From

conversations that I had with Stanley, he was never one to compromise for the audience, so we kept the designs truthful to what he wanted.'

The SuperMechas' excavation uncovers the amphibicopter, which has been encased in ice during the past two thousand years. The discovery of David is the only piece of evidence that links the future to a time when man walked the earth. David is 'awakened', and is finally able to approach the Blue Fairy. He places his hands on the statue, only for her literally to shatter at his slight touch. His two-thousand-year prayer has been unanswered, and his only hope splinters and falls in front of his very eyes. The SuperMechas download David's memories to learn about their new discovery, their ancestor and their origins.

THE SWINTONS' APARTMENT
Ian Watson writes: 'The excavators cut an obstructing girder apart, and at last they opened the creaking gull-wing door. When one of the black robots carried David out of the tunnel, the sunshine reflecting from the endless ice sheet dazzled the boy.... David scanned the bright, dead, white horizon....' Watson then began a new text section with David back in the Swintons' apartment: 'Teddy, we're home!' Stanley Kubrick discussed this with Chris Baker, and – to extend the magic of the fairy-tale ending by avoiding expository scenes – Baker suggested a dissolve shot (see p. 142). Steven Spielberg took this further in combining the literalness described in Watson's treatment with Kubrick's desire to retain the ambiguity of the 'dream' sequence. The resulting shot is a bright white-out – referencing

Watson's dazzling ice sheet – filling the entire frame, with a close-up of David opening his bright blue eyes (see p. 143). The camera then pulls back to reveal David sitting in the Swintons' kitchen.

David has returned home, where, finally, he has the chance to experience what it is like to be a real boy. The SuperMechas have recreated a simulation of the apartment in order to observe their discovery. 'To his astonished delight, the Blue Fairy herself waited in the lounge, an aura of light surrounding her,' wrote Watson. 'Before he could rush toward her, though, the lady raised a cautionary hand. "Don't be too sad," she entreated him. "We'll cherish you. You're precious to us, David."' The SuperMechas have created an artificial simulation of the Blue Fairy (voiced by Meryl Streep) to act as a familiar guide figure: the figure for whom David has been searching for more than two millennia. As she is generated from David's memories, her image is a composite of the Blue Fairy in the storybook *Pinocchio*, the hologram at Dr Know's and the statue at the bottom of the ocean. She acts as a portal through which the SuperMechas can inform David that two thousand years have passed and that, in order to bring back his mother, they will need her DNA. Equally, the Blue Fairy is the medium through which David can communicate his own desire and ultimate wish to the future robots.

The SuperMechas encircle a suspended disc in which they observe their simulation, reminiscent of the gods watching events unfold in *Jason and the Argonauts* (1963). Once Teddy hands over the lock of Monica's hair that he has kept all these years, the future robots decide to give David what he wants. A SuperMecha, known

in Spielberg's screenplay as The Specialist (voiced by Ben Kingsley), explains to David that it is not yet possible to resurrect anyone for more than one day, and that Monica's return will therefore be temporary. 'Maybe ... maybe she'll be special,' says David. 'Maybe she'll stay.... Maybe the one day will be like the one day in the amphibicopter. Maybe it will last forever.' The Specialist, realizing that David is adamant, gives him his one true desire.

A simulated new day dawns, and David discovers Monica in bed, asleep. He makes her a cup of coffee. As Ian Watson writes: 'He was proud of doing it.' In the day that follows, and in a reversal of previous events, David and Teddy are now the only real things in the Swintons' apartment. Henry and Martin are excluded; Martin's birthday party, which led to David's abandonment, becomes David's own birthday party; the game of hide-and-seek that went disastrously wrong is now full of laughter and enjoyment; David paints all the characters he met on his journey, which of course have no meaning to Monica. It is a perfect day for just mother and son. 'In fairy tales, unlike myths, victory is not over others, but only over oneself....'[1] At the end of this day and future fairy tale, David receives his ultimate wish: his mother tells him she loves him. After David has heard these long-awaited words, the narrator tells us that he goes to the place where dreams are born.

The ending encompasses Kubrick's desire to combine an exploration of immortality through Artificial Intelligence and DNA with a future fairy tale of magic and enchantment represented through dream, imagination and memory. The ending also has the ambiguity associated with Kubrick's films: not all is as it seems.

David's journey is purposeful and successful, yet in actuality it is futile. The ending is as much an illusion as David's delusion of his own mother. His desire for affection and love has failed to be reciprocated, other than in his dreams, and instead his odyssey has exposed him to mankind's cruelty, greed, exploitation and depravity. One cannot fail to notice that humankind has become extinct.

The fairy-tale narration ends in the simulation, but the film ends with the camera pulling back to reveal the apartment in a black void. David's perfect moment remains captured in its own time – for outside of this simulation, it is impossible for David to become a real boy. Mommy is dead and he is alone, forever trapped in an icy world where the SuperMechas are still unable to resurrect humans for more than a day. As with Bowman's captivity in the bedroom at the end of *2001: A Space Odyssey*, the simulation has the 'timelessness of a dream'.[2]

David's construction of Monica, resurrected by the SuperMechas, is how he was programmed to see her emotionally, with 'a love that will never end'. He is a robot 'caught in a freeze-frame' of unwavering devotion and love; a robot who will continue to 'chase down his dreams'. His desire and self-delusion are no different from the love and loss that drove Professor Hobby to 'resurrect' his own dead son, or the love and loss of Martin that drove Monica to use David as an artificial son-substitute.

Both David and Monica are now artificial creations on which a loved one has projected their imagined image, their perception, rather than acknowledging the reality. In *2001*, the 'characteristic of the "magical" aspect of the film is that the human properties built

into [the super-computer] HAL have had a "curse" laid on them'.³ David is ultimately a tragic figure, doomed from the outset – like Professor Hobby and Monica – to want what he cannot have. In his case, his curse is having been programmed with a very human trait of pursuing a false wish and desire, driven by the emotion to love.

He is the last evidence of humanity, but, although he represents a link to mankind's descendants, his very existence and transcendence via dream and imagination represent the beginning of humankind's eventual evolution, its immortality, and its transfiguration into a higher life form – the SuperMechas.

Ian Watson conjectures that humans created numerous explanations for the meaning of life through poetry, philosophy, art and mathematical formulae. This creative spark existed in humans because of their mortality, which opened up a world of spirit and dream – the source of all inspiration – that only those who were mortal possessed. As the sagacious Gigolo Joe ('Hey, Joe, whaddaya know?') comments: 'Only Orga believe what cannot be seen or measured. It is that oddness that separates our species.'

What, then, was the meaning behind the SuperMechas' existence if they were robbed of the world that created the genius in humanity? 'Is the knowledge of our mortality the only thing that gives "meaning" to life, that without that it has the meaning a stone feels[?]' questioned Kubrick. Humankind has wrestled with questions about the meaning of existence and the knowledge of mortality for thousands of years. It is this questioning that allows us continually to rediscover the miracle of being. In their desire to resurrect humans, the SuperMechas are searching for the answers to the very same philosophical questions that eluded humankind. However, in the same way that David does not understand why the pursuit of his dream 'to be real' is impossible, so the SuperMechas will never know why it is impossible for them to understand the human desire to find explanations for the meaning of life. If the knowledge of our mortality gives 'meaning' to life, then the SuperMechas' search is an act of futility due to their immortality. They also desire what they cannot have: they are as cursed with their 'inherited' human properties and desires as David is with his.

We are not told when, in our future, David has been created, or indeed how long his entire journey has taken him. We have no knowledge of this future world outside of David's own experience. The film has a sense of timelessness, which is furthered by the use of mode jerks that insulate us against a 'realism' of passing time. A.I. the film is, of course, itself an artificial creation. It is a fairy tale of the future illustrating the past – and, as Monica says, 'stories aren't real'. It is not until the end of the film that we learn the identity of the narrator: he is the 'human' voice of the SuperMechas (in Ian Watson's story treatment as well as in the final film, his is an omniscient voice other than at the end, when the narration switches to the first person). When The Specialist tells David that 'human beings must be the key to the meaning of existence', and describes the SuperMechas' resurrection project, we remember Gigolo Joe's long-ago words to David: 'The ones who created us are always looking for the ones that created them.' The Specialist's narration then becomes the telling of a creation myth – the recounting of the SuperMechas' evolution.

Like humankind (including the filmmakers), the SuperMechas have created their own story about a world of spirit and dream; a reflection of their own search to find meaning behind their existence; a story that, in the course of endless time, will be passed to others of their kind. Perhaps the story is being played out in the minds of our 'ethereal grandchildren' in one of Hans Moravec's simulations, which will create whole scenes from our history and individual lifetimes in faithful renditions, artistic variations, or as works of fiction.⁴

Stanley Kubrick's and Steven Spielberg's *A.I. Artificial Intelligence* is a film that contains numerous themes and levels of interpretation: a future tale, but more importantly a story about humankind. For underneath the fairy-tale-like veneer lies a bleak, cold and dark tale of the human condition; a tale of humankind's vanity, irrationality, intolerance, greed and self-delusion. When humankind has gone, no doubt by means of its own self-destruction, the only hope is that Intelligence will survive and surpass humankind, not by the presence of an advanced extraterrestrial Intelligence as in *2001: A Space Odyssey*, but by an Intelligence of humankind's own creation. 'Pure spirit,' comments Kubrick, 'may be the ultimate form that intelligence would seek.' *A.I.* uses the subject of Artificial Intelligence as a vehicle and a mirror with which to raise questions about the human predicament, and to explore the very essence of our own existence.

JANE M. STRUTHERS

THE ICE EXCAVATION

Two thousand years have passed and humans have become extinct.
During this period, mankind's 'children' have continued to evolve
into the ultimate, intelligent, self-sustaining machine. These robots
excavate the ice to find traces of a lost age and civilization.

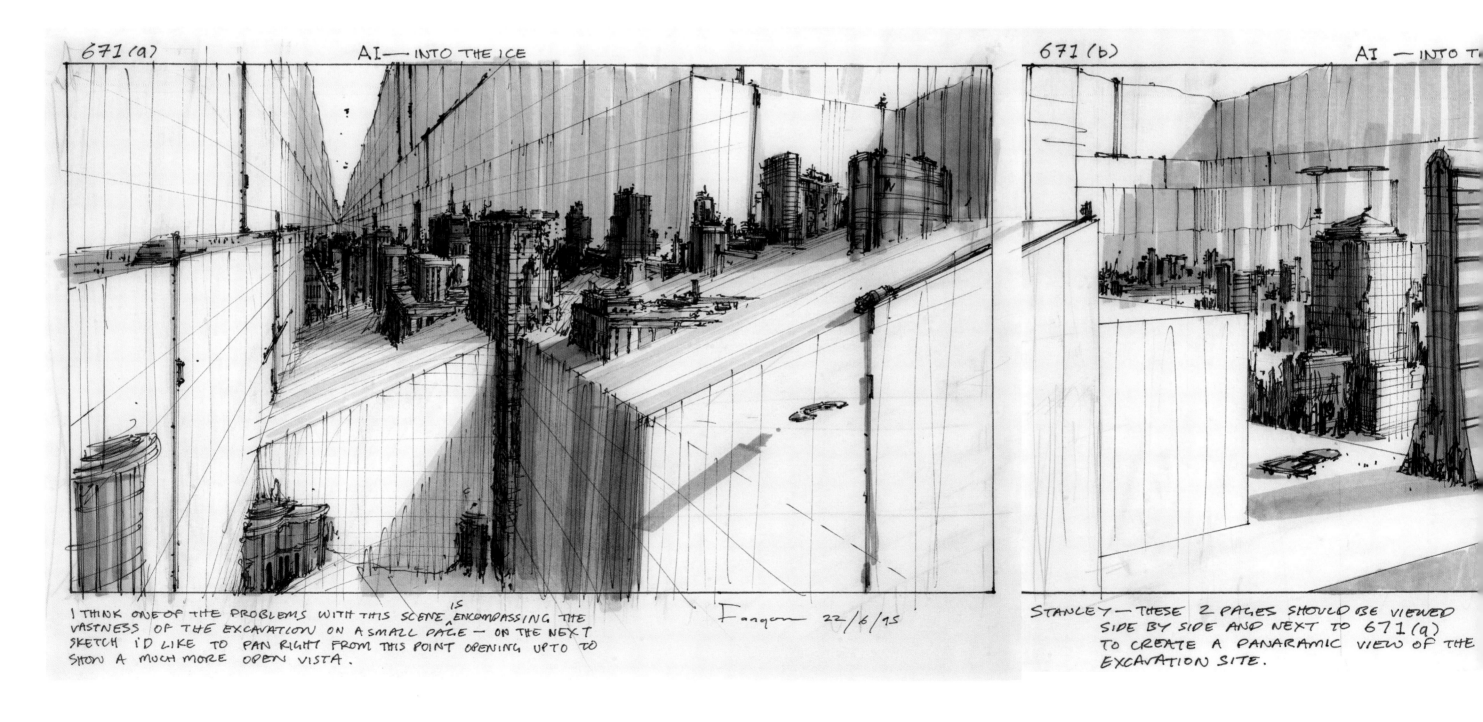

671 (a) AI — INTO THE ICE

671 (b) AI — INTO T

I THINK ONE OF THE PROBLEMS WITH THIS SCENE IS ENCOMPASSING THE
VASTNESS OF THE EXCAVATION ON A SMALL PAGE — ON THE NEXT
SKETCH I'D LIKE TO PAN RIGHT FROM THIS POINT OPENING UP TO TO
SHOW A MUCH MORE OPEN VISTA.

Fangorn 22/6/95

STANLEY — THESE 2 PAGES SHOULD BE VIEWED
SIDE BY SIDE AND NEXT TO 671 (a)
TO CREATE A PANARAMIC VIEW OF THE
EXCAVATION SITE.

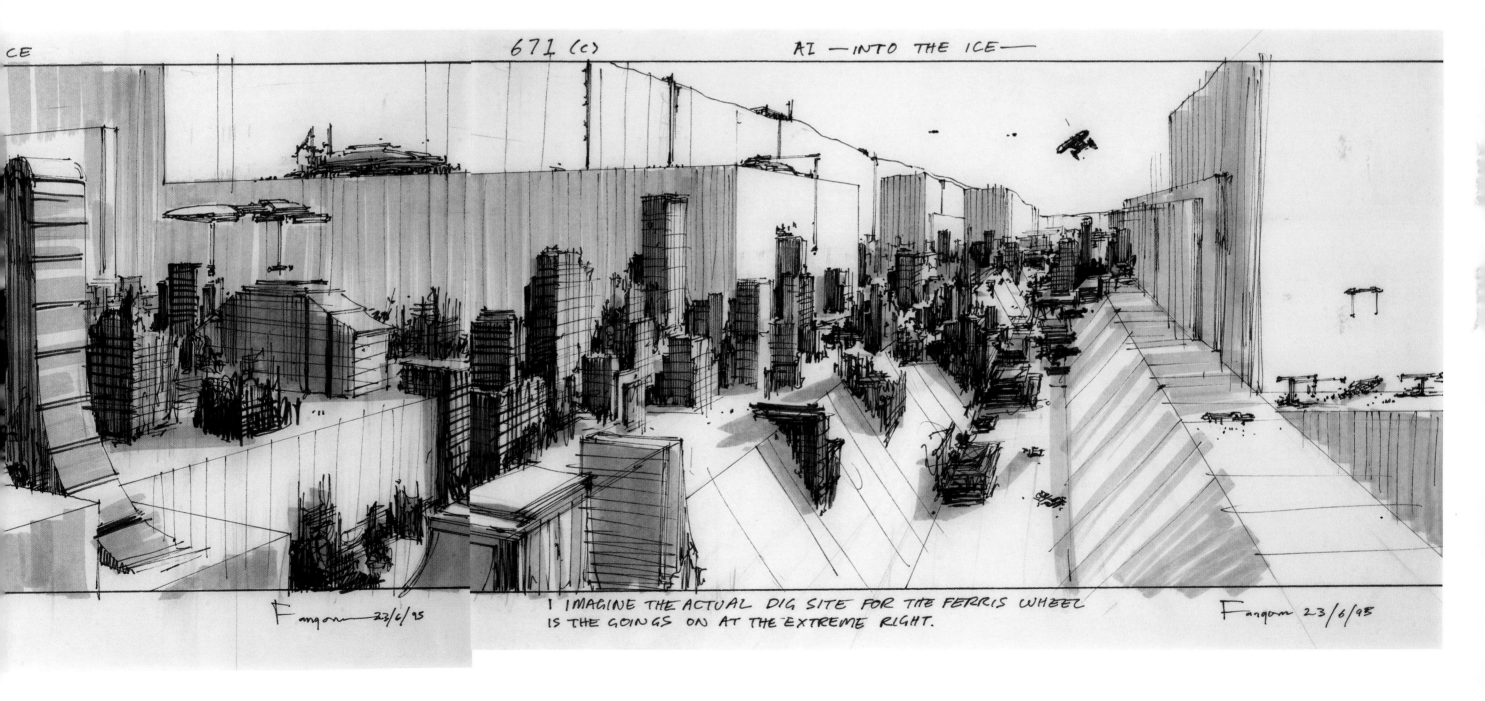

671 (c)

AI —INTO THE ICE—

Fangorn 23/6/95

I IMAGINE THE ACTUAL DIG SITE FOR THE FERRIS WHEEL
IS THE GOINGS ON AT THE EXTREME RIGHT.

Fangorn 23/6/95

> 'As the dig moves closer to the Ferris wheel, much more sensitive machines are brought in to sculpt away the ice.'
>
> CHRIS BAKER, CONCEPTUAL ARTIST

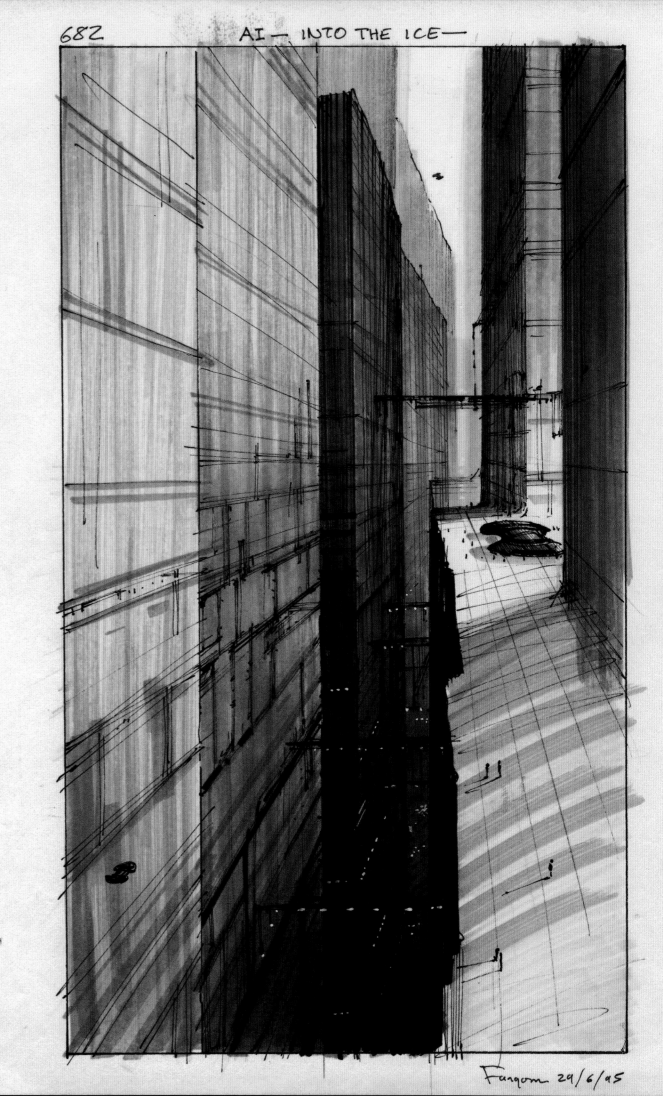

682 AI — INTO THE ICE —

Fangorn 29/6/95

ABOVE **Film stills** showing the cube made of separate parts, and the camera following its journey as it travels through narrow corridors until it comes to rest at the site of the frozen and encased amphibicopter.

OPPOSITE AND RIGHT **Chris Baker's drawings** of the carved-out trench that holds the SuperMechas' unique discovery.

OVERLEAF **Chris Baker's panorama** of the dig, including a switch in the 'point of view' of the excavation site.

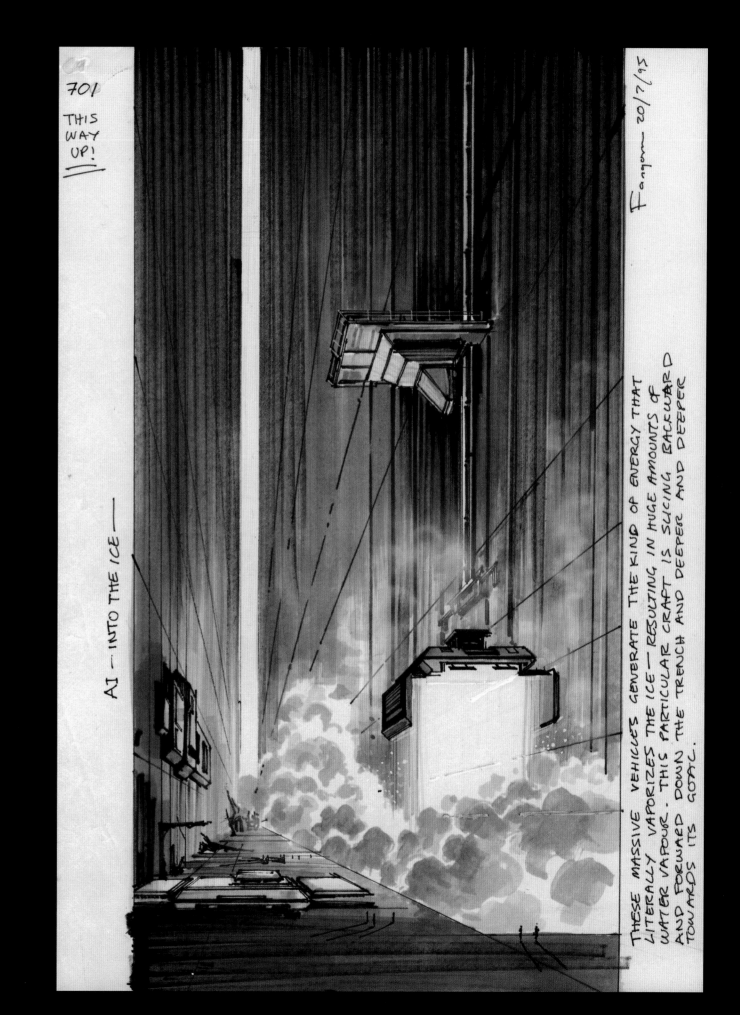

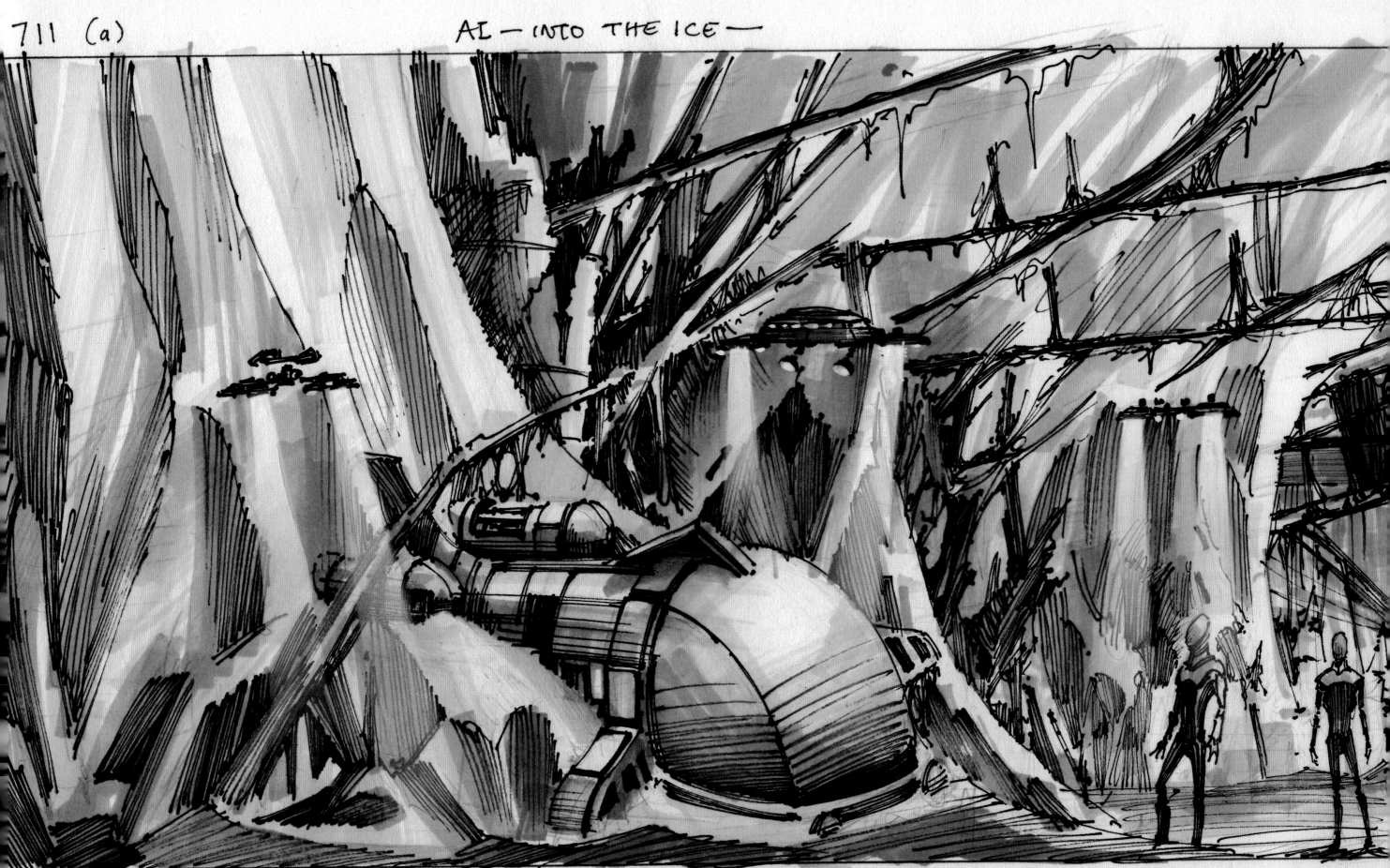

I'VE TWISTED THINGS AROUND WITH THIS SHOT — THE 'SHELF' IS
AT THE <u>END</u> OF THE TRENCH. THIS ALLOWS US TO HAVE A
DRAMATIC BACKDROP LOOKING DOWN THE LENGTH OF THE
TRENCH.

Farguson 2/8/95

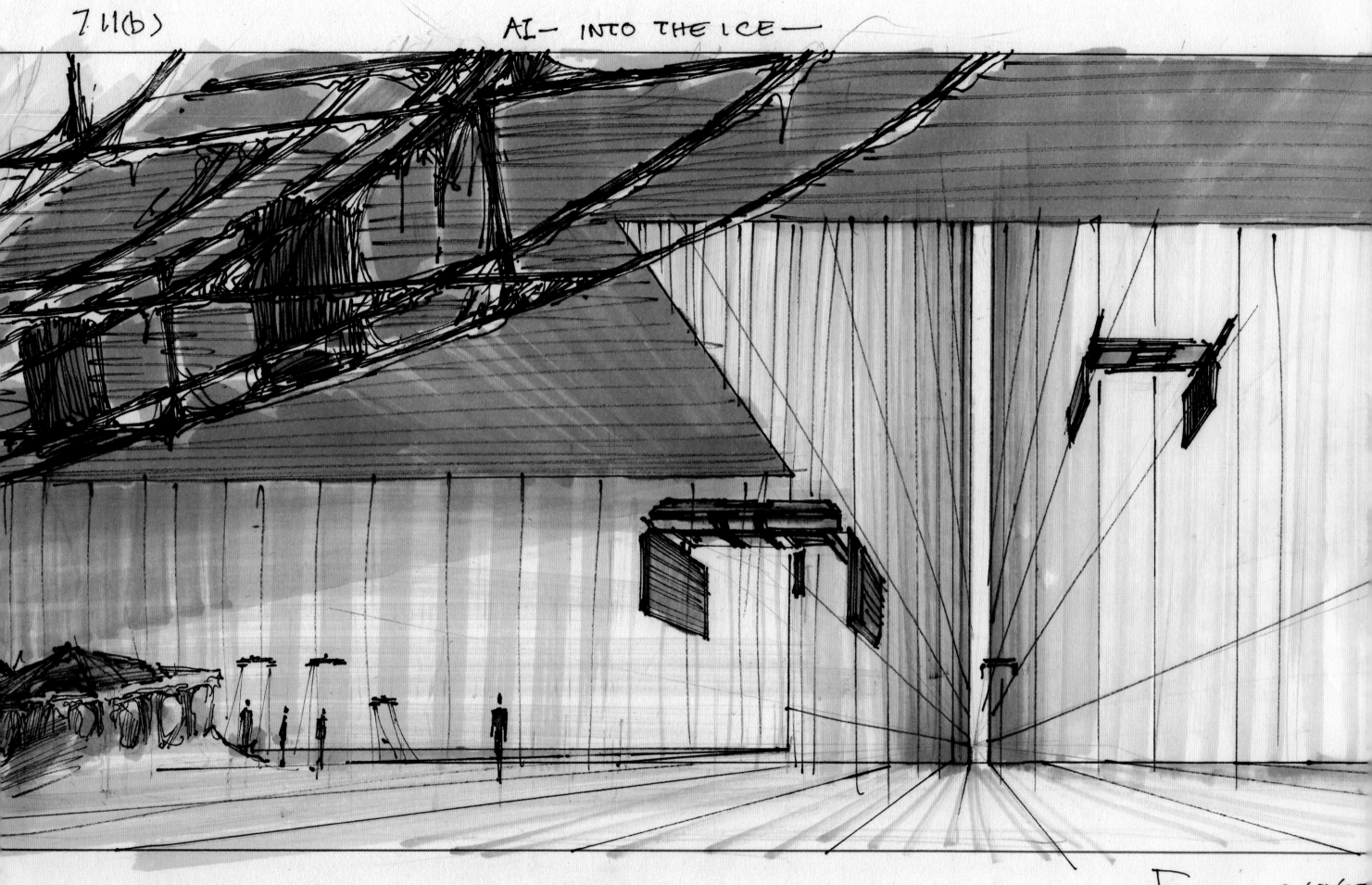

Fangom 2/8/95

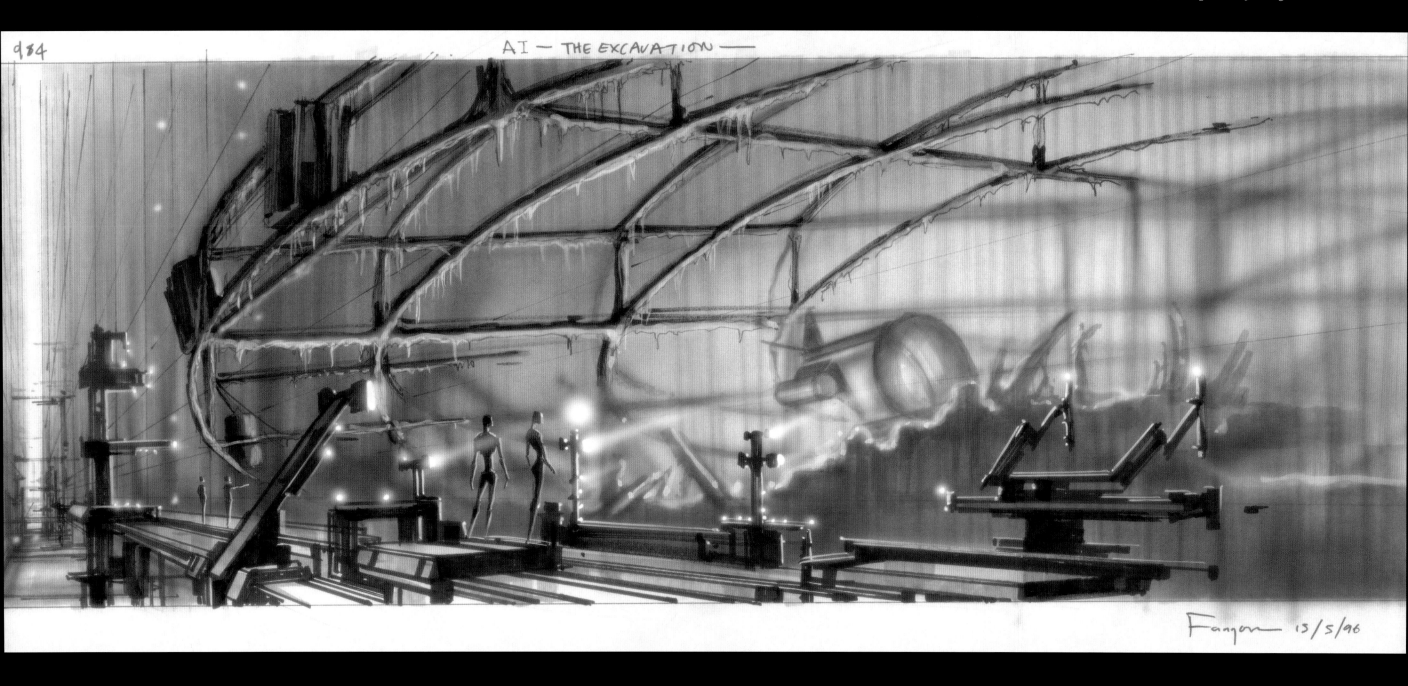

984

AI — THE EXCAVATION —

Fanon 13/5/96

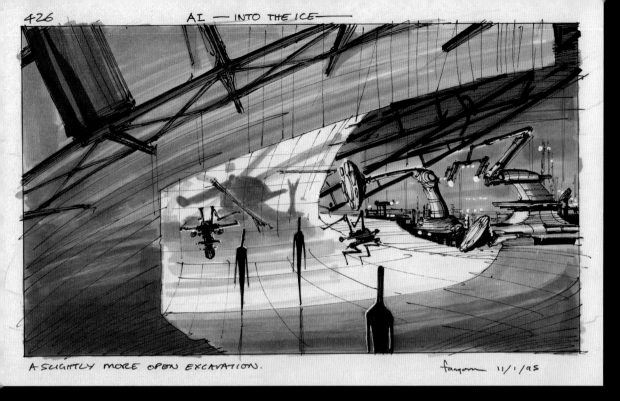

426 AI —INTO THE ICE—

A SLIGHTLY MORE OPEN EXCAVATION.

Fangorn 11/1/95

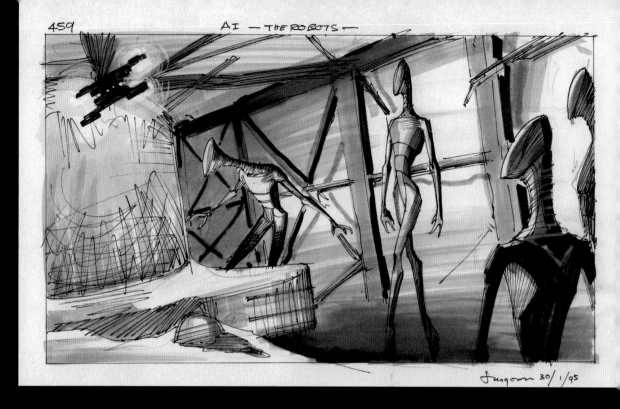

459 AI —THE ROBOTS—

Fangorn 30/1/95

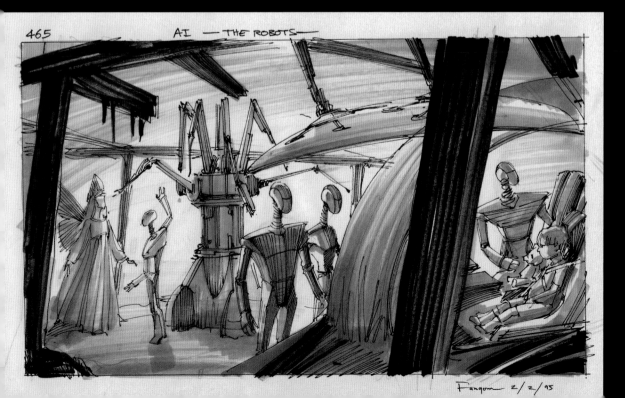

465 AI —THE ROBOTS—

Fangorn 2/2/95

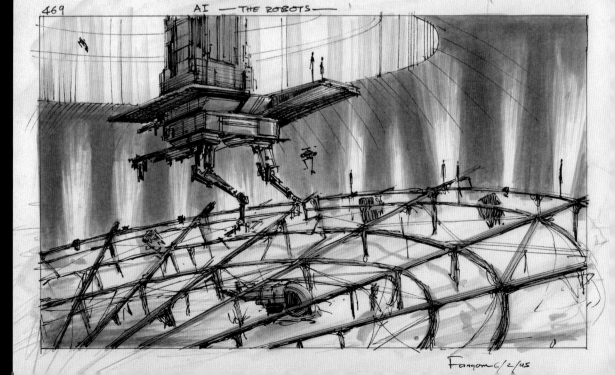

469 AI —THE ROBOTS—

Fangorn 6/2/95

'Pure spirit may be the ultimate form that intelligence would seek.'

STANLEY KUBRICK, 'IN 2001, WILL LOVE BE A SEVEN-LETTER WORD?', *NEW YORK TIMES*, 1968

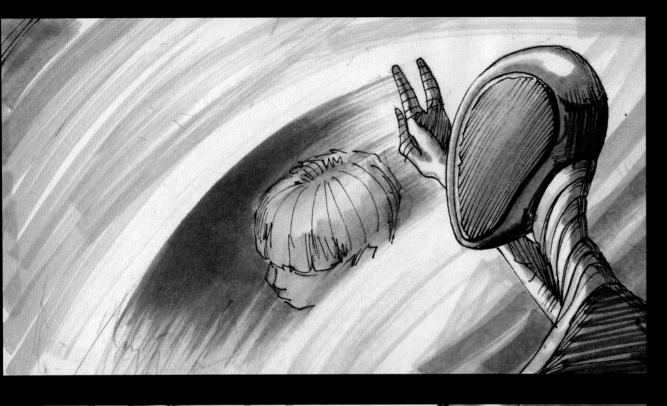

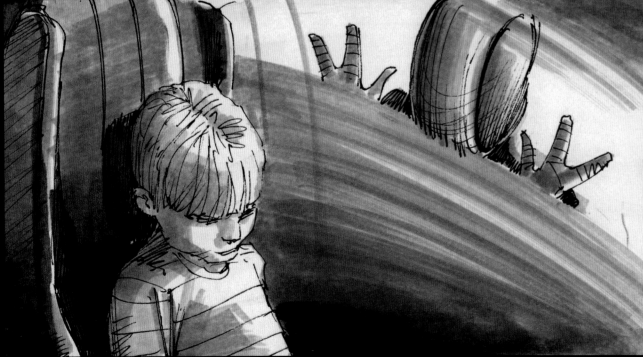

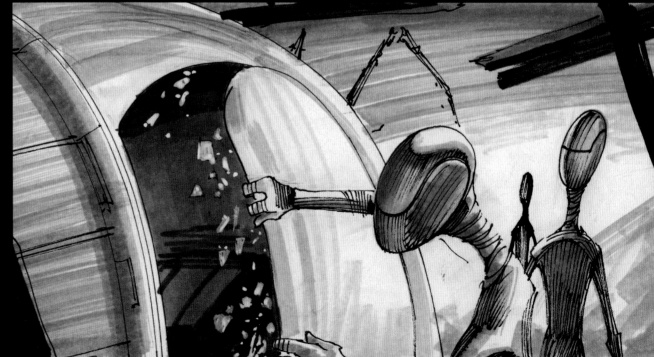

THIS PAGE AND OPPOSITE **Concept drawings by Chris Baker and film stills** showing the SuperMechas discovering David and Teddy.

'What a wonderful discovery. A witness of the Old World! Why, it's almost akin to resurrection.'

IAN WATSON, STORY TREATMENT

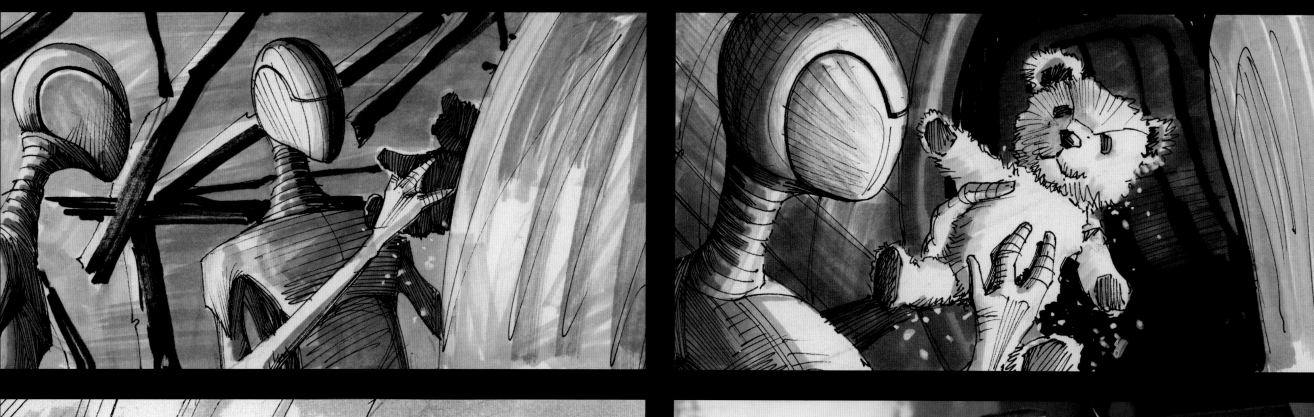

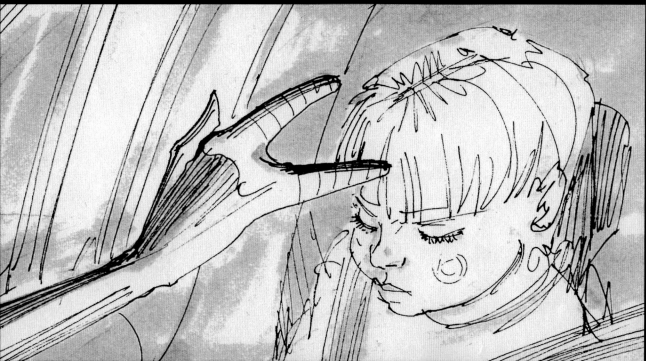

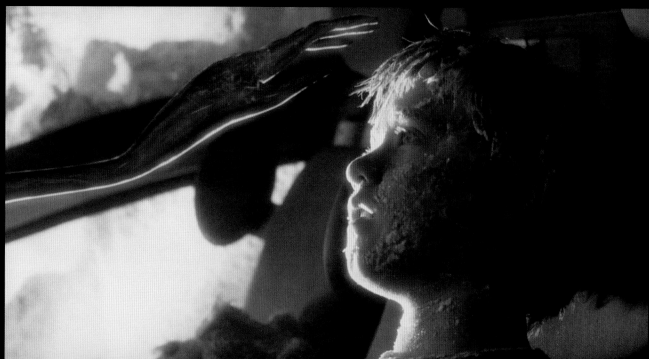

THE SUPERMECHAS

The SuperMechas, evolved from humans' artificial creations, have developed an advanced form of physicality and intelligence. However, driven by their 'human' desire to find meaning behind their existence, they search the lost and frozen world of their ancestors.

'It was great to see all of Chris's ideas that he had developed for the robots, in particular those with gem- and coral-type shapes on their faces, as you really saw his ideas in their purest form.'

LINDSAY MACGOWAN, EFFECTS SUPERVISOR

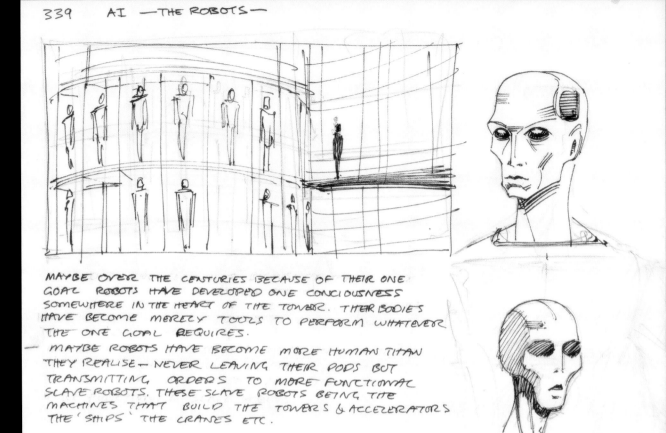

339 AI —THE ROBOTS—

MAYBE OVER THE CENTURIES BECAUSE OF THEIR ONE GOAL ROBOTS HAVE DEVELOPED ONE CONCIOUSNESS SOMEWHERE IN THE HEART OF THE TOWER. THEIR BODIES HAVE BECOME MERELY TOOLS TO PERFORM WHATEVER THE ONE GOAL REQUIRES.
— MAYBE ROBOTS HAVE BECOME MORE HUMAN THAN THEY REALISE — NEVER LEAVING THEIR PODS BUT TRANSMITTING ORDERS TO MORE FUNCTIONAL SLAVE ROBOTS. THESE SLAVE ROBOTS BEING THE MACHINES THAT BUILD THE TOWERS & ACCELERATORS THE 'SHIPS' THE CRANES ETC.

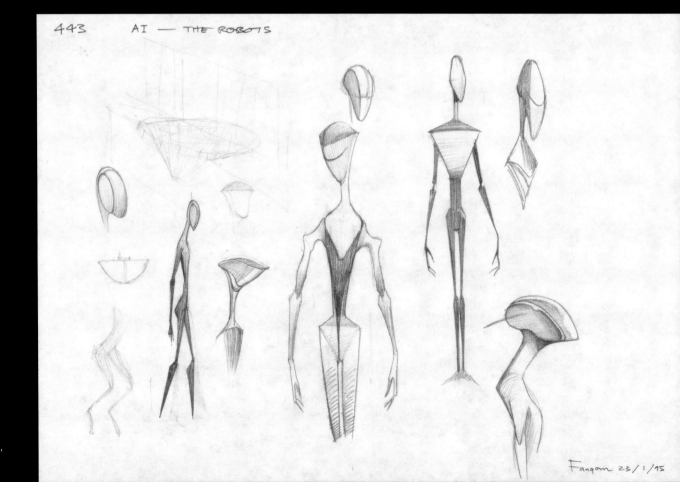

443 AI — THE ROBOTS

RIGHT AND OPPOSITE **Chris Baker's** drawings and annotations for the future robots, featuring ideas of a shared consciousness, hard porcelain-like exteriors, and internal circuitry. All featured in the final film.

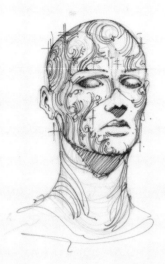

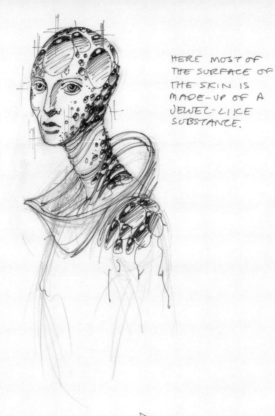

HERE MOST OF
THE SURFACE OF
THE SKIN IS
MADE-UP OF A
JEWEL-LIKE
SUBSTANCE.

IT MIGHT BE INTERESTING FOR THE
SKIN TO BE CONSTANTLY CHANGING
ITS APPEARANCE OR HAVE A STRANGE
LIQUID MARBLE LOOK TO IT.

Fangorn 5/9/95

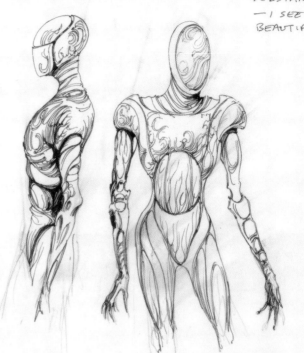

IN THIS CASE THE ROBOTS APPEAR
TO BE MADE OF A HARD SHINY
SUBSTANCE LIKE PORCELAIN
— I SEE THEM AS BEING QUITE
BEAUTIFUL.

Fangorn 5/9/95

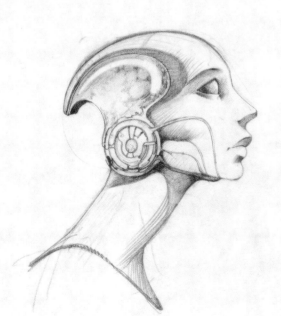

JUST RECENTLY A FEW
FURTHER IDEAS FOR
THE ROBOTS HAVE BEEN
FLOATING AROUND IN
MY HEAD, SO I THOUGHT
I'D GET THEM DOWN
ON PAPER WHILST
THEY WERE STILL
THERE.

THERE IS AN ARGUMENT
THAT THERE IS NO REAL
REASON WHY, EVEN THOUSANDS
OF YEARS INTO THE FUTURE,
THE ROBOTS FACIAL
FEATURES WOULD CHANGE
RADICALLY AND TO ALL
SENSE AND PURPOSES
ONLY THERE DRESS
WOULD CHANGE

Fangorn 17/11/95

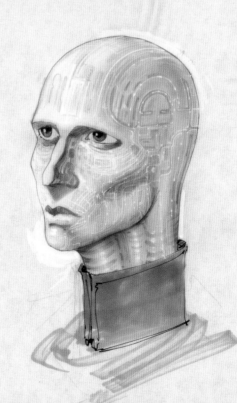

TOOK ME A WHILE TO GET
THE EFFECT THAT I WANTED
WITH THIS ONE.
THE ROBOT IS ESSENTIALLY VERY
HUMAN TO LOOK AT HOWEVER
THE SKIN IS SLIGHTLY
TRANSLUCENT ALLOWING US
TO SEE AN AMAZING NETWORK
OF MICRO CIRCUITRY THAT
LOOKS ALIVE. TINY PINPOINTS
OF LIGHT CAN BE SEEN
TRAVELLING ALONG A
FILIGREE OF WHAT MIGHT BE
FIBRE OPTICS.
I SEE THIS AS BEING A
VERY SUBTLE EFFECT —
MORESO THAN I'VE
INDICATED.

Fangorn 20/11/95

BELOW **Aaron Sims** develops Chris Baker's designs at Stan Winston Studio.

BELOW **One of** Aaron Sims's digital creations of a SuperMecha, which was then passed to ILM.

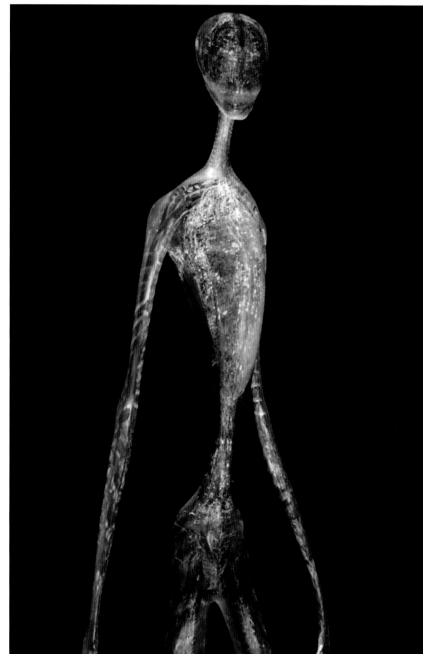

BELOW **Film still** of the final SuperMecha design, following ILM's additions of subtle facial features and moving internal circuitry.

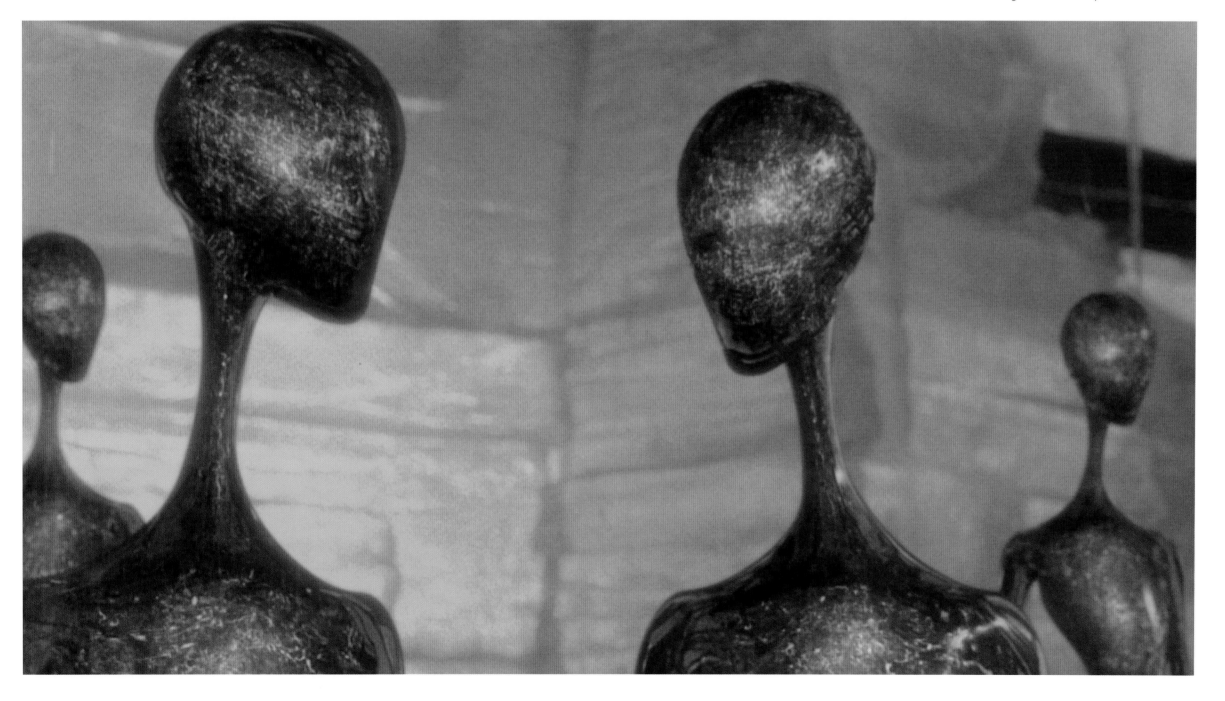

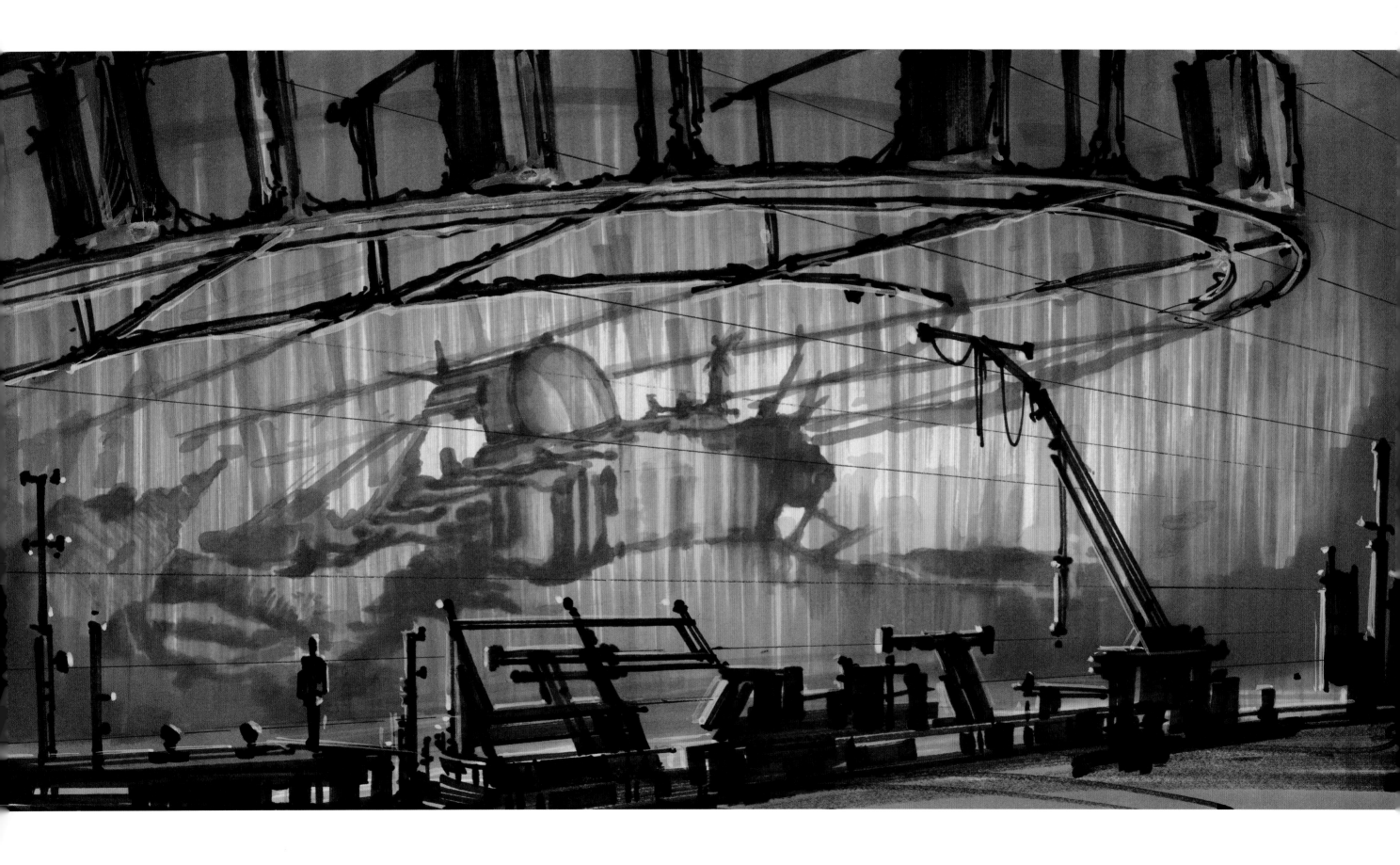

THE BLUE FAIRY

Having been revived by the SuperMechas and freed from the trapped amphibicopter, David is finally able to approach the Blue Fairy. This is the moment he has been waiting for for two thousand years. But as soon as he touches her, she shatters – and with her shatters his two-thousand-year-old dream of being made real.

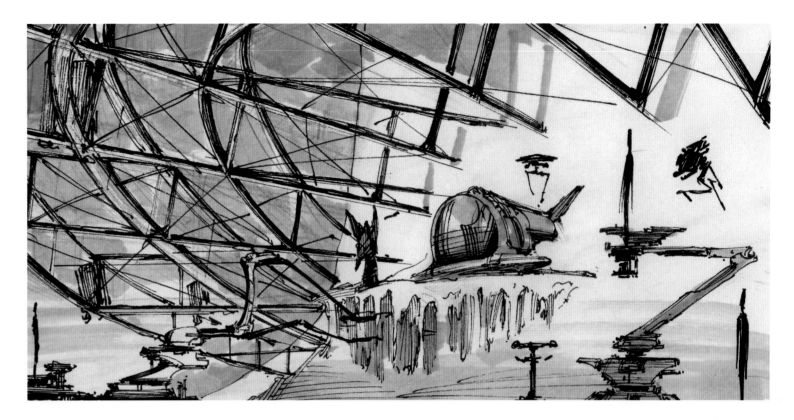

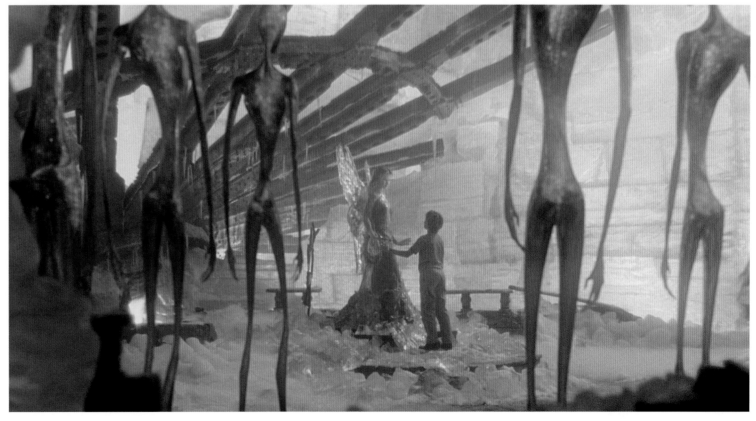

OPPOSITE **Chris Baker's drawing** showing the Ferris wheel only partially dug out of the ice.

ABOVE RIGHT **Chris Baker's artwork** showing the amphibicopter resting in front of the Blue Fairy.

RIGHT **Film still** of the excavation site. Rather than using fake ice, the production used eight tons of real ice a day. Every morning, three hours before shooting, real ice was brought to the constructed set in order for it to melt, realistically.

"—AND WE MUST AVOID
TRAUMA

"——WE MUST PROVIDE A
BENIGN FAMILIAR
ENVIRONMENT, AND A
GUIDE-FIGURE....."

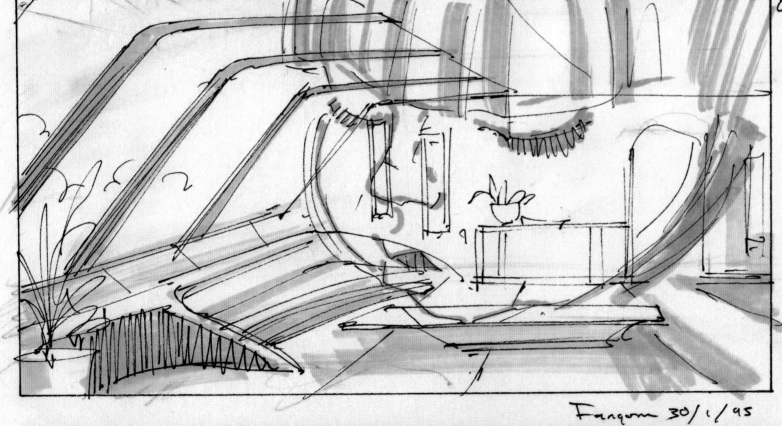

AT THIS POINT I IMAGINE
THERE COULD BE A
DISSOLVE TO THE
DUPLICATE SWINTON
APARTMENT.

Fangorn 30/1/95

ABOVE **Chris Baker's artwork** for the link from
David's discovery to the Swintons' home.

DAVID'S MEMORIES

The SuperMechas download David's millennia-old memories, and are thus able to reconstruct the Swintons' apartment, the locus of his heart's desire. When we emerge from the white-out of the close-up on his face, we are back in the apartment as he remembers it.

' We'll scan his mind. '
' We'll provide a familiar environment. '
' Yes, indeed. And a guide; he'll need a guide. '

IAN WATSON, STORY TREATMENT

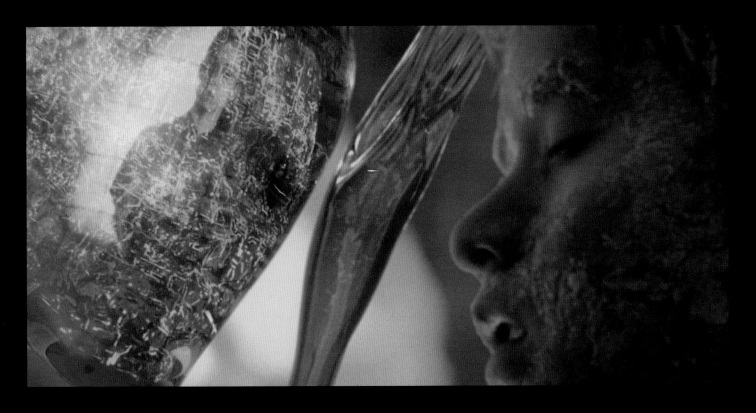

ABOVE **Film still** showing the robots tapping into David's two thousand-year-old memories.

ABOVE **Film still** showing the moment when we enter David's subconscious. Soon his dreams will be externalized in the SuperMechas' simulator, as created by them from his memories.

THE HOMECOMING

In the Swintons' apartment, David hopes to be with his mother again. He hears a voice calling his name and runs to the lounge to find the beautiful Blue Fairy waiting for him. She explains that, in order to bring back Monica, the SuperMechas will need her DNA. Teddy has kept her lock of hair, and so Monica can return. David re-lives scenes from past events to construct the one perfect day with his mother that ends with his ultimate wish – his mommy telling him she loves him.

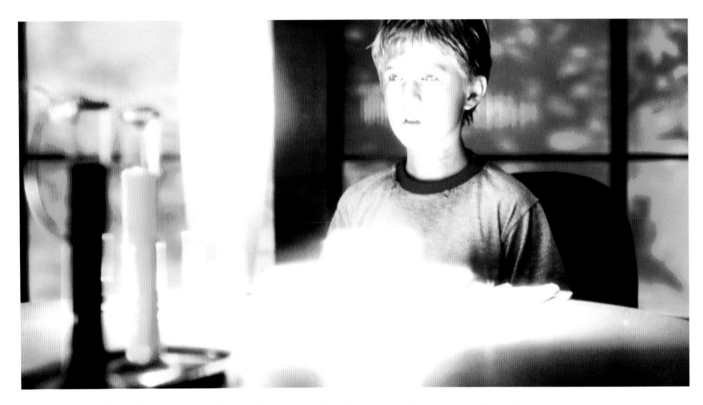

ABOVE **Film still** of David's return to the Swintons' apartment. For this sequence the colours are hyper-intense.

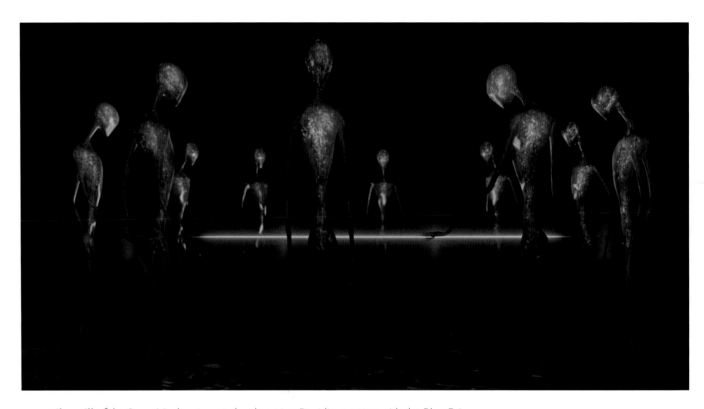

ABOVE **Film still** of the SuperMechas in a circle, observing David's meeting with the Blue Fairy.

' "Teddy, we're home!" exclaimed David, staring around the familiar lounge.... This was home, perfect home.'

IAN WATSON, STORY TREATMENT

' A new morning has come. Go to her, David. She's just waking up this instant. '

STEVEN SPIELBERG, SCREENPLAY

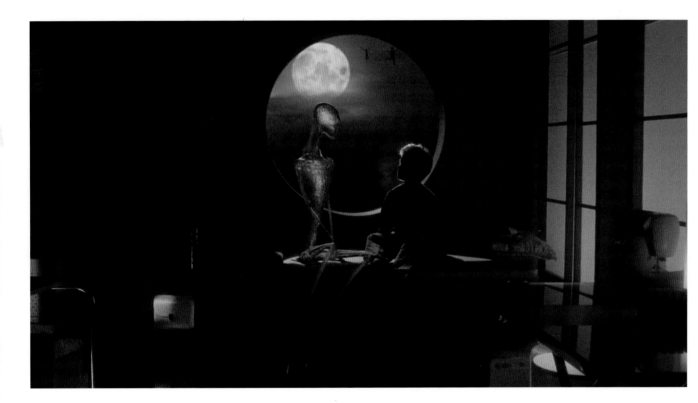

ABOVE **Film still** showing The Specialist explaining to David that Monica can only be resurrected for one day.

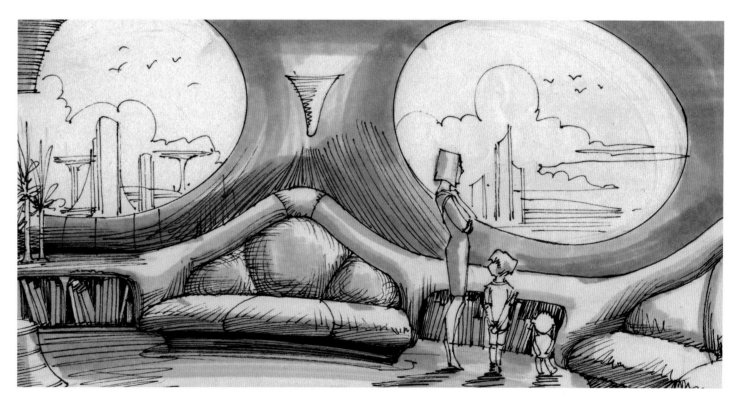

ABOVE **Chris Baker drawing** showing Monica, David and Teddy in the apartment.

"Such a beautiful day.... I do love you, David... I do love you... I do love you." That was the everlasting moment he had been awaiting during all of two thousand years. But already this moment had passed, for Monica was sound asleep — more than merely asleep: should he shake her, she would not, could never, rouse.'

IAN WATSON, STORY TREATMENT

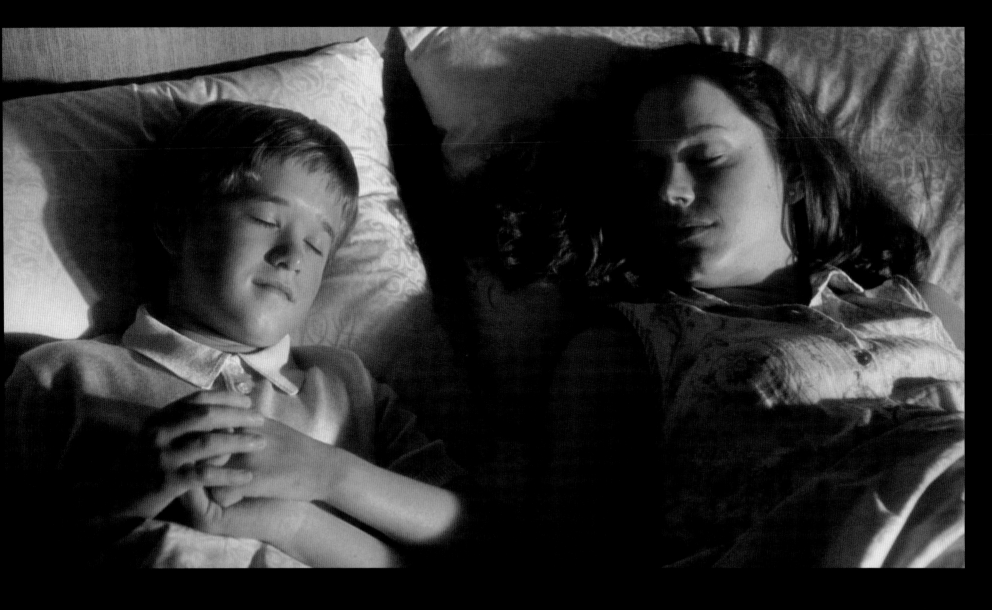

LEFT **Film still** of the SuperMechas' fairy-tale ending: David's transcendence to the state of a real, dreaming boy. For the first time in his life he falls asleep and goes 'to the place where dreams are born'.

RIGHT **Chris Baker concept drawing and film still**.
In the film, the camera pulls back to reveal the
simulation of the apartment. Outside of this
perfect simulated moment, David is motherless,
in a frozen world, two thousand years in the future.

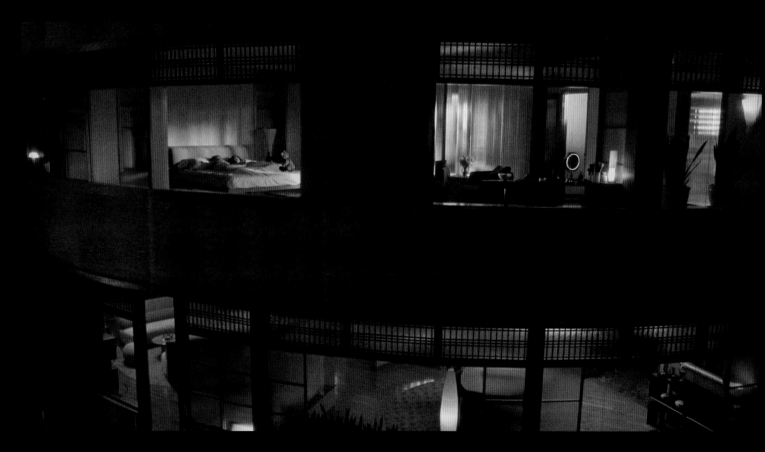

Afterword: The Two Masters

I have often been asked: 'Why was Stanley Kubrick so interested in this strange story?' The question is usually put with some bewilderment, or implication that it was an extremely unlikely choice. If I succeeded in answering to the satisfaction of the questioner, the follow-up was usually: 'But what would Kubrick have said about Steven Spielberg's version?' – insinuating that he couldn't possibly have been satisfied with the result....

Stanley had fallen in love with Brian Aldiss's short story 'Super-Toys Last All Summer Long' many years before he started to seriously prepare his film. Here was a subject that allowed him to add yet another genre to his repertoire – the Futuristic Fairy Tale – focusing on the dark side of human nature. To Aldiss's short story he added elements of the children's classic *Pinocchio*, in order to build the fairy-tale envelope around his grim subject. Working with his writers, he developed further ideas. Figuring prominently in Ian Watson's story treatment is a grotesque version of the universal human need for a scapegoat – of central importance in the justification of the most hideous crimes committed by man against his fellow men. This culminates in the sadistic destruction of man-made robots, held responsible for the grievances of the unemployed and unemployable masses. But those robots do not just represent the new working class; they have become the new sex slaves, tending to man's and woman's every sexual whim and fantasy. The explosion of pornography – a trend we can well discern in our times – is presented as a matter of fact and without any judgment. Pornographic and suggestive images are everywhere, and were even incorporated in the architecture of whole towns. Chris Baker's fantastic drawings inspired Stanley to elaborate further on this aspect of the story; it was therefore no surprise that Steven Spielberg also included Chris Baker in his art department team, though he softened Chris's hardcore vision of a futuristic Sodom and Gomorrah for a family-movie audience and particularly for any censorship board.

In the final chapter, two thousand years hence, all life on earth is gone. We never learn why and how exactly we become extinct: Stanley would have said, 'How should I know? Anyway, that's detail'. Our disappearance is treated as a given, the result of our relentless working towards our own destruction on this once-flowering and beautiful planet. Now, only the ethereal shapes of robots hover weightlessly above the ice, developed to such a high standard that they are able to function and sustain themselves forever without human help. As they excavate David, our little robot prototype hero, from the ice, they realize that he represents their one link with that long-gone species, humans; and in their gentle, cooperative way they download his infantile memory to their own 'minds' with the admiration and respect this unique 'archaeological' find deserves. Without explanation, it is clear that there is no jealousy or competition between these robots: the elements that were at the root of human self-destruction have vanished with the species.

This is a story of biblical proportions in the guise of a fairy tale – a story for Stanley Kubrick indeed. In *2001: A Space Odyssey* he took a bow to the Unknowable that somehow ensured our survival; in *A.I. Artificial Intelligence*, this dark and bitter story of the future, no such hope exists.

'What would Kubrick have said about Spielberg's version?' He would have been proud of it. Stanley's version was too black and cynical for an expensive film that had to appeal to a broad family audience. Steven had the ability to lighten the tone without changing the substance.

It is the sign of much intelligence and humility when a great artist comes to the conclusion that a colleague would be better suited to take over a story with which he himself has long been involved. Stanley had always admired Steven, whose style was so different from his own. For the same reason, he had also admired Ingmar Bergman, Woody Allen, Edgar Reitz and Carlos Saura, to name just a few. It was this very difference that Stanley felt was needed.

Great artists are generous; they can afford to be. The result was very much what Stanley had hoped for – a true collaboration, even though he was no longer alive to see it. I hope purists will forgive me for comparing this to Beethoven writing variations on a theme by Mozart.

A.I. Artificial Intelligence chimes with the reality of current developments, including the striving for technical innovation in our society, but it is at the same time an expression of fear about mankind's future. We can only hope that its extraordinary vision will never come true.

JAN HARLAN

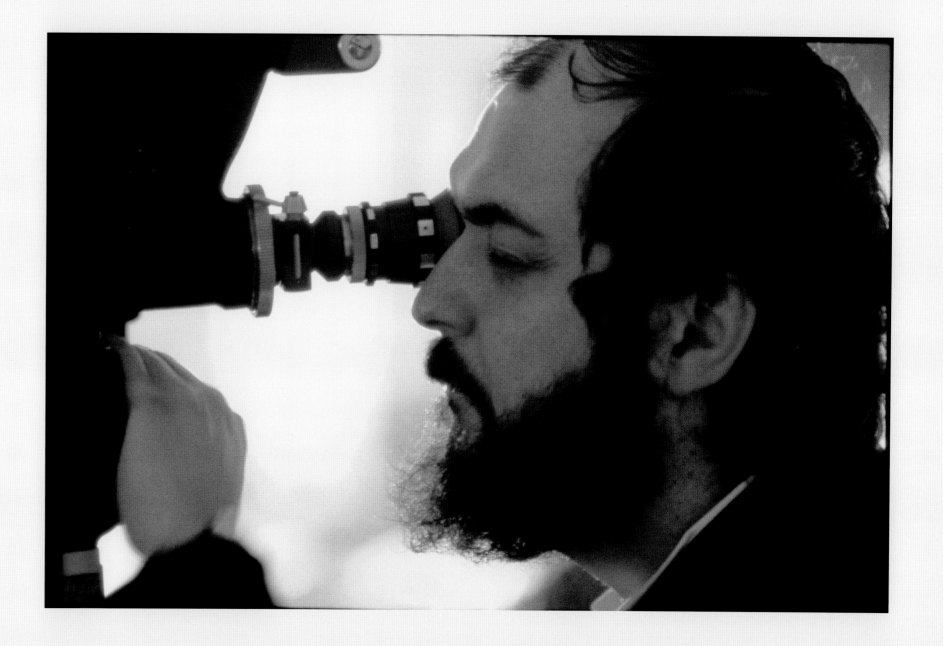

A.I.: Building Robots in Our Image

The dream of building intelligent robots is certainly not new. In fact, it is a uniquely and profoundly human quest. Long before people could build such life-like machines, we told stories about them. As far back as the Ancient Greeks, the idea appears in Homer's *Iliad*, in which Hephaistos, the god of metalsmiths, fashions mechanical helpers – strong, vocal and intelligent maidens of gold. The idea surfaces again in medieval times in the Jewish legend of the Golem, a robot-like servant made of clay brought to life by Rabbi Loew of Prague. We created these myths both to inspire as well as to warn ourselves of the danger of creating something we are not able to control.

As technology advanced, we began to build more life-like machines. In 1739, for instance, in response to the eighteenth-century craze for animated objects, Jacques de Vaucanson created the famous mechanical duck that could flap its wings, eat and 'digest' grain. About a hundred years later, Joseph Faber invented Euphonia, a mechanical talking head that an operator could reputedly make speak in several European languages. These antique automata were built to instil a sense of wonder in the audience, and in some cases to try to understand ourselves through the creation of mechanical simulations of behaviour.

By the late 1800s Charles Babbage and Ada Byron had invented the Analytical Engine, the first machine to perform complex mechanical computations. Its descendant, the ENIAC computer – the first large-scale, general-purpose, electronic, digital computer – was invented in 1946. Just a few years later, in 1950, the famous British mathematician, Alan Turing, wrote a provocative paper entitled 'Computing Machinery and Intelligence', in which he discussed the possibility of building machines that could think and learn, and outlined a test – the 'imitation game', later known as the Turing Test – to determine whether or not a machine could really think. That same year, Isaac Asimov published his famous three Laws of Robotics: 1. A robot may not injure a human being or, through inaction, allow a human being to come to harm; 2. A robot must obey orders given to it by human beings, except where such orders would conflict with the First Law; 3. A robot must protect its own existence, as long as such protection does not conflict with the First or Second Law.

The field of Artificial Intelligence (A.I.), established in 1956, has changed our world forever. Today, computers coordinate and schedule complex flight plans for the airline industry, vehicle navigation systems are commonplace, and millions of people use search engines daily to find information on the World Wide Web.

These and many other A.I. applications have performed sophisticated tasks that have made our lives more productive and manageable. It is important to recognize the vast success of A.I. in our everyday lives, even though we have yet to see real-world versions of intelligent computers such as HAL from *2001*, or droids from *Star Wars*, or the android Astro Boy from the classic Japanese comic.

Such iconic characters, however, continue to inspire generations of scientists and engineers to create real-world intelligent robots. Some now perform dangerous tasks, such as helping scientists to explore ocean depths or other planets. Other robots take more familiar forms, including the Roomba vacuum cleaner, of which over 2.5 million units have to date been sold, or Stanley, the self-driving car that won the DARPA Grand Challenge and is ushering in a future of autonomous vehicles with the promise of reducing traffic congestion and air pollution. Meanwhile, research labs are inventing robotic technologies to help address the challenges posed by a global ageing society to enable the elderly to live independently longer and to provide them with adequate care despite an anticipated shortage of eldercare professionals. In the movie *A.I.*, it was an environmental catastrophe brought on by global warming and climate change

that led to the widespread commercialization and deployment of intelligent robots in society. Climate change remains a significant concern of governments all over the world. Today, there exist numerous societal challenges over the coming decades that could dramatically increase global demand for personal and service robots.

In an effort to build robots that can carry out more sophisticated tasks in more complex environments, an increasing number of A.I. and robotics researchers are looking to nature for inspiration and guidance. Living creatures exhibit impressive agility, robustness, flexibility, efficiency, and the ability to learn and adapt as they go about the complex business of surviving in the real world. As a result, modern autonomous robots – inspired by a myriad of creatures ranging from insects to fish, to reptiles, to birds, to mammals, including humans – are becoming more life-like in their morphology and their movement. Even their software is beginning to resemble the organization and functionality of central nervous systems as these robots must perceive, interpret, respond and adapt to their environment.

Beyond robustness and proficiency in the physical world, the ability of these robots to partake in the daily lives of people is pushing robotics and A.I. research in new directions. Whereas robotics has traditionally focused on developing machines that can manipulate and interact with *things*, the promise of personal robots challenges us to develop robots that are adept in their interactions with *people*. In research labs across the globe, scientists have begun to build robots that are increasingly capable of interacting and communicating with people through speech, gesture and emotive expression. Progress continues in building robots that can learn from people, either through observation or direct tutelage. Modern robots are beginning to participate as members of human–robot teams to cooperate with people to achieve shared goals. Furthermore, as people begin to interact with robots more closely, it is important that robots' behaviour and rationale be easily understood. The more these mirror natural human analogs, the more intuitive it becomes for us to communicate and interact with robots. Hence, in dramatic contrast to the traditional view of robots as sophisticated tools that we use to do things *for* us, this new generation of socially intelligent robots are envisioned as partners that collaborate to do things *with* us.

What issues will confront us as we try to humanize the relationship between human and machine? Humans are the most socially and emotionally advanced of all species. Furthermore, it takes years for humans to develop these competencies fully from repeated encounters with others. The idea of directly programming this vast repertoire of skills, abilities and knowledge into a robot is a daunting task, if not impossible. Where might we possibly begin?

As a doctoral student at MIT Artificial Intelligence Lab, I began to implement a strategy of modelling (at least aspects of) the simplest human possible – namely, an infant. I then played the role of 'caregiver' for my robot 'baby'. The robot baby, Kismet, was the first ever developed to explore interpersonal social-emotional interaction and communication with people. It was pioneering work that broke new ground into a new area of inquiry called 'social robotics'.

Guided by insights and theories from developmental psychology, the scientific goal was to explore how a robot might learn and develop social skills and abilities through interaction with adults, mirroring infant social development. And, as any parent knows, it begins with face-to-face interactions and the sharing of emotion. Of course, this posed the fascinating question of what it would mean to model emotions (or at least emotion-inspired behaviours) in a robot to enable it to participate in similar kinds of infant–caregiver exchanges that make social and emotional development possible.

Endowing robots with emotion-inspired abilities is also fascinating from a learning perspective. Today, people expect robots to learn a specific task very quickly and efficiently (if they expect a robot to learn at all). But look at the way infants learn: it's opportunistic, curiosity-driven, creative and serendipitous. Even very young children are naturally motivated to learn. They actively seek novelty to push the boundary of what they know. They experience pleasure upon mastering something and bringing about the expected outcome. We need to make robots that can learn in a much more open-ended fashion if robots are going to be able to grapple with the full complexity of the world around them. How might we instil robots with a sense of exploratory curiosity and creativity? These qualities lie at the intersection of emotion and cognition, and both are deeply intertwined in the way children learn. Much of my original inspiration for building Kismet was to explore this kind of learning robot.

And, as fate would have it, my work with Kismet – a robot baby that I was willing to nurture – would ultimately get me involved with the movie *A.I.* Of course, it is purely coincidence that my work with Kismet shares so many parallels with the character of David. Both of these robots are inspired by children – how children learn and mature, and how they become part of the human community. Whereas a robot like David challenges us to consider the societal

implications and our responsibility to such an achievement, Kismet is the first physical instantiation, quite primitive when compared to David, but a significant first step in endowing robots with social and emotional qualities.

Science-fiction robots like David, or even Teddy, become mirrors that we use to reflect upon our own humanity. This raises profound questions about whether machines can ever have emotions, or empathize, or relate to others and form genuine friendships. I adored the character of Teddy, the little robot bear who established a genuine friendship with David (despite the fact that supposedly only David was capable of feeling love). If Teddy was not capable of love, empathy or friendship, then why was this little robot so devoted to caring for and helping David in his quest to become 'real'? What ultimately matters when we make a judgment as to the authenticity of the emotion or friendship of another? Is it how they treat us? Is it how these attributes are implemented in biological (or silicon) brains? Is it how such things are grounded in experience? How human-like does the exchange have to be? If we are willing to grant other species with genuine emotion – e.g., dogs with dog emotions, dolphins with dolphin emotions, etc. – then are we willing to grant robots with robot emotions? If so, then what is robot emotion? And what is the nature of the emotion or relationship that it might evoke in us?

My research with Kismet was discovered by Kathleen Kennedy (a producer of *A.I.*) via a *TIME* magazine article. I was invited to serve as a scientific consultant for the promotional phase of the project. In effect, my job was to field the questions raised by the media regarding the themes of the movie, the state of Artificial Intelligence and robotics, and what we might expect in the future.

I took the opportunity to ask Kathleen Kennedy if she could arrange an introduction to Stan Winston, the pre-eminent special-effects animatronics expert. Stan Winston Studio created Teddy and the other robots in the movie. The timing was fortuitous, as my research with Kismet was ending and I was just starting the transition from finishing my doctoral research to beginning my career as an assistant professor at the MIT Media Lab. I was looking to build my next robot, and I pitched the idea to Stan that we should build Teddy for real – to forge a collaboration that combined expertise in building highly expressive animatronics with state-of-the-art Artificial Intelligence, also extending my work with Kismet. To my surprise, Stan enthusiastically agreed. The reason, which he later told me, was that we actually shared the same ultimate dream – what Stan called building 'a *real* character'.

In the movies, animatronic characters are sophisticated robotic puppets that a team of puppeteers operate to 'bring to life' in front of the camera. It is robot-mediated performance. Once the camera

goes off, however, the character is just a 'dead' machine. In Stan's mind, the ultimate pinnacle of achievement would be to build a robot character whose personality and mental life endured, whether on or off the set. Stan's vision originated from storytelling and performance, mine from science and technology, and we needed each other to realize the dream. The result is 'Leonardo', the most socially intelligent robot in the world today (named after Leonardo da Vinci – the human embodiment of science, art and invention).

Unlike most robots today, which have a mechanical look and feel, Leonardo was designed with a life-like appearance, thanks to the artistry of Stan Winston Studio. Leonardo looks like a furry, fanciful, anthropomorphic creature – a little like a Mogwai such as Gizmo from the 1984 movie *Gremlins*. Leonardo stands about two and a half feet tall, with big brown eyes, and wonderfully expressive ears. It has over seventy points of motion, giving it more expressive range than any other robot today. Half of the motors are in its head for facial expression. Stan and I called Leonardo the 'Stradivarius' of robots.

Stan's role was to create the magnificently expressive body – the most complex his studio had ever attempted. But rather than have a team of human puppeteers bring Leonardo to life, my role was to breathe 'life' into the robot through a sophisticated ensemble of sensors, networked computers and A.I. algorithms,

to enable Leonardo to perceive the world around 'him', to think, to learn, and to communicate and interact with people. With the assistance of my team of talented graduate students, my work with Leonardo made significant advancements beyond Kismet. Leonardo has been able to demonstrate a range of abilities to collaborate with people as an ally, to learn from human tutelage, to respond to simple spoken phrases, and to communicate using gesture, eye contact, facial expression and other non-verbal cues. Perhaps the most significant advancement is endowing Leonardo with a theory of other minds – to begin to understand people not only in terms of observable actions, but also in terms of our mental states (e.g., beliefs, intentions, goals, feelings, desires, and more).

Along with the practical reasons for building personal robots that are socially savvy and emotionally adept is the other powerful motivating factor – the scientific quest to better understand ourselves. Through the process of building a synthetic creature, adapting scientific models and theories of natural intelligence to a robotic instantiation, we come to a deeper appreciation and understanding of our impressive abilities. It is in this spirit that I pursue my own work in building social robots. Robots such as Kismet and Leonardo serve as a mirror, reflecting our humanity back at us as we interact with them and they engage us. As we look into these mirrors, we can better see ourselves – scientifically,

socially and ethically. Science fiction does the same through a different medium.

It is easy to predict that robots will continue to become more intelligent and more life-like. There are plenty of economic, scientific, technological and human motivations to continue this trend. These robots will never be human, but that is not the point. The question is whether some day our synthetic progeny might cross the threshold from the inanimate to the 'thinking and feeling', from being an automaton to becoming something that challenges us to grant it the status of personhood. There is a long way to go, but robots like Kismet and Leonardo are real-world examples that are starting to challenge us to consider the boundary. This possibility poses many intriguing and important questions about our humanity, where we are going as a species, and what kind of society we want to create for ourselves.

What distinguishes 'us' from 'them'? Humankind has steadily been retreating from our notion of specialness for hundreds of years. Science has shown us that we are not at the centre of our solar system, that we share a surprising percentage of our genome with other species, that certain animals (and certain machines) are also able to use tools, communicate with language, and solve cognitive problems in at least limited ways. Now technology is even entering into the social and the emotional realms, as computers

Stan Winston and Cynthia
Breazeal with Leonardo, 2006

begin to recognize facial expressions and reason about socio-emotional states of people.

Meanwhile, robots are slowly becoming more like us, acquiring more human qualities and competencies. Robots may eventually incorporate more biological technologies to leverage from biochemical processes, such as the ability to self-repair. Research in genomics and genetic engineering is making impressive progress. Meanwhile, we strive to enhance ourselves by integrating technology into our lives and even into our bodies and brains. Technological visionaries argue that we are well on the path to becoming cyborgs, replacing more and more of our biological matter with technologically enhanced counterparts. Will we still be human? What does it mean to be human? What do we want to preserve of our humanness? What are the implications for granting the status of personhood?

Were robots to become sentient, how would we recognize it? Today there is no standard empirical measure for consciousness. Instead, we just seem to know it when we see it. We assume other people are conscious like ourselves because they are like us. As robots become more socially and emotionally intelligent, their behaviour will more convincingly suggest that they are sentient in broader and more complex contexts. As the well-known technologist Ray Kurzweil sometimes quips, just as you might become annoyed if someone refuses to recognize that you're conscious, these robots may feel the same. In time, their behaviour may never suggest otherwise. At this point, would they be 'real' or just an imitation of the 'real' thing? Should we be so prejudiced against their genuineness because they are – at least partially – inorganic?

I predict that just as there remains open debate as to whether and how animals are conscious, it will be the same for robots once we seriously begin to wonder. But in daily life we will treat them as if they are because that will be the most natural way for us to interact with them. To what extent and under what conditions, however? Will we accept them into the human community and treat them with respect; shun them as in Mary Shelley's *Frankenstein* and deny them personhood; or perhaps something in between? Will we grant them certain rights and privileges? If so, we must hold them responsible and accountable for their actions. These are not black and white issues.

I am heartened to have seen so many people respond to Kismet and Leonardo with such tenderness, compassion and kindness. If Kismet and Leonardo mark a new chapter in this profoundly human story of building robots in our image, then I hope we will all remember that it began with people experiencing and demonstrating these noble human qualities. I do not know if or when we will create robots that will challenge our intellect and emotions to the extent that David does in *A.I.* But I think it is worthwhile to keep our minds and hearts open to the possibility. How we perceive our humanity will be reflected in how we treat the robots in our midst.

Respected philosophers, theologians, scientists, technologists, ethicists and artists already ponder these questions. The movie *A.I.* raises them in staggering visuals and special effects. These are questions not just for the experts; they are for everyone, and especially for our children. The generations of A.I. and robotics researchers yet to come will be those who create intellectually intriguing and beautifully poetic synthetic entities of the future. Invent well. This is a journey that requires stewardship so that we may progress with wisdom, respect, sensitivity and a sense of responsibility towards all our children – whether biological, synthetic, or some wonderful combination of the two.

DR CYNTHIA BREAZEAL
DIRECTOR, PERSONAL ROBOTS GROUP
MIT MEDIA LAB

Notes

Page 2

Stanley Kubrick quotation taken from *Stanley Kubrick, Director: A Visual Analysis* by Ulrich Ruchti, Sybil Taylor and Alexander Walker, W. W. Norton & Company, 2000, p. 32

Birth of *A.I.*

1. Brian Aldiss, *Supertoys Last All Summer Long and Other Stories of Future Time*, Orbit, 2001, p. xvi
2. Penelope Houston, 'Kubrick Country' (1971), in Gene D. Phillips (ed.), *Stanley Kubrick: Interviews*, University Press of Mississippi, 2001, p. 114
3. Ulrich Ruchti, Sybil Taylor and Alexander Walker, *op. cit.*, p. 13
4. Quoted paragraphs from Bruno Bettelheim's *The Uses of Enchantment: The Meaning and Importance of Fairy Tales*, Alfred A. Knopf, 1976, were underlined or marked up by Stanley Kubrick.
5. Bruno Bettelheim, *ibid.*, p. 145
6. Ulrich Ruchti, Sybil Taylor and Alexander Walker, *op. cit.*, p. 47
7. Bruno Bettelheim, *op. cit.*, p. 179
8. Anthony Frewin (ed.), *Are We Alone? The Stanley Kubrick Extraterrestrial-Intelligence Interviews*, Elliot & Thompson, 2005, p. 109
9. Joseph Gelmis, 'The Film Director as Superstar: Stanley Kubrick' (1970), in Gene D. Phillips (ed.), *op. cit.*, p. 95
10. Marvin Minsky, *The Society of Mind*, Simon & Schuster Paperbacks, 1988, p. 163
11. Anthony Frewin (ed.), *op. cit.*, p. 162
12. Anthony Frewin (ed.), *op. cit.*, pp. 38, 101–102
13. Anthony Frewin (ed.), *op. cit.*, p. 168
14. 'In 2001, Will Love Be A Seven-Letter Word?', *New York Times*, April 14, 1968
15. Quoted paragraphs from Hans Moravec's *Mind Children: The Future of Robot and Human Intelligence*, Harvard University Press, 1988, were underlined or marked up by Stanley Kubrick.
16. Hans Moravec, *ibid.*, p. 1
17. Hans Moravec, *ibid.*, p. 112
18. Hans Moravec, *ibid.*, p. 4
19. Ulrich Ruchti, Sybil Taylor and Alexander Walker, *op. cit.*, pp. 30–31
20. Ulrich Ruchti, Sybil Taylor and Alexander Walker, *op. cit.*, p. 187
21. 'In 2001, Will Love Be A Seven-Letter Word?', *New York Times*, *op. cit.*
22. Arthur Koestler, *The Ghost in the Machine*, Pan Books, 1971, p. 11. Koestler explains that the evolution of our brains happened so quickly that there is insufficient co-ordination due to a missing link between the primitive brain (archicortex), containing primary emotions that were imperative to our survival, and the 'new' intellectual brain (neocortex). Koestler argues that it is this 'malfunction' that manifests itself in our delusional and paranoid streak which is evident throughout our history, in particular its representation in militarism, extreme beliefs in oppressive regimes, and war, most of which, he argues, are generated by collective delusions generated by emotion-based belief systems.
23. Arthur Koestler, *ibid.*, p. 379
24. Hans Moravec, *op. cit.*, p. 149
25. Hans Moravec, *op. cit.*, pp. 123–24
26. Marcel Proust, *Remembrance of Things Past* (trans. C. K. Scott Moncrieff), Vol. 1, Wordsworth Editions, 2006, p. 1169
27. Renate Bartsch, *Memory and Understanding: Concept Formation in Proust's 'A La Recherche du Temps Perdu'*, Advances in Consciousness Research No. 63, John Benjamins Publishing Company, 2005, p. 104.

The Arrival

1. Carolyn Jess-Cooke, 'Virtualizing the Real: Sequelization and Secondary Memory in Steven Spielberg's *Artificial Intelligence: A.I.*', *Screen*, Vol. 47, No. 3, Autumn 2006, Oxford Journals, Oxford University Press, p. 349
2. Renate Bartsch, *op. cit.*, pp. 56–57
3. Carolyn Jess-Cooke, *op. cit.*, p. 352

The Journey

1. Michel Ciment, *Kubrick: The Definitive Edition*, Faber and Faber, 2003, p. 92
2. Carlo Collodi, *Pinocchio* (trans. E. Harden), Puffin Classics, 1996, p. 8
3. Brian Aldiss, *op. cit.*, p. xviii
4. Brian Aldiss, *op. cit.*, pp. 33, 34

The Discovery

1. Bruno Bettelheim, *op. cit.*, p. 127
2. Ulrich Ruchti, Sybil Taylor and Alexander Walker, *op. cit.*, p. 191
3. Ulrich Ruchti, Sybil Taylor and Alexander Walker, *op. cit.*, p. 187
4. Hans Moravec, *Robots: Mere Machine to Transcendent Mind*, Oxford University Press, 2000, pp. 167–68. In mid-1993 Stanley Kubrick contacted Hans Moravec, as he had read that Moravec was working on a new book entitled *Mind Age: Transcendence through Robots*. From June 1993 to May 1994, Moravec sent Kubrick his early transcripts, chapter by chapter (eventually published as *Robots: Mere Machine to Transcendent Mind*, with additional chapters, in 1999). The book elaborates on the ideas discussed in *Mind Children*, but also introduces the idea of entire worlds being absorbed into and resurrected in a future cyberspace, whereupon our ethereal grandchildren will be able to replay world histories, scenes and individual lifetimes in numerous variations in full living detail.

Further Reading

Archive material
Story treatments by Brian Aldiss, February 1990–April 1990
Foxtrot by Ian Watson, April 1990
Story treatments by Ian Watson April 1990–January 1991
Two story treatment synopses by Ian Watson, June 1991
Stanley Kubrick's notebooks, 1993–1994
Story treatments by Sara Maitland, May 1994–February 1995

Books
Aldiss, Brian, *The Moment of Eclipse*, Faber and Faber, 1970
——, *Supertoys Last All Summer Long and Other Stories of Future Time*, Orbit, 2001
Asimov, Isaac, *The Complete Robot*, Doubleday and Company, 1982
Bartsch, Renate, *Memory and Understanding: Concept Formation in Proust's 'A La Recherche du Temps Perdu'*, Advances in Consciousness Research No. 63, John Benjamins Publishing Company, 2005
Bettelheim, Bruno, *The Uses of Enchantment: The Meaning and Importance of Fairy Tales*, Alfred A. Knopf, 1976
Ciment, Michel, *Kubrick: The Definitive Edition*, Faber & Faber Inc., 2003
Collodi, Carlo, *Pinocchio* (trans. E. Harden), Puffin Books, 1996
Duncan, Jody, *The Winston Effect: The Art and History of Stan Winston Studio*, Titan Books, 2006
Frewin, Anthony (ed.), *Are We Alone? The Stanley Kubrick Extraterrestrial-Intelligence Interviews*, Elliot & Thompson, 2005
Good, I. J. (ed.), *The Scientist Speculates: An Anthology of Partly-Baked Ideas*, Basic Books, Inc., 1962
Herr, Michael, *Kubrick*, Picador, 2000

Koestler, Arthur, *The Ghost in the Machine*, Pan Books, 1971
Kolker, Robert, *A Cinema of Loneliness*, Oxford University Press, 2000
Kolker, Robert (ed.), *Stanley Kubrick's '2001: A Space Odyssey': New Essays*, Oxford University Press, 2006
Kubrick, Christiane, *Stanley Kubrick: A Life in Pictures*, Little, Brown, 2002
Minsky, Marvin, *The Emotion Machine: Commonsense Thinking, Artificial Intelligence, and the Future of the Human Mind*, Simon & Schuster Paperbacks, 2007
——, *The Society of Mind*, Simon & Schuster Paperbacks, 1988
Moravec, Hans, *Mind Children: The Future of Robot and Human Intelligence*, Harvard University Press, 1988
——, *Robot: Mere Machine to Transcendent Mind*, Oxford University Press, 2000
Phillips, Gene D., *Stanley Kubrick: A Film Odyssey*, Popular Library, 1975
Phillips, Gene D. (ed.), *Stanley Kubrick: Interviews*, University Press of Mississippi, 2001
Proust, Marcel, *Remembrance of Things Past* (trans. C. K. Scott Moncrieff), Vols 1 and 2, Wordsworth Editions, 2006
Ruchti, Ulrich, Sybil Taylor and Alexander Walker, *Stanley Kubrick, Director: A Visual Analysis*, W. W. Norton & Company, 2000
Stork, David G. (ed.), *HAL's Legacy: 2001's Computer as Dream and Reality*, MIT Press, 2000
Wimmers, Inge Crosman, *Proust and Emotion: The Importance of Affect in 'A La Recherche du Temps Perdu'*, University of Toronto Press, 2003

Articles
Fordham, Joe, 'Mecha Odyssey', *Cinefex*, 87, October 2001
Holben, Jay, 'Boy Wonder', *American Cinematographer*, Vol. 82, No. 7, July 2001

Jess-Cooke, Carolyn, 'Virtualizing the Real: Sequelization and Secondary Memory in Steven Spielberg's *Artificial Intelligence: A.I.*', *Screen*, Vol. 47, No. 3, Oxford Journals, Oxford University Press, Autumn 2006
Kloman, William, 'In 2001, Will Love be a Seven-Letter Word?', *The New York Times*, April 14, 1968
Kreider, Tim, 'A.I. Artificial Intelligence', *Film Quarterly*, Vol. 56, No. 2, 2002
Magid, Ron, 'Views of the Future', *American Cinematographer*, Vol. 82, No. 8, August 2001
Morrison, James C., and George J. Stack, 'Proust and Phenomenology', *Man and World* 1, 1968

Films
A.I. Artificial Intelligence, dir. Steven Spielberg, 2001, © Warner Bros., a division of Time Warner Entertainment Company, LP & DreamWorks, LLC
Stanley Kubrick: A Life in Pictures, dir. Jan Harlan, 2001, © Warner Bros., a division of Time Warner Entertainment Company, LP

Picture Credits

pp. 1, 9, 54, 55, 57, 77, 81 above, 86, 91, 99, 102, 114 © Warner Bros. Entertainment Inc. Photography © Uwe Dettmar; pp. 2, 4–5, 6, 10 right, 11, 13, 14, 15 left, 26–27, 30–31, 36–47, 51 right, 52, 53, 56, 59–61, 68, 69, 71–76, 78–81 below, 83 above left, 84, 85, 87–90, 92–95, 96 below, 97 top and bottom, 98, 100, 101, 103–113, 115 right, 116–121, 126–137, 139–147, 159 © Warner Bros. Entertainment Inc.; p. 10 left © Gerome Gask, Faber and Faber Ltd; pp. 12 Stanley Kubrick note, 1983; 15 above and below right, 16, 18 Stanley Kubrick notebook, December 1993–April 1994; 17, 22, 23 Stanley Kubrick notebook, November 1993 © SK Film Archives, LLC, provided by and reproduced with kind permission of the copyright owner. Photography © Luke Potter; pp. 21, 24 © Warner Bros. Entertainment Inc. Photography © Luke Potter; pp. 48–50, 51 left, 70, 82, 83 below left and right, 138 © Stan Winston Studio, Inc.; pp. 96 above, 97 centre, 115 left © DreamWorks Productions, LLC; p. 149 © SK Film Archives, LLC, provided by and reproduced with kind permission of the copyright owner; p. 154 © Sam Ogden.

Acknowledgments

The editors wish to thank Steven Spielberg for his support and encouragement, and for his foreword to this book.

Thanks also to Jeremy Williams and the legal department of Warner Bros. and DreamWorks in California for removing all barriers.

With thanks to Chris Baker for his beautiful concept artwork and for his enthusiasm for this book.

We also wish to express our gratitude to Brian Aldiss for letting us reproduce here his handwritten notes on the margins of the original short story that inspired the whole project.

This book would not have been possible without the generosity, knowledge and encouragement of the following people: Dr Cynthia Breazeal and Polly Guggenheim at MIT; Rick Carter; Jane Crawford; Uwe Dettmar; Mike Cavanaugh, Tim Everett, Julie Heath, Hal Jones, Joshua Leibig, Adam Ohl and Ned Price at Warner Bros.; Anthony Frewin; Tim Heptner; Tom Linnane; Lindsay Macgowan, Lyn-Del Pederson, Jim Charmatz and Laurie Charcut at Stan Winston Studio; Kristie Macosko and Samantha Becker at DreamWorks; Sara Maitland; Dr Hans Moravec; Dennis Muren and Greg Grusby at ILM; Sam Ogden; Luke Potter; and Ian Watson.

The editors would also like to thank Phil Grosz; Roger Arar and Martyn Goodger; the Stanley Kubrick 1981 Trust; the Archives and Special Collections Centre at University of the Arts London; and the staff at Thames & Hudson.

Jane M. Struthers would like to extend her heartfelt thanks to Jan Harlan and Christiane Kubrick for such an incredible opportunity and experience. She would also like to thank her parents and her brother for their unwavering support.

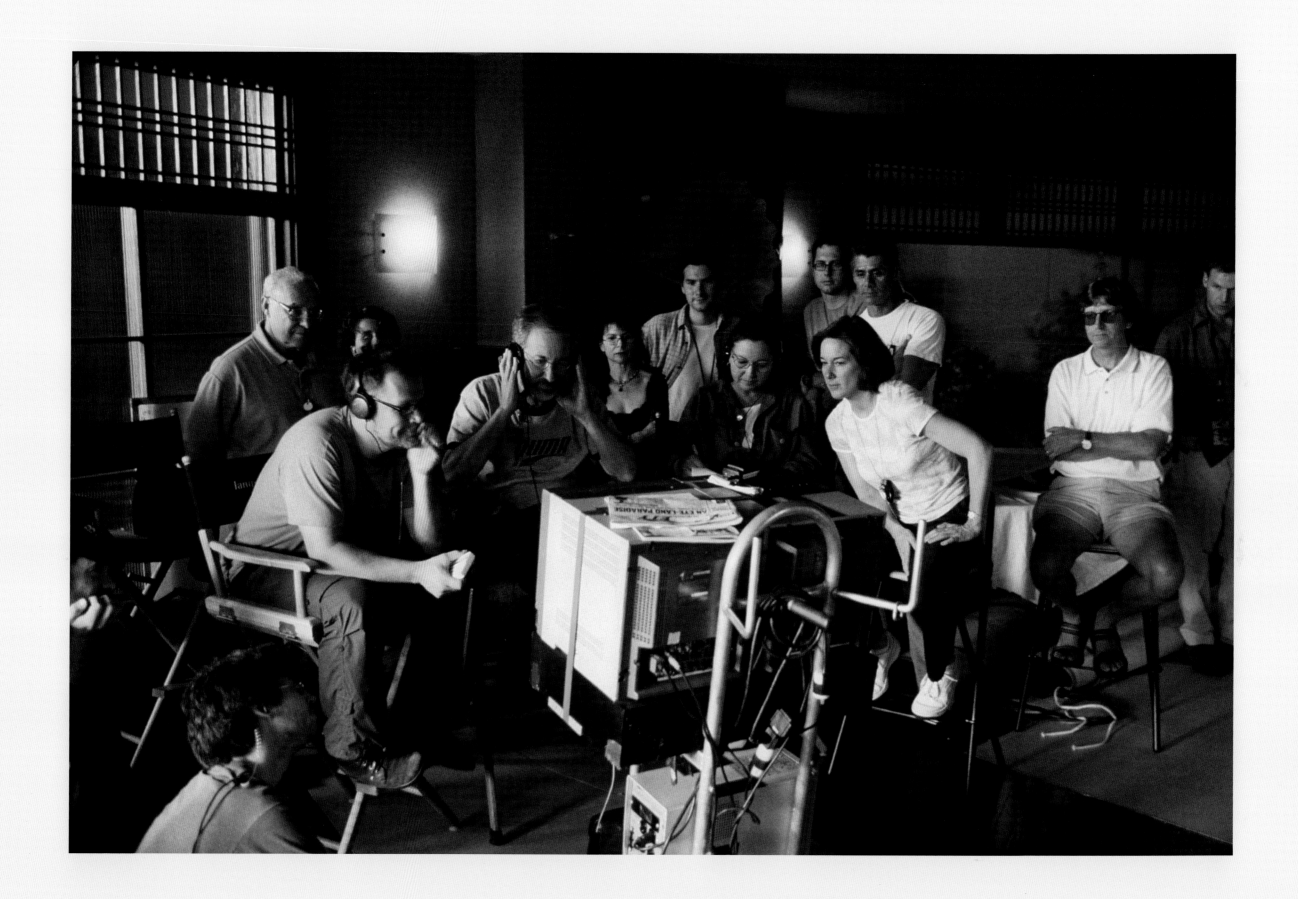

First published in the United Kingdom in 2009 by Thames & Hudson Ltd,
181A High Holborn, London WC1V 7QX

thamesandhudson.com

*A.I. Artificial Intelligence: From Stanley Kubrick to Steven Spielberg: The Vision
Behind the Film* copyright © 2009 University of the Arts London and
Christiane Kubrick

Foreword copyright © 2009 Steven Spielberg
'Blown by a Strong Wind Over the Legal Mountains' and 'Afterword:
The Two Masters' copyright © 2009 Jan Harlan
'The Birth of *A.I.*', 'Part 1: The Arrival', 'Part 2: The Journey' and 'Part 3:
The Discovery' copyright © 2009 University of the Arts London
'Chris Baker's World' copyright © 2009 Brian Aldiss
'A.I.: Building Robots in Our Image' copyright © 2009 Cynthia Breazeal

British Library Cataloguing-in-Publication Data
A catalogue record for this book is available from the British Library

ISBN 978-0-500-51489-4

Printed and bound in China by SNP Leefung Printers Ltd